GREAT-GRANDMOTHER, SIMONE LEIGH AND ELI ALBA... GRANDMOTHER AMELIA GRIFFITH ₪ **IBIYANE: EL**... GRANDFATHER, ROGER NUMA, AND MY PARENTS,... **TANIA DOUMBE FINES** MY MATERNAL GRANDFATHER, BENOIT DOUMBE, AND MY BROTHER, JULIEN FINES DOUMBE ₪ **ISHKA DESIGNS: ANISHKA CLARKE** MY MOM, JOAN JAGARNAUTH, AND MY PATERNAL GRANDFATHER; OSWALD CLARKE. **NIYA BASCOM** ALL MY ANCESTORS, BUT IN PARTICULAR, MY GRANDMOTHER MS. ABBY FREY. AND MY COLLEGE PROFESSOR OF AFRICAN STUDIES, KENNETH JENKINS ₪ **JASMINE THOMAS-GIRVAN** MY GRANDMOTHER FRANCES SMELLIE AND MY PARENTS, EVELYN AND DONALD THOMAS ₪ **JOHANNA BRAMBLE** SHEILA HICKS; JOCELYNE ETIENNE-NUGUE, AN ETHNOLOGIST FOCUSING ON AFRICAN CRAFTS AND THE AUTHOR OF MANY BOOKS; AND A WOMAN I CALL MY MAMA OF WEAVING: MAÏTÉ TANGUY ₪ **JOIRI MINAYA** MY GRANDMA ₪ **JUANA VALDÉS** MY MOTHER, ZORAIDA VALDÉS ₪ **KATRINA COOMBS** ALL THE WOMEN WHO CAME BEFORE ME IN MY FAMILY ₪ **KELLY ANN WALTERS** ZELDA ICYLIN WALTERS, MY PATERNAL MATRIARCH, WHO IMMIGRATED TO THE UNITED STATES IN 1970. SHE WAS A POWERFUL FORCE WHO CONTINUES TO GIVE ME STRENGTH AND INSPIRATION EVERY DAY ₪ **KRAIG E. YEARWOOD** MY UNCLE ANTHONY PHOENIX ₪ **LA VAUGHN BELLE** MY FATHER ₪ **LAVAR MUNROE** MY PARENTS, BEVERLY ELIZABETH AND FREDLIN MUNROE; MY GRANDMOTHERS, SADIE CURTIS AND REBECCA HANNA; AND MY CHILDREN, BEVERLY ANN AND ENZO CALYX MUNROE ₪ **LEONARDO BENZANT** MY GRANDMOTHER IBAYE PATRIA ₪ **LEYDEN YNOBE LEWIS** MY FATHER, LIONEL JOSEPH LEWIS, AND MY MOTHER, SHIRLEY ANGELA LEWIS ₪ **LISANDRO SURIEL** DECOLONIALITY AND THE MYSTERIES OF NATURE ₪ **M. FLORINE DÉMOSTHÈNE** THE DEITIES THAT WE'VE SUMMONED FOR YEARS IN OUR PRACTICE ₪ **MALENE DJENABA BARNETT** ALL BLACK WOMEN MAKERS ₪ **MARK FLEURIDOR** MY PARENTS AND MY OLDER SISTER, AND THE MOTHERS IN MY LIFE ₪ **MARLON DARBEAU** MY GRANDFATHER BENJAMIN DARBEAU; MY DAD, RONALD DARBEAU; AND MY GREAT-UNCLE EGBERT DARBEAU

₪ **MOREL DOUCET** MY COLLEGE PROFESSORS DAVID EAST, CERAMICS DEPARTMENT CHAIR; DR. LESLIE KING-HAMMOND, PROFESSOR OF AFRICAN STUDIES; SARAH BARNES; SUSAN BANKS; LINDA DRAESEL-ATKINSON; GERALD OBREGON; AND CLYDE JOHNSON, ASSOCIATE DEAN FOR IDENTITY AND INCLUSION. AND MY MOM, NOULA DOUCET ₪ **NADIA LIZ ESTELA** MY FATHER AND THE WOMEN IN MY FAMILY ₪ **NINA COOKE JOHN** MY GRANDMOTHERS, PEARLINE WARREN AND MURDELLA COOKE ₪ **NYUGEN E. SMITH** ANTHONY TRIANO, MY FIRST ART PROFESSOR AS AN UNDERGRAD. D. DENENGE DUYST-AKPEM, A SPACE SCULPTOR, EDUCATOR, ARTIST, AND WRITER WHOSE PRACTICE AND SCHOLARSHIP BRIDGE THE DISCIPLINES OF DESIGN, RITUAL, AND ECOLOGY. MY MOTHER, CLAIRE PHILLIPS. MY LIFE PARTNER, SHERENE THE QUEEN ₪ **OUIGI THEODORE** ALL OUR FOREFATHERS AND FOREMOTHERS WHO FOUGHT FOR OUR INDEPENDENCE, INCLUDING THE THREE MATRIARCHS WHOSE NAMES INFORM OUR SPACE, THE ROSE MARIE INES GALLERY: MY GRANDMA ROSE NICHOLAS; MY MOTHER, MARIE SOLANGE THEODORE; AND MY YOUNGEST SISTER, INES BAPTISTE ₪ **PAUL ANTHONY SMITH** MY GRANDFATHER WHO CAME FROM CUBA, WALTER DEHANEY ₪ **PAULINE MARCELLE** MY GRANDMOTHER ELIZA ABRAHAM ₪ **RENEE COX** MY GREAT-GRANDFATHER SAMUEL CONSTANTINE BURKE AND THE MAROONS OF PORTLAND ₪ **ROBERT YOUNG** MY FATHER, JOE YOUNG, AND MY AUNT JEAN COGAN ₪ **ROBERTO LUGO** PEOPLE WHO ARE VOICELESS ₪ **SHENEQUA** MY FAMILY, AND BLACK WOMEN ₪ **SIMON BENJAMIN** THE SPIRIT OF INGENUITY AND CREATIVITY THAT HAS ALWAYS BEEN ALIVE IN THE CARIBBEAN ₪ **SOCA: SHANE LAPTISTE** MY GRANDPARENTS ERIC LLEWELLYN AND VERA RENAUD. **TURA COUSINS WILSON** MY GRANDMOTHER VIOLETA WILLIAMS ₪ **SONYA CLARK** ALL THE ANCESTORS KNOWN AND UNKNOWN TO ME ₪ **STORM SAULTER** MY MOTHER, GREER-ANN SAULTER ₪ **STUDIO 397: SAMANTHA JOSAPHAT** MY GRANDFATHER CONRAD GEORGE RODNEY. **LUIS MEDINA** MY GRANDFATHER EZEQUIEL CARRDITO ₪ **TERRY BODDIE** MY GRANDMOTHER SUSANNAH BODDIE

CRAFTED KINSHIP

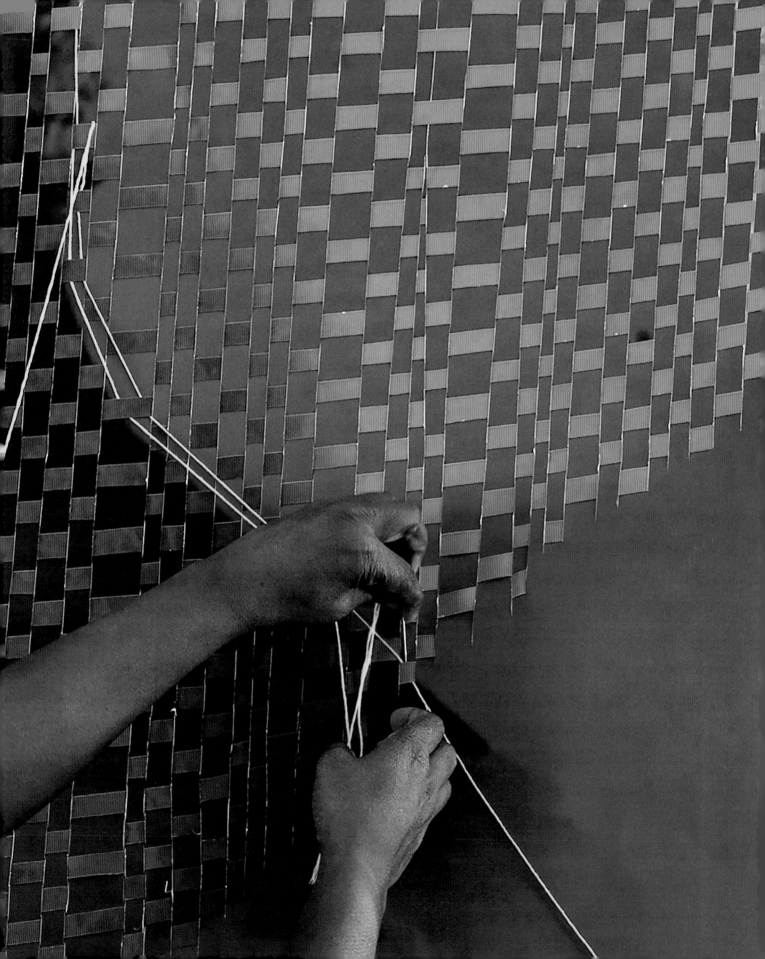

MALENE BARNETT

CRAFTED KINSHIP

INSIDE THE CREATIVE PRACTICES OF CONTEMPORARY BLACK CARIBBEAN MAKERS

PRINCIPAL PHOTOGRAPHY BY ALARIC S. CAMPBELL

ARTISAN BOOKS | NEW YORK

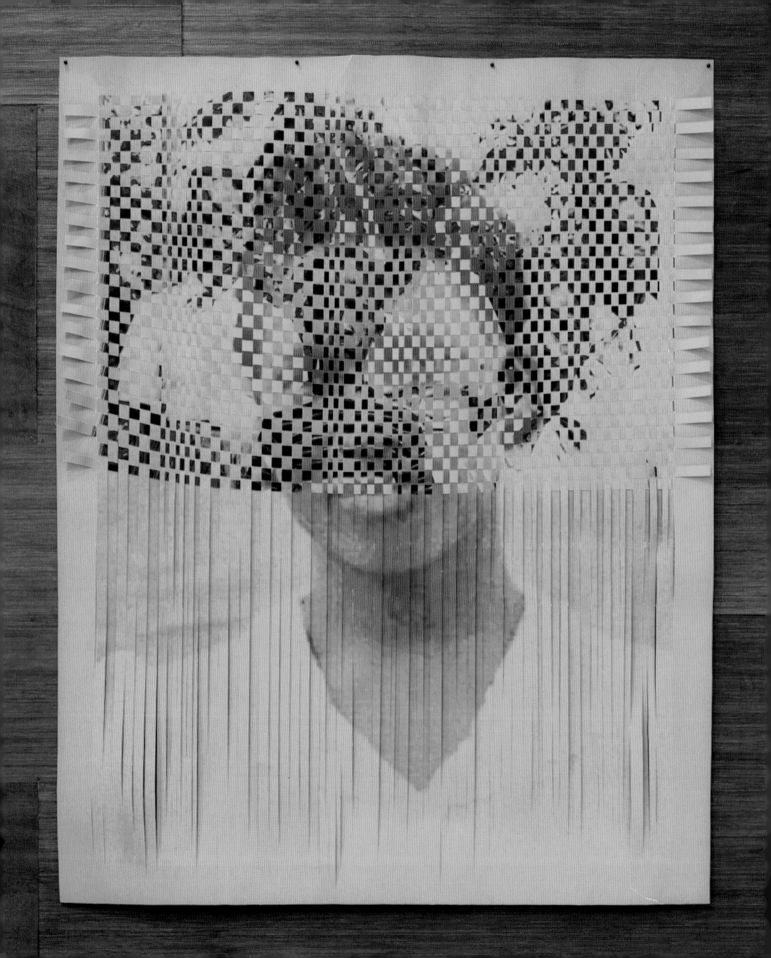

TO THE GARIFUNA OF ST. VINCENT AND THE
GRENADINES, AND THE MAROONS OF JAMAICA. YOUR
FEARLESSNESS IN PURSUIT OF BLACK LIBERATION
GROUNDS MY STUDIO PRACTICE IN REIMAGINING
BLACK ARCHIVES AND FUTURES THROUGH THE
HANDS OF BLACK WOMEN MAKERS.

TO MY GRANDMOTHERS, LINDA LONDON AND RUTH
REBECCA ALEXANDER. THANK YOU FOR YOUR
FORESIGHT TO PUT FAMILY FIRST IN THE INVESTMENT
OF OUR COLLECTIVE NARRATIVE. YOUR SEED SHOWS
US THE POWER OF ONE. WE ARE THE HARVEST.

TO MY MOTHER, CYNTHIA BARNETT, AND MY AUNTIES
JANET STEWART AND MARIE KING. YOU HAVE
SHOWN ME THE POWER OF MAKING AS A TOOL FOR
INDEPENDENCE AND CREATIVE EXPRESSION.

TO ALL THE ANCESTORS.

CONTENTS

INTRODUCTION

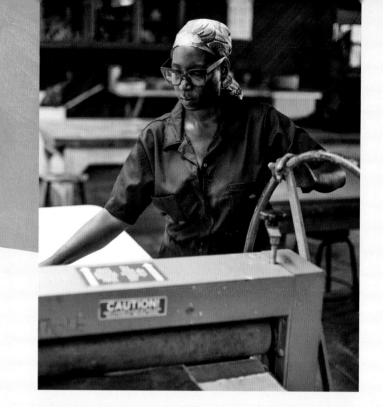

Art has always been a part of my life, defining who I am and the impact I want to make on the world.

I am a child of Caribbean immigrants from a lineage of makers: my maternal grandmother was a gifted fashion designer and my mother turned jute yarn into intricate macramé wall hangings. Witnessing the care and artistry they put into their work set the stage for my appreciation of craftsmanship, and it sparked my interest in archives that preserve—or in some cases, fail to preserve—the histories of our Caribbean creative practices.

After working as a textile and rug designer for two decades, I decided in 2020 to pursue an MFA in ceramics at Tyler School of Art and Architecture at Temple University, which is where I spent two years unraveling my romantic relationship with my Caribbean origins. My investigation began with researching my own Caribbean heritage, asking, "How does having a mother from St. Vincent and a father from Jamaica—the first and last Caribbean islands to be colonized—inform my sense of identity and my multidisciplinary creative practice? How does my identity as a member of the diaspora inform my work, and how does it intersect with the work of Caribbean makers who were raised in the region, including those who have remained in or returned to their Caribbean lands?"

I was born in the Bronx, New York; grew up in Norwalk, a small city on Connecticut's shoreline; and settled in Brooklyn, New York; and so my research necessitated the reverse journey as that taken by my parents—back to Jamaica, St. Vincent and the Grenadines, and across the Caribbean islands.

My queries served as guides on my journey of self and cultural identity and in my search for Caribbean makers asking similar questions who were also on a mission to deconstruct the region's colonial past by creating art, objects, and spaces for Black diasporans.

Learning about each new maker, I saw common threads emerging in the materials, processes, and themes across our collective studio practices. Yet each maker had a different approach to creating new futures for the region, from reimagining colonial narratives through an Afrofuturistic lens, to repurposing everyday objects and materials, to implementing ancestral processes such as Manjak weaving, coil building in clay, and painting with sugar to expand Black diasporic experiences. From my research, I started to imagine what it would be like to converse with these Caribbean makers and document what they had to say and how they worked. And since my studio practice centers on Pan-Africanism by connecting the community and reimagining Black archives, I wanted to gather a group of like-minded Caribbean makers, create the book I wish I'd had in graduate school, and contribute to a historical record for future generations.

Hence *Crafted Kinship* was born—a book by Black Caribbeans about our rich heritage. Here, more than sixty voices from across the Caribbean explore how, through practices of making with our hands, we have each formed a kinship with the land where our ancestors began a life of forced servitude. Of course, this book is also about hearing each maker reflect on the specific provocations that inspire their practices, what I'm calling the Threads of Kinship. These threads are the strands of DNA that run through their work, establishing their particular salience as artists, Caribbean artists, and Black Caribbean artists.

Core to this book is the understanding that the Caribbean is a small place that significantly impacts the world. It doesn't matter where we are; we return to our Caribbean homes as a source of our work, identities, and spiritual belonging. Keeping this in mind, I was interested in each maker's process rather than the outcomes. I searched the Caribbean and its diaspora, bringing together a group of contemporary Black Caribbean makers to reflect on prominent themes in their work: African origins, ancestors, Black womanhood or manhood, colonial histories, community and collaboration, identity, joy, land, climate, sustainability, materiality, memory, migration and diaspora, and spirituality.

As you will read in these pages, most Caribbean artists self-identify as multi- or interdisciplinary, just as they identify as makers who bridge the artificial divides between art, craft, design, and artisanship. The labels that society attaches to "artists," "designers," and "craftspeople" all apply but are almost meaningless on their own. They are inventions of a reductive, commodified view intended to impose a value system on the people and their products. The makers always create their work for self-expression, engagement, conversation, and aesthetic pleasure.

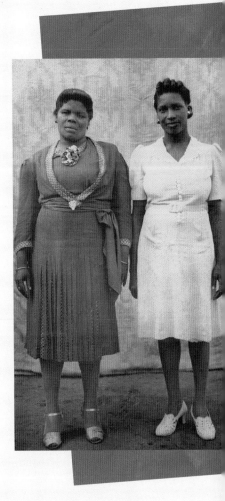

Above: My maternal grandmother, Linda London (right), and her friend, my mother's godmother, in St. Vincent and the Grenadines before Linda immigrated to New York.

Opposite: In the ceramic studio at Edna Manley College of the Visual and Performing Arts during Fulbright Jamaica 2022–23.

This is both intentional and organic. Historically, ancestrally, art and design were not separate. Design always needed art to thrive, and artists were always thinking about space, usage, and audiences to connect with. But we often distinguish between these two making practices to simplify commercial transactions with buyers. Many of us expressly reject this means of segregating art and design based on colonial value systems, sometimes offering our critique of the terms themselves—the meanings and value systems implicit in words like *art*, *design*, and *craft*. When you read the interviews, read between the lines because these makers are reshaping the boundaries around art and design by describing their studio practices as action-oriented rather than being defined by a medium or discipline—they are crafting kinship. For that reason, the book is not organized by discipline, last name, or chronology—all Western narrative constructs. Instead, we honor chosen names and invite you to engage with the makers by their definitions of their practices.

Crafted Kinship is intended to serve as an archival record, comprising interviews and photographs. The featured makers are multidisciplined, multigenerational, and gender-inclusive. The interviews provide insight into each person's exploration of their "crafted kinship" to the land, people, and culture around their Caribbean identity and how it informs their studio practice. For some of the makers profiled here, their connection to the land is to a specific island home, while for others, it's to the broader region. Some are relatively new while others are deeper in their practices. Several makers employ the tools of art, design, and craft to explicitly explore their relationships to island homes, while for others the themes are more subtle or innate. Navigating a kinship to the Caribbean is multifaceted and complicated, whether you were born inside or outside the region. I want you, the reader, to gain insight into how each maker examines and reconstitutes our fragmented histories through their craft.

Interviewing each of the makers was a singular honor. Some are colleagues and friends I have known and collaborated with—mainly through the Black Artists +

Designers Guild (BADG)—for many years. Others are new acquaintances and makers I've encountered through my research and travels. Their perspectives felt both familiar and profoundly unique to each of them. At times, their words don't do justice to the articulateness of their work. I invite you to experience both word and image as constantly interacting with each other.

The Caribbean and its makers are essential to recontextualizing Black diasporic experiences. Everyone must rally around Black Caribbean makers, especially those who have dedicated their studios to deconstructing a colonial past for the betterment of the community. These makers continue to transcend form, function, process, and practices as they manifest multitudes of new visual languages that inspire. Many threads connecting the Black diaspora continue to grow through art, objects, and spaces. Each work weaves together historic legacies that create new futures. This book will lead you to deeper conversations about the history and culture of the Caribbean and encourage you to consider becoming a custodian of the archives. It's impossible to profile every Black Caribbean maker, but this book is a tool to begin recognizing their contributions.

In addition to interviewing the makers, I asked prominent scholars, collectors, and advocates of contemporary Caribbean art to contribute their perspectives on the state of Caribbean art and design, including a view of the support networks that continue to gain strength in the region and in the diaspora.

The photography in this book was as important as the interviews. Portrait photographer Alaric S. Campbell set the visual direction for each maker's portrait and studio tour. Alaric and a team of freelance photographers across the Caribbean, North America, Central America, and Africa took stunning images of the makers in their studios, homes, and places of inspiration.

Like my studio practice, this book has been a collaborative process. I see power in making space for many of us to share the spotlight. I invite you into this shared light as well. Immerse yourself in the space held for and by these makers around our shared stories and practices.

I hope this window into these makers' lives is a source of inspiration for you, whether you're a budding or seasoned maker from the Caribbean, an advocate for Caribbean makers, a curator, a collector, or simply someone curious to know more about the region. Slowly turn the pages, absorb the words and visuals, and figure out what *crafted kinship* means to you.

Opposite, left: My mother, Cynthia (far left), with her siblings (from front row, counterclockwise) Roy, Marie, and Janet, and Granny, my great-grandmother (back row, middle).

Opposite, right: Me in art class in 1988, painting a self-portrait from a photo taken on my first trip to Barbados.

Below: My mother during her first Christmas in the United States, in the Bronx, New York, in 1965.

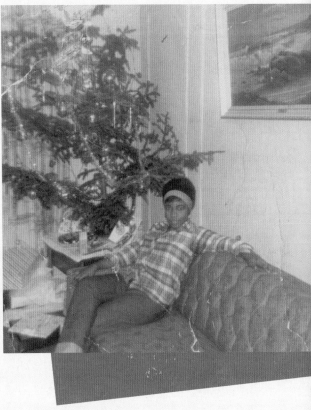

THE BAHAMAS

CARIBBEAN SEA

DOMINICAN
REPUBLIC

HAITI

BRITISH VIRGIN
ISLANDS

PUERTO RICO

ST. MARTIN &
ST. BARTHÉLEMY

ST. MAARTEN &
ST. EUSTATIUS

U.S. VIRGIN ISLANDS

ANTIGUA &
BARBUDA

ST. KITTS & NEVIS

MONTSERRAT

A VIEW OF THE
Caribbean

GUADELOUPE

DOMINICA

MARTINIQUE

THIS MAP OF THE CARIBBEAN IS KEY TO
UNDERSTANDING WHERE MAKERS ARE CRAFTING
THEIR UNIQUE FORMS OF KINSHIP TO LAND, CULTURE,
AND PEOPLE THROUGH THEIR PRACTICES.

ST. LUCIA

BARBADOS

ST. VINCENT &
THE GRENADINES

GRENADA

TRINIDAD &
TOBAGO

GUYANA

VENEZUELA

THREADS OF KINSHIP

While each of the makers featured in *Crafted Kinship* creates art and design from their unique personal, cultural, geographic, and political perspective, a number of common threads bind them together. There are motifs, sources of inspiration, and expressions of identity woven throughout. These are cultural signifiers that identify the work as uniquely Caribbean, or uniquely diasporic, or uniquely of the maker's island home. These signifiers situate the works featured here, and the vast bodies of work produced by these and many other contemporary makers across the Caribbean, within a time and place, within a gendered or socioeconomic context, within an ancestral or linguistic tradition. Each thread of significance speaks to the specificity of Caribbean history and identity. The makers occasionally speak explicitly about how some of these motifs surface in their work and in their practices, but we invite you to consider how other, perhaps unspoken, threads of kinship are visible to you.

AFRICAN ORIGINS

For artists and designers throughout the Caribbean diaspora, African cultural and geographic origins are a profound source of connection, tension, and inspiration. In fact, the word *origins* presents a persistent challenge to our identity, as few of us can access specific geographical or familial ancestries. Many Caribbean makers forge unique relationships with Pan-African cultural practices, rituals, symbols, and motifs, while others name specific countries and cultures, like Senegal, Ashanti, and Yoruba. Those influences are discernible in the materials and processes—traditional weaving and ceramic techniques—and surface in stories of joy, sadness, loss, and hope. They appear in the symbols, colors, and textures that speak to shared and unique interpretations of African Caribbean legacies.

ANCESTORS

Makers across the Caribbean call forth ancestors in their work, employing forms and materials that have been passed down through generations in their families, through makers in their regions, and throughout the diaspora. These relationships are often nuanced. We hear makers talk about leaving behind or unlearning ways of navigating the world that have been harmful, that have not always served them. In some cases, they are actively discovering, reimagining, or reconstructing ancestral narratives in their work. And as they call forth their discoveries into the present, they're often also speaking into the future, evoking and embodying new possibilities for generations to come.

BLACK WOMANHOOD/BLACK MANHOOD

Many artists challenge preconceptions of Black womanhood or manhood through their work. Where this theme was salient in a maker's work, we asked how their provocations about Black womanhood or manhood might reshape viewers' perspectives, how they might trigger new ways of being within the self and in relation to others.

COLONIAL HISTORIES

Stories from and about the Caribbean cannot avoid shared colonial legacies, often through the lens of trauma and reparations. The sources that inform the makers' work—including oral histories, objects, places, and archives—are

found in their homelands, but also in the countries of the colonizers: England, France, Germany, the Netherlands, Spain, and the Vatican among them. Several artists explain how they make sense of historical documents and artifacts held in distant archives. They reveal how they navigate the institutions that house collections related to the colonial histories of their regions, and the kinds of postcolonial futures they imagine through their work.

IDENTITY

Self-identity is present in the work of every maker, more discernibly for some than for others. The makers here explore how their expression of self has changed over time—from childhood, through experiences in the diaspora to the present—and whether there are aspects of identity that can be truly seen or understood only by other Caribbean people. We also see how the makers' art practices reflect their unique Caribbeanness and their specific regions.

JOY

The artists and designers here reflect on the complexities of joy and how it must be nurtured with intention and often employed as a conduit for healing. Joy in the Caribbean can take the form of Carnival, soca music, and bachata dance, and it can appear in a contemplative walk along a familiar path through the woods, the collecting of materials at the banks of a river, or a gathering on Zoom with other Caribbean women seeking community and an understanding ear. The work of these artists is not always joyful in the traditional sense of the word, but joy shows up in both subtle and explicit ways: elated, angry, painful, complex, intimate, intense, spiritual, critical.

LAND, CLIMATE, SUSTAINABILITY

Our ancestors were forced to create a connection to the Caribbean soil on which they landed, having been brought to the region against their will over several hundred years. Current generations of makers have different ways of maintaining their relationship with the physical land, and connecting to the Indigeneity of the land in the context of forced diaspora. Many of the artists here reflect on issues of climate change—its impact on the use and availability of certain materials and how it shifts their practice, and also its effect on their islands.

MATERIALITY

Materiality, like identity, is truly the core of every maker's practice. The artists featured here use a wide range of materials, including traditional ones like wood, clay, stone, and fiber as well as materials that are particularly symbolic for Black Caribbean makers, like sugar, salt, and human hair. Materials signal connection to the land—the specific wood of a certain forest, the clay from ancestral soil, the fiber and sand and hair that represent the textures, aromas, and colors of particular places. These materials are encoded with the artists' connection to the earth, to diasporic lands, to memory, often to personal histories and gender, and to deep feelings of love, loss, and repair.

MEMORY

Memories are personal but can also comprise collective experience. For many makers in the diaspora, memory is a material of art-making. Personal memory fuels stories, while cultural memory informs the design of symbols, sense memory forms the invisible tether between artist and viewer or maker and user, and spiritual memory lays the path toward revelation. The makers here evoke memories of specific people and places, but they also employ them as invocations of feeling: joy, pain, longing, anger. Several makers share the sources they consult in their search for memories, including places that hold cultural memory, like the market, historic districts, and ancestral waterways.

SPIRITUALITY

Many artists experience the act of making as a spiritual or sacred practice, and here, some of the artists explain how materiality, the making process, and symbols drawn from ancestral stories invoke or evoke a spiritual practice.

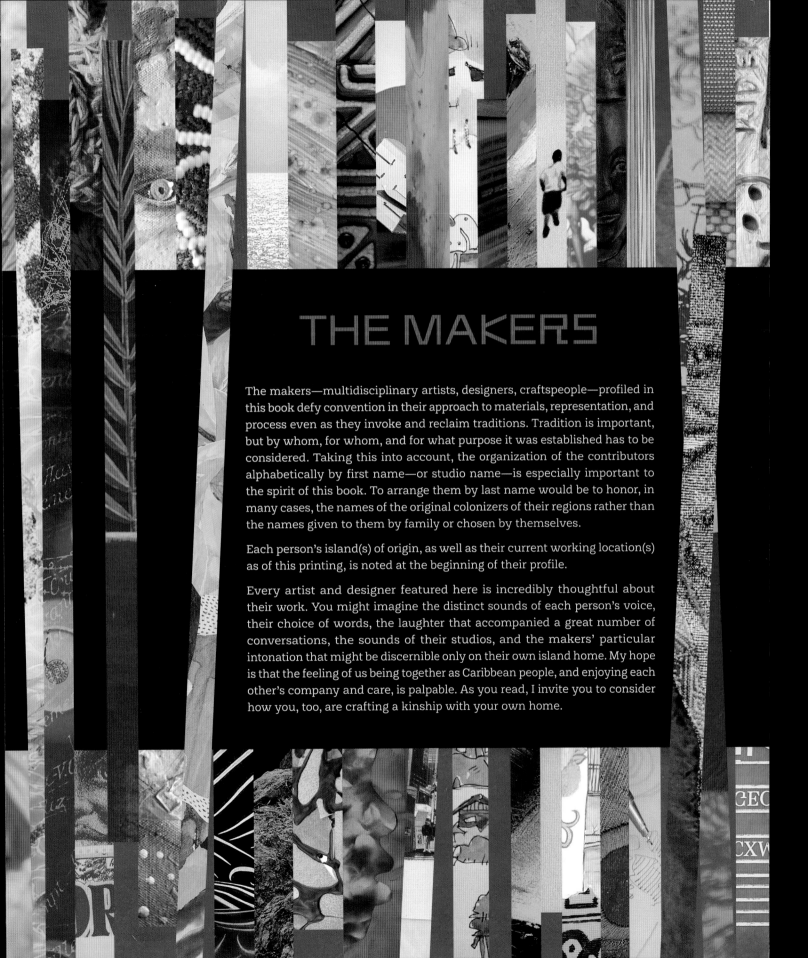

THE MAKERS

The makers—multidisciplinary artists, designers, craftspeople—profiled in this book defy convention in their approach to materials, representation, and process even as they invoke and reclaim traditions. Tradition is important, but by whom, for whom, and for what purpose it was established has to be considered. Taking this into account, the organization of the contributors alphabetically by first name—or studio name—is especially important to the spirit of this book. To arrange them by last name would be to honor, in many cases, the names of the original colonizers of their regions rather than the names given to them by family or chosen by themselves.

Each person's island(s) of origin, as well as their current working location(s) as of this printing, is noted at the beginning of their profile.

Every artist and designer featured here is incredibly thoughtful about their work. You might imagine the distinct sounds of each person's voice, their choice of words, the laughter that accompanied a great number of conversations, the sounds of their studios, and the makers' particular intonation that might be discernible only on their own island home. My hope is that the feeling of us being together as Caribbean people, and enjoying each other's company and care, is palpable. As you read, I invite you to consider how you, too, are crafting a kinship with your own home.

Alison
CRONEY MOSES

A WOOD-BASED ARTIST EXPLORING MOTHERHOOD AND BLACK JOY

I'm trained as a furniture maker, but I primarily make sculptural objects now, using bent lamination and coopering to make curved forms that mimic shells or other natural objects.

What did you make as a child before you knew to call it art or design?

I was the kid who was into whatever the adults were doing. If my mom was cooking, I was cooking. If my dad was building furniture, I was there under his feet trying to help. If he was changing the oil in the car, I was there. I remember designing and sewing hair bows with my mom's help, and I would sell them to my teachers. Making was part of doing things ourselves, our home traditions that stem from our culture.

Was there a moment in your career when you had to reinvent yourself or your practice because of an obstacle?

I studied graphic design for a bit, then switched over to furniture design. At that time, I wanted to be viewed as a craftsperson, a maker or furniture designer, and I tried to suppress my personal, visual identity in my work (even though that's impossible).

I always wanted to engage community in some way; for my senior thesis at the Rhode Island School of Design, I worked with high school students to design children's furniture for a local elementary school.

The work I'm doing now is a series called *Black Body* for the *Designing Motherhood* exhibit. The second iteration of that is *unADULTerated Black Joy*, which I'm working on with two other Black mom artists. My work merges these three aspects of my being: identity, community, and craft.

What feelings are you trying to evoke through your work, and what do you hope viewers will do as a result of their interactions with it?

I've been creating vessel-like shapes or curved forms that mimic the womb, forms that speak to safety. This mirrors how I am in the world: I try to bring people in and support them, help them find safe spaces. These pieces are very smooth and silky on the outside. I love when someone asks if they can touch them.

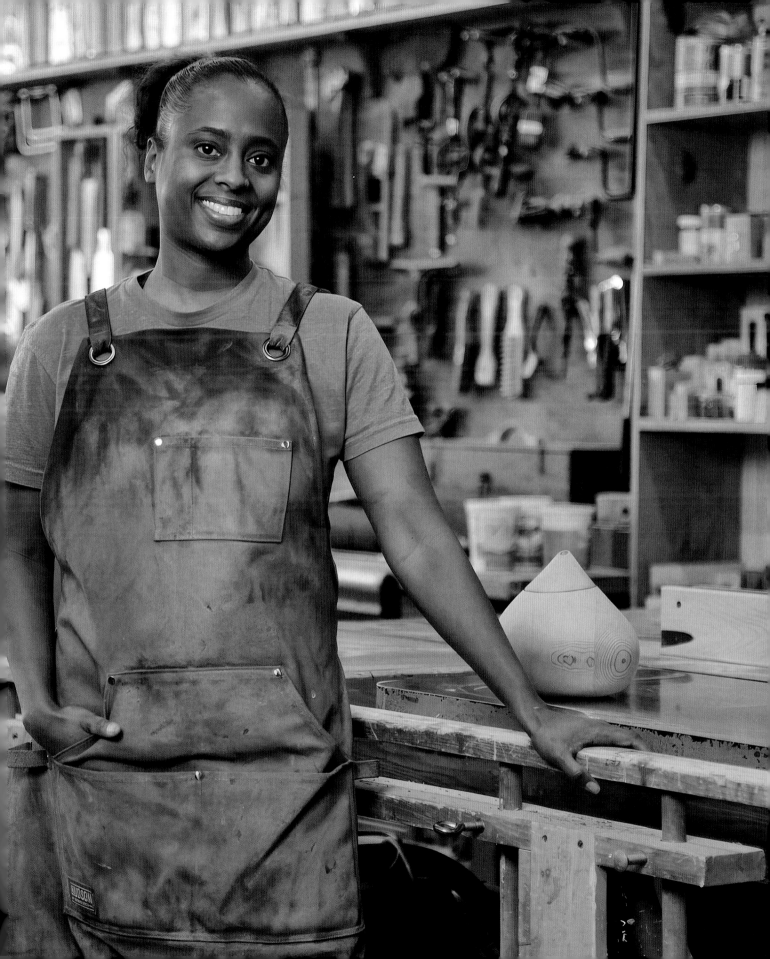

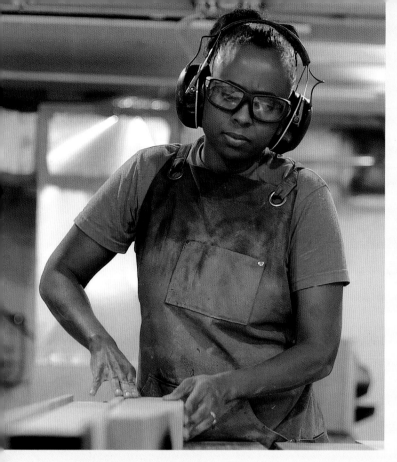

up in our aesthetic, in our parenting, in our communication and our language.

Can you talk about how or whether your work closes the gap between art and design practice, or whether you would like to close that gap more?

I consider myself a craftsperson, someone who likes the material and the process of making and designing. You absolutely cannot have art without design or design without art, but you have to categorize yourself in order to sell. Both craft schools and art schools influence how we categorize making practices and what gets called art, craft, or design, but they are basically the same thing. I've been teaching woodworking to Black, femme-identifying folks who don't necessarily consider themselves artists, craftspeople, or designers. I want to empower folks to see themselves as makers and designers helping to shape our society. We are just people doing what humans do, which is make, create, influence, be fulfilled, exist, love—all the things.

What does joy mean or look like to you? Why is it an important form of expression for you through your work?

Community-based art practice is joy for me. Working on projects around *unADULTerated Black Joy* has been challenging, yet also very fulfilling. I sit down with two other Black women—friends of mine—when our kids are in bed, to catch up and debrief; we find joy in planning art projects with one another and for our community.

I also recently roller-skated with some Black moms, which really brought me back to what was fun about Black girlhood.

Are there aspects of your identity that can be seen or understood only by other Caribbean people?

When I connect with Caribbean Americans, I feel seen in a way that I don't with other folks. We have similar experiences of how we were raised.

Any words of encouragement for young artists who are interested in materiality that isn't the "norm" when it comes to being creative?

It's hard to forge your own path when adults around you aren't encouraging or supportive. There's something to be learned from the wisdom and lived experiences of our elders. But there are also moments when you're just going to fall on your face; that's how you learn. You may believe passionately in something and not be able to explain it, but stay true to that because that is likely what you should be doing.

What does community look like for you as a maker living and working in the diaspora?

My art practice fulfills my values of building community. I started Moms of Color, a Facebook group, and created smaller spaces for Black moms: Caribbean Black moms, African American Black moms, however they identify. We try to engage in person and online to support each other.

How has your work sought to expand the view of non-Caribbean Black identity and culture?

When the pandemic hit, I started hosting Zoom meetings for Black moms, who were grieving in a different way than other folks during the racial awakening of white society. That led to the in-person work after the lockdowns were lifted, which was specifically for Black moms. In my art practice and in these mom spaces, we talk a lot about anti-Blackness as something our society has not rid itself of. That's what connects us in those Black-only spaces, where we recognize that Blackness shows up in many cultures. How do we uproot anti-Blackness? I remember artist and educator Tanya Nixon-Silberg saying that if you uproot an anti-Blackness, you uplift all Black folks. That's what comes to mind when I think about non-Caribbean Black identity and what connects us. I'm starting to investigate how that shows

"Community-based
art practice is joy
for me."

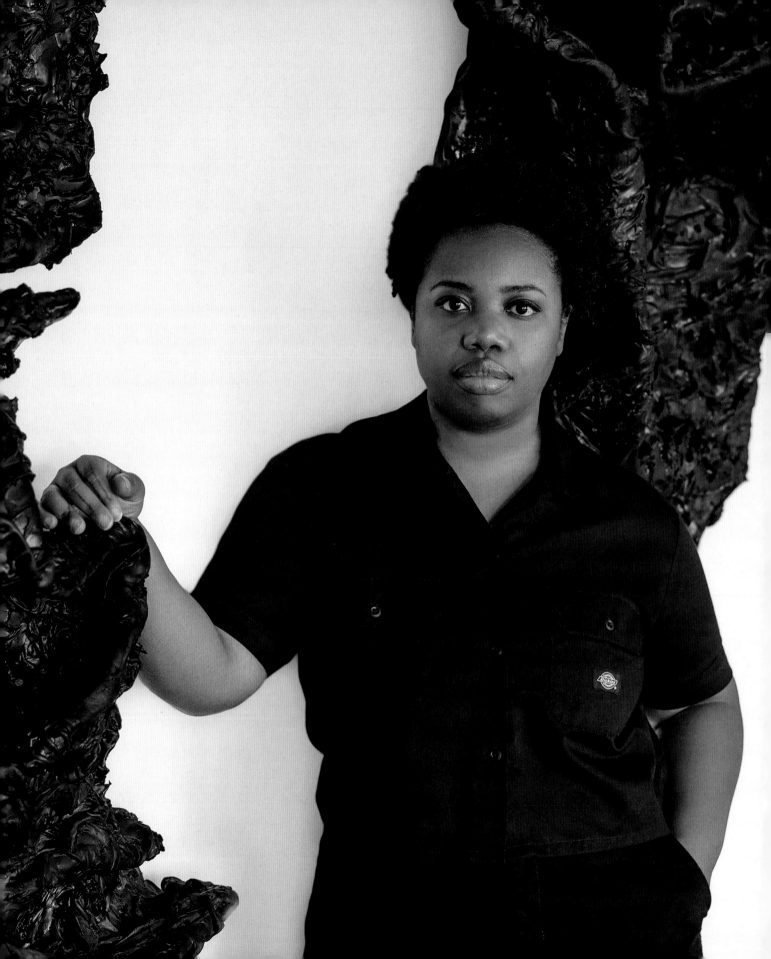

Allana
CLARKE

**A CONCEPTUAL ARTIST EXPLORING IDEAS
ABOUT INHERITED, DIASPORIC HISTORIES**

My formal training is in photography, but now I work in performance-, sculpture-, video-, and text-based mediums.

Can you talk about how you've been exploring materials in your work?

I'm often interested in materials that I have a personal connection to. They've lately been materials that deal with caring for the body or presenting it to the world. I've used them in beautification practices that informed my sense of self as a woman, as a Black woman in this world. The two materials I've used a lot for the past few years are cocoa butter and hair-bonding glue. The cocoa butter has cultural significance, because it's something you would find in the homes of people of color. But when I brought it into my studio, it took on a different meaning. It made me think through my complicated relationship with the matriarchs in my family and how they shaped my understanding of my womanhood in both positive and negative ways.

I would squeeze the bridge of my nose every night, hoping to narrow it. That ritual was passed down to me by someone who cares about me. Why would this not be a form of care? At the time, I didn't think about it, but I was absorbing it as a process intended to make me more desirable in the world. My mother had an understanding that I did not at the time that Blackness is not elevated or appreciated. Her solution was to try to diminish Black features instead of appreciating, accepting, loving, elevating who you are. As I grew up and started researching it, and also experiencing the damage it did to me, the *lack* that I was taught existed within me innately became real.

The cocoa butter represents intimate and caring experiences I had with my mother, being rubbed with it, absorbing it into my skin, its scent. But it is also through her that I understood Blackness to be a negation, and a thing to be diminished. Some notions of care were actually perverse: the practices of hair-straightening and adding extensions, which is where the hair-bonding glue comes in. It is far more complex than a simple beautification practice. Bringing these materials that are from the social structures of my upbringing into the studio helps me tackle some of the anti-Black rituals I adopted from her.

This idea of not being enough, never being enough, never being good enough, never being desirable, having to change, transform, be something else, creates so much tension in your body. Now I'm using my work to unburden myself of those traumas and tensions.

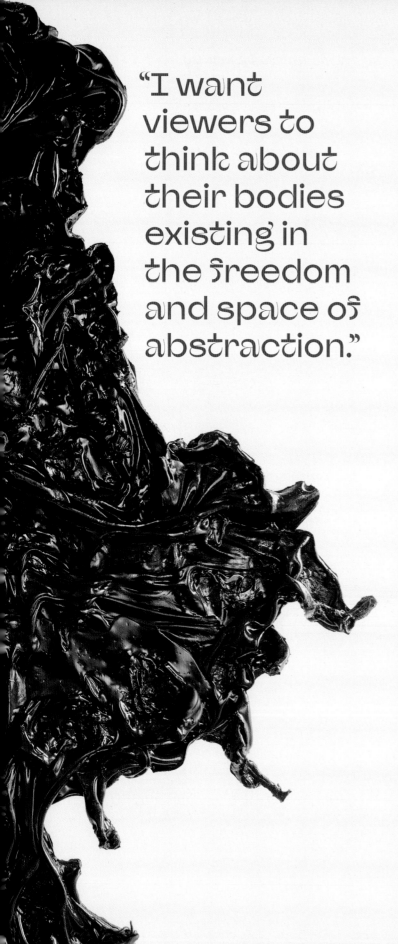

> "I want viewers to think about their bodies existing in the freedom and space of abstraction."

I wanted to think through these concerns and through the materials, especially the hair-bonding glue, which I have so many memories around that absolutely speak to trauma. I didn't know what I wanted to do with the glue, but I knew I wanted to do something. And I engaged in an intense process of experimentation and discovery, buying a dozen bottles and pouring it out on surfaces in my studio and poking it and probing it and taking notes about what happened, letting time become a part of the material, too.

Through this intense process, I understood how my work wanted to exist in the world in a more expansive way. I started making abstract sculptural wall installations where the gestures on the surface of the material are an accumulation of actions that I perform on the material using my whole body. Pouring the glue out in very thick layers, allowing it to cure over a few hours or a day; and as it cures, the top develops this leathery skin, while underneath, the glue is still liquid and malleable. Using my hands, elbows, and feet, I push it, rip it, pull it, twist it. It's this transference of energy where I engage in conversation with the material.

That was extremely joyful, fun, freeing, and cathartic. This thing that was so traumatic was now operating in a completely different way. It became all the things I wanted to be: futurity, an accumulation of experiences, and really beautiful.

How have you crafted a kinship with the land, people, and culture of the Caribbean?

Through materials, but also through what can often be a common experience of feeling disconnected from the idea of home. When my parents came to the United States, they kind of abandoned that location, that identity, to exist in a part of the world that offered a specific promise. I was born in Trinidad but grew up in the States. Often when I went back to Trinidad, it felt like my body fit there. But when I spoke to people who lived in Trinidad, they didn't think I was from there. And I also didn't fit in the States.

I feel this sense of displacement in my body. While I belong to the land, people, and culture of Trinidad and Tobago, I can't claim it because it doesn't want me. It's a very complicated space, but I use these feelings as a way to talk about the complexities of being "unhomed."

What feelings are you trying to evoke through your work, and what do you hope viewers will do as a result of their interactions with it?

I work figuratively through video, photography, and live performance. And I work nonfiguratively through sculpture, which

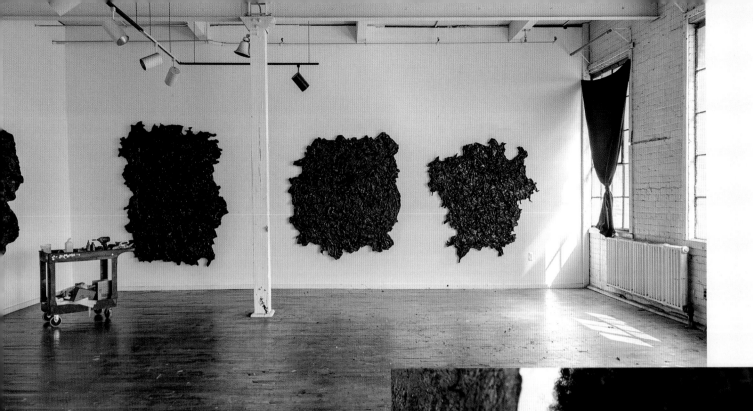

includes text-based works. The ways in which people receive each of those modalities can be really different.

When I work figuratively, often either I'm the subject or other Black women are depicted. If I'm working collaboratively with other women who look like me, it always starts from a conversation. Many times, the topics unfold intuitively from talking about issues of the body, about how we are categorized in the world, and about how our bodies communicate information to the world. We're all born into a preexisting system: there are specific conditions placed upon your body—depending upon your race, your gender, your class, where you were born—that have nothing to do with you. As you grow up, so much of how you experience the world is based on these things that others have decided for you. When I work figuratively, this is often what I'm thinking about—other people's associations.

When I work in a nonfigurative, abstract manner, I want viewers to think of bodies existing in the freedom and space of abstraction. I want them to think about their own physicality in relation to the work—how seeing someone else's body makes you think about yourself, or, through scale, where you position yourself in relation to the text or poems.

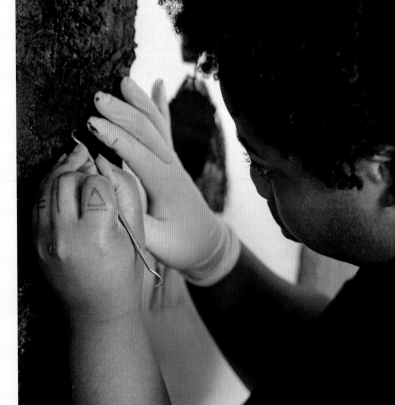

What does community look like for you as a maker living and working in the diaspora?

The most important part of the work is creating conversations around it. I love giving lectures and gallery talks and speaking on panels. Having those opportunities to discuss the work is an important part of community, because I'm tackling very difficult issues. Being curious and inquisitive, and trying to gain a deeper understanding around something, is how we create transformation. That is how we create connections.

Performance video work is another form of community, because it's never just me as a facilitator or as the sole maker telling everyone else what to do; it's about coming together in a space and talking first about our lives, and then about how everyone in that room connects or doesn't connect.

How has your work sought to expand the view of non-Caribbean Black identity and culture?

This is important, but also tricky. What I'm hoping to do in the work is create multiplicity. If you are a member of a marginalized group within our larger culture, each individual bears the weight of that identity. They represent everyone else who might be associated with that identity. And the burden of that representation is problematic because then you're perceived to be monolithic, singular, even though we all have nuanced experiences and understandings in this world. But we're not allowed to live in that expansiveness. I'm trying to do two different things: speak to an individual, nuanced experience while making work that is complicated and complex, work that is unsettling a singularity, and saying, "This is Black identity, too. It's not one thing. It is a collection of many, many, many different experiences and understandings."

You've talked about all the modalities you've used to express your work. Is there also a conversation you're having around the intersection of fine art and design? Are these binary definitions for you, and do you see them as overlapping and connected?

Art is design. But the gap between art and design can be very useful because of the ways in which art helps you think about the meaning of a material beyond its practical purpose in the world.

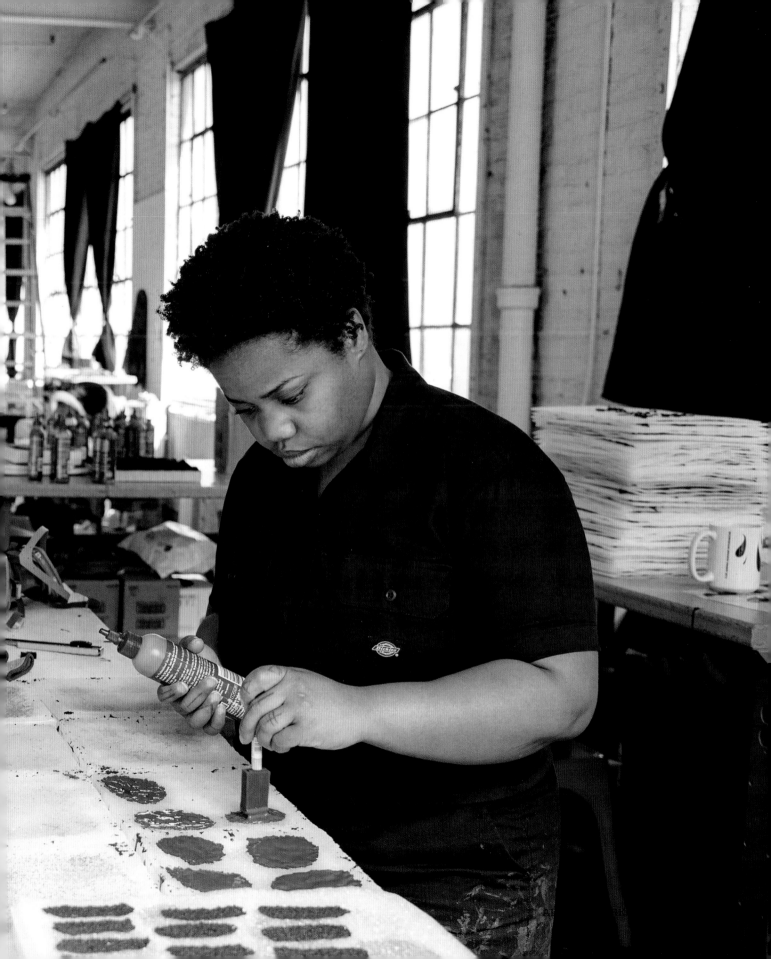

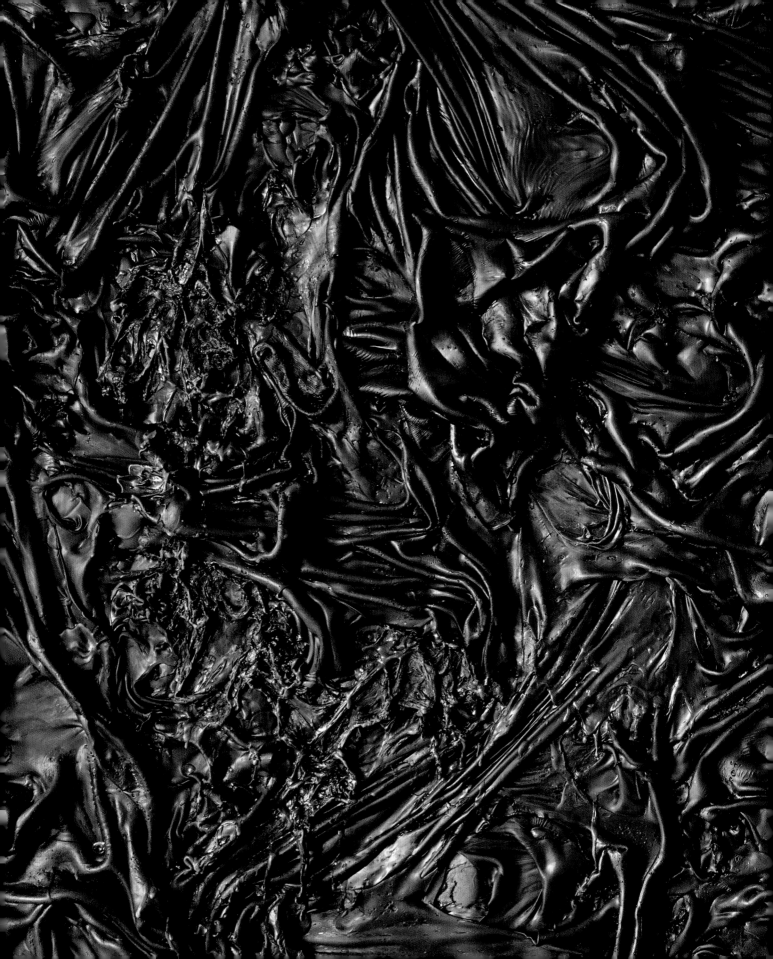

The way you live,
the standards you hold
yourself to, and your work as a
maker must reflect a constant
craving for discovery.
—ALLANA CLARKE

1924–2020
TRINIDAD AND TOBAGO

ALTHEA McNISH

BY CHRISTINE CHECINSKA

In addition to the contemporary artists profiled in these pages, a number of ancestors remain situated in the discussion of contemporary Black art and design practice.

Althea McNish was born in 1924 in Port of Spain, Trinidad and Tobago, and moved to London in the early 1950s. Taught and mentored by the artist Eduardo Paolozzi, McNish used exuberant color and energetic brushstrokes in a way that defined the 1950s/1960s era of printed textile design for both fashion and interiors. Her creolized aesthetic, informed by her Trinidadian roots, overthrew the sterile rules of taste that had previously shaped British and European design houses. Her work might be understood in the context of modernist art and the Caribbean Artists Movement, since these were the artistic communities that she inhabited.

In conversation, McNish emphasized the expressionist elements of her print-based works; their basis in nature, pattern, and color as language; and the sensory importance of feeling the mark of the hand. There are echoes of modernism's underlying principles and characteristics. There is a move away from realistic depictions of her subject matter, such as wheat fields, in *Golden Harvest*, and poppies, casino wheels, and train tracks in other designs. McNish was innovative, experimental, expressive, bold. Forms are abstracted, layered, and textural, and colors are saturated and intense in each design.

McNish began painting at an early age. She was mentored by artists Sybil Atteck and Pierre Lelong from the age of ten, going on to have her first exhibition with the Art Society of Trinidad and Tobago at sixteen. After leaving school, McNish apprenticed with a private architect. Following that, she was employed in the civil service as a cartographer and entomological illustrator, a job previously held by Atteck, but left government employment to take up studies in London, initially in graphic design at the London School of Printing and Graphic Arts.

McNish's interest in textiles began during this period, when she took textile design evening classes run by Paolozzi at Central School of Art and Design. She then received a scholarship to study at the Royal College of Art (RCA), making the switch from graphics to textiles. She and her peers would have been influenced by the abstract expressionism that dominated Western art between the 1940s and '60s. McNish visited Matisse at his studio in Vence. She admired his work and that of Picasso, Braque, Van Gogh, and Gauguin. She met the artist and collector William Ohly, and ethnologist and curator Cottie Burland, of Abbey Arts Centre Museum and the Berkeley Gallery, where Ohly showed African art. McNish was thus exposed to an important new influence. She began to study the African arts housed at the British Museum.

In 1957, during her final year at the RCA, McNish visited the Essex home of her tutor, painter and graphic artist Edward Bawden, and his wife, Charlotte, a potter. While on this trip, McNish saw a wheat field for the first time. It reminded her of the sugarcane plantations in Trinidad and Tobago. This proved to be a pivotal moment, and in 1959, she mobilized the wheat motif in *Golden Harvest*—her first design for Hull Traders. Printed on heavy cotton satin furnishing fabric and produced in four colors, *Golden Harvest* became a bestseller when it was released in 1960, staying in production for a decade.

On graduation, McNish was commissioned by Arthur Lasenby Liberty to create exclusive designs for Liberty, in London, and thus began her career as artist/designer. For McNish, there was no separation between her work as an artist and her work as a textile designer. She approached textile design as a painter would; that is, with no regard for boundaries of scale, use of technique, and repeat. Her designs are modernist works of art destined to dress the body through cutting-edge fabrics and the interior space through soft furnishings, wallpapers, and architectural murals. As design curator Lesley Jackson wrote in 2009, McNish was "a painter by instinct, but a designer by calling."

Dr. Christine Checinska is the inaugural senior curator of African and Diaspora Textiles and Fashion at the Victoria and Albert Museum (V&A) in London. She was lead curator of the V&A touring exhibition Africa Fashion *in 2022 and the exhibit* Between Two Worlds *in 2023. In 2016 she delivered the TEDx Talk "Disobedient Dress."*

GRENADA + HAITI ₪ NEW YORK CITY

Alvaro
BARRINGTON

A MULTIDISCIPLINARY ARTIST WHOSE WORK
ADDRESSES MIGRATION AND LOSS

I have always trusted my hands. I let my senses guide me and help me figure out what the world is saying to me.

What kind of materials are you using to make the discovery?

Everything, to be honest. As a kid, I would watch my aunt sew. I wanted to see the act of sewing through her eyes. I realize that I was probably tapping into a longer history of mostly women in my family who sewed. That helped me see them a little more clearly, and deepened my connection to making.

Was there a moment in your career when you had to reinvent yourself or your practice because of an obstacle?

No, I haven't really had to reinvent myself, but I knew I had to come to the art world in a way that gave me space to grow and not get stuck. I always relate it to music, where someone puts out a pop album and the first song is so good that people never listen to the rest of the album. Even if that artist puts out new music, people only want to hear that one song. I was very careful to make sure that wasn't going to happen to me or my art—that people would fall in love with one work and I'd be stuck making the same painting for fifty years. I'm making sure as an artist that I get to be a fuller person.

How have you crafted a kinship with the land, people, and culture of the Caribbean?

Part of my practice is crafting a relationship with the idea of home. I start by asking myself, "What would have made my mom leave the island and go somewhere else only to work eighty hours a week and not be able to see her son?" In New York, that's the story of so many folks from the Caribbean. I grew up in Brooklyn, really, really poor. My artistic practice has been about asking how culture can be a tool that gives us pride in our land, in the home. How do we reimagine the home?

What does community look like to you as a maker living and working in the diaspora?

Community means actively engaging and listening and being in a position where we're working together. My boy Paul Anthony Smith and I had a show last year at the Sadie Coles gallery. One of my first exhibitions in New York was at my aunt's storefront that had been a barbershop but was sitting empty. She ain't really know

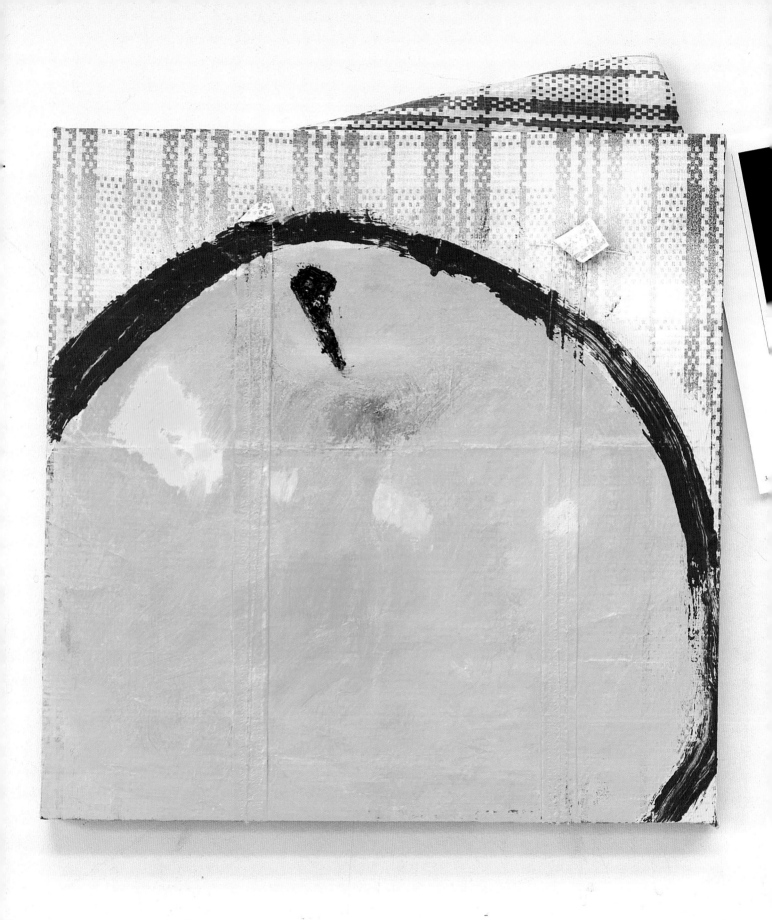

It's my flesh that holds
on to facts. It's my spirit
that holds on to truth.

ALVARO BARRINGTON

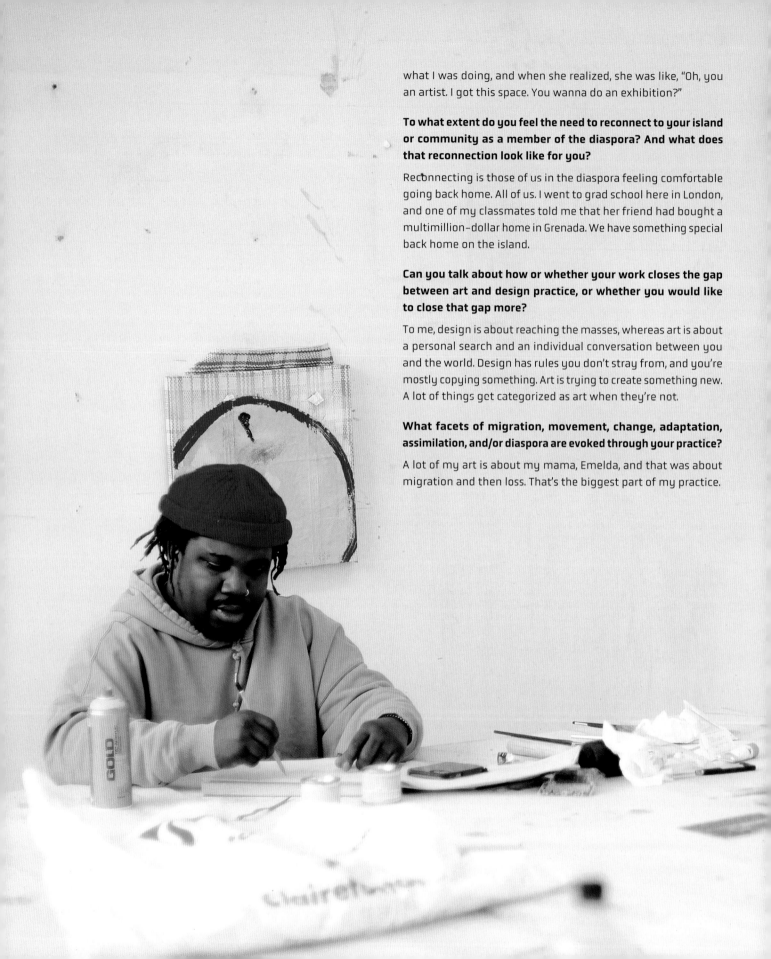

what I was doing, and when she realized, she was like, "Oh, you an artist. I got this space. You wanna do an exhibition?"

To what extent do you feel the need to reconnect to your island or community as a member of the diaspora? And what does that reconnection look like for you?

Reconnecting is those of us in the diaspora feeling comfortable going back home. All of us. I went to grad school here in London, and one of my classmates told me that her friend had bought a multimillion-dollar home in Grenada. We have something special back home on the island.

Can you talk about how or whether your work closes the gap between art and design practice, or whether you would like to close that gap more?

To me, design is about reaching the masses, whereas art is about a personal search and an individual conversation between you and the world. Design has rules you don't stray from, and you're mostly copying something. Art is trying to create something new. A lot of things get categorized as art when they're not.

What facets of migration, movement, change, adaptation, assimilation, and/or diaspora are evoked through your practice?

A lot of my art is about my mama, Emelda, and that was about migration and then loss. That's the biggest part of my practice.

Andrea
CHUNG

A MULTIDISCIPLINARY ARTIST WHOSE WORK REFLECTS ON ANCESTRAL
HISTORIES AND THE EXPERIENCES OF BLACK WOMEN IN THE DIASPORA

A big part of my practice is learning how to approach each new project I take on.
I'm more interested in the materials and the making process than in the finished
product. I fluctuate between a lot of different materials. They just find their way
to me, which is exciting.

What did you make as a child before you even knew to call it art or design?

I drew a lot as a kid. I treasured my crayons. I had a book on how to draw fashion
illustrations, and that's how I started drawing the figure more, and getting into design.

**Was there a moment in your career when you had to reinvent yourself or your
practice because of an obstacle?**

My God, being a mother! Trying to figure out how to navigate my career and the
art world. Becoming a mother was actually what made me a better artist. You value
time in a much different way. You figure out what you're willing to put up with and
what's worth sacrificing your time for. I love what I do for a living, but life cannot
revolve around work.

**All the artists and designers in this book are connected through the lands of the
Caribbean. You've talked about how important the materials of making are to you
and how the materials and processes of making are more inspiring to you than
just the finished product. Would it be fair to say that it's through the materials
and the actions of making that you craft your personal kinship with the land,
people, and culture of the Caribbean?**

I can't speak for the region. I'm a first-generation Caribbean American, a child of
immigrants, which is a specific and nuanced lens. It's a very different experience
than if I had been born in Jamaica or Trinidad, where I wouldn't have to constantly
explain who I am to everyone. I haven't spent as much time in Trinidad as I would
like. Jamaica does feel like home in some ways, but there's also a sense of not quite
fitting in because I have an American accent. I wonder what my life would be like
had I grown up there. I try to understand what it was like for my grandfather to
emigrate from China to Jamaica at seventeen and lose contact with his family.

Psychologically, I'm always trying to discern the mental space of people living in the time of my grandparents, in those situations. I always feel like my parents are my audience, so I'm continually trying to make work that we can have a healthy conversation about, and that allows them to see my perspective, and me to see theirs. I want my child to know where he came from.

What part of your Caribbean identity or art practice do you think speaks to what is needed in the world right now?

I don't think Caribbean people understand how much other Black countries look to them as a source of inspiration. I had the good fortune of receiving a Fulbright scholarship to study in Mauritius, where reggae has a huge social and political impact as a form of resistance against the government and the police. Mauritians have their own version of reggae called sega. Kaya is sega's Bob Marley. Mauritians draw inspiration from Jamaica. They have a sense of shame that comes from being the descendants of slaves. But they feel that Jamaicans do not feel that same sense of shame, that they share a sense of pride behind it.

My Caribbean identity is also about challenging the binary thinking that's common in the United States, where people tend to misunderstand cultural mixing. The world could learn from Jamaica how to accept that mixing without expecting people like me to explain every aspect of our being. I don't have to do that when I go home, and there's a comfort in that.

What feelings are you trying to evoke through your work, and what do you hope viewers will do as a result of their interactions with it?

Opening a dialogue is the most important thing for me. I'm not an artist who feels like art can change the world. It's not stopping police brutality or coming up with a cure for cancer or Covid. But I would hope that it could create conversation around how we consider the complexities of colonialism, for example. I would hope that it could change people's perspectives.

What does community look like for you as a maker living and working in the diaspora?

Like every maker from the Caribbean, I've been very fortunate in that it doesn't matter what country you're from, for the most part; everybody either knows each other or tries to get to know each other. We all try to help one another. There's a lot of support. Ebony Patterson has provided me with a lot of opportunities. I talk to Lise Ragbir, a Trinidadian curator based in Montreal, a lot, and it's nice to have someone to hash things out with whom you don't have to explain the background to. I went to school with Cosmo Whyte at the Maryland Institute College of Art. Paul

Anthony Smith and I vibe not just about making work but also about parenting now that he's a father. It's important to have that community, especially when you're not on the island.

How has your work sought to expand the view of non-Caribbean Black identity and culture?

The work I did for a show at Kohler began with research on midwives in Jamaica. That led me to think about the role of Black midwives throughout the world; about Toni Morrison's book *Beloved*; and about Drexciya, a techno-music duo from Detroit who created a myth about pregnant women on slave ships jumping overboard and giving birth underwater. My work was based on questioning the reasoning behind a decision like that. I've been interested in midwives who performed abortions on plantations as a revolutionary act, as a way of protecting children from a life of enslavement and from possibly being raped and tortured. Is it murder, or is it an act of kindness born out of love? Coincidentally, *Roe v. Wade* had just been reversed when I created that work.

I'm making work now that employs different teas and medicinal herbs that midwives used to perform abortions or to provide contraception to women. It didn't matter what country they ended up in, they were able to identify these herbs, and they were great botanists. Europeans feared the midwives because they were afraid of being poisoned.

I'm really interested in what it means to be powerful in a different way and how you can protest in a lot of different ways. Dr. Kevin Dawes, a professor at UC Santa Cruz, wrote about our relationship with water and how African women would entice Europeans into their waters so they would drown. There's power in being able to determine your own life, including how you live or die.

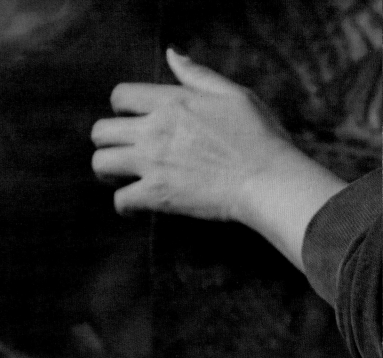

To what extent do you feel the need to reconnect to your island or community as a member of the diaspora? And what does that reconnection look like for you?

My community is my audience. That's who I want to gain the most from the work. I want people from the diaspora to own it, and I really want to work with curators from the diaspora. There's a certain level of care that they will take with the work beyond that of somebody who just wants to hang it above their sofa.

I'm sure there are challenges around trying to control who buys your work.

I am very fortunate that my gallery owner, Tyler Park, and I have an understanding that he will always ask me for my permission before he sells the work. With certain pieces, I am explicit about who I want the owner to be. I don't want a collector coming in to buy a piece and then flip it. Don't buy the work if you don't love it, and if you don't want to live with it. I don't need to make a million dollars. I just want my work to go someplace where someone is going to love it and pass it down through their family, or gift it to an institution.

I'm struck by how your work uses methods and materials associated with both art and design. Can you talk about how or whether your work closes the gap between art and design practice, or whether you would like to close that gap more?

I was an illustration major at Parsons, which has a huge focus on design. A lot of the early design courses I took influenced my practice, particularly how I create compositions, and how I lay out patterns and materials. I used to use text a lot, and compositionally it hugely impacted the way I make work, particularly because I've moved into more installation art recently. So I do think about design and how people interact within a space. And sometimes I think of form and function. With the Kohler project, I wasn't working in a white cube—the exhibition was in a space that was formerly part of the original Kohler house, so it looks more like a Victorian interior—so I was designing how people moved through the space. I was trying to get people to physically interact with the work so that they would sit down and read. I created a gigantic terrarium where I grew the herbs that midwives used to induce the abortions. I looked very specifically at how that room was designed and made sure it worked within the dimensions of the space.

I also think a lot about design when I'm making collages, including the work I've done on tourism, which looks at how graphic design has impacted the way we understand tourism on certain islands. There are often phallic symbols in ads, or Black figures in very submissive positions, which is similar to what you'll find

if you look at archival images of laborers in the Caribbean. The ads were designed to make white tourists feel safe as they came into this space. I sort of embrace the design strategies that were used in constructing these images, because they never go away.

Krista Thompson's book *An Eye for the Tropics* was my bible for a long time because she really broke down how a lot of postcards and posters were made by the Jamaica Tourism Board for an audience that did not include us.

Has your approach to or use of materials changed over time in your practice?

I'm definitely cognizant of my materials and what is problematic. I try not to use anything that is sacred to or would be insensitive to any group. I've been working with sugar since around 2007. I always think I'm done with it, and then it creeps back in.

It was the bane of my existence for a long time until we finally figured out how we wanted to work with each other. I'm very much of the belief that you let the material do what it wants to do. It has its own life, and I just respond to the way it chooses to behave. That has served me well, because I used to try to control the material too much, and then I would just find myself really frustrated. I couldn't get the results that I wanted. But by allowing it to be what it wants to be, I embraced ephemera and time and what time does to an object.

A huge part of my practice now is allowing things to deteriorate. In some ways, it's like my middle finger to the art world, 'cause I'm like, "Try to sell this." But in other ways, I find that there are people who are really invested in the deterioration of the work. A couple of years ago, I did stereotypes and had them dipped into sugar that would eventually crystallize like rock candy. We explained to collectors that over time, the sugar crystals are going to fall off and collect at the bottom of the frame. That the work is going to shift and alter and change, and that it's its own living piece.

Sugar is an interesting material because it's the most addictive drug there is. It's in everything. You can't escape it. There's a heavy price that came with people's fascination with sugar, and I'm interested in investigating that so that people think about the things they buy and how that's impacting somebody else in the world.

I love working with mundane objects that we take for granted, showing how special they are or discussing their history. From my interest in sugar, I've made everything ephemeral now. Like cyanotypes. If you expose them to light over time, they will turn white, but if you put them in the dark, the image will reappear.

I've also been sculpting with paper and seeing how far I can push its limits. It's a fun material to work with. During a residency at the Women's Studio Workshop in 2016, I was supposed to be working on printmaking but was immediately interested in their paper-making studio. They taught me, and I lived in the studio for about two months. That's essentially how I started making collages. I made paper from handkerchiefs that had been used by some of the midwives as birthing cloths, and then I would imbue the collages with the teas and medicinal herbs the midwives used. That paper was so precious to me.

Can you talk about how your work reflects cultural, familial, or personal memory?

That's my goal. It's not just one emotion; I try to complicate the work so that you're thinking about all of it: cultural memory, familial memory, personal memory, sense memory. I've made sculptures with spices so that when you come into the space, you remember the first time you had curry, and ask, "What did it take for that to end up in the Caribbean? Why is curry such a common dish in the Caribbean, and how is that curry different from the curry that you may get in India or Thailand?" I want to encourage people to think about expansion and migration in that way.

All art is personal in some sense. Some works are more personal than others. The most personal piece I ever did was a video I made for the Pérez Art Museum. My dad and I have been estranged for the last eight years. He would never accept me for who I was. But no matter how much he tries to assimilate, he, too, will never quite be accepted, which is true for the Windrush generation or anyone else coming into the UK. You're never really going to be seen the way that you should be seen. So the video I made was of these barrister wigs on Styrofoam heads and my hands trying but failing to dreadlock the wigs. In the background, you hear a Derek Walcott poem about the end of a relationship and learning, while it's quite painful, to love yourself, to fall in love with yourself.

Making art is me just doing what I was meant to do. It is the thing that I love the most, and I can't put the same kind of devotion and passion into anything else.

ANDREA CHUNG

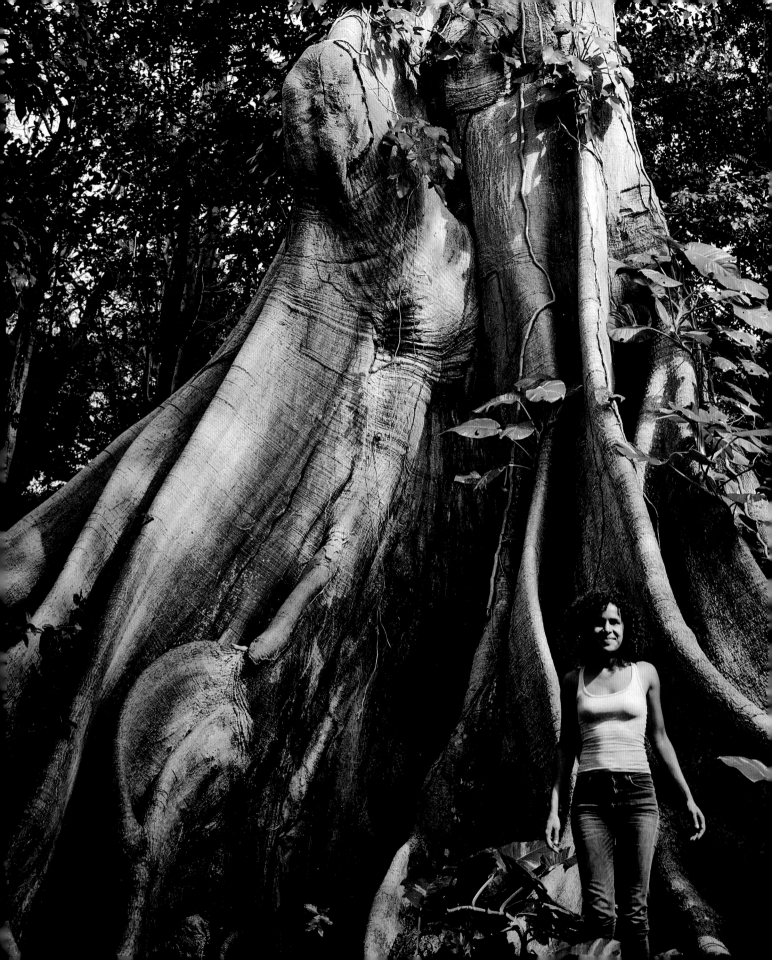

Ania FREER

A FILMMAKER WHOSE WORK CREATES INTIMATE VIGNETTES OF THE EVERYDAY

I stepped into my current practice when I moved to Jamaica in 2016, and it has been a way for me to understand and connect with my Jamaican heritage. Building a relationship with Jamaica and developing a new sense of identity have been the motivating factors behind my work. Creating short video portraits that capture memories, stories, oral histories, anecdotes, sentiments, desires, and intentions is an essential part of my practice. I am not concerned with facts as much as I am with human experiences, feelings, and sensations.

What did you make as a child before you even knew to call it art or design?

I bought a Hi8 camcorder when I was ten years old, and I spent a lot of time making little films—claymation, stop-motion, home movies—and conducting interviews with friends and family. This camcorder was my prize possession, which I'd saved up for with any birthday, Christmas, or pocket money. When I was eleven, my mum took me out of school and the two of us drove across Australia for a year. I used my camera to tell stories and interpret the world around me, something I continue to do now in my creative practice.

Was there a moment in your career when you had to reinvent yourself or your practice because of an obstacle?

The journey of moving to Jamaica, finding my creative voice, and stepping into an art practice has been something of a rebirth for me. When I left my life in Australia, my family, friends, and career in documentary production in 2016, I began the process of reinventing myself. I wasn't conscious of this at the time, but over the years I've grown into a very different person from who I was then. I realize now that this was my opportunity to get to know myself in a way I never imagined possible. I spent a long time in Jamaica in quiet meditation: reflecting, journaling, feeling, being. This transformative experience has allowed me to find my voice and confidence as an artist.

How have you crafted a kinship with the land, people, and culture of the Caribbean?

Moving to Jamaica on my own and getting to know the culture through making the country my home, finding a routine and building meaningful connections, has been the most incredible way of crafting a sense of kinship and belonging for me. I came to Jamaica looking for healing, and it is here that I have developed my own set of tools to provide this for myself and, in some way, for others.

The Caribbean is a small place that significantly impacts the world. What part of your Caribbean identity or art practice do you think speaks to what is needed in the world right now?

The films I make ask an audience to step into someone else's world and listen to them with compassion. Listening is a huge part of my practice and something the world needs more of.

Moving to Jamaica allowed me to slow down in a way that I have never had the space or courage to do before. By pursuing my curiosity and giving myself time and freedom to respond to the shifts and changes in my life in a creative way, I am connecting to the part of myself that I feel capitalist and production–fueled societies prevent us from accessing. I believe a better world is pos-sible if more people connect to a deeper sense of self and purpose, which many of us have become detached from in everyday life.

What feelings are you trying to evoke through your work, and what do you hope viewers will do as a result of their interactions with it?

Connection, intimacy, joy, and curiosity. I want to share unique perspectives, document fading memories and mythologies, and inspire new conversations. I want my work to provide the type of window into everyday life and culture in Jamaica that disrupts ingrained stereotypes and moves conversations away from just tourism, music, crime, and violence. I want my stories to show

the raw humanity, generosity, and love that prevails in Jamaica and to be a calling to the diaspora to return, spend time, explore, learn, and absorb.

What does community look like for you as a maker living and working in the diaspora?

Discovering and forging my Jamaican identity has been coupled with the powerful desire to understand my Blackness. Over the last couple of years, I have been visiting New York and seeking out other artists in the diaspora who are similarly exploring their identity and Caribbean homes through their art practice. I love the strength of this connection and how it pulls and holds communities within the diaspora together.

Can you talk about how or whether your work closes the gap between art and design practice, or whether you would like to close that gap more?

I explored closing that gap through the curatorial intervention *All That Don't Leave*, in 2019, where I exhibited the works of

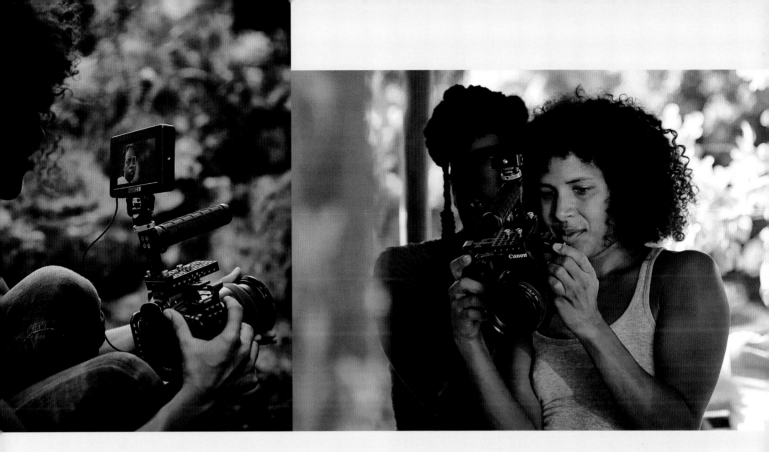

seven craft artists from across Jamaica at NLS (New Local Space) Kingston, a gallery in the heart of the city. The exhibition interrogated the line between art and craft, challenging local perceptions of craft by exhibiting the works within a contemporary gallery. The exhibition also included intimate video portraits and studio visits, which gave audiences an insight into each artist's process and practice.

Are there aspects of your identity that can be seen or understood only by other Caribbean people? Is it important to you to maintain that intimacy with your community?

A big part of my identity is this longing for connection with people in the diaspora, who have similarly grown up in communities that are disconnected from their Caribbean identity. When I arrived in Jamaica, I went through a process of reimagining myself and feeling confident enough to accept this new version of myself. I am slowly and gradually building my community, a sisterhood of other women who, like me, have a complex but fluid relationship with the Caribbean—with movement, expansion, contraction, and long periods of time here, but also long periods of time away. Through these friendships, I've been able to better understand my own push and pull with Jamaica—a deep love coupled with frustration.

Do you think non-Caribbean viewers misunderstand, misinterpret, or misrepresent your work? Should they be corrected? Who should have the responsibility of educating them?

Non-Caribbean audiences or people who don't have an intimate relationship with Jamaica may miss certain subtleties, the tensions of nostalgia and longing that are a big part of my work. I don't mind. The work I do in Jamaica is for an audience that already has a connection to the region. My films have primarily been for me and for my Caribbean community. It's only recently that I've started to share my work with wider, international communities. Although I'm curious about how my work is understood and interpreted by outside communities, it's my Caribbean audience, especially those in the diaspora who are actively expanding their relationship with the region, that I'm more interested in.

Does your work reflect your personal memories or, more broadly, the idea of memory as a form or material of art-making?

Memory plays an important role in my work. My films inspire and generate memories for me. By working with other people's stories, I am bringing light and color to the gray areas in my own history. I didn't grow up with my own or anyone else's memories of Jamaica, which is why they're so important to me now. My video portraiture practice is a form of collaborative memory-making that feels generative and purposeful. These memories heal gaps

To what extent does the theme of memory evoke specific feelings: joy, pain, longing, anger?

Living here, I appreciate the healing power that joy, love, and human connection can have on a daily basis. My work requires people to slow down and go inward in order to tap into their personal memories. Memory is powerful and has the ability to evoke all sorts of emotions, which is why I am very careful about the stories I tell, for the sake of both my collaborators and my audience. I'm particularly interested in documenting memories that touch on intimate moments of joy and feelings of longing. This is a beautiful and powerful dynamic. There is a lot of pain, frustration, inequality, and injustice in Jamaica, but there is also a huge amount of love, care, loyalty, ancestral knowledge, and deep human connection. Working with memories that evoke joy, pride, and self-determination is transformative, and can shift realities. It's very important for me that the work I create is contributing to a healing collective memory.

What are some of the sources you consult in your search for memories, or in your discovery of new memories? Can you talk about places that hold cultural memory, like the market, historic districts or buildings, natural spaces, and libraries or archives? To what extent are these sources sites of inspiration?

Most of the stories I'm drawn to are those of people living and working outside of mainstream society, generally self-taught artists who started their own practice from knowledge and techniques passed down to them. I find the work of craft artists who are independently creating in small shops or home studios particularly exciting and inspiring. Weaving, sculpture, crochet, beading, wood carving, and sign painting are all practices that to me hold cultural memory. Nature, specifically rivers and the stories that surround them, is also an important source of inspiration for me. The story of Riva Mumma, Jamaica's freshwater mermaid, has provided me with a living thread to oral histories that were brought to Jamaica by our African ancestors. As with the craft practices, I love to see how traditional processes of making are rediscovered and reimagined by current generations. I am fascinated by how contemporary culture, materiality, and the tensions and realities of everyday life are woven into the fabric of the stories I encounter in Jamaica.

in my history and have shifted the way I create new memories. Through my practice, I continue to be surprised at how powerful and transformative memories are.

What does cultural memory mean to diasporic people or in the context of Black Caribbeanness?

I grew up separated from any form of Black or Caribbean cultural memory, so I've had to build, seek out, experience, and absorb it much later in life. When I moved to Jamaica, I began the process of cultural memory-making. I developed vital connections to the food and was able to spend time in nature and to experience day-to-day life, which allowed me to understand what my Jamaicanness means to me. There is so much cultural memory held in oral histories. Over the years, I have oriented myself in Jamaica through storytelling, and I want my work to have the power to reach people who, like me, are growing up isolated from their Caribbean roots and culture.

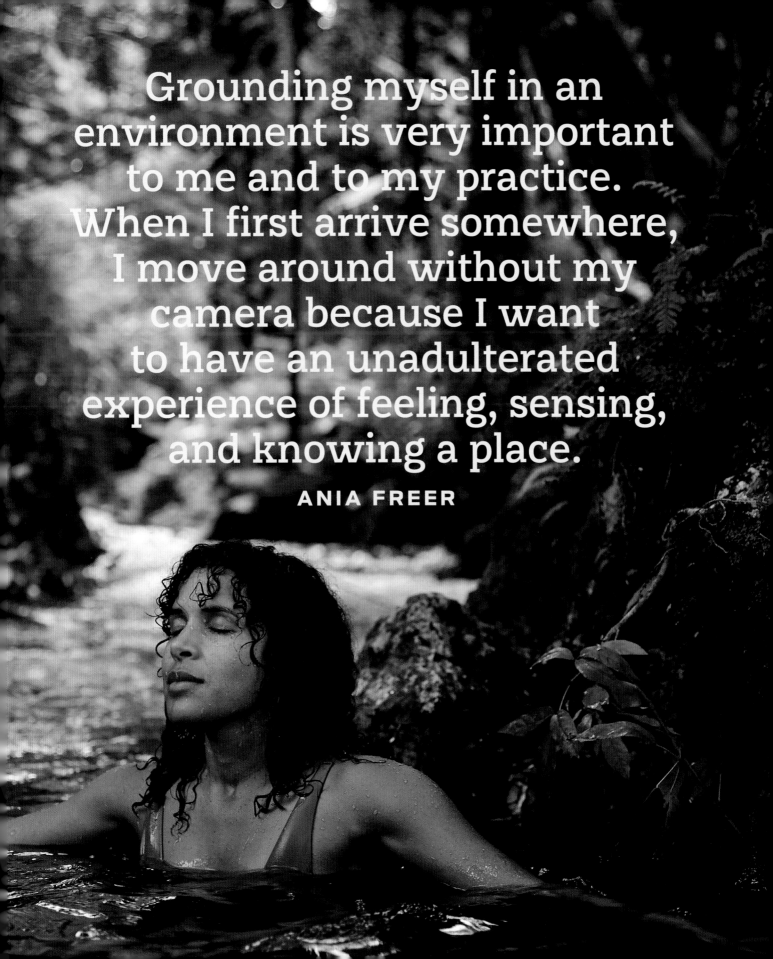

Grounding myself in an environment is very important to me and to my practice. When I first arrive somewhere, I move around without my camera because I want to have an unadulterated experience of feeling, sensing, and knowing a place.

ANIA FREER

Anina
MAJOR

A VISUAL ARTIST WHOSE WORK SEEKS TO UNPACK THE EMOTIONAL COMPLEXITIES IN TRANSCULTURAL DIALOGUE

My practice is a rigorous investigation of culture and its defining influences. I am motivated to explore the relationship between self and place. By utilizing the vernacular of craft to reclaim experiences and relocate displaced objects, my practice exists at the intersection of nostalgia and identity.

What did you make as a child before you even knew to call it art or design?

There wasn't anything I didn't make for the purpose of completing the narratives I created for my toys. This would range from drawings and paintings to dollhouse furniture and doll clothing and accessories.

What feelings are you trying to evoke through your work, and what do you hope viewers will do as a result of their interactions with it?

Expertise originates from many different sources, especially underrepresented communities with nondominant historical narratives. As viewers interact with the work, I hope they can appreciate and value the contributions of such communities.

My work contends that traditional straw work is a salient indicator of our heritage, not just a response to the demands of foreign tourist markets. At the same time, a decline in demand for such objects, a lack of documentation, and fewer people weaving and teaching this skill means this craft is nearing extinction. For example, there were at one point up to sixty weave styles, yet only twenty-five are practiced today. As the economic value of this craft diminishes, my work attempts to increase, record, and interpret its significance. Viewing it through a postcolonial lens, I believe that this practice passed down from my enslaved West African ancestors highlights cultural mobility.

How has your work sought to expand the view of non-Caribbean Black identity and culture?

In his book *The Antilles*, Derek Walcott writes that "the islands [of the Caribbean] sell themselves" at the cost of "the seasonal erosion of their identity." Historically, the region has been romanticized with commercials that present not only landscapes but also the jovial servitude of the people for foreign consumption. How does one's self-identification develop under these circumstances? How do they influence one's understanding of self-worth? Because oftentimes these portrayals are third-party interpretations. My practice provides a counternarrative.

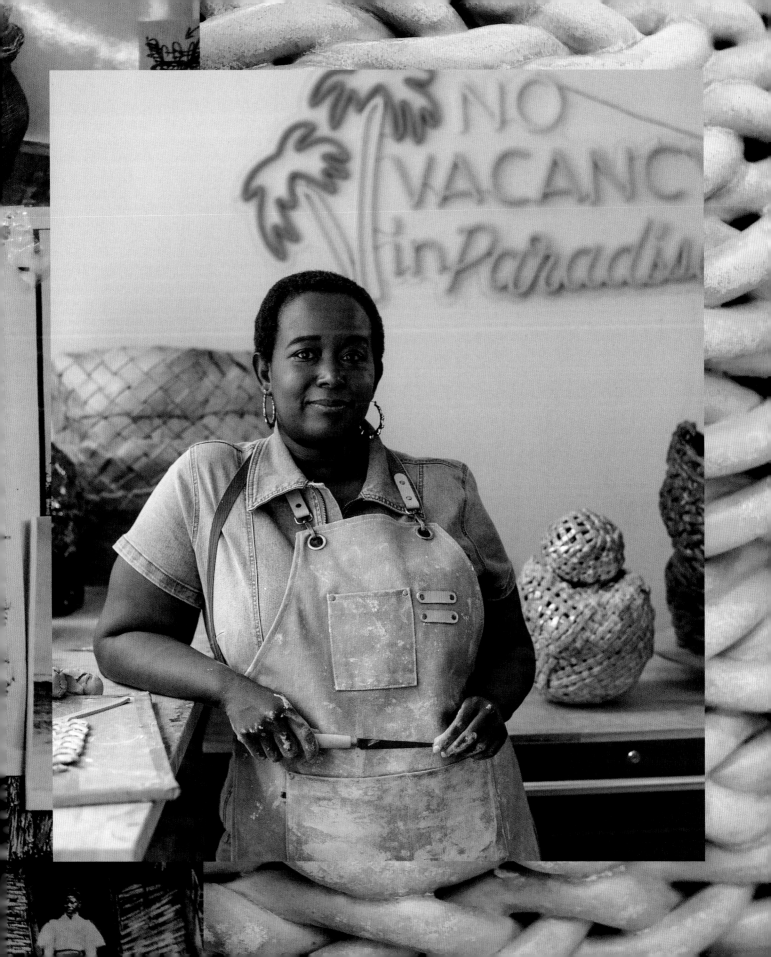

To what extent do you feel the need to reconnect with your island or community as a member of the diaspora? And what does that reconnection look like for you?

So much of my understanding of self is related to The Bahamas, which is the reason I try to maintain a pulse both here and in the States. Being able to spend significant time here allows me to consider the ways in which I may best be able to contribute to the community.

Can you talk about how or whether your work closes the gap between art and design practice, or whether you would like to close that gap more?

At this stage in my career, my primary focus is the content and attributes of the work. Very rarely do I consider the classification of it. Thinking about how my work fits into a particular category feels restrictive and can be a distraction during my creative process. That being said, I do appreciate well-designed objects and great art. Some of my favorite things blur the line between them, and history has shown that objects have navigated from one category to the other over time.

How do you approach memory in your work? What sources do you draw from?

Many aspects of my practice are rooted in nostalgia. Initially, my motivation to create came from a desire to surround myself with objects that reminded me of home. It wasn't until I found a discarded straw doll in a Brooklyn thrift store that I started thinking about how this displaced object evoked similar emotions to those I was experiencing living abroad. The abandoned doll made me question the series of events and value structures that deemed this object dispensable, as I was intimately aware of the narratives associated with its creation. The deconstruction of this object eventually led to the manner in which I work.

Conceptually, I pull from a variety of sources: personal memories and experiences, private and public archives, articles and oral histories. Combined, these sources act as a springboard for my creative thinking, which usually takes form as a series of questions. For example, a conversation with an older family member on a visit home may encourage me to research a tradition at the national archive, which in turn prompts me to consider the ways in which this tradition can be abstracted and expressed via sculpture.

What does cultural memory mean to diasporic people or in the context of Black Caribbeanness?

Cultural memory is our survival. Of the history that has been documented, a lot of it has been written from outside of our perspective. Today we have agency to create our own narratives, placing emphasis on the aspects we deem important.

To what extent does the theme of memory evoke specific feelings: joy, pain, longing, anger?

My practice conjures a deep-rooted passion to celebrate the work of those who contributed to the life I have today. How can I acknowledge and pay respect to their sacrifices? In what ways can my actions emphasize intrinsic values?

What traditions or expressions do you use in your practice and/or daily life that were kept alive through the Middle Passage and survived to this day?

The primary technique I use to create sculpture is a form of braiding, or as Bahamians say, "plait." It is a complex structure or pattern of three or more interlaced strands of flexible materials such as yarn, wire, and hair (or straw in my grandmother's case and clay in mine). This method of making baskets from natural grasses traces back to the slave trade. Many enslaved Africans used their basket-weaving skills not only to increase the efficiency of labor but as a means of communication that signified tribal identity, age, marital status, wealth, religion, and social position. I believe that the transfer of these skills intergenerationally is one of the ways in which we preserve our oral history and culture.

What facets of migration, movement, change, adaptation, assimilation, and/or diaspora are evoked through your practice? To what extent does your work engage with the feelings of both loss and gain in the experience of migration?

I am interested in illuminating kinship connections across the Black diaspora. At the moment, I am exploring that through the vernacular of craft. Craft is one of the ways in which we are able to identify the movement of people and the evolution of culture over the years.

My process of making reconnects me with aspects of my heritage and provides a beautiful metaphor for feelings of loss and gain. I manipulate the clay at the beginning of the process, when it's moist and malleable. The soft tension created by weaving over and under I liken to waves coming and going at the shoreline, a continuous influence and influx of information. As the work continues to take form and harden, it is at its most fragile, and it is at this point that I subject it to extreme heat, which transforms the work into its strongest material state. There is a poetic parallel between my work and lived experiences that is recorded with my practice, moments of vulnerability evolving to a permanent yet still fragile state.

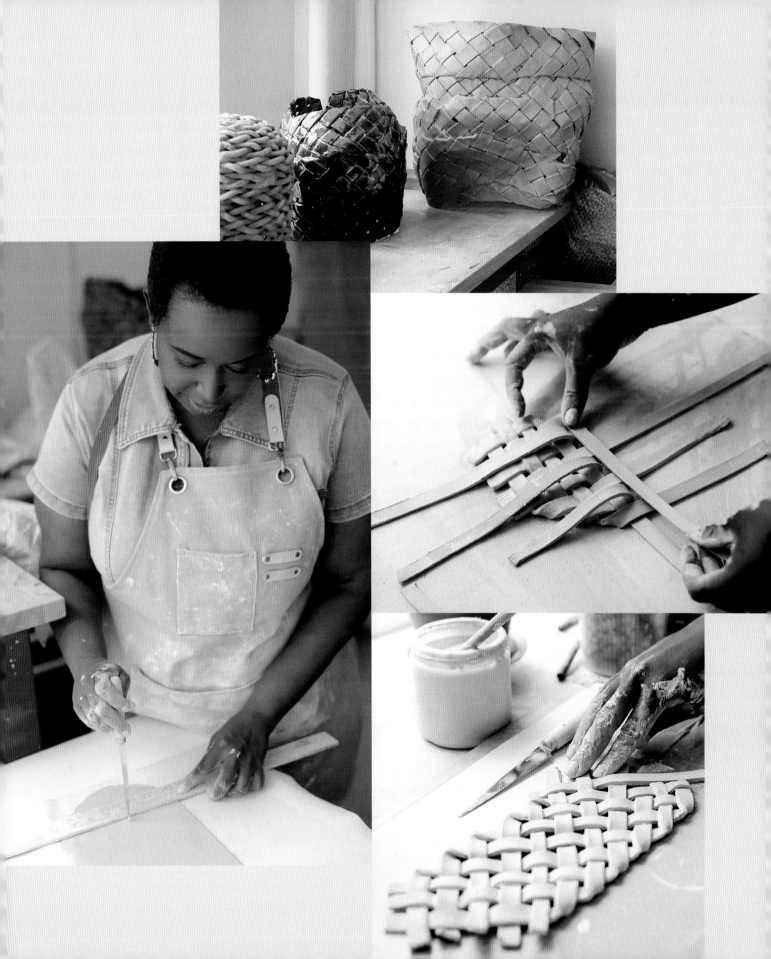

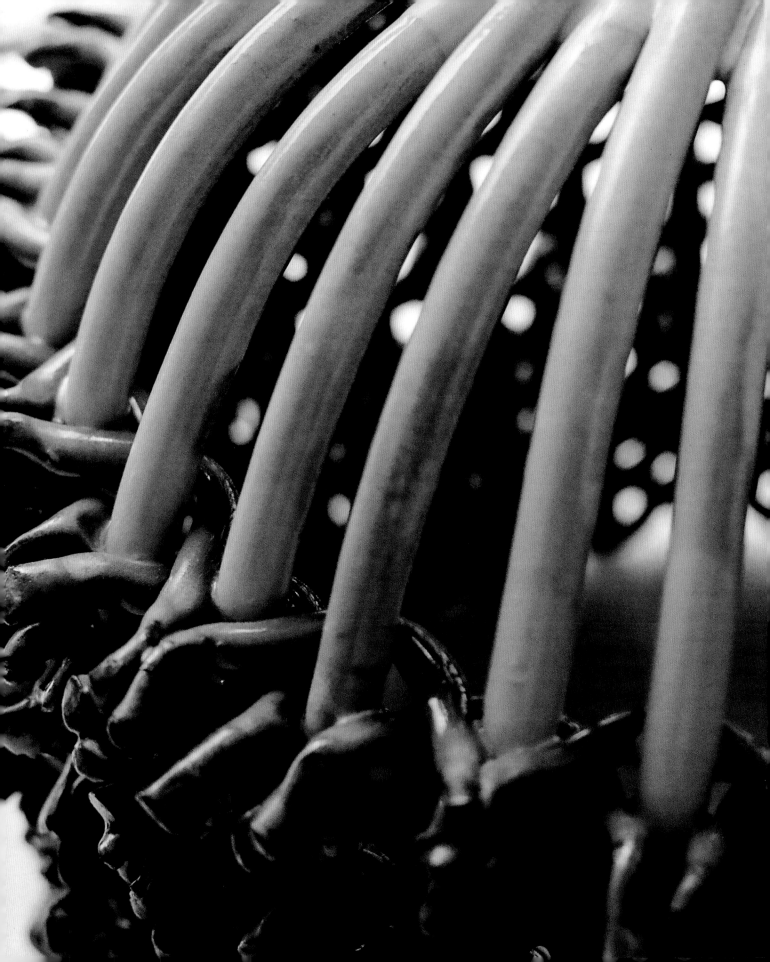

Cultural memory is our survival.
ANINA MAJOR

April
BEY

AN INTERDISCIPLINARY VISUAL ARTIST WHOSE WORK EXPLORES THEMES OF AFRICAN DIASPORIC SPECULATIVE FUTURISM AND ALIEN IDENTITIES

My practice combines speculative futurism with environmental worship and Black opulence to illustrate fictitious lands and places where diasporas can thrive.

What did you make as a child before you even knew to call it art or design?

I used to spend a lot of time in The Bahamas—on Eleuthera, which is where my grammy and cousins lived. I played in the bush and in the ocean. I would fantasize about having an apartment under the ocean inside the coral reefs. I would make a lot of fake food out of dirt and leaves. I used to play with the sea urchins and sea cucumbers that would squirt out ink, and I would paint on the rocks. My cousin showed me how to pull pigment out of plants and flowers. I didn't know that all of these things were art; they were just decoration for the imaginary environments that I had created for myself to be alone in.

Was there a moment in your career when you had to reinvent yourself or your practice because of an obstacle?

I started my career painting portraits of celebrities and placing them within a narrative of them living on after their Earth years, saying that they were really aliens from another planet. They were just sent to Earth to see if they could impact it. For example, James Baldwin is president on my planet. He came to Earth, did what he could, and then left. That became an obstacle for me because it was making my work seem like it was pop art, and there are copyright issues like model consent. It was really an institutional awakening that helped me realize that I needed to start bringing real people into my work and making real people kings and queens and presidents and ministers of cultural affairs. People stopped seeing my work as glorified fan art featuring unattainable beings; instead, they started seeing their grammies, aunties, girlfriends, and sisters. Now I feel like people are able to add to my narrative and help me create this world that I'm trying to build.

No matter where we are in the world, we return to our Caribbean homes as a source of inspiration for our work identities and spiritual belonging. How have you crafted a kinship with the land, people, and culture of the Caribbean?

When I was little, I would get in trouble for picking flowers from other people's gardens. But I would do it to give the flowers to people I loved, and I was fascinated by the fact that plants grow with pigment in them. Now I make a lot of large tapestries

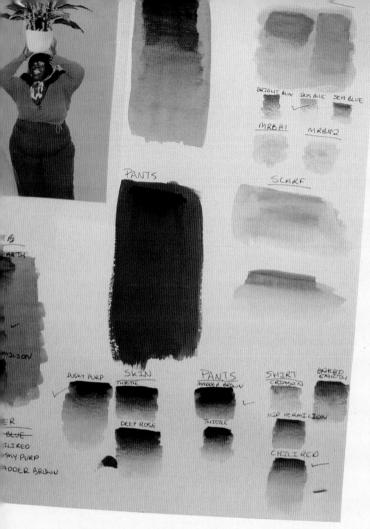

"It's not fiction, it's futurism."

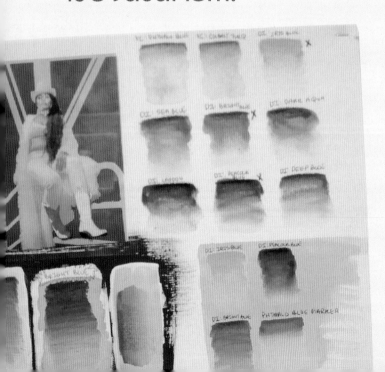

with plants in them, specifically plants like calatheas and other tropical plants that grow in the region where I grew up. Those plants represent a means of transport from Earth to Atlantica, so they're in everything. The flower part of the plant, the fruit part, is always a Black woman's fist with acrylic nails. That becomes the thing that you have to sniff to see if the plant is ripe or that you have to look at to make sure it's the plant you want.

The Caribbean is a small place that significantly impacts the world. What part of your Caribbean identity or art practice do you think speaks to what is needed in the world right now?

Broughtupsy! Broughtupsy! That's been the biggest thing. I still struggle with that. I've been in the United States for a very long time, and people just don't have the same courtesy. America is so individualistic; people don't care about whether their neighbor has heat or not. You get lost, and nobody knows who you are. I grew up on such a small island that I couldn't do anything wrong without Miss Roll seeing me out the window, calling my mummy at work, and being like, "I just saw April going to the lodge. She's supposed to be in school." People looked out for you. It's similar in Ghana, where we say, "Good morning," "Good afternoon," and "Good evening" to people we pass along the street. It's to acknowledge that I see you, and if something goes wrong, I will be there for you because we're all in this together.

In my work, I'm creating a planet where we're all genetically linked and don't have the ability to approach each other with anything but love. It creates a collective understanding. Just because it's not a small island doesn't mean we don't have a responsibility to look out for each other.

What does community look like for you as a maker living and working in the diaspora?

Financial proceeds going to the people in my community who are represented in the work. I was intentional about whom I worked with and where my funding went when I sourced fabric in Ghana. It's the idea of leaving something better than you found it and being able to fund your own community, and of creating a self-sustaining community by using whatever currency you have and disseminating it.

What feelings are you trying to evoke through your work, and what do you hope viewers will do as a result of their interactions with it?

In my work, I like to show people what reality is. Sometimes they start questioning things, like, "Why do you have a three-hundred-pound Black woman in a bikini? That's really provocative." Why? And how? We're thinking this way because we have these

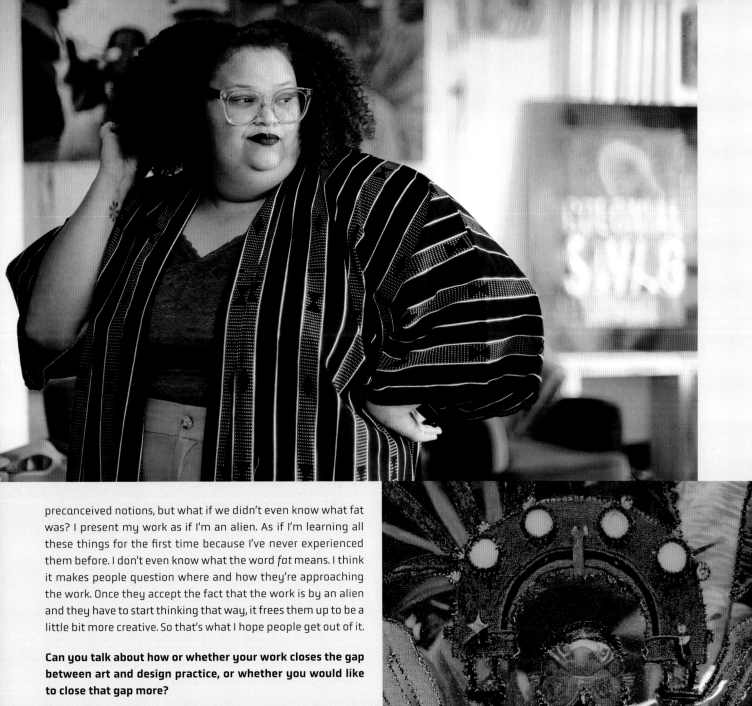

preconceived notions, but what if we didn't even know what fat was? I present my work as if I'm an alien. As if I'm learning all these things for the first time because I've never experienced them before. I don't even know what the word *fat* means. I think it makes people question where and how they're approaching the work. Once they accept the fact that the work is by an alien and they have to start thinking that way, it frees them up to be a little bit more creative. So that's what I hope people get out of it.

Can you talk about how or whether your work closes the gap between art and design practice, or whether you would like to close that gap more?

I have a background in graphic design. In school, all the design-ers and artists had to do foundation courses, so we were all in the same classes the first year, but then we fractured off into our majors. All the studio artists went to drawing, printmaking, and painting, while the graphic designers and product design-ers went to another floor and we never saw them again until graduation, which was so weird. The way I teach design speaks to the intentionality in any visual art form. It's the science and tech behind getting your audience to see what you're trying to see and having the skill to get them to understand the message

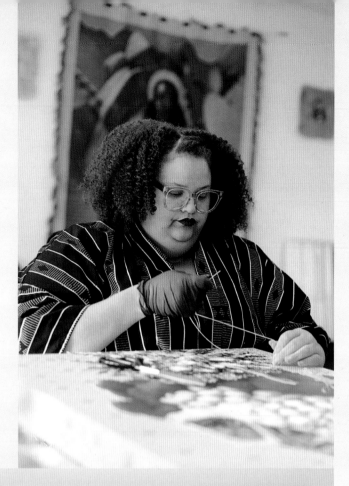

you're trying to get across. My work is pretty, but when people get up close to see what it's about, they learn that Colonial Swag is a satirical brand using racism to make high fashion. It's sinister and sweet. Design is sexy and intentional, but art-making can be chaotic and messy. It's a balance.

How do you employ speculative futurism in a specifically Black, Caribbean context?

Afrofuturism is an African American term. There's also African futurism and diasporic futurism.

That said, human beings are essentially visual learners. If we can see something, then it exists. That's why illustrators are so important. They're the ones who help people put their IKEA furniture together and help doctors recognize tumors. They instruct us and future generations by showing what's possible, and making it something worth working toward. If you see a fat Black woman portrayed as a deity in my work, you can slowly be coerced into thinking that that's real. If I tell you there's a world where we have to take mandatory vacations and I depict that in my work, then you've seen it now and there's no excuse to not start doing that in the future. It's not fiction, entirely; it's futurism.

Joy feels like a thread that weaves through your work as both an offering and a form of critique.

Joy is a big thread in my work, as are Black opulence and plea-sure. My 2022 solo show in Los Angeles, *When You're on Another Planet and They Just Fly*, featured images of Black people on vacation. I wanted to show that Black people should have the most opulence. We should have the most recovery time. I like to show Black people lounging about, or buying a $3 million house, or wearing luxurious clothes. You have the money, and you've done the work.

As an educator, is there anything you'd like to share with students, in particular?

Don't be so lusty to leave home. My Bahamian art family has advanced my career so much. I wish I could go back to my teen-age self when I was like, "Ah, I wanna get off this rock. I wanna go to the States." I wish I could tell her, "Go and just know it's a moment, an experience that you're gonna have." Look for new experiences, but don't forget where you come from.

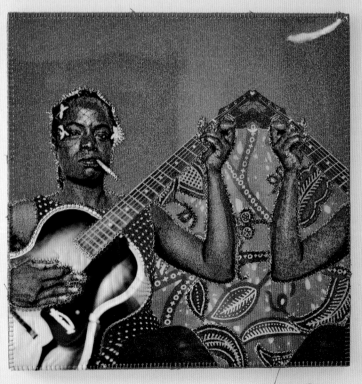

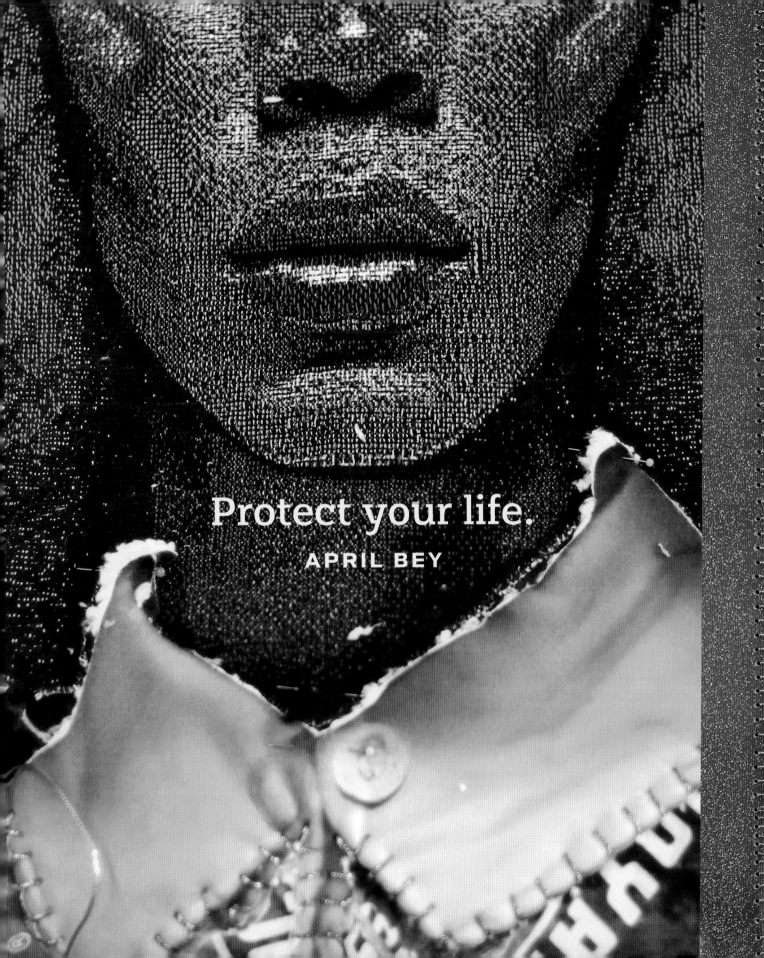

Protect your life.

APRIL BEY

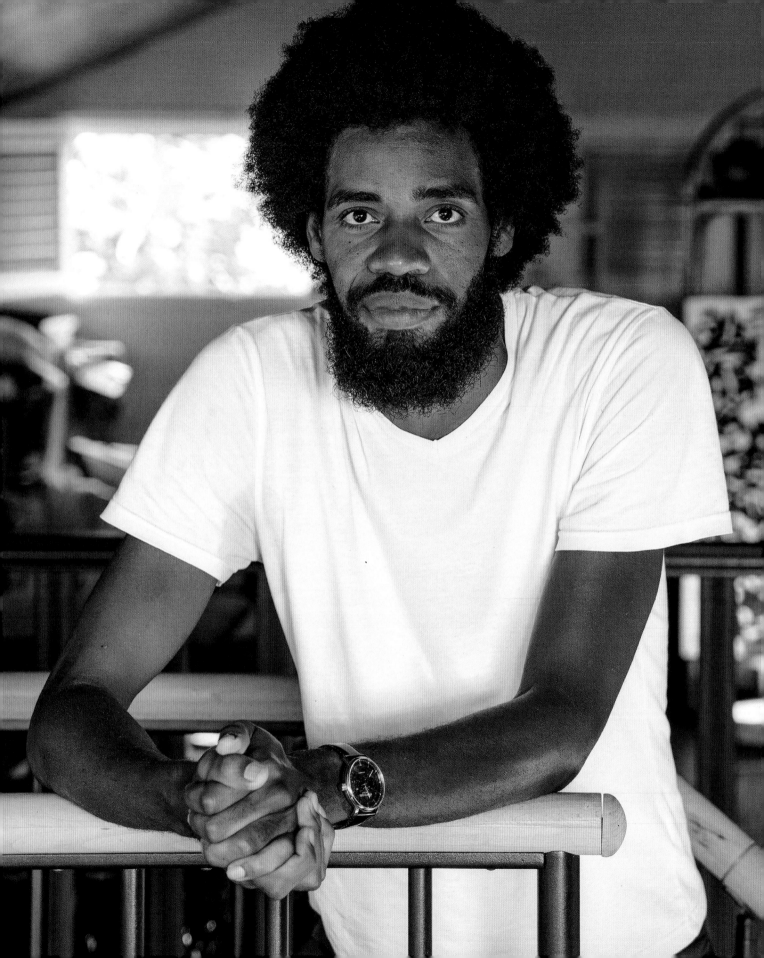

Arthur
J. FRANCIETTA

A MULTIDISCIPLINARY ARTIST WHOSE WORK ADDRESSES SYSTEMS OF WRITING AND AUTOMATIC DRAWING

I play with letters, alphabets, and phonemes to create new shapes, to merge and combine shapes, and I bring drawing into alphabets to create new images.

What did you make as a child before you even knew to call it art or design?

I would grab an object and ask myself how it was built, opening it, breaking it, or destroying it to go inside and understand all the engineering behind it. My father built our house with friends and family, and I was always with him. I did a lot of things with my own hands, too.

Was there a moment in your career when you had to reinvent yourself or your practice because of an obstacle?

I started my studies in Martinique's fine arts school and then traveled to Paris to learn type design and calligraphy. When I had to share my end-of-year project, I tried to explain where I was coming from, but the teacher just didn't understand. In Paris, I don't know all the culture, but I'm French, so it's also my country. My friends said the only thing you can do is to create and use that work to talk about your culture, your environment, where you grow up, and how you interact with people. So I pivoted to focus my work on the Caribbean.

The Caribbean is a small place that significantly impacts the world. What part of your Caribbean identity or art practice do you think speaks to what is needed in the world right now?

How we use graphic elements in our culture, in clothes and objects. How we use shapes or fabric to create new styles, and how we combine visuals with sounds or words to create something new and beautiful.

What feelings are you trying to evoke through your work, and what do you hope viewers will do as a result of their interactions with it?

I want this work to open a door for someone to think something new and create new environments.

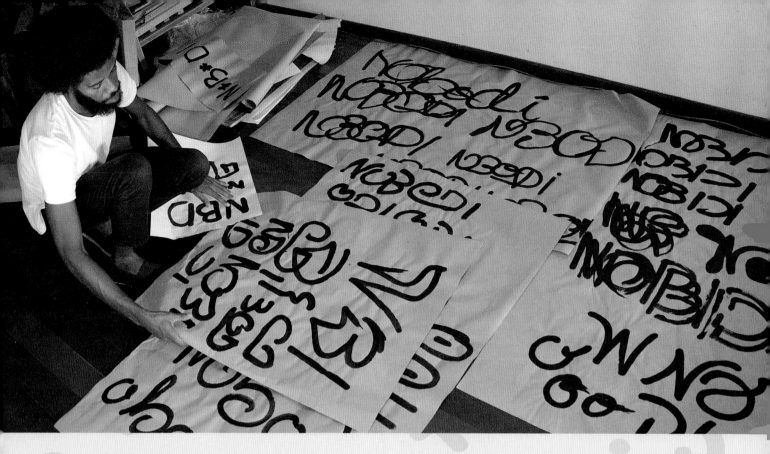

Can you talk about how or whether your work closes the gap between art and design practice, or whether you would like to close that gap more?

The gap is narrow. Sometimes it's difficult with graphic design because I want to bring some aesthetic and not only give people what they want but also share something new, maybe a new way to create shapes, a new way to create letters, a new way to read and to create an editorial design.

What regions or cultures most influence you?

Nigeria and Cameroon. I haven't had the chance to travel to Africa, but I spent a lot of time studying the writing systems in the precolonial and postcolonial periods. During the colonial administration, European people impacted the writing system, and in the postcolonial period, West African people had to try to rebuild and bring back some of their own traditional letters, shapes, and alphabets to create new writing systems. I've been studying the motifs, how they use shapes, and how these systems are shared among several communities with many languages. I don't speak those languages, but the visual patterns influence me. For me, a letter is a drawing, and you embed definitions or codes within these drawings. The work from these regions informs my own graphic style.

What stories are you seeking to tell about colonial histories in the Caribbean?

The languages, the shapes, and the typographic forms we use are influenced by colonial history. We lost many things about our historical African culture that have to be re-created. We feel the empty space inside our culture. Part of my work is to show non-Caribbean people—mostly white people, white French people—what they've ignored about how beautiful these cultures are.

At the beginning of my practice, I was afraid to use African, Nigerian, Cuban, or Asian shapes in my typographic designs. But I had no difficulty incorporating ideas and images from French or German culture. I needed to change my point of view and respect my heritage. I use it to create new and beautiful things that honor our historical cultures. Those African forms that had been discarded and treated as if they didn't matter, I'm bringing them back to create a new African futurism.

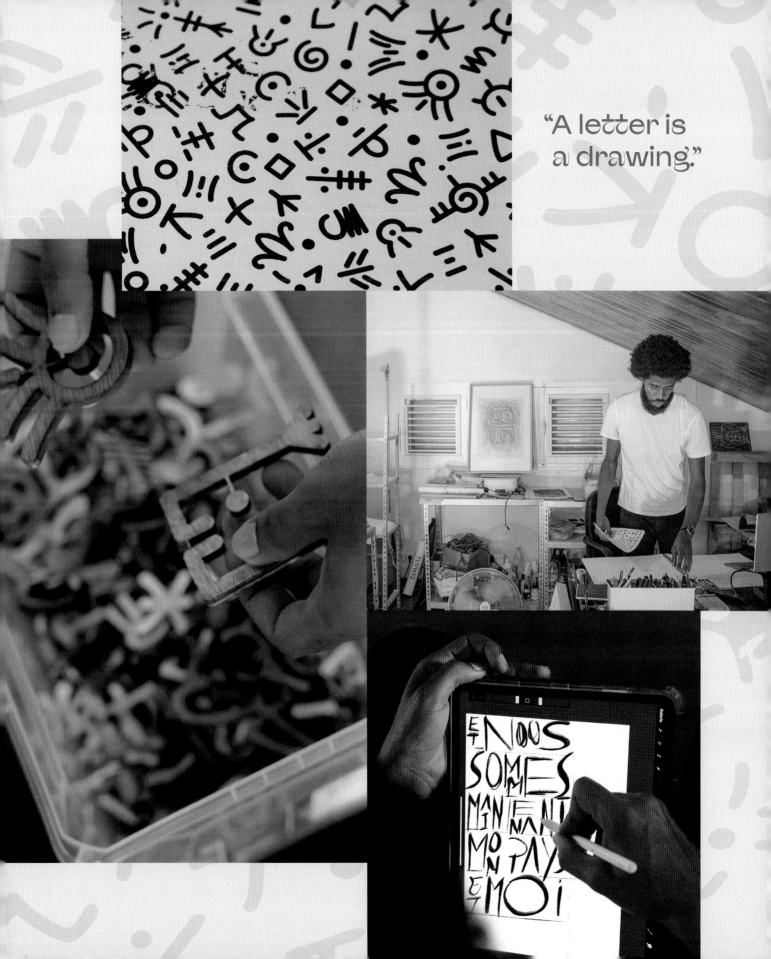

"A letter is a drawing."

Basil
WATSON

A FIGURATIVE ARTIST AND SCULPTOR WHOSE WORK EXPLORES THE HUMAN PSYCHE

My ultimate goal is for people to understand a little bit more about themselves.

What did you make as a child before you even knew to call it art or design?

I was always doodling. In school, I would sit at my desk and doodle in my notebooks. My earliest recollection of doing anything sculptural was making pigeon piggy banks out of clay obtained at a clay pipe factory.

What feelings are you trying to evoke through your work, and what do you hope viewers will do as a result of their interactions with it?

Everyone has a public identity and a personal identity, and because a lot of our values have been passed down as cultural laws, those values need to be questioned. I hope my work can initiate that process of self-inquiry. Whether through a private piece that speaks to relationships, sex, or self-awareness or a public piece that is conveying public issues and stories, we need to explore it all.

Can you talk about how or whether your work closes the gap between art and design practice, or whether you would you like to close that gap more?

I think art needs design in order to thrive probably more than design needs art to thrive. Design is more scientific, more structured, more basic. Art carries design or uses design to transcend to another level. So within a table, within a glass, within a car or whatever the object, you have to include design as a technique. But art carries it further, beyond technique.

What facets of your identity are most prominent in your work?

I strive to be inclusive of influences from around the world. I recognize within myself Black influences, African influences, European influences, Caribbean influences, American influences. My grandfather was white, and when I go to England, I see so many things, physical items, that I grew up with in Jamaica. These items, like many other cultural and psychological influences, come from the colonial pasts of countries that form parts of my identity.

But the world is far from being this way. I am seen as a Black man; in many ways, I live a Black experience, particularly growing up in a Black-dominant society in Jamaica. I feel that the world has to move toward a state of inclusiveness for it to

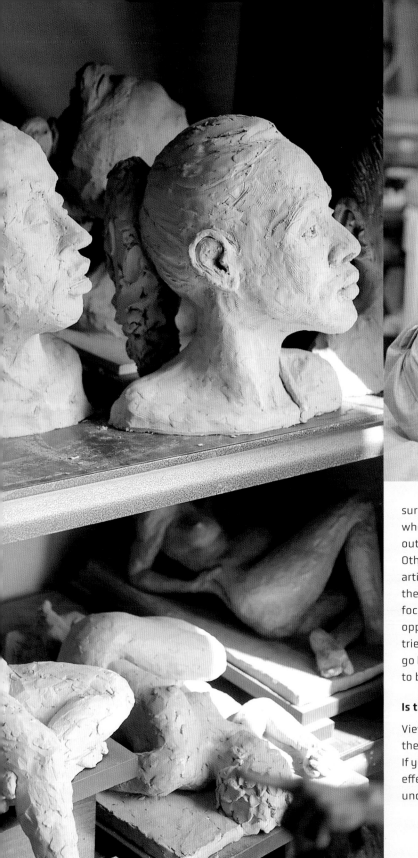

survive, but I also think we are at a stage of the world's journey where it has never been so open. I try to look at the world without bias, seeking understanding rather than passing judgment. Other artists would explain that maybe if I were a white British artist creating images of Black people, the noses would be flared, the lips would be extra thick, the hair would be extra kinky. The focus would be on representing the message of Blackness as opposed to looking at life objectively in all its diversity. My work tries to transcend the stereotypes. The representations I create go beyond just being Black. To create transcendent art, we need to be human beings first.

Is there anything else you'd like to share?

View the making of art not in terms of the object but in terms of the process, the process that brings you toward enlightenment. If you go through the process honestly and that process includes effective technique as well as the search for understanding, that understanding will be passed on to others.

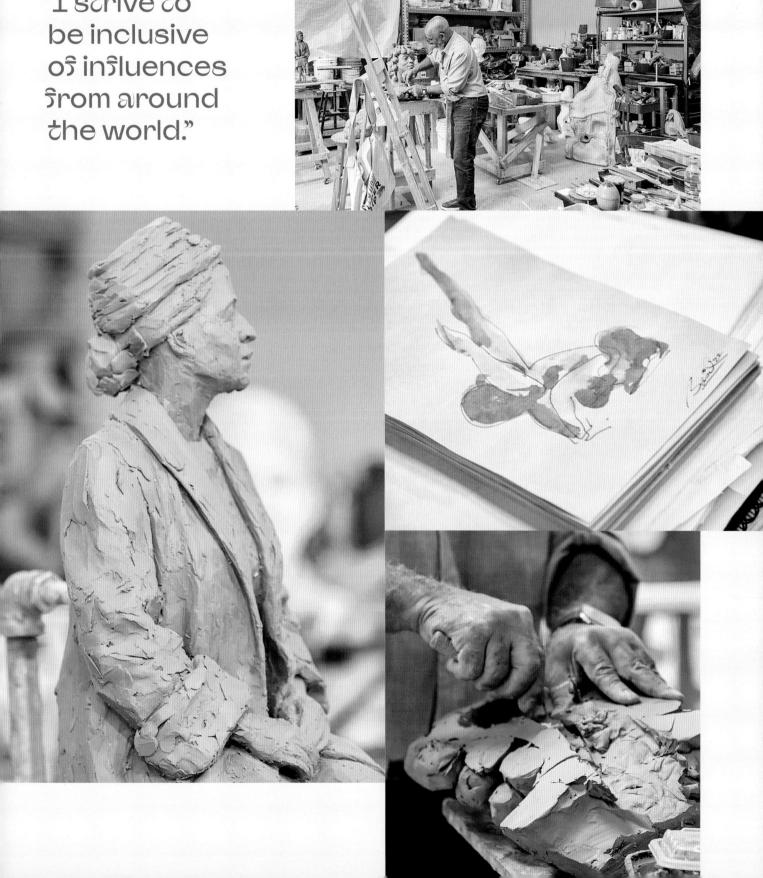

"I strive to be inclusive of influences from around the world."

Start with the big picture,
the big shapes, and then develop
the subordinate shapes.

BASIL WATSON

Billy
GERARD FRANK

A MULTIDISCIPLINARY ARTIST AND EDUCATOR WHOSE WORK EXPLORES IDENTITY THROUGH THE LENSES OF COLONIALISM AND POSTCOLONIALISM

My last three projects incorporated painting, sculpture, and filmmaking, as well as text. A lot of my work is informed by historical research, connecting to my own identity and to the Caribbean: postcolonialism, colonialism, and similar motifs.

What did you make as a child before you even knew to call it art or design?

Grenada comprises a main island and two small islands: Carriacou and Petite Martinique. I grew up on the smaller one, Petite Martinique, which has a population of about seven hundred. Mainly people of African, Scottish, Irish, and French ancestry. Grenada was a French colony for a hundred years, and the people have maintained a lot of their rituals and culture connected to France, Africa, and other parts of Europe.

My dad was a self-taught boatbuilder who also built his own homes. I would stay near him when he was constructing boats and was able to absorb what he was doing and learn to make things with wood. He never really considered his craft "art," or thought of himself as a designer, but in reality he was a very established, successful boat designer. He built many boats that went to regattas throughout the Caribbean. Carriacou has one of the oldest regattas in the Caribbean, and his boats won many races. I've used images of his boats in my paintings, including the large one that was in the Venice Biennale in 2019.

Launching each boat was a whole ritual, with a ceremony incorporating many African rituals—sauerkraut had to be cooked, rum and wine water had to be poured, and there was drum dancing. The whole island would come out. Everything on the island incorporated a ritual where the ancestors were acknowledged or brought in to help.

No matter where we are in the world, we return to our Caribbean homes as a source of inspiration for our work identities and spiritual belonging. How have you crafted a kinship with the land, people, and culture of the Caribbean?

I felt a deep calling to return to Grenada after having been in exile from my family and the landscape for over eighteen years. Something was always missing in my life and art; because I studied art from a Western perspective at universities in New York and England, there was a disavowal of my Caribbean and African roots. Returning to Grenada and making two bodies of work that look at my own history has been a phenomenal experience in terms of healing some of the inner fragmentation I felt in the past.

Apart from my art practices, through the Nova Frontier Film Festival and Lab, which I cofounded five years ago, I've connected to the larger Caribbean diaspora—in Africa, the Middle East, and Latin America—through meeting other filmmakers and artists from those regions. We have a lot to give and learn from each other in terms of cross-cultural fertilization, in art, literature, music. The work I'm doing now is deeply inspired by the Caribbean landscape, our culture and history. I'm proud of that. My multidisciplinary bodies of works *Second Eulogy: Mind the Gap* (2019) and *Palimpsest: Tales Spun from Sea and Memories* (2022)—featured in the Venice Biennale in their respective years—were both shot in Grenada. They show our culture and this larger transatlantic relationship. Working in Grenada and participating in the Biennale are both personally profound and deeply prophetic experiences, particularly as they question larger themes of cultural heritage, identity, and colonialism.

The Caribbean is a small place that significantly impacts the world. What part of your Caribbean identity or art practice do you think speaks to what is needed in the world right now?

Our connection to the land gives us a sense of rootedness. For African and Caribbean people, the land has always played a very important role as a source of not only nourishment but also rituals and mysticism.

What feelings are you trying to evoke through your work, and what do you hope viewers will do as a result of their interactions with it?

My most recent bodies of work mined both personal and collective cultural history and memory. As an educator, I work with students on mining personal memory, mining personal history, as something that connects us to our center and to the ancestors. My art reflects on postcolonial trauma, postcolonial history, but not in a negative sense. I work from the perspective of a historian who is offering evidence. How you want to perceive it or take it in is up to you.

In my case, the fact that I was able to go back to the Caribbean and confront my own past and look at my relationship with my father, and at his relationship with his father, has helped me reconcile the bereavement I felt in my own life, personally, collectively, and in relationships. I repeated a lot of the things that happened to me in childhood in my adult relationships, and this type of mining does help us understand where we come from, especially as we talk about the complexity of identity. Right now, a lot of my students seem conflicted, or maybe uncertain, about who they are, and this exercise is useful to them. DNA and genealogy are also things that I think a lot of Black people, specifically African

Americans, could learn from in their own lives. When I did my genealogy and looked at where I came from, the specificity of the place did allow me to say, "Oh, now I know where my tribe or my people come from" versus having this vague idea of being an Afro-Caribbean.

What does community look like for you as a maker living and working in the diaspora?

My community begins and ends with my queer brothers and sisters in the Caribbean, as well as in the community I developed over my years of living in the United States. Brothers like Leyden Lewis, Lyle Ashton Harris, Thomas Allen Harris—we founded a collective of sorts called the Untitled Group that met once a week for over ten years before Barack Obama was elected president in 2008. We were exploring our queer histories and place in the world, as Black men and in relationships with our family and practices. We cooked and ate and laughed and cried and shared visions together. These types of communal spaces have played a significant role in helping me develop as an artist over the years. We don't meet as often, but we are all still in touch.

I'm involved in a lot of projects in Grenada now, and as a result, I'm able to allow the landscape, the rituals, and the people I've felt estranged from for so long to welcome me back.

How has your work sought to expand the view of non-Caribbean Black identity and culture?

A lot of my work explores and contests narratives that are not necessarily connected to the Caribbean. I made a body of work in 2005 called *Truth Is Contrary* that looked at the last two decades of uprisings in the world, specifically the uprisings among Africans and Arabs in Paris that started when I lived there. It included women and the hijab and the riots that started when Zyed Benna and Bouna Traoré, two teenage boys of Tunisian and Malian origin, got electrocuted in a power substation in Clichy-sous-Bois while fleeing police. The incident led to several weeks of rioting. I was interested in examining France's relationship with its colonial past, specifically in Algeria and the Middle East. Some of the racism in France that I addressed is very similar to the racism in the United States that spurred the Black Lives Matter movement during Covid. In my work, I continue to interrogate the global landscape and histories, both the personal and the collective.

Can you talk about how your work closes the gap between art and design practice?

As a multidisciplinary artist who has worked in production design, film, 3D sculpture, and writing, I've always felt that art and design are deeply connected. I've never seen any separation. In the

"For African and Caribbean people, the land has always played a very important role as a source of not only nourishment but also rituals and mysticism."

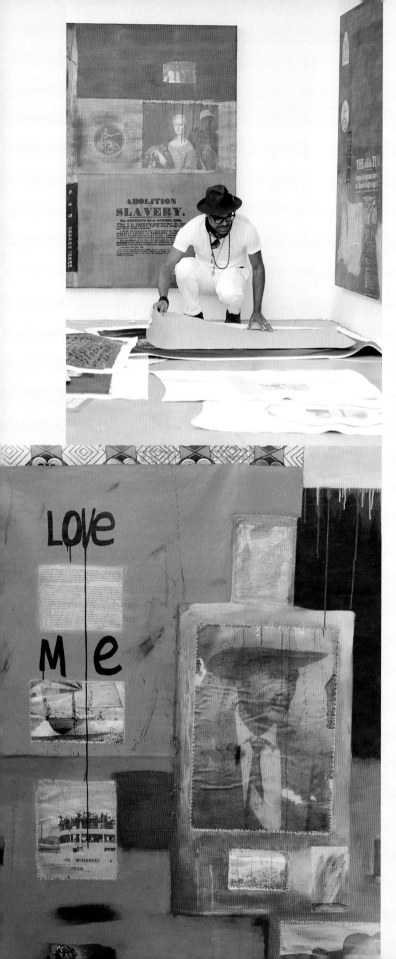

Caribbean, people are always making and designing things—boats, pottery, homes—without formal training. We just inhabit those spaces naturally. I do think that in the West, specifically because of all these MFA programs, and the institutionalization and cooperativization of art, there is no space in which people can move as freely as they would like. I've met with resistance from outsiders who want to put me in a box. So much of the art world is controlled by corporations and the market.

Can you talk about an ancestral making practice? How are you discovering, reimagining, or reconstructing ancestral narratives in your work?

I recently made a film about Ottobah Cugoano, an eighteenth-century African abolitionist. He had been kidnapped in Ghana and brought to Grenada as a slave, then was brought to England as a free man and became a major voice in the abolitionist movement. He's one of the few people who experienced the triangular voyage. As I was mining his work and his history, I discovered that he came from an Ashanti and an Igbo tribe, which is not unusual in the Caribbean, as it was common practice in Africa to kidnap people from certain tribes and hold them for ransom. I was very curious about the Ashanti, and so I conducted research for a new body of work that explored indigo and entanglements—incorporating African tribal fabric and using natural indigo as a material that helps connect me to Africa and the Caribbean. Indigo was also used in eighteenth-century European paintings to symbolize nobility, class, and pretense. My use of fabric, masks, and patterns in my work speaks to the entangled relationships between Africa, Scotland, and England, where my own ancestors came from, through the trade in this precious material of indigo.

What facets of your identity are most prominent in your work? How do you use your practice to speak to your Caribbeanness?

As a filmmaker, artist, and educator, I explore queer issues and underrepresented voices in the Caribbean and beyond in all my projects. Though, at times, I feel as if my identity as a queer mixed-race man is the area where I have felt most misunderstood my whole life. It's been a source of pleasure, joy, and spirituality as well as a source of pain, grief, and exile from my own people, my own ancestors. Grenada and a lot of the Caribbean Islands still have buggery laws that date back to the colonial period. I personally feel that as a queer Caribbean man, I will not be fully decolonized until these laws are abolished. Reconnecting with rituals and the landscape is a way to reinhabit my body in certain kinds of colonial spaces where, as a queer person, I need to almost disrupt the narrative. In my work, I try to disavow a lot of the rituals and culture that have a more heterogenic or hegemonic feeling connected to British or European colonialism. For me,

disavowing, deconstructing, and contesting are things I need to do in the Caribbean when I'm looking at our rituals, traditions, religion, spirituality, or even the landscape itself. The need for intervention and the decolonizing of these spaces offer a portal for new personal and collective narratives to unfold, while offering the possibility for liberation and release from colonial trauma.

Are you thinking about an actual structure, or is it more conceptual or like the space to feel safe as a queer man in the Caribbean?

A lot of my films incorporate rituals. I work with a lot of queer artists in the Caribbean, as well. Together as we research and explore things, we are able to find other forms of expression. I've lately been interested in the juxtaposition of queer bodies within this landscape, which is another way in which we, as queer people, could begin to feel some sense of decolonization and a spiritual connection to the land. The trauma that we experience as queer people in the Caribbean is connected to religion, which was brought to the Caribbean by the colonizers. There is a lot of work that still needs to be done in our communities—physically, spiritually, creatively, and also politically. There's work that needs to be done in terms of repealing some of those laws. In the Caribbean specifically, we talk a lot about decolonization and reparation, but we can't begin to address those issues until the laws that are binding us are finally broken.

What are some of the sources you consult in your search for memories, or in your discovery of new memories?

I've been mining archives connected to slavery, ethnographic imagery of Black people, Shango Baptists, and certain tribes in Africa. I've been searching for my own family genealogies connected to Nigeria, Somalia, and other countries in that region because I'm interested in the kind of memories I'm not able to access, so I have to turn to history. I've been thinking of places I would like to visit and the kinds of objects I want to bring back with me. A lot of the masks that I work with are from West Africa, or are connected to Caribbean culture, but I'm also drawing inspiration from England, Scotland, and other hybrid cultures that are evoked by Caribbean rituals. All these cross-cultural memories and histories serve as source material for my work.

⧮OA

A DESIGNER OF FURNITURE AND INTERIOR OBJECTS WHO CENTERS SUSTAINABLE MATERIALS AND METHODS IN HER PRACTICE

I design objects for the home, including accessories and both indoor and outdoor furniture. My style is minimalist and contemporary, and can sometimes be interpreted as futuristic.

What did you make as a child before you even knew to call it art or design?

When I was growing up, we only had three English-language TV stations (the others were in Spanish). One of them was ABC, which aired *Wide World of Sports* every Saturday morning. That's where I first saw skiing, and I thought it looked exciting. We lived on a hill and had a steep driveway with giant flamboyant trees in the yard. So I retrieved several of the long seed pods from the tree—we call them shak-shak—around two or three feet long, and me and my sisters crafted skis out of them using rubber bands, twine, and string or whatever we could find to attach them to our feet. And then we would try to go down the hill on them using sticks as our ski poles. That's one of the first things I can remember making.

And I was always drawing the landscape. We lived above a beach, and on a clear day, we could see St. Croix from our porch, and all the boats going by—cruise ships, sailboats. I drew that same scene a million times, with a pen and ink, charcoal, pastels, crayons, whatever.

Do you have any of those drawings?

A hurricane destroyed all of them. The only thing I have is a book about Caribbean fruit from when I was in first grade with my little drawings in the margins.

Was there a moment in your career when you had to reinvent yourself or your practice because of an obstacle?

Multiple moments. The major obstacle I faced was access to capital. It takes a lot of money to make prototypes. I've stopped and restarted my business three times in the last twenty years because I've had to get a full-time job to earn a salary. I've had to make a lot of compromises and put my personal work aside in order to make a decent living.

When I moved to New Orleans, the obstacle wasn't the financial challenge, although that was significant. Louisiana has the fourth- or fifth-lowest per-capita income in the United States, but I have to set higher price points for anything I produce here because materials are more expensive and I have to pay fair wages. But beyond that, my design style didn't seem to appeal to the culture of that city.

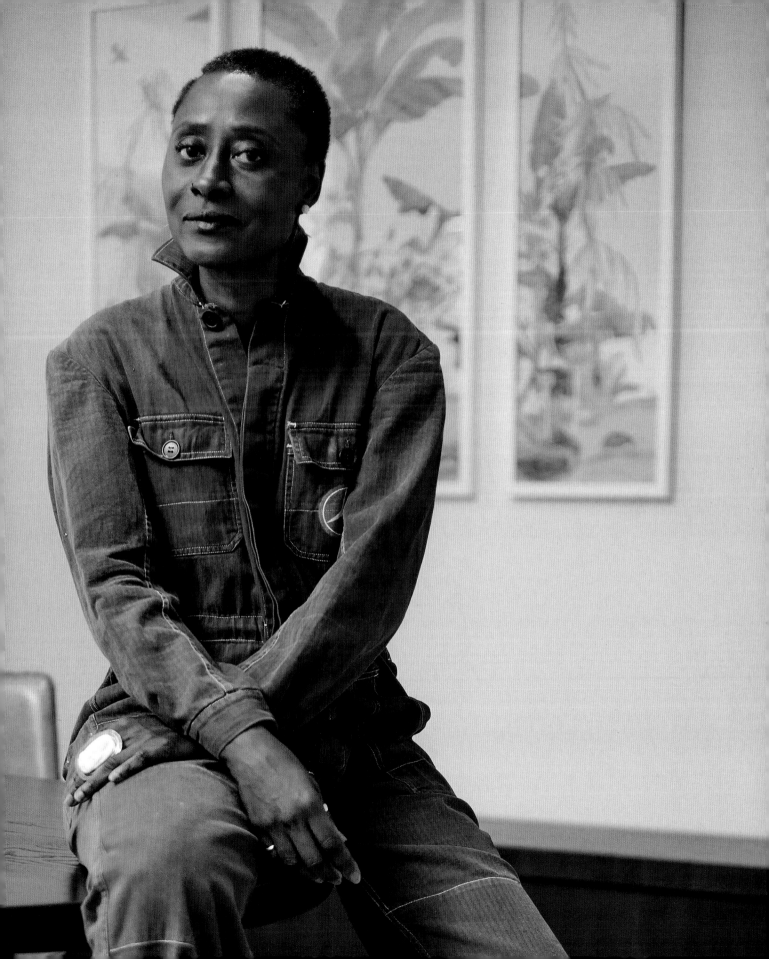

There was also a barrier to visibility. For twenty years, I was knocking on doors that wouldn't open. Nobody was paying any attention to me. The press was not paying any attention to me or my work. After the racial reckoning that took place in 2020 in the wake of the George Floyd murder and amid the rise of the Black Lives Matter movement, all of a sudden they were like, "Oh, she just popped up." No, I was here. I've been here. For more than a while.

Can you describe what freedom looks like for you as a maker?

Freedom is having fear. Recognizing and acknowledging it, and then moving through it in a way that's self-actualized. It's realizing that what you want or dream or desire is completely valid, even if it doesn't align with the way other people think. Freedom is not having to explain my choices to anyone. I feel like I'm not constricted.

How have you crafted a kinship with the land, people, and culture of the Caribbean?

Sharing food is really important in West Indian culture. For the multiple decades I lived in the United States, my mother sent me food via FedEx or priority mail. Yes, she sent crab and rice. She sent bush tea. She sent fried fish and johnnycake dough, peas and rice, pumpkin rice, cassava bread—anything you can imagine. My West Indian friends who came to the U.S. from other islands got to know Virgin Island cuisine through the food she sent me that I then shared with them.

Also, by traveling throughout many different Caribbean island nations, learning about their cultures: where we feel a kinship, where our differences are, and where we meet and overlap. I've been to islands where people speak Spanish, Dutch, French, Creole, English, and Papiamento—there are all these different cultures within the Caribbean, and that keeps me connected, as does going home often.

The Caribbean is a small place that significantly impacts the world. What part of your Caribbean identity design practice do you think speaks to what is needed in the world right now?

In the Caribbean, we've always employed sustainable practices. Before there was this trendy name for it, before people talked about upcycling, it was a regular way of life for us. Because we have limited resources in the Caribbean, we are used to taking what little we have and making it work in a multiplicity of ways. With the advent of cable TV and the internet, we've become more Americanized, more Westernized. But I grew up seeing everything being repurposed. Being able to use whatever's around you and to give it another life is a Caribbean thing.

The Caribbean is a made-up region of the world, isn't it?

Yes, but despite our colonial past, there's still this sense of kinship. There's a sense of allegiance. Even countries like Belize and Guyana that aren't technically in the Caribbean are West Indian in their culture. Bermuda, which is in the Atlantic Ocean, is also West Indian. And we all share that culture. We have this cohesiveness where we all recognize and acknowledge that we belong in this wider net.

We are so many island nations with different contributions, different languages, different cultures, different histories, but the kinship that we feel means I could land right now on an island and not speak the language, not know anybody, and still feel at home and that people will see me as being a part of them as well.

What feelings are you trying to evoke through your work, and what do you hope viewers will do as a result of their interactions with it?

I want people to feel tranquility and a sense of well-being. At the same time, because I put a lot of thought into multifunctionality, I want them to be pleased that they discovered a piece that is well-designed, well-thought-out. I very rarely get to see how people interact with my work, because I design it, it goes to the customer, and I never see it again.

In 2022, when I exhibited at WantedDesign/ICFF in New York, I had an opportunity to observe people walking into my booth and looking at my work, and I was so surprised. People smiled and laughed and clapped their hands and were so joyful about so many little details. I felt especially affirmed when Black women walked into the booth and responded to the imagery in my work, and equally to me standing there representing it.

What does community look like for you as a maker living and working in the diaspora?

Community is not centered on a specific place. I have always felt like a global citizen. I've lived in three countries and five or six U.S. states. I have people everywhere, so community for me is a disparate group of friends and family I've collected and stayed connected with throughout the years and despite the distance. It's wherever I am, wherever I have a phone signal or internet access. Even before that, it was wherever I could get a stamp to send something to somebody, because I didn't have carrier pigeons, but I always wrote letters. I've always, always, always stayed in touch with people.

I also feel like during the pandemic, having access to Zoom opened up this whole new idea of community. Joining professional groups like the Female Design Council and the Black Artists

+ Designers Guild ushered in access to a creative community that I had never had before.

To what extent do you feel the need to reconnect with your island or community as a member of the diaspora? And what does that reconnection look like for you?

The way that Westerners, meaning Europeans and Americans, view me and my work is not as important to me as recognition from my peers. My validation comes from the Caribbean community; I want them to be proud of me. Reconnecting with community in the Caribbean has become even more important to me in the past few years. I want to be a steward of the Caribbean design aesthetic, because I see it being perceived or misperceived as one thing when it's so much more.

A little over a year ago, I founded ICI—which means "here" in French—as a brand of furniture and household objects. Since then, I've left the U.S. and moved to St. Thomas, but when I initially launched the business, I planned to import products to the U.S. from around the world, starting with the U.S. Virgin Islands

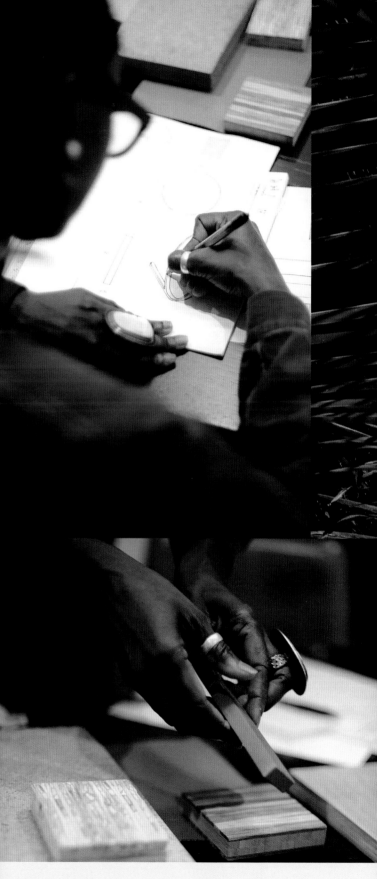

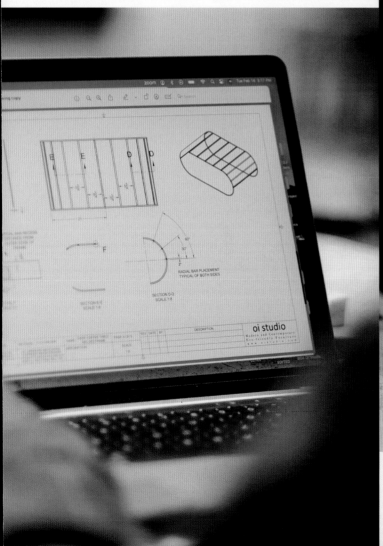

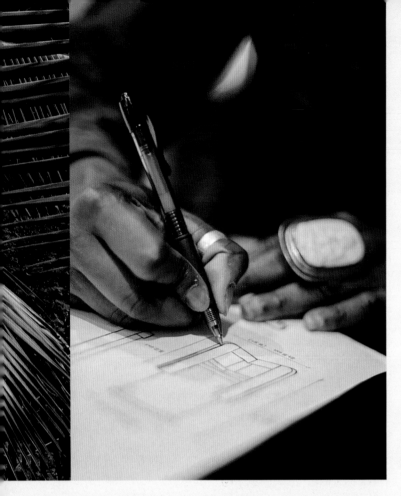

Pende, and Kuba people, but branded for an American market. Being minimalist and having clean lines is Black, is African, is Caribbean. I push back strongly against the assertion that Westerners invented the aesthetic known as modernism.

Can you talk about how or whether your work closes the gap between art and design practice, or whether you would like to close that gap more?

I've always seen designers as artists because creativity is a language that artists and designers share. The creativity stems from the same place but is expressed in different mediums. The gap exists in the narrow way that art is defined in our society. A way to address this is to, for example, curate more museum exhibitions featuring the work of designers in the same way that we curate shows of artists. The Art Basel/Design Miami event has made some inroads with elevating design to the level of fine art because they've created a marketplace where both disciplines are displayed equitably in galleries across the city.

I see my work as functional art. People view art as something that you invest in, that you can pass down to future generations. Speaking for my field, well-designed and well-made furniture is something that you should be able to pass down as well and that should withstand trends—legacy collectibles.

Again, mid-century modern designs are now collectible items. They were designed at the time to be mass-produced, to be affordable pieces made using the limited resources that were available during World War II. Generations later, they're considered art. Maybe my work, generations from now, will be considered art. Who knows?

Has your approach to or use of materials changed over time in your practice?

In 2003, when I became a sustainable designer, I abruptly stopped using solid wood because it wasn't milled responsibly. It was over-harvested. Sustainable materials were more expensive and harder to get, and it made my products more expensive, in general, but I felt better as a global citizen because I reduced my contribution to climate change. I didn't want to participate in deforestation.

I started thinking about what else I could use, doing research and going to trade shows looking for materials that would align more closely with my ideals. I started using formaldehyde-free MDF (medium-density fiberboard) and FSC-certified wood. The veneer is from managed forests where only a quarter of the trees can be cut down at any one time, while the remaining trees are regrown.

Also, twenty years ago, it was difficult to make certain shapes from wood, like those with radius corners, and I wanted a more

because that's where I'm based. Then I'm going to expand the product line to goods from the British Virgin Islands, St. Martin, and Anguilla. It's not just a way of making a living; it's my reconnection to my culture and a way to broaden the scope of Caribbean design by offering contemporary work in materials that stand up to our climate and fit our laid-back lifestyle.

How has your work sought to expand the view of non-Caribbean Black identity or culture?

There are many designers who are immediately identifiable as Black designers. People might look at their work and say, "That designer is referencing the motherland or the Caribbean." With my work, they might say, "Her aesthetic is European" (or white American or something similar). But then I would have to jerk their chain and tell them that modernism is not a European concept. Modernism predates Europeans. The ancient pyramids are the most modern structures I've ever seen. Mid-century modern design directly references African culture. The inspirations of designers like Charles and Ray Eames, George Nelson, and Isamu Noguchi came from non-European sources. The Eameses' walnut stools are near replicas of West African stools made by Dogon,

contemporary aesthetic. You'll see wood throughout my work, but there won't be a lot of solid wood.

Do you consider any materials sacred? Are you concerned about the misuse of any materials that you consider sacred by those who do not appreciate or understand their cultural or spiritual importance?

I'm a tree hugger. I consider trees sacred. Many traditional cultures consider trees sacred. My favorite beach on St. John's is unrecognizable from when I was a child. Due to erosion, half the sand is gone, and the coral reefs that took millions of years to grow are now dying off because of the cruise ship business and the oil that drips into the water. Most of the native mahogany trees are no longer there. Even with people all around the world pushing for us to plant more trees and to have more reverence, we're still building, we're still taking away instead of adding, we're still impacting the planet in an extremely negative way.

What facets of spirituality are most present or potent in your work? Do you see the act of making as a spiritual or sacred practice? And how do materiality, the making process, symbols, or figures invoke or evoke your spiritual practice?

I have a whole collection called the *Spirit Series* . It was originally designed for meditation, because I'm a student of Eastern spirituality. The pieces support my spiritual practice; however, they're also adaptable to anybody's spiritual or religious practice. I meditate versus pray. That's my connection to the source. And I decided to design a collection specifically to honor and to support that. For example, a meditation table with the ohm symbol laser-cut into the top. I want people to see the spiritual component to my craft. I'm not designing pieces that are just functional. In terms of materials, the reverence I have for nature is part of my spiritual approach. The pieces in the *Spirit Series* are all made of materials that are 100 percent eco-friendly. No metals, no plastic of any kind.

Does your work channel a particular diasporic and/or ancestral spirituality into the present? And how legible do you want your spiritual expression to be for "outsiders"?

I feel like my work does channel ancient spiritual practices. If you think about the African diaspora specifically, many domestic tasks such as cooking are done close to the ground, whether you're sitting on the ground itself or on a low stool. A lot of my work, especially the meditation table, is very low, close to the earth.

Is there anything else you'd like to share?

I would love readers to realize that what they think of as Caribbean art and design is extremely limited. They need to give room and grace for abstract expressionism in the mix for sculpture, for performance art, for every discipline. We all need to start expanding our concept of what a Caribbean designer or artist is or can be.

I was talking earlier about designers who reference the motherland, and how people think that's the only way you can be a recognizably Black designer—how it seems that if you don't incorporate those shapes and iconography, what is perceived as tribal or ethnic references, then you're centering Western culture. When people see furniture in the Caribbean, they see colonial, they see mahogany, they see plantation chairs. Those all have to do with the extended period of enslavement. They all have to do with another country slamming their foot down on this place, planting their flag and saying, "This is our interpretation." But we are an amalgamation of many people: Indigenous Tainos, Caribs, and Arawaks; Europeans; Africans; Indians; Chinese; and Middle Easterners. Caribbean design and designers are all of that, and more. We're not one thing. There's no way to put us in any kind of box because we are from a made-up region, in a sense, but our kinship is 100 percent genuine. We created this Caribbean culture, whether it was forced upon us or it was created through ingenuity because we had to survive.

SIGHTS/SITES OF DIVINITY

BY TIANA WEBB EVANS

The Caribbean is a cacophony of roaring stops, starts, and remixes. Despite the environmental turbulence and the ever-changing sociopolitical landscapes, we have formed a resilient hybridity anchored in the philosophies and values of our ancestors.

Our West African lineage is rooted in creative power as a divine resource. When that lineage is applied as a broad brushstroke connecting a string of islands with nuanced histories and cultures, there are three loci: nature, sound, and material culture. Living in communion with nature is a primordial way of being. The still observation, a source of nourishment and vast wisdom that recognizes the kinship of land, plant, animal, and ether, is central to our epistemology. The respect for what is, what was, and what will be marks a fluid temporality that emerges in creative and spiritual practices. A commitment to seeking the sum of the whole rather than separating and dissecting it is foundational to an intergenerational cognitive schema and to the transference of wisdom and ways. Although our family stories and tribal affiliations have been lost and our languages forgotten, we have retained their sounds, rhythms, and physical movements.

Coded into a blood memory, these complex systems of communication and protection offer rebellion and release, activate repositories of strength, and foster unfathomable beauty and creative might. A material culture informed by utility and engaging nature continues to inform contemporary practices. What is natural is conditional; the respect and regard for what is available fosters engagement with position and place as a practice of relationality.

Caribbean artists and makers have continued to work with and through their creative lineages while engaging the tension between the natural and the manufactured. In the region, there are silent partners that exert a legible and perceptible difference, or what we identify as "Caribbeanness." Proximity to water and its moods, vulnerability to weather, and the presence of the mystic are undeniable influences. Our ancestral influences are mitigated and mediated by flora and fauna, the temperament of water, and spiritual systems that have been preserved and evolved over hundreds of years and that quietly inform alternate ways of seeing. This sensibility tethers our constellation of islands.

We are all tasked with unearthing, preserving, and celebrating the creative legacies of Caribbean artists to ensure that future generations can continue to engage with the material and sensorial eloquence of our ancestors.

Tiana Webb Evans is a cultural producer, writer, and entrepreneur. She is known for her transdisciplinary social practice encompassing art, design, and culture through the founding of Yard Concept and the Jamaica Art Society. She is also the CEO of ESP Group, a brand strategy and communications consultancy founded in 2014. Evans sits on the boards of Project for Empty Space and the Female Design Council, and is an advisor to the Laundromat Project and the Association of Museum Curators.

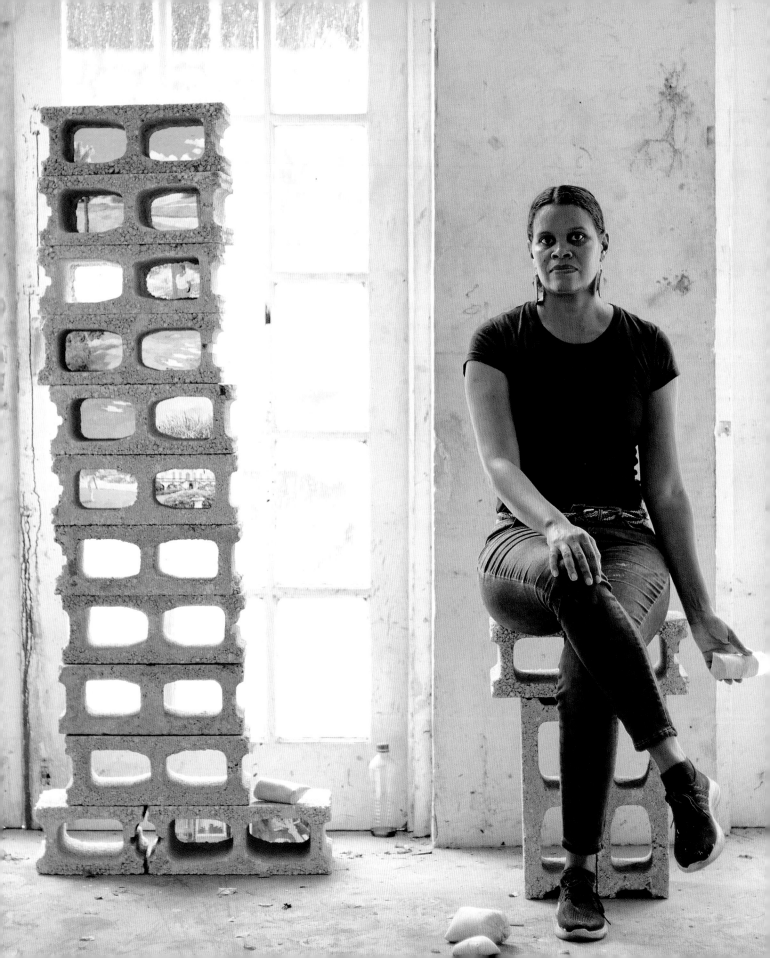

Camille
CHEDDA

**A MULTIDISCIPLINARY ARTIST WHOSE WORK EXAMINES
TOURISM AS AN ARTIFACT OF COLONIALISM**

I started my practice using plastic grocery bags for a collage, and I kept using them. Now I have several works using the plastic bags. I also work with cement blocks and cement. I work with more traditional materials, like drawing charcoal, too, but I enjoy taking something that already exists and has its own history and creating something that I have a personal and sociocultural connection to.

What did you make as a child before you knew to call it art or design?

I used to draw a lot as a child. I have an older sister who used to draw cartoon characters from Disney movies, and I would try desperately to copy her. Eventually she stopped drawing, and I kept going.

Was there a moment in your career when you had to reinvent yourself and or your practice because of an obstacle?

I'm in that process right now. Something happened during the pandemic; it gave me a lot of time to work, but it also brought on this sense of isolation that was different from my original sense of isolation, perhaps a stronger recognition of the need for community. I did love to be by myself. Loved it. But the pandemic forced me to change, and post-pandemic, everything felt heavy, mostly due to returning to the physicality of teaching, planning exhibitions, and the day-to-day hustle. Maybe my sense of time is different now, and so that has meant figuring out what adjustments to make to balance my energy, make my own work, and engage with the art community.

During the pandemic, I started working digitally because of the difficulty of moving objects around with all the sanctions placed on how we used public space at the time. There was an ease with working digitally that allowed for the image to be shared through various online formats. Now I continue to go back and forth between working with objects like cement blocks and drawing on paper or painting, and working digitally. Each mode requires varying amounts of energy. I just have to know my limits.

What feelings are you trying to evoke through your work, and what do you hope viewers will do as a result of their interactions with it?

I would like people to slow down, look at the work, and try to get their own feeling from it. Get a sense of what I'm trying to say as well, but through their own understanding.

What does community look like for you as a maker living and working in the diaspora?

Community for me is having a support group. Our community is very small, and it has branched out into different groups. Sometimes these groups don't get along, for some reason. But in community, we can put our differences aside and support art and the idea of trying to impart knowledge or care to each other.

Can you talk about how or whether your work closes the gap between art and design practice, or whether you would like to close that gap more?

In developing my practice with art installations, I've had to think about how to get people into and through the installation. Bad design can disrupt that experience.

What stories are you seeking to tell about colonial histories in the Caribbean? Can you share specific archives or institutions that house collections related to the colonial histories of your island? And what kind of postcolonial futures or futurism do you imagine in your work?

I've been looking at tourism, especially sites that confront us with questions about who uses the land, who used it in what way in the past versus who has access now to enjoy themselves on it. Often, the narratives about heritage and tourist sites in Jamaica hardly mention slavery or colonialism. One site that I reference a lot is Rose Hall Great House, where tourists visit a former sugar plantation to hear a myth about the owner's wife, Annie Palmer, the so-called White Witch of Rose Hall. The narrative fails to commemorate the people of Jamaican ancestry who were enslaved there. I am looking at those histories hoping to fill gaps even in my own mind about why we continue to neglect the more honest tellings of our history today, while sites like Rose Hall continue to be glorified and romanticized.

I've done series of paintings of people who were killed by police in Jamaica. Of course, the majority are Black people, even though we have a society that has Black, Indian, Chinese, and white people. Why does that happen? I'm looking at colonial history to understand that.

Where are you looking for source material to investigate that?

The book *Unsilencing Slavery* by Celia E. Naylor features a story that has been recounted to tourists for years about the wife of a white plantation owner who was murdered by one of her lovers. The common telling typically neglects to mention that her lovers were enslaved. In that narrative, Black women are entirely erased. The stories and the erasures they represent are among my sources. There's also *Mirror Mirror* by Rex Nettleford.

As an educator thinking about the next generation, what advice would you share?

Whatever you're interested in, do it passionately and take it seriously. Develop a sense of confidence and consistency in your work, and try to establish a studio practice so that you're able to work, even if it's on the floor. Lastly, don't worry about what people say and don't let their opinions stop you in your tracks.

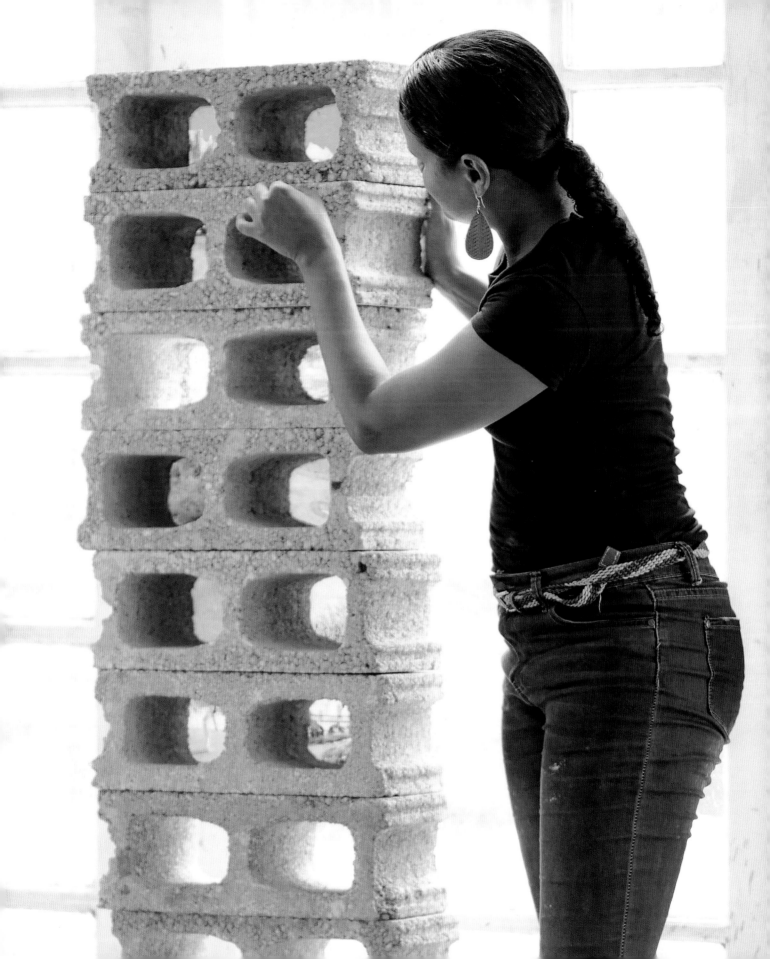

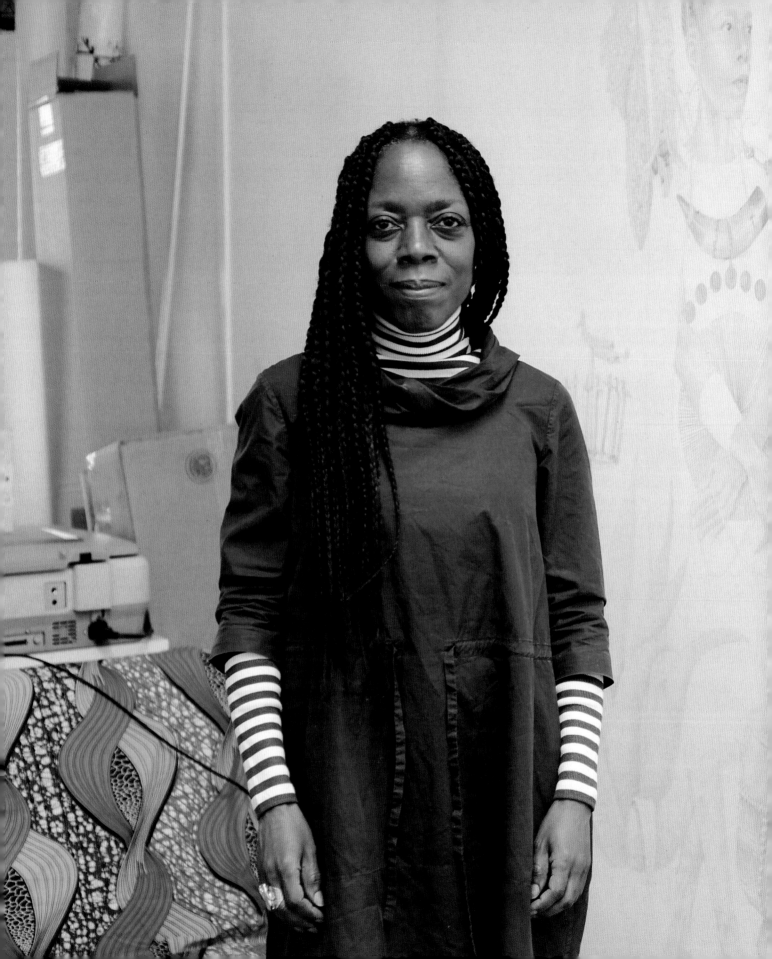

Charmaine
WATKISS

A MULTIDISCIPLINARY ARTIST WHO TAPS INTO COLLECTIVE MEMORY

My practice is centered around drawing, but in my heart I'm a multidisciplinary artist.

What did you make as a child before you even knew to call it art or design?

I actually made a pair of shoes. I must have been five or six, and I remember using a cornflakes box and drawing around my foot. And then my mum had cotton reel, and I stuck it to the cutout of my foot. I couldn't understand why the heel wouldn't stay in place when I walked, but then later I became a footwear designer.

In fact, my mom was a dressmaker, so I started sewing at a really young age. I made all of my dolls' clothes. And then in my teenage years, I made my own clothes. I was always making things.

Was there a moment in your career when you had to reinvent yourself or your practice because of an obstacle?

Many times! It almost feels like I'm coming full circle now. I was a footwear designer, and now thirty years later, I'm using my knowledge about making shoes to make 3D objects again. I'm not going to school to learn how to make sculpture in a traditional way. I'm just going to use the skills I already have, because then it's my own unique approach and that's kind of what makes me, me.

I began selling handmade shoes when I was twenty-two and knew nothing about business, so I made a lot of mistakes. I was just full of creativity. I had done a three-year course at Cordwainers College, learning to make shoes, and soon I was exporting my footwear to Japan, The Bahamas, and the Middle East. It was difficult to export back then before the internet. But it was also a time in Britain when people were open about their racism. They'd come to my studio and say, "I didn't realize you were a Black person." Friends were saying, "Why don't you get a white person to front the business?" I wouldn't; I was stubborn, and I dug in my heels. I felt at the time it was right as a matter of principle. But I didn't have enough orders to give to a huge factory. The small factories didn't want to make shoes for me, even though they made shoes for other footwear designers. I had to close the business because I literally ran out of money, and I ran out of steam working seventeen-hour days. I was completely burned out by the age of twenty-five.

That's when I decided to be a filmmaker because I was inspired by Spike Lee. That was my first reinvention. I did three years of film school but came out in the mid-nineties when the UK film industry was on its knees. A former tutor introduced me to an arts organization he worked for that needed someone to help facilitate digital projects

online, which led to an unexpected, twenty-two-year digital design career. It was around 2007 that I had this strong calling to draw the figure, and I knew that I needed to be an artist.

My practice is young. I've been making work full-time since 2020, just as the pandemic hit. I quit my day job in advertising with no idea of what would happen, and my art career took off. In July 2020, I was invited to do a two-person gallery show. When it opened, people were ready to see an in-person show after experiencing lockdown for so long. The success of that show led to representation for me and the other artist.

When you're doing the right thing, there's no hurry, really. It just takes as long as it takes.

How have you crafted a kinship with the land, people, and culture of the Caribbean?

I've been to Jamaica three times now. When I'm there, I just want to absorb as much about my ancestry as I can so I can carry that with me. The first two times I went, I could literally feel myself exhale because it was the first time I'd been in a place where everyone was Black and so I became just another person. I'd never experienced that before, and it was powerful. That's the kind of freedom white people have all the time.

What part of your Caribbean identity or art practice do you think speaks to what is needed in the world right now?

The strength, dignity, and vulnerability of Black womanhood. I've been making pencil drawings because there's something about drawing that speaks to intimacy, care, and time spent that is not really afforded to Black women. I don't think that care and labor would be as apparent in a painting.

What feelings are you trying to evoke through your work, and what do you hope viewers will do as a result of their interactions with it?

I would like viewers to slow down, because my process is very slow. Because of the time it takes to make, I would also like the viewer to spend time with the work. It's a meditation for me, making the work, but also a meditation for the viewer when they're in the presence of it.

What does community look like for you as a maker living and working in the diaspora?

I'm very fortunate to have a good network of artist colleagues. There is a small group of us who meet regularly to exchange ideas and information, and to provide support for each other.

How has that impacted your creativity or your work opportunities?

Early on in our group, we spoke a lot about what it is to be Black artists working in isolation. But now that it's more established, we talk about each other's work, and we share ideas and resources.

Can you talk about how or whether your work closes the gap between art and design practice, or whether you would like to close that gap more?

I'm happy to be over here on the art side because I've spent so much time on the design side. There is this kind of blurring of art, theater, and design; Salvador Dalí designed the Chupa Chups logo, and Picasso designed campaign posters. Artists have always crossed that bridge. That space excites me, and that's what I would like to explore in my making. I'd like to make wearable pieces.

Does your work reflect your personal memories or, more broadly, the idea of memory as a form or material of art-making?

I call my work memory stories. I am tapping into a collective memory through my work, and the trigger is the archive. My response to what I read in archives or in books is to take this journey inward to feel what the source material means to me.

For the twelfth Liverpool Biennial, in 2023, *uMoya: The Sacred Return of Lost Things*, which addressed Liverpool's troubled history as the epicenter of the transatlantic slave trade in Britain, I made drawings of an earth deity and a water deity. I had been studying healing traditions of the Caribbean, reading about botanical legacies and the knowledge the enslaved carried with them. The drawing of the earth deity tapped into those kinds of memory stories, using the figure as someone who's telling this multilayered history of connection to land and to spiritual tradition. She's got a couple of historical artifacts around her, one of which is from the British Museum.

The water deity, very loosely inspired by Mami Wata, is bringing artifacts connected to Liverpool's history out from the water. She is a reminder of how Liverpool made its fortune, and that Jamaica was a key part of that. The title of the work, *The Water Goddess—Ode to the Land of Wood and Water*, is referencing the Indigenous word for Jamaica, Xaymaca, which means "land of wood and water." I also made a shrine object that was placed in the center of the room, my first time exploring sculpture with clay.

In many ways, my work is to remind those of us from the diaspora who connect to the work of our legacy, of our heritage, of our past—not in the colonial sense, but in an emancipator sense. None of the stories I'm telling are of victimhood. They're all stories of strength in spite of adversity.

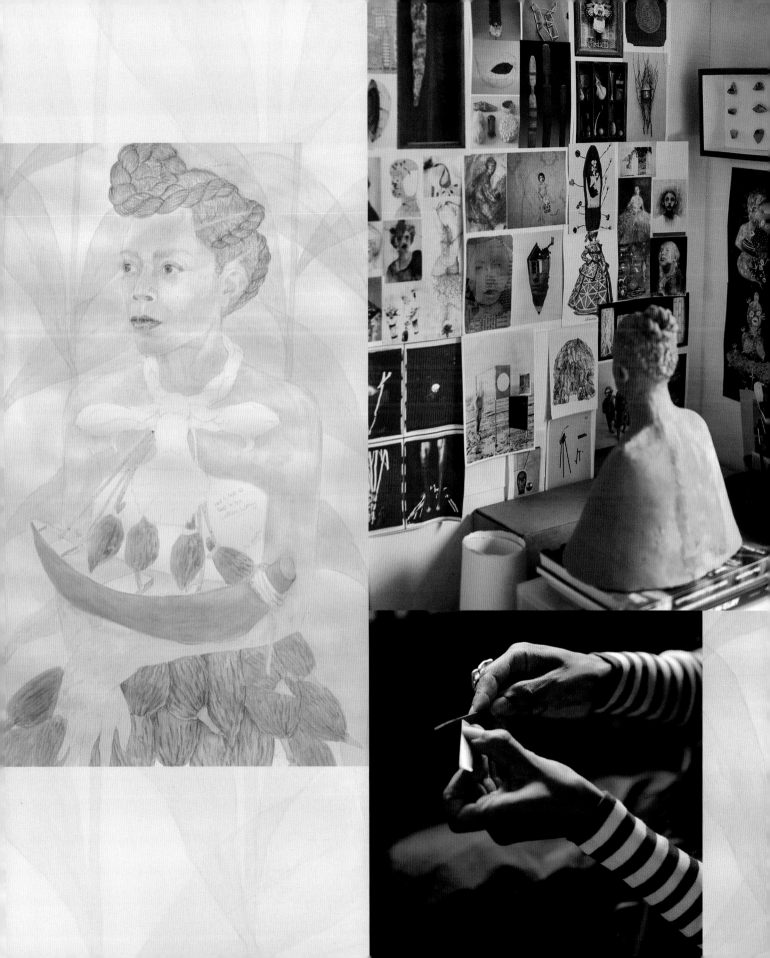

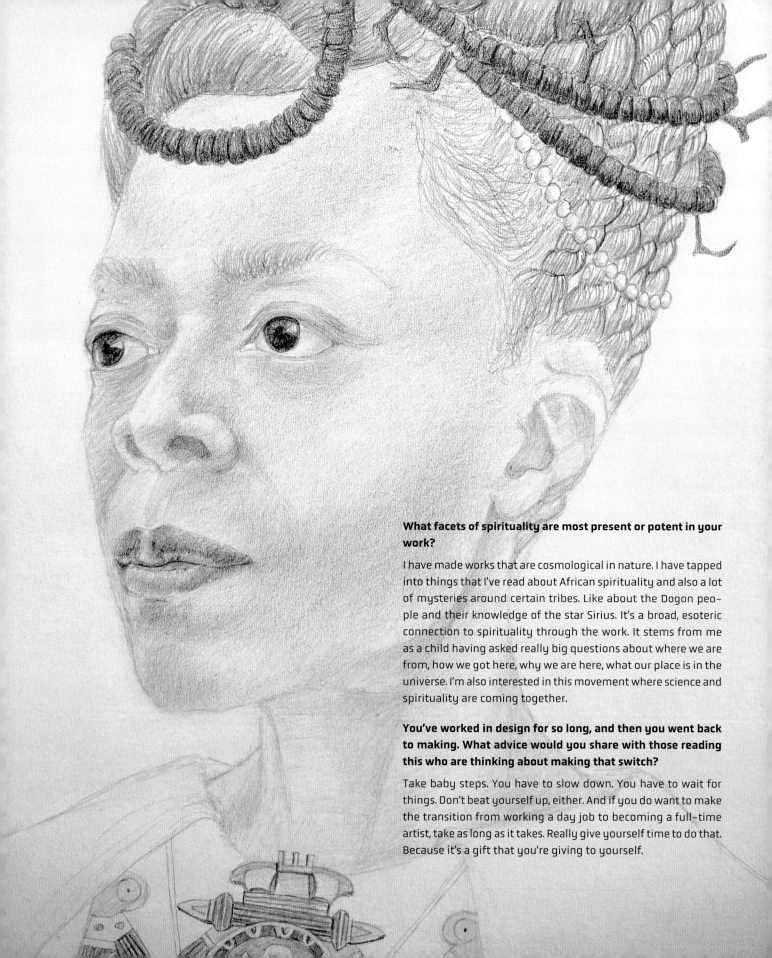

What facets of spirituality are most present or potent in your work?

I have made works that are cosmological in nature. I have tapped into things that I've read about African spirituality and also a lot of mysteries around certain tribes. Like about the Dogon people and their knowledge of the star Sirius. It's a broad, esoteric connection to spirituality through the work. It stems from me as a child having asked really big questions about where we are from, how we got here, why we are here, what our place is in the universe. I'm also interested in this movement where science and spirituality are coming together.

You've worked in design for so long, and then you went back to making. What advice would you share with those reading this who are thinking about making that switch?

Take baby steps. You have to slow down. You have to wait for things. Don't beat yourself up, either. And if you do want to make the transition from working a day job to becoming a full-time artist, take as long as it takes. Really give yourself time to do that. Because it's a gift that you're giving to yourself.

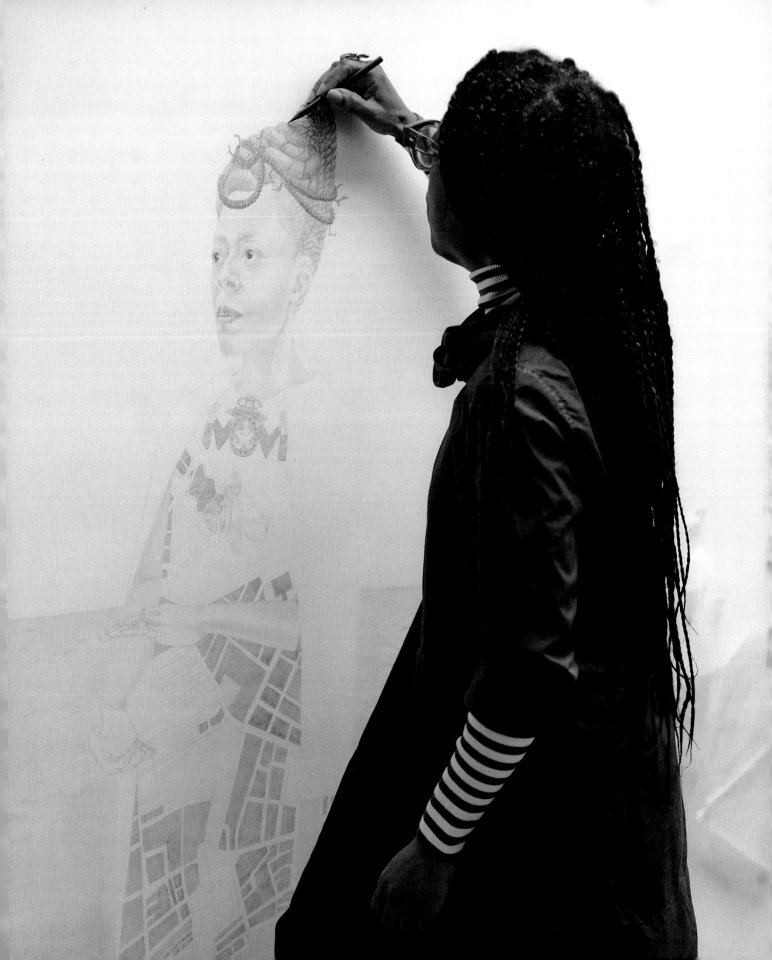

Chelsea
McMASTER

A CERAMIC ARTIST WHO EXPLORES MATRIARCHAL
TIES TO THE AFRICAN DIASPORA

I make ceramic sculpture steeped in pot-making traditions to examine the people, oral customs, and traditions of the Caribbean.

What did you make as a child before you even knew to call it art or design?

Because I am the youngest of four girls, many of my toys were hand-me-downs. I remember my mother teaching me how to sew new clothes for old dolls, and making dollhouses out of cardboard boxes. Using my hands and problem-solving has always been a part of my life and plays a big role in my practice.

Was there a moment in your career when you had to reinvent yourself or your practice because of an obstacle?

Graphic design was the only logical option for me in Antigua, as someone who wanted to settle into something creative. After studying and then doing it for a year, I left the island to continue my education. In the States, my options expanded as I was introduced to studio art. The process was gradual, but there was a shift where I realized that the art I made for myself meant more than work I designed for others. I was able to leverage my design background and experience to fund my ceramics for a few years until I made the decision to get my master's. My career is still very young, so I'm sure there will be more reinvention in the future.

How have you crafted a kinship with the land, people, and culture of the Caribbean?

I spent most of my life in Antigua, but I feel like I left the island before I could begin asking questions and truly become curious about it. I cultivate my kinship by spending time discovering new things and relearning things I took for granted. I do not get to visit as often as I'd like, so I revisit my memories to observe the beauty within the everyday.

The Caribbean is a small place that significantly impacts the world. What part of your Caribbean identity or art practice do you think speaks to what is needed in the world right now?

I can't speak for the entire world, but when I began to make research a part of my practice, I found that there really is a lack of scholarship and information on the history of ceramic art in the Caribbean region. Which is unbelievable considering

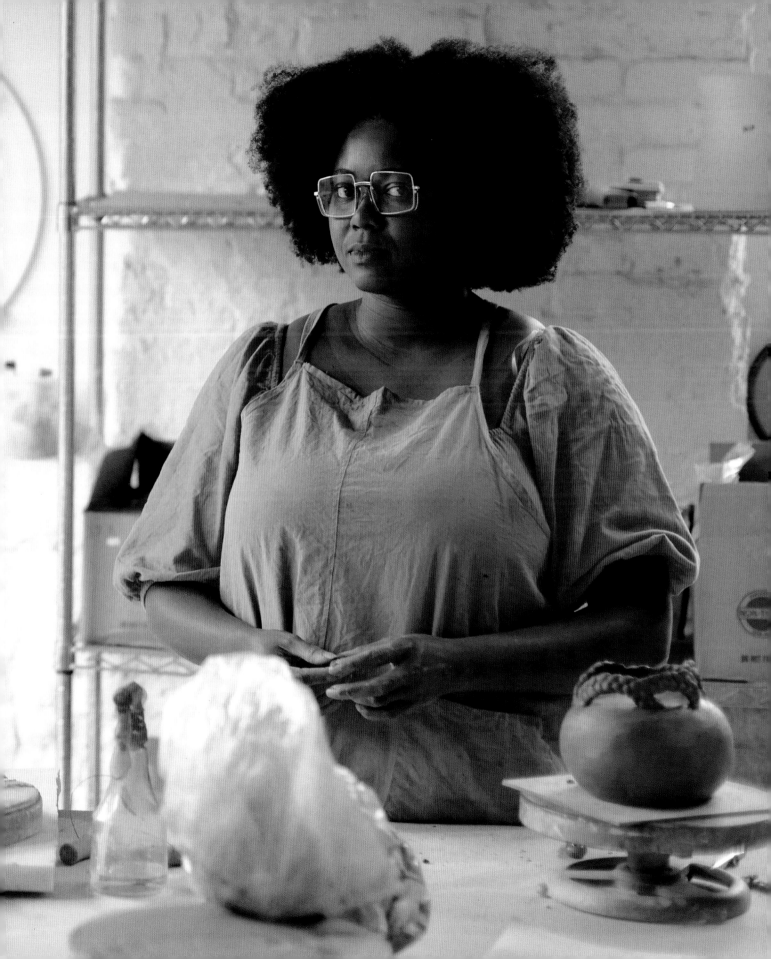

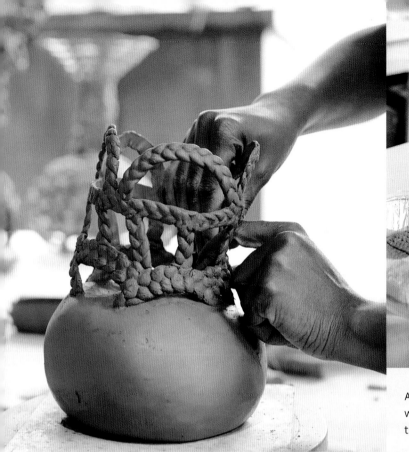

the important role it played for each set of peoples that have occupied the islands over the millennia. There have been studies in archaeology and anthropology, but historically there has been little appreciation of pottery from the region as art objects or acknowledgment of the West African heritage that informs this work in the postcolonial period. The art historical record needs to include in-depth and authentic research on Caribbean pottery, which is something I want to change. I needed it when I was a student, and I'm sure there are others who do, too.

What does community look like for you as a maker living and working in the diaspora?

For me, connection comes in the random times when I travel somewhere or walk into a building and hear an accent or someone speaking a dialect. Regardless of the island it's from, I immediately feel at home and relaxed. My need to connect to my island comes in waves. At those times, I speak with my sisters or friends. Sometimes cooking Antiguan food and sharing it makes me feel at home. The nine years I have been in the States, I have lived in places with few to no Black people or people of color.

As a maker, I have had to actively seek out other Black artists, whether on Instagram or at conferences or workshops. Creating that community is important for me.

Can you talk about how or whether your work closes the gap between art and design practice, or whether you would like to close that gap more?

My craft is the creation of tangible objects for people to interact with. My process engages both art and design; I don't see them as mutually exclusive. It is cultural conditioning to believe that they are discrete practices that aren't in constant conversation with each other. This gap becomes apparent only with the market's need to categorize and assign a monetary value to the things we create. The artist's role is to make. We lose control of so much once the work leaves our hands. This is an obstacle I am honestly still trying to figure out.

What preconceptions of Black womanhood or manhood are you seeking to address in your work?

Women have always played an important role in my life. My grandmothers were the matriarchs of my family. When I was growing up, it seemed like everything revolved around them. They were single mothers who raised large families and gave us all a sense of stability. They helped me form my ideas around authority, strength, marriage, independence, home, and community. At the root of my work, I reflect the importance of women, the knowledge they hold, and the work of passing it down.

What facets of your identity are most prominent in your work? How do you use your practice to speak to your Caribbeanness? Has the expression of yourself changed over time?

I make aesthetic choices to reflect the history of traditional pottery in the Caribbean and West Africa. Two years into my practice, I realized that I needed to reeducate myself and reorient my reference points. This began as a way to redefine my home base within the medium and has continued to show up in the work in different ways. The type of clay and the decorative methods I use, the building techniques I employ, and the forms and types of vessels I create all harken back to those traditions.

Does your work reflect your personal memories or, more broadly, the idea of memory as a form or material of art-making?

I think a lot about oral traditions. They are directly tied to memory, and the way in which the presence or absence of that knowledge is valued can completely color how much a person knows about who they are. I engage in the push and pull of cultural and personal memory. Hair is heavily featured in my work. Braids represent different things for different cultures, but within the diaspora, they hold so much power. They are not only a form of adornment but also a reflection of history, tradition, communication, and community.

What are some of the sources you consult in your search for memories, or in your discovery of new memories?

I consult friends and family. Stories and people have always anchored me to my homeland. At home, drives with my family would often turn into impromptu island tours, with my father telling us stories of his youth while he pointed out places as we rode past them. They would always leave me thinking about how the past lives with us. St. John's Cathedral is one of those places. It is often used as a resting spot for people between locations. It is a complicated space for me. The baroque stone building has a large cemetery in the back with elaborately carved gravestones and steel-framed mausoleums that people sit and relax on. I've never been inside the church, but the dominating structure always had a presence in St. John's. For me, it was simply something I passed on the way to my after-school classes. When I think about the people buried there, I know that I would not have been allowed through the gate in the past. This was one of the first places that made me feel that push and pull between past and present both physically and visually. My thoughts about acts of rebellion and reclaiming space may have started in places like this. These things don't always have direct references, but I think of my pieces as vessels that create a space to value ideas, memories, and stories while keeping them alive.

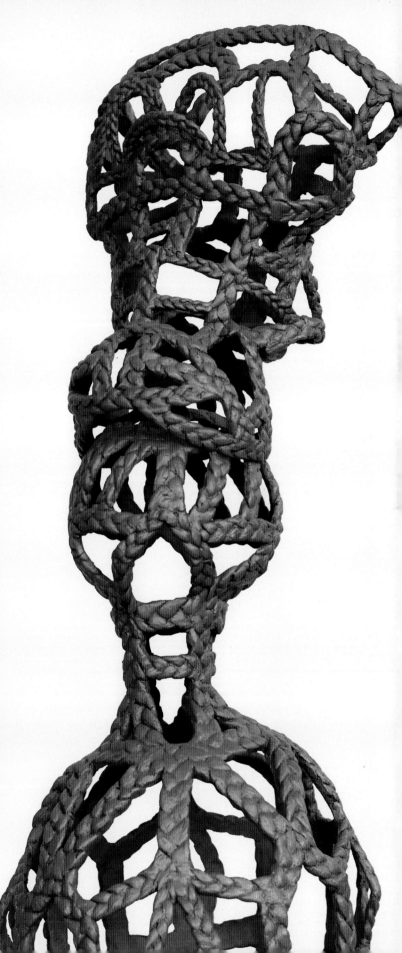

Braids are a
reflection of history,
tradition, communication,
and community.

CHELSEA McMASTER

Cornelius
TULLOCH

**A MULTIMEDIA INSTALLATION ARTIST WHOSE WORK
CENTERS COMMUNITY STORYTELLING**

At its core, my practice is narrative and storytelling. But now it's becoming a more social practice as I want to engage in community, using 3D activations to immerse viewers in the subject matter more than focusing on only the work itself.

What did you make as a child before you even knew to call it art or design?

I was always sketching. I just loved to create. I'd sit for hours, making up stories and characters.

How have you crafted a kinship with the land, people, and culture of the Caribbean?

A lot of my kinship is through food, which appears all across my photographs and paintings. I view my ties to the landscape through the lens of the cuisine and the idea of tending to the land. What's available to us is also what helps develop the culture. So many things grow here, and there are specific dishes that are so Jamaican. If you see a recipe featuring jackfruit, you know it's Jamaican. When I have guineps in a painting, where you're from is clear just by your understanding of what that is. I did my series *Fruits of Our Mother's Labor* to show how these things speak to our history and to colonialism.

My work was very focused on Jamaica or Miami, but now that I've met artists from other regions, I've been interested in the migrating or nomadic experience of the Caribbean, between the different islands or even from south Florida—this connection to the Caribbean and how far the cross-pollination of culture extends. I went to Colombia in August and witnessed how Caribbean Cartagena is. Seeing that influence gave me a much broader perspective of the Caribbean. My work exists in the space of cultural performance—and not *just* Jamaica or *just* my African American side, but the fusion of the two and the dialogue between them.

What feelings are you trying to evoke through your work, and what do you hope viewers will do as a result of their interactions with it?

I want people to feel the complexity. I'm experimenting with collage, so people have a multilayered experience that they really have to think about and reflect on. Their understanding of it in the moment may be drastically different from when they're thinking about it later.

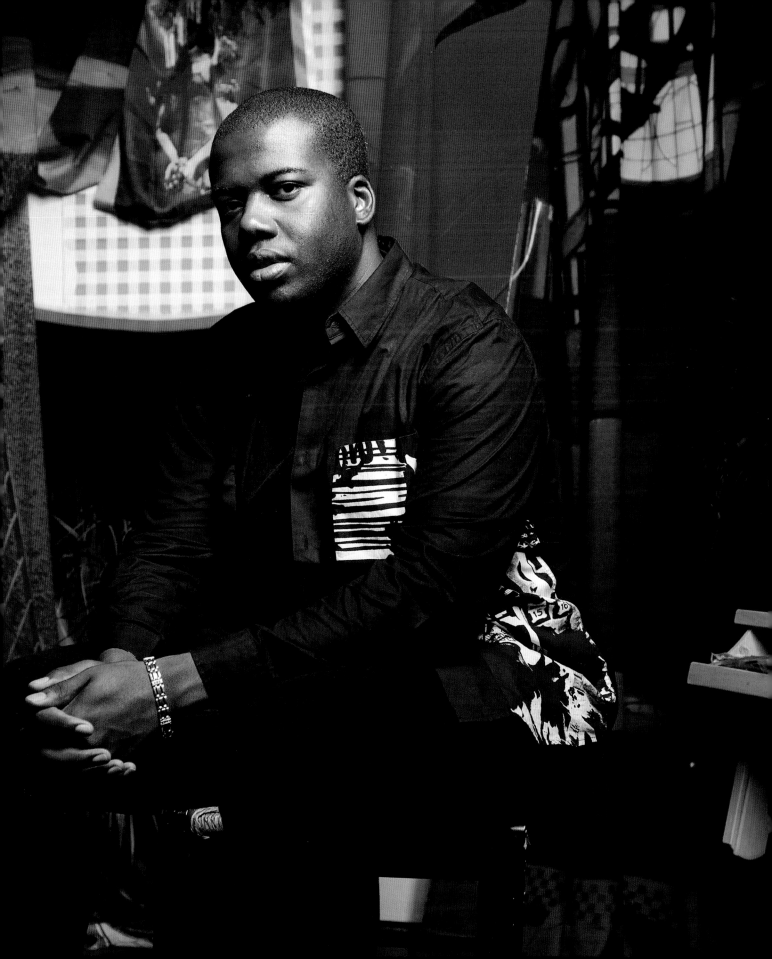

As my work expands into installation, I want viewers to not only see the spaces but also have some sort of lived experience with the work. My last exhibition, *Bougainvillea* at Faena Art, was about fashion and dancehall, and how we define our identities through clothing. At the opening, I had photos and multilayered fabric sculptures. In Jamaica and the Caribbean, what you wear reflects the culture in this very structured but maximalist way. I was able to hire a DJ for my opening, and people were dancing, moving through the space. With that exhibition, it was great to go and just see it, but the real substance of it was demonstrated at that opening by the people activated in that space.

The Caribbean is a small place that significantly impacts the world. What part of your Caribbean identity or art practice do you think speaks to what is needed in the world right now?

There's no one way to do something. There's this shape-shifting mindset that I think the world could benefit from. Things can be more fluid, like the fluidity of the Caribbean.

What does community look like for you as a maker living and working in the diaspora?

I would not be able to do the work I do without my community. I'm realizing more and more that my strength is my ability to work with other people, and to allow others' ideas to contribute to a much bigger body of work. I think Black people, in general, understand community in a way that doesn't necessarily mean giving something finite but could mean giving time or support. With *Bougainvillea*, I worked with two other Caribbean creatives: Nadia Wolff, a Haitian American artist and poet, and Diana Eusebio, an artist and fashion designer, who designed the Junkanoo masks. Collaborations like this are an opportunity for me to work with people from my community and also give them a financial opportunity they can build on. And that's a mindset I wish I saw more in the art world. A lot of people are like, "If this is *my* moment, this is *my* moment." I've learned to trust, and not to bring people on and then manage them. I was like, "I brought you on because I trust your vision and I trust I'll like what you contribute. Yes, this is mine, but also feel free to make aspects of it your own." It allows people to shine in a way where they're not second-guessing themselves and they can just do what they came to do.

My *Genesis* series was a different type of community project. I documented African American and Caribbean families in Miami throughout the Covid-19 pandemic. My goal was to show Black families as they are at home, the extraordinary in the everyday of Black life. I was able to mount public installations using kiosks around Miami so people can just see them and have an immersive

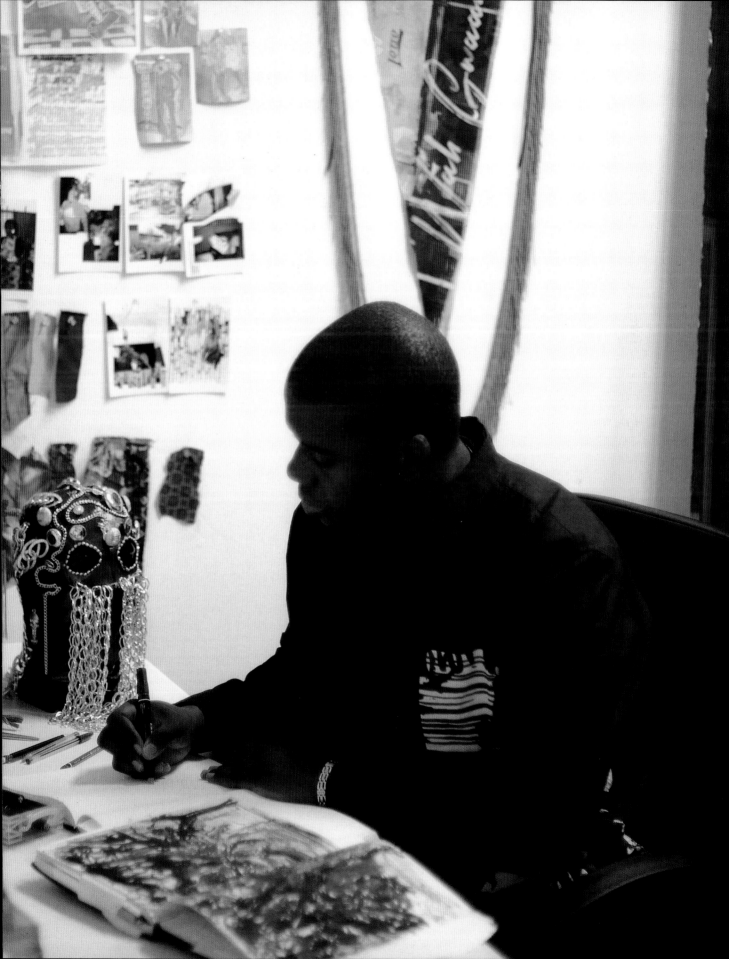

Pan-African identity and connecting back to the homeland, I really feel like the Caribbean is the heart of the story because it occupies the space between the Americas and Africa. Everywhere is somehow connected to the Caribbean. It is a bridge, culturally and geographically.

Can you talk about how your work closes the gap between art and design practice, or whether you would like to close that gap more?

That gap is the bane of my existence. The struggle. I've been unsure of my identity as an artist-designer because I felt pressured to answer the question, "Are you an artist? Are you an architect? Are you a painter?" I've always gravitated toward the storyline and how I convey that. I have photos superimposed onto architectural frames. I might throw a painting in there. But I feel like there is this demand to define your work as either art or design, to fit it into a box so that the market can fit you into one. I'm hoping people come around to the idea of me just being an interdisciplinary artist who creates work in all its complexity.

What traditions or expressions do you use in your practice and/or daily life that were kept alive through the Middle Passage and survived to this day?

In my work, I explore the zeitgeist of existing between Caribbean tradition and assimilation to new landscapes. I don't look at culture as something that is static. It's always evolving, and how do we capture what the now is? How do we capture who we are in this moment living in between cultures and identities?

I've been looking more into Maroon figures, like Queen Nanny, and stories of Maroons in the United States. Are there connections between Maroons in the Caribbean and those in the States? A lot of my work reflects respect for the past but also looks forward to this future space in which cultures evolve into new subcultures and identities.

Is there anything else you'd like to share?

Being an interdisciplinary designer comes from being Caribbean. All Caribbean artists are doing a million different things at once. I've never met one who works in only one medium and sticks to it. I think we get our stories out there through whatever means we choose.

experience right there—art doesn't have to fit in a gallery. In 2023, I began working on a new project called *Porch Passages*, from my architecture thesis at Cornell University. It is a series of artistic and architectural installations, or architectural manifestations of culture, throughout Miami to house storytelling spaces, where people can document and share the oral histories of these neighborhoods where there's so much development. The first one of these installations, *Porch Passages: Liberty*, opened in Liberty City in 2024. I'm choosing architectural sites that resonate with our stories, like the segregation wall that was in Miami. There's a new development rising at the segregation wall, and it's like history repeating itself. The work is bringing light to developments like this, making these spaces for us to reflect on what happened in the past, what's happening now, and where we go from here.

How has your work sought to expand the view of non-Caribbean Black identity and culture?

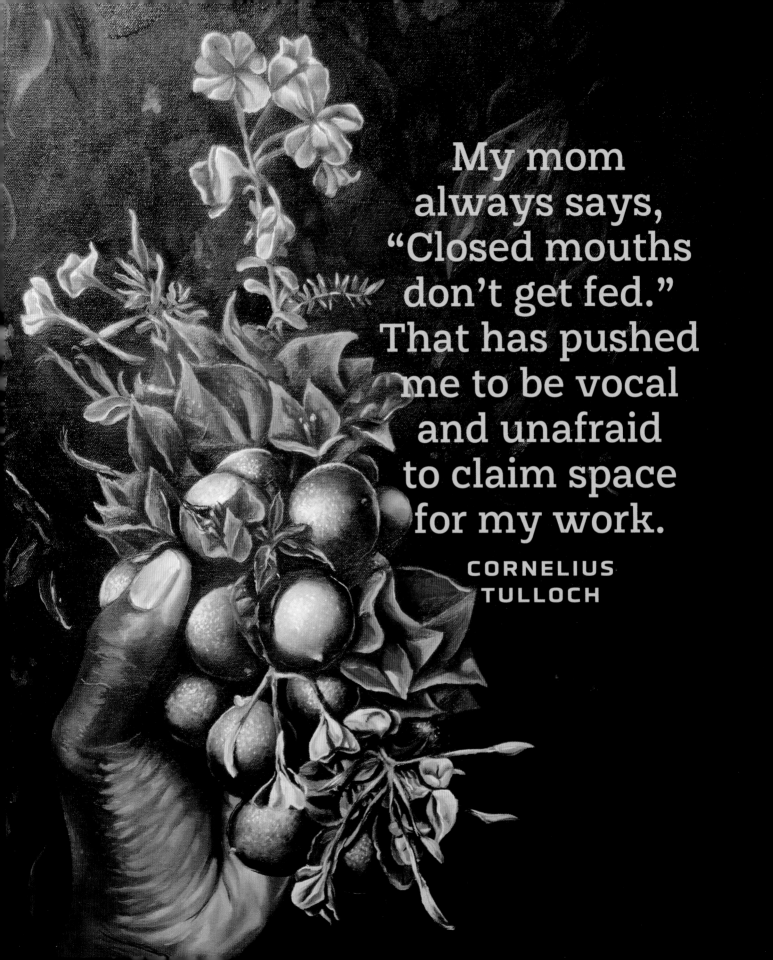

My mom always says, "Closed mouths don't get fed." That has pushed me to be vocal and unafraid to claim space for my work.

CORNELIUS TULLOCH

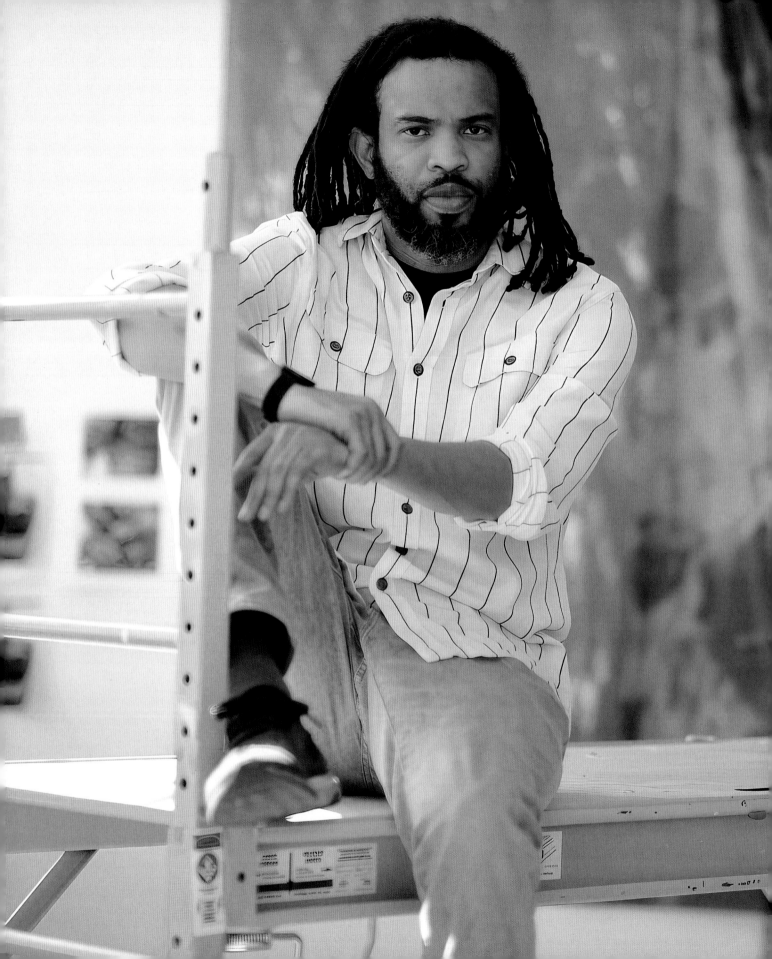

Cosmo
DOUGLAS WHYTE

A MULTIDISCIPLINARY ARTIST WHOSE WORK
EXPLORES DISPLACEMENT

I employ drawing, sculpture, and installation to create conceptual works.

Was there a moment in your career when you had to reinvent yourself or your practice because of an obstacle?

Two weeks before I applied to attend Maryland Institute College of Art's post-baccalaureate program, my father suddenly passed away. That was my introduction to this kind of self-reinvention—grappling with what art means in the face of trauma, loss, and mourning. For the first time, art was more than simply the act of making; it was a means of processing. That was a profound moment of transformation and led me to do more conceptual work, which signaled a shift in my trajectory.

No matter where we are in the world, we return to our Caribbean homes as a source of inspiration for our work identities and spiritual belonging. How have you crafted a kinship with the land, people, and culture of the Caribbean?

The Caribbean has always existed beyond the geographical boundaries of the islands and archipelagos. I am part of a Caribbean community and network that stretches from Jamaica outward. As my own migration continues, I have had to recalibrate what a "return to home" means. There is my physical home in Montego Bay and there are the diasporic Caribbean communities that have become like family (to varying degrees) scattered across the United States—where I live now—and beyond. As of late, my practice has led me in search of "home" in the collection of various Caribbean photographic archives. In terms of kinship with the people and by extension the culture of the Caribbean, I am part of various diasporic communities. Some are small and intimate, such as those of my close friends whom I check on, break bread with, seek or offer counsel to, and show up for in various ways. I am also part of a larger, more formal gathering of cross-generational Caribbean artists. What has been fantastic about this gathering is that through technology like Zoom we have been able to be in dialogue with one another across vast geographies spanning from Guyana to the UK.

I also use my platform as a contributor to *Art Papers*, a quarterly publication based in Atlanta. As an educator, I have had the pleasure of mentoring a number of Caribbean students across three different U.S.-based institutions and beyond.

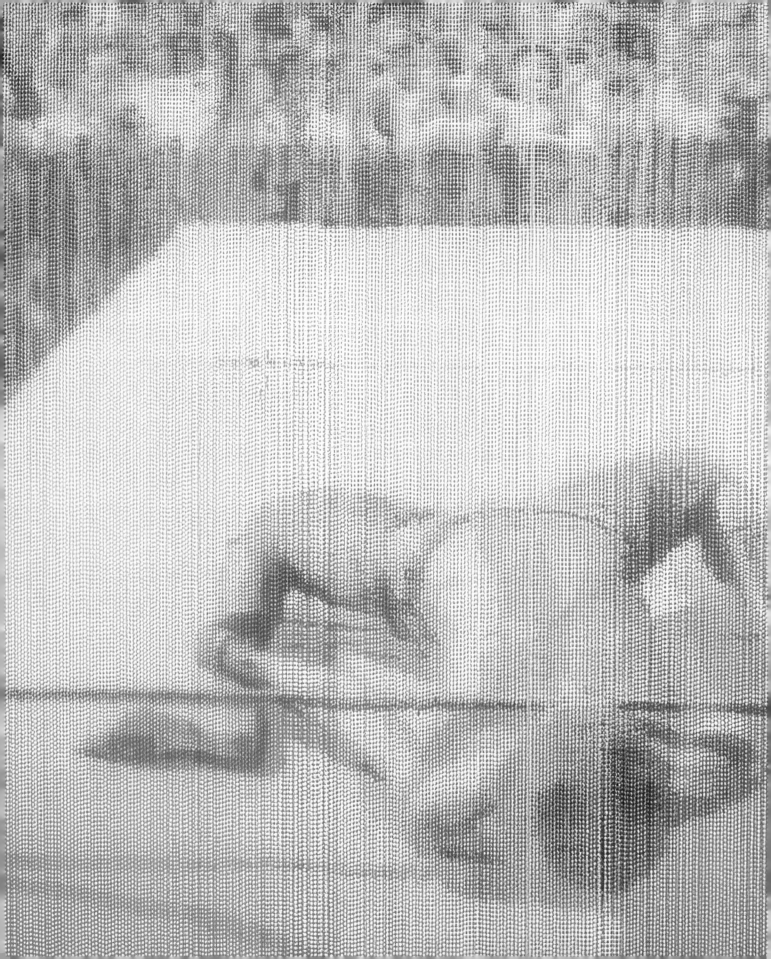

The Caribbean is a small place that significantly impacts the world. What part of your Caribbean identity or art practice do you think speaks to what is needed in the world right now?

I have more questions than I do answers. There is a proximity to colonialism and its present-day ramifications that's inescapable in the Caribbean and its diaspora. This is something that will always demand interrogation. Great thinkers have wrestled with the conundrum of being both the products and benefactors of colonization and empire, while also being its illegitimate and disregarded children. Today we are witnessing genocides across the world wherein governments or other violent agents use tactics of oppression and misinformation learned from past regimes who have yet to atone for their sins of the past (and present). We are witnessing the articulation of foundational forms of violence developed and perfected during transatlantic slavery. What does it mean to be an artist who inherits these conditions and histories? How do we engage with them while avoiding falling into the trap of using stereotypical tropes that lie on the surface?

What feelings are you trying to evoke through your work, and what do you hope viewers will do as a result of their interactions with it?

I want people to sit with the questions I'm working through.

What stories are you seeking to tell about colonial histories in the Caribbean? Does the work address issues of reparations or repatriation?

To answer that question, I have to go back to the moment when I became bodily aware—as a child, as a teenager—of how we, on a daily basis, are navigating our histories in the Caribbean. There were moments when I felt discomfort on a corporeal level. Those moments spoke to how we've normalized and retained colonial practices or traditions, or the ways in which we unconsciously still work to adhere to them. I've always appreciated the writing of sociologist Stuart Hall, who talks about how we have to grapple with this cultural identity. The fact that we were a precolonial invention and that we're always in this process of becoming. Within my work, I try to sit in that space of navigating and renegotiating.

What sources and materials are you using to inform your work or in the work itself?

There are traditional sources, like the British Museum and the Getty Center in California, which has an extensive Caribbean archive. In Brixton, England, there's the Black Cultural Archives. Then there are the archives of our local newspaper in Jamaica, *The Gleaner.*

I'm always interested in the everyday object and how that can be transformed. For instance, in the Buckingham Palace gift shop

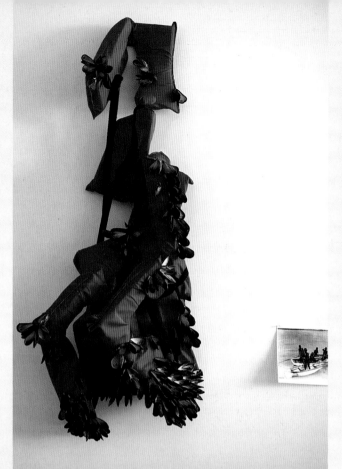

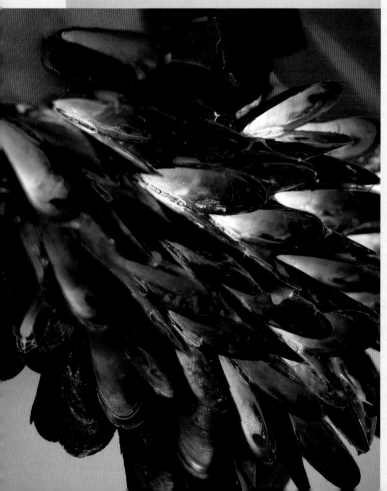

there's a whole set of royal china, and it blows my mind how such objects can become mass-produced tchotchkes that people collect. They come with such a loaded history and, although there are some who choose to look at them as simply beautiful objects, we all grapple with their symbolism in some fashion—be it through nuanced or more overt manifestations of the systemic racism and colonial ideological frameworks to which they are tied. I did a series using my father's ties, and while that speaks to my connection to him personally, it can also be read as a colonial retention of what is considered acceptable Western attire.

Does your work reflect your personal memories or, more broadly, the idea of memory as a form or material of art-making?

I always start with a personal interrogation, and through that process I contend with my sense of being a racialized Black man. From there, I think about the larger societal implications. Memory plays a pivotal role in that. It's fascinating to see the links that are created between disparate moments. In 2020, for example, we were all activated by the murder of George Floyd and the racial reckoning that was happening in the United States. It was interesting to see the echoes of it all over London, where people were taking down colonial monuments. In Jamaica, you saw Black Lives Matter protests, which also led to discussions about the value of queer lives.

As that was happening, I was working on a project around the Brixton riots of 1981. Suddenly I was trying to link these two moments. What does it mean to still be protesting about the loss and the devaluing of Black lives so many decades later? By focusing on Brixton, I was centering my work on a British Caribbean experience, but also linking it to what was happening in America and globally, trying to draw from diasporic memory to make these connections.

For that project, I was looking through the photo archives of the *Guardian* to create a more tactile experience with the archive. The archival images were reinterpreted as paintings on metal curtains that you have to walk through. And they're heavy, so you feel the weight of the image. The moment you walk through the curtains, you disrupt the image, and then it snaps back into place. I was also thinking about how intrusive the camera can be in terms of documenting the othering of Black and brown people. The act of walking through the curtain momentarily resists that kind of legibility.

"Histories have echoes in the present."

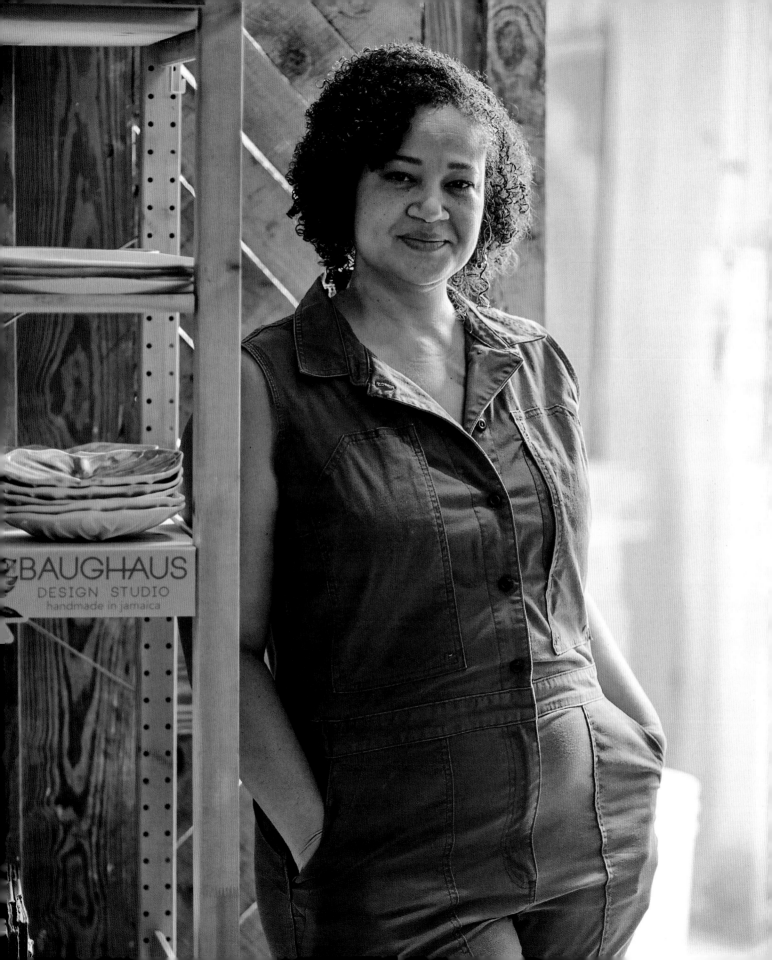

Dana
MARIE BAUGH

A CERAMICS DESIGNER WHOSE WORK RESISTS CULTURAL ERASURE

I'm known for ceramics, but I love products made with any type of material. My practice is not just about making things that are pretty, but about trying to authentically represent my culture as I see it, to express it to people who don't know about the arts or culture of Jamaica, or who only see Jamaica as one-dimensional.

What did you make as a child before you even knew to call it art or design?

I grew up in a rural area, so I had to entertain myself and be very imaginative. Because I liked to use my hands and figure stuff out, my parents and aunt gave me weaving and glassmaking materials. I used to love making Christmas ornaments. I made a little basket of fruit out of clay, and I donated it to the church. Giving these things to people always made me feel good when they appreciated it.

Was there a moment in your career when you had to reinvent yourself or your practice because of an obstacle?

When you're doing something you love, you often miss the whole point of it being a business. There was a pivotal moment in my career that prompted me to reinvent both myself and my practice. Being deeply passionate about my craft makes it easy to overlook the business aspect of it. The fear of undervaluing the products I worked tirelessly to create led me to a moment of realization. I recognized the need to transition and rewire my mindset to be more protective of my business. It's about putting valuable creations out into the world and acknowledging their worth without hesitating to ask for what they rightfully deserve.

This shift in mindset has translated into a strategic reevaluation. While my love for what I do remains unwavering, I've come to understand that there must be a purpose beyond passion. It's about creating a sustainable business model that not only allows me to live comfortably but also empowers those I employ to do the same.

How have you crafted a kinship with the land, people, and culture of the Caribbean?

Kinship is about similarities and togetherness in community. A lot of my work has to do with culture and people. I created a starfruit ornament that reminds people from across the diaspora of home. The same thing can have different meanings for different people, but there's a soft, warm, fuzzy feeling because it reminds you of sitting under a tree eating the fruit. I'm doing what I set out to accomplish, which is to create things that are memorable or remind people of family, friends, and camaraderie.

Kinship is also about celebrating the history and the story of Africa before slavery or the stories of victory within slavery. How do you tell that story in your own way that's true to you and the way you see it?

With my work, I predominantly focus on telling Caribbean stories, and therein lies the beauty. It's a direct homage to the resilient spirit of our ancestors who ingeniously preserved their stories and culture, passing them down through creative and often covert means. This, in turn, enables us to continually reap the richness of our African heritage. In every piece I create, I strive to embed elements of my own culture, ensuring that my work becomes a personal and authentic tribute to the enduring legacy of our African ancestry.

The Caribbean is a small place that significantly impacts the world. What part of your Caribbean identity or art practice do you think speaks to what is needed in the world right now?

Jamaica is such a small island, and we've done and influenced a lot of things that people don't know about. I would love for people to know the origin stories so that they can appreciate and not look down on or dismiss the opinions and contributions of the Caribbean. Jamaica's national motto, "Out of Many, One People," speaks to the fact that people came to Jamaica from different nations, but we don't have Chinese Jamaicans, Lebanese Jamaicans, Greek Jamaicans, Syrian Jamaicans, Black Jamaicans, or white Jamaicans. We just have Jamaicans. We do have our issues around class, even racism. But we are all Jamaicans. We are all just humans, and no one is better than the next. We all have something to contribute to the betterment of society.

What feelings are you trying to evoke through your work, and what do you hope viewers will do as a result of their interactions with it?

I want people to feel good, happy, joyful memories of family. I want them to live their best life.

Can you talk about how or whether your work closes the gap between art and design practice, or whether you would like to close that gap more?

I think my work closes the gap because the pieces are telling a story, and they're trying to evoke a feeling. Some people may consider them art, but they're also functional. However, I don't think we should be forced to try to close the gap. Art is art, and the purpose of it is to elicit an emotion. It's just that sometimes as artists, we may need to also recognize that there's a business aspect. If we were to mince words and get very technical, I'm not an artist; I'm a maker. I make, I design, and I like to use my hands and figure things out.

What stories are you seeking to tell about colonial histories in the Caribbean?

In my latest collections, I draw inspiration from the iconography of dancehall. I also pay homage to the grace of Georgian architecture from the colonial era with a fretwork teapot, and concurrently, my creative journey unfolds in the development of a collection celebrating Junkanoo, a vibrant display of our African heritage that emerged as an act of resilience and resourcefulness in the face of slavery. With each piece, although it is functional, my aim is to evoke a visceral response, urging viewers to find beauty in the enigmatic, the uncharted, and the unconventional. It's a plea to appreciate the allure of the unknown, even when it may seem intimidating. Beyond the aesthetics, these creations serve as visual anthems against the erasure of the beauty, history, and greatness of entire nations inflicted by colonialism. I seek to communicate a message of remembrance, urging us not to forget and to find beauty in the diverse narratives embedded in these pieces. In essence, my art is a celebration of resilience, an affirmation that despite the shadows of history, there's much to admire and celebrate..

What material are you most connected to?

My material of choice is porcelain. I have to admit that Jamaica doesn't have an industry for mining clay and bauxite, so it has to be sourced from overseas. The reason I chose porcelain even though it's notoriously difficult to work with is that I just love the outcome—the feel of it, the look of it, the quality of it. It's beautiful to me.

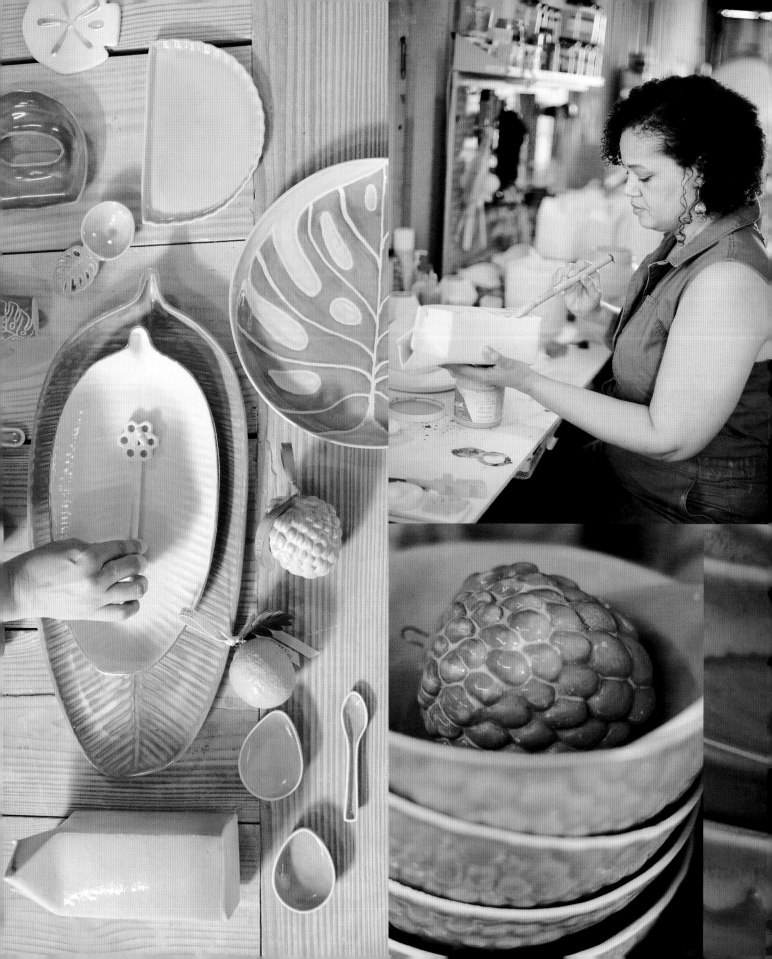

David
GUMBS

A MULTIMEDIA ARTIST WHOSE WORK IS INSPIRED BY NATURE

My practice is mixed media and includes interactive or immersive videos.

Was there a moment in your career when you had to reinvent yourself or your practice because of an obstacle?

I have the impression that I'm always facing obstacles, the first one being myself. I don't show my drawings or submit my photography because curators didn't have much interest in them. But I followed my intuition to push on with the digital work that I started when I was a student. I still find it challenging every day to accept that I have no clue what I'm doing [*laughs*]. I feel like I'm one of those artists who do things that make sense three or four years later.

How have you crafted a kinship with the land, people, and culture of the Caribbean?

I noticed that when I'm abroad, I don't create the same way as when I'm home. I have this love–hate relationship with the islands in the sense that I'm constantly asking myself, "Where can I go to have more sustainable opportunities?" And yet I realize that the food, the magma, that I get from where I live is the source of my best work. My relationship with the land comes from the unique species of flowers and trees and the link to the sea. My relationship with the people is a bit different. A bit more complicated. In St. Martin, you hear people speaking so many different languages. That cultural and linguistic heterogeneity influences the way I use colors. It translates in the vibrancy, in the tonal value, of colors in my work, and in how colors play off of and interact with one another.

What feelings are you trying to evoke through your work, and what do you hope viewers will do as a result of their interactions with it?

It changes all the time, but I do see families enjoying playing with the works and being united while interacting with them. That's something that I seem to be drawn toward: the idea that work needs human interaction to be complete.

What does community look like for you as a maker living and working in the diaspora?

To be a beacon for young people, so they see that it's possible to be an artist.

designers working on a certain scenography. You cannot design the whole project on your own, although it's your idea.

Thinking about the region as a space where we were forced to create a connection to the land, how do you see your relationship with the land itself?

When I was younger, I could have walked from my home two or three kilometers down the beach. Today when I try to go to the same spot, there are homes that people built in the water, and the sand is gone. I can see the rise of the sea level. That comes into play in my work. I always use water poetically, like in my *Water and Dreams* video. The water becomes a medium representing dreams or mental projections.

How is climate change impacting how you use materials and/ or think about the land you're situated in?

I became more aware of how the impacts of climate change show up in my work intuitively, unconsciously, after speaking with other artists and curators about my work, such as when I use the conch as an object you can touch or blow into. My work talks about two aspects of climate change: (1) conservation and the use of certain seafoods, and how those foods can become endangered species in certain areas of the Caribbean, and (2) hurricanes, like Luis or Irma, which I represent in my animations with circular, repetitive motifs.

What facets of spirituality are most present or potent in your work? Do you see the act of making as a spiritual or sacred practice? And how do materiality, the making process, symbols, or figures invoke or evoke your spiritual practice?

When I speak of spirituality, it's more energy-based than religious. It's mostly something that comes from within and expands out. Interactive pieces in which the body changes colors and the patterns surrounding them follow their movements speak more about memory and a relationship with the land going beyond the physical to the invisible realm. At times I think my work reflects an out-of-body experience.

There's another space dimension that is about honoring my grandmother. I have a few memories from when I was small of holding her dress when she would take me to pick conch, helping her make bread, and listening to her stories. My work has to honor ancestors and the things they gave us that we are in danger of losing today.

You talked about going abroad for more opportunities and that you create differently when you're abroad. To what extent do you feel the need to reconnect to your island or community when you're away?

When I come back from abroad, there's about a four-day window when I see things more clearly; like how beautiful the patterns are, how beautiful the broken windows or the roofless house are. There's something I see in the light, and how the light hits the skin. I walk everywhere with my camera or cell phone in my hand when I get back. Because when I'm abroad, I'm just in production mode, unless I'm doing a residency. But when I come back, I feel like I have a stronger artistic eye.

Can you talk about how or whether your work closes the gap between art and design practice, or whether you would like to close that gap more?

When I think of design, I think of the body's movement in space. Working as a multimedia artist is sort of like building a bridge between various mediums: sound, digital art, sculpture, painting— especially now with VR [virtual reality] and AR [augmented reality]. Depending on the commission, there might be a team of

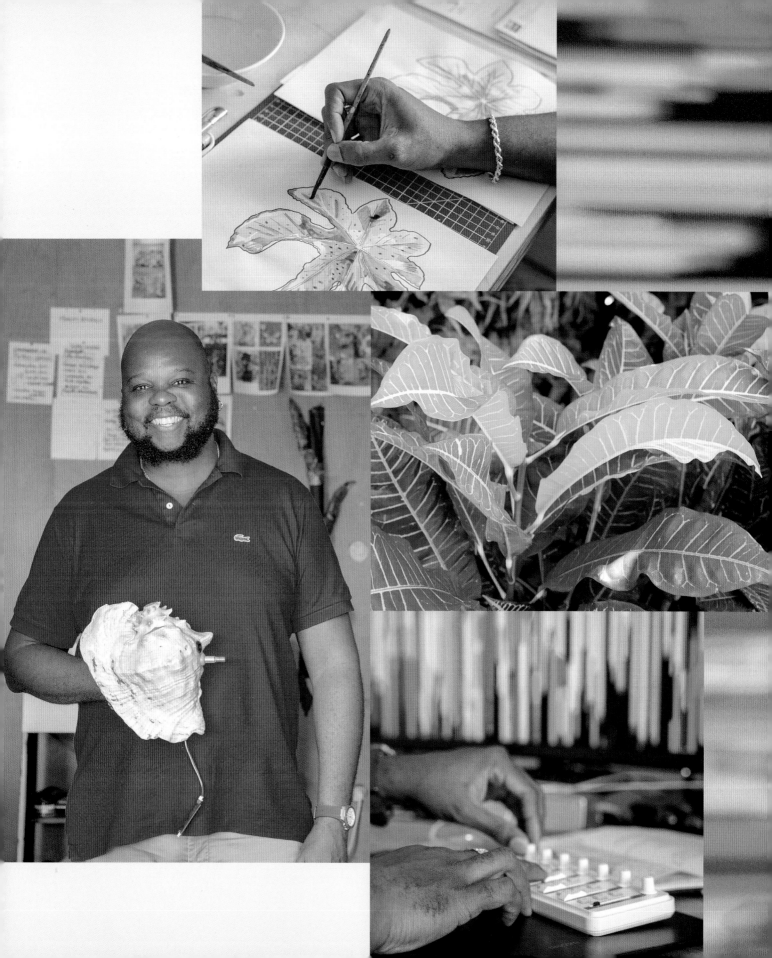

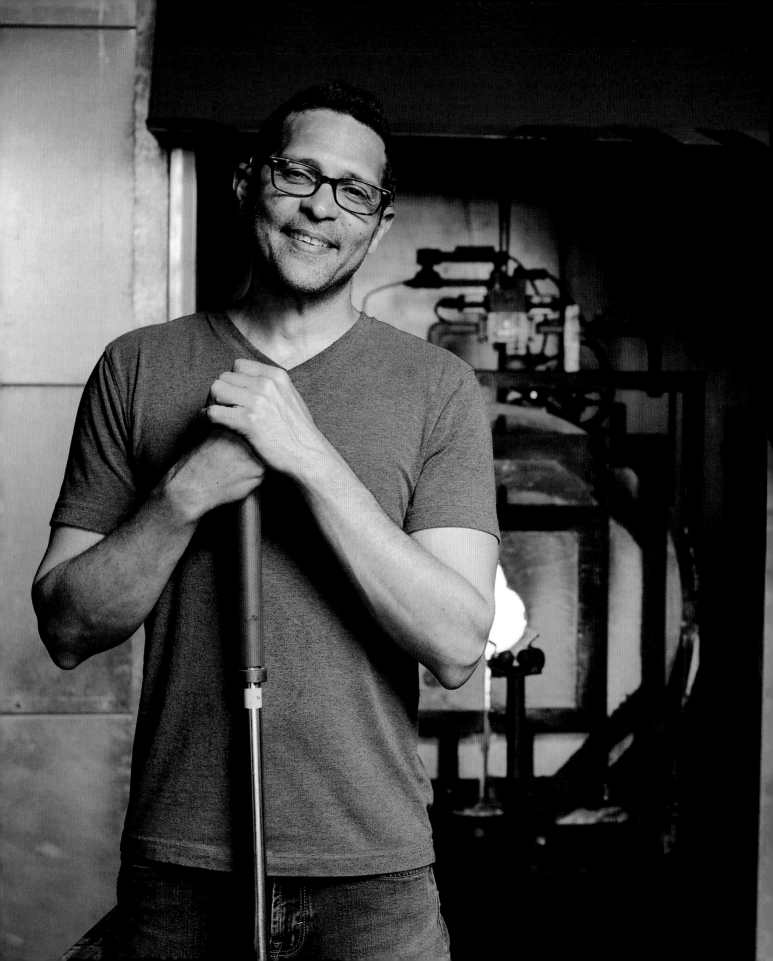

Davin
K. EBANKS

A GLASS SCULPTOR WHO CREATES AS A WAY TO THINK ABOUT IDENTITY AND PLACE

Some of my recent work reflects my process of thinking about what it means to be a Caribbean person of mixed race and a member of at least two diasporas: the African diaspora and the Caribbean diaspora. So, in a weird way, I would think of my work as self-portraiture, even though it's not all strictly literal.

What did you make as a child even before you knew to call it art or design?

I did a lot of drawing. Every little kid draws, and most of my friends did it better than me, but I just never stopped.

Was there a moment in your career when you had to reinvent yourself or your practice because of an obstacle?

The obstacle was the kind of education I got and the pervasive myth of the genius artist. Maybe it's instilled in us in elementary school that an artist imagines a thing and then makes it. That leaves no room for the work and the way an artist thinks through their hands.

I got my undergrad degree in graphic design, which is very much "A, B, C": concept, design, execution. That is a streamlined, straightforward, and, I think, flawed way of thinking about artistic activity. I don't think creativity works like that. It's more like "A, B, yellow." Like a quantum leap to a whole different place. You still have to do A and B, you still have to do the work, but you end up somewhere you don't expect. You can predict "C"; you can't predict "yellow" because it just comes out.

It took me a long time to realize that that's how creativity works. And I held myself back. I struggled. I loved glass—I wanted to keep my hands in the material—but I made other people's work for years, and it took a slow process of revelation to make me not care and just say, "This is not working. I have to do something different." That was the moment when I actually gave myself permission to figure out what my work was and start making it.

How have you crafted a kinship with the land, people, and culture of the Caribbean?

Everything about how I think of myself comes from my experiences growing up on an island populated by people from all over the Caribbean. Cayman Islands was settled over five hundred years ago, so it's older than the United States, but at the same time, it doesn't have the same rich culture as other islands. It was a subsistence living place. There was nothing there for a long time except sand and mosquitoes,

and the work I make looks back to that subsistence lifestyle. I kind of grew up on a boat with my grandfather, listening to stories about turtle and shark fishing and wanting to be able to do that but not being able to because life had changed for the better. Something is lost with that loss of culture.

It's also a land of mixed-race people—there are over 130 nationalities there now—so I grew up around all kinds of people. An island with so little material culture is different from the place that invented Carnival. I'm totally aware of culture from other islands, but when I'm making my artwork, I try to be true to myself as much as possible and not appropriate somebody else's story.

The Caribbean is a small place that significantly impacts the world. What part of your Caribbean identity or art practice do you think speaks to what is needed in the world right now?

That we are connected to a bunch of different countries, whether it's through food or an accent or just a particular kind of appreciation for music or culture. The Caribbean identity is fluid, not fixed, especially if it's a diasporic identity.

What feelings are you trying to evoke through your work, and what do you hope viewers will do as a result of their interactions with it?

A feeling of serenity, but also attention. Recently I've been obsessed with these impossible surfaces that are hard to locate in space. It seems as if you're looking through something, or you're not sure whether if you reach out your hand, you're going to put it through something or touch something. You're sort of meditative when you're looking at them, but behind each surface might be some not 100 percent pleasant stories.

Can you talk about how or whether your work closes the gap between art and design practice, or whether you would like to close that gap more?

Yes, and the obstacle is just perception. I talked about my early education first as a negative thing—what I thought I was being taught for a design process: concept, design, execution. On the other hand, it was based around Bauhaus principles, which saw no separation between art and design.

I think a Western notion of fine art is that it is a singular, unique object that is 100 percent different from any other. A more honest version of what fine art can be is embodied by the work of Rodin. Do you realize how many *Thinkers* he produced? Rodin was a modernist, but he came from an old-school way of thinking, which was that you make work that people buy. "I'll sell as many *Thinkers* as I want." For a long time, I worked in a serial kind of way. You need to make a lot of pieces to make any one that is good.

I used to want to be in the fine art realm, but working as a designer is easier for me because I'm embracing and studying more this history of glass as a medium that has its roots in craft. I've always liked producing well-made things that I can sell to somebody and that become a part of their life. I don't see that as being that different from me selling one of my fine art pieces that hangs on their wall. So yes, I do see a synthesis between those things. I think it's slowly becoming more of my practice.

What facets of your identity are most prominent in your work? How do you use your practice to speak to your Caribbeanness?

I think it's a certain fluidity or fluidness. There's a way in which the work floats and can't be nailed down to a single identity, which I think is what makes my use of glass so necessary—the visual metaphor of an identity that floats. Glass can be opaque, translucent, heavy, light, clear, colored, decorative, or industrial. These qualities are important to me. It's been an active part of my practice to connect, reconnect, to those from the broader Caribbean, from specific islands, and what they relate to in terms of stories. A mixed-race Caribbean person living in some other country might relate to their sense of floating and how it represents being at sea. Always traveling rather than being settled.

What materials are you most connected to?

I don't think you can grow up in the Caribbean, especially around water, and not have an appreciation for light as a medium. At a particular time of day, everything seems to glow, and it doesn't even seem like it's a liquid, that water. So I'm really interested in light, which of course means I'm interested in seeing and how people perceive stuff. The thing about water is that it refracts light and makes you see what you think you see, not what you actually see, because it's bending light and it's changing it. Glass can be a revealing material—we think about it for its clarity, but at the same time, it can distort reality.

Has your approach to or use of materials changed over time in your practice?

When I first started using glass, it was difficult to get close to my vision, which might have been a flaw in the way I think about art. But I would fold a lot of other materials—concrete, fabricated wood or fabricated steel parts, paintings, drawings—into the objects and sculptures. Now it's just the glass. As I've gotten older and know how to use it better, I feel more comfortable with thinking through that material.

Deborah
JACK

A PHOTOGRAPHER WHOSE WORK IS CONNECTED TO THE HISTORY EMBEDDED IN THE LAND

My practice is lens-based. I use photography and video to create images that are rooted in community and personal memory, ecology, and the environment.

What did you make as a child before you even knew to call it art or design?

I remember being craft-oriented. In elementary school in Sint Maarten, the girls did sewing and the boys did crafts. I was terrible at sewing, and after I'd ruined many embroidered pillows, my home ec teacher let me do crafts with the boys. I made rugs. St. Martin's a really small island, so every now and again the gift store or the toy store would bring in a little craft set and I would buy it. That's my earliest memory of making things intentionally to give as gifts.

Was there a moment in your career when you had to reinvent yourself or your practice because of an obstacle?

Until graduate school, I worked as a journalist and a civil servant and had only worked with paint as an art form and used photography and video for my job in the news. My interest in photography was rooted in wanting to be a war correspondent, and I was introduced to video art at the University at Buffalo. The obstacle was how difficult it was to access film back home. I could access video, but film as a material was almost impossible to find. In the 1980s, Puerto Rico was the closest place you could get film processed, if you could even get it off the island without it being x-rayed. A lot of times, reinvention is necessary because of a lack of resources.

How have you crafted a kinship with the land, people, and culture of the Caribbean?

It's home. The island's almost a collaborator in my work. That's the kinship. Filming has taken me to places on the island I might not otherwise have visited. I've gotten to know my island better by photographing the coastline, which is now inundated with sargassum. I can't think about my work without thinking about Sint Maarten and vice versa. It's almost like a conversation with the land and with the people.

The Caribbean is a small place that significantly impacts the world. What part of your Caribbean identity or art practice do you think speaks to what is needed in the world right now?

The richness of the Caribbean is that so many people and cultures have come through, and because they're on these islands, we're forced to interact in a way that people who live on the continent may be able to avoid. It's hard to isolate on an

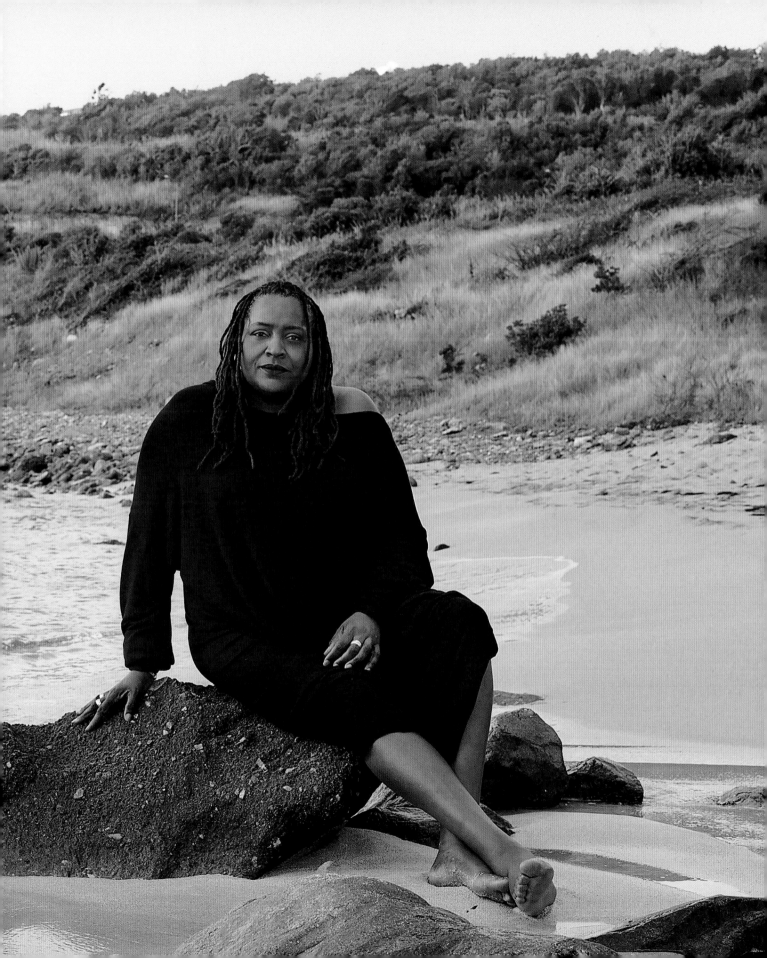

island. You have to confront things that are difficult sometimes, and to figure out a way to navigate joy through that, and find solutions. That's what the Caribbean offers the world. This idea of being able to live with differences.

What does community look like for you as a maker living and working in the diaspora?

Community is pretty fluid. A good example, for instance, is when I went to *Loophole Retreat: Venice* in October and met up with friends I've known through the years. We only see each other every now and again in person, but when we do, it's like we never parted. The word *diaspora* means "scattering." So when we come together, we really enjoy those moments and feed off them. We grow from them and we feel rejuvenated, and then we go our separate ways again. When you're away from home, it can get lonely, so we know how to craft family out of the connections we have. I think that's beautiful.

What feelings are you trying to evoke through your work, and what do you hope viewers will do as a result of their interactions with it?

The main thing I want people to feel is connection. I've sat in rooms with my work with people not knowing I was the artist. I want to see what they're doing. A lot of times I'm thinking about colonialism and the history of slavery and the Middle Passage, which are dark and painful themes, but at the same time, it becomes easy to walk away from because you could say, "I don't

want to engage with that; it's too traumatic." I've intentionally tried to make the work so that people will want to sit in the space whether or not they initially get what the work is about.

But there are parts of it they connect to. I use the sea a lot in my work. People who live close to Mexico see it and it makes them think of home, or someone who lives off the coast of France thinks about a time they went to the beach. Sometimes it evokes nostalgia. Viewers make space to ask, "What am I seeing?" Because now they care about it, they've connected to it. I like that conversation.

Can you talk about how or whether your work closes the gap between art and design practice, or whether you would like to close that gap more?

With photography and video, I don't know how you compose an image without thinking about design. A lot of the same compositional strategies are used in both, even in terms of space. A photograph is a two-dimensional representation of a three-dimensional space. In that flattening, there still has to be depth. In the work, I don't think of art and design as separate. Even now in my studio practice, I have a joke that my laptop is my studio for video, but then I have a studio where I can make a mess because I need to work with my hands. So many younger artists are getting rid of all those labels and doing the work they want to do. It's up to us as artists to reject labels and divisions, and make the work we want to make using the tools we want to use. Artists are always the ones to pull society forward.

Thinking about the region as a space where we were forced to create a connection to the land—for you, Sint Maarten—how do you see your relationship with the land itself?

Sint Maarten has two Indigenous names: Soualiga, which means "land of salt," and Oualichi, meaning "land of beautiful women." The salt comes from the ponds; the rolling hills represent the women. I use salt in my work—it's there all the time conceptually as a material—so I honor that idea. Indigenous people recognized that salt was an important part of the island, the culture, and their bodies. That's the way I maintain connection.

I photograph my work in nature, by looking closely at the landscape, by zooming in. The land for me is crucial. I have a friend who is almost a collaborator in the sense that she knows what I'm looking for in terms of the landscape. We hop in a Jeep and go to places that even people who live on the island don't necessarily encounter on a day-to-day basis.

A lot of my work is connected to the history embedded in the land of the Caribbean, to the ruins and what's underneath.

the land has taught me that sites of trauma are also sites of healing. In the moment of devastation after a hurricane, you're thinking, "How are we ever going to get out of this?" And then the land starts to get green again. Things regenerate. The land itself is a holder of memories—an eyewitness to atrocities, but also a balm.

Does your work reflect your personal memories or, more broadly, the idea of memory as a form or material of art-making? Or to put it differently: Are you reflecting on personal memory or cultural memory or sense memory, intergenerational or epigenetic or spiritual?

All of it. An early project that I did called *Foremothers* uses images of my paternal grandmother to reflect an absence of personal memory. I connect the artifacts of memory—pictures or stories—to personal memory. The newer project, the video installation *the fecund, the lush and the salted land waits for a harvest . . . her people . . . ripe with promise, wait until the next blowing season*, uses archival footage of Sint Maarten that most Sint Maartens haven't seen; arguably 99 percent of the population hasn't seen that footage because it lives in the Netherlands. That cultural memory is stored in an archive that we don't have access to, and mining that kind of archive is something that's important to me.

The early work was about creating these types of images because I didn't have them—and now having found them, I'm bringing them to light and reassessing how we look at them. I use an archival film that was made in 1943 in the Netherlands as a way to introduce Dutch people to the Dutch Caribbean islands; and I replace the narrator's voice with the voice of a local elder, a cousin of mine. Hers is the only voice you hear. That's a kind of personal history embedded in the work. It's a kind of inter-generational memory, questioning, passing down stories in the oral tradition. Even when some memories are personal, because so many of us have the same sort of personal memories, they become community memories.

What sources are you using to inform your work?

There was an absence of our history in Sint Maarten when I was growing up. Our history lived in people's minds, but nobody wrote it down. Nobody documented it. If you weren't there to hear the story, you missed it. Documenting it has become really important.

One of the people I work with is Clara Reyes, a choreographer, cultural worker, and anthropologist. When she interviewed elders about their memories of dance, sometimes they would get up and demonstrate. They couldn't tell you what the movement was, but even in their ninety-year-old bodies, it was easy for them to move. For me, that was impactful because it demonstrated

that these memories live in our bodies—it's muscle memory. That was the first time the term made sense to me. We've done something similar with songs. For a video piece I made, *the water between us remembers, so we carry this history on our skins, long for a sea-bath and hope that the salt will heal what ails us*, I wanted a folkloric song from Sint Maarten. Clara had just learned a new song from an interview she'd conducted with this older gentleman, and she sang it to me over the phone. We then went to a friend's recording studio and she recorded it. These are the sources, the people and their memories, that we're documenting and sharing through my practice.

People's memories are an archive. Their objects are materials for making new art. Someone's mother's curtains are not just some old curtains when used in an art piece. My films feature old houses, so then people think, "Should we be preserving these?" Yes. Because we have a whole generation of young artists who are interested in looking and asking those questions. In the 1980s and '90s, we were taught to let go of our history. Now there's a return to it, and people are dedicated to saving our libraries, our archives, our homes. We're saving them and not just erasing them for a new resort or to accommodate people from somewhere else.

I go home to give talks, because for me, the work isn't meant to live only abroad, it is meant for the people who are in Sint Maarten to find their own connection to it. Even though it's conceptual, I can talk about all these larger ideas of the sublime, and a person who lives in Sint Maarten understands a hurricane not as a metaphor for the sublimeness of nature but as something that takes their roof. If you explain what "sublime" means within that context of being in the face of this powerful natural force, they get it. For me, representations of that connection and of our land, and the salt, and the history of the people, the songs, the voices, are worthy of being in museums, are worthy of being in art spaces and being collected.

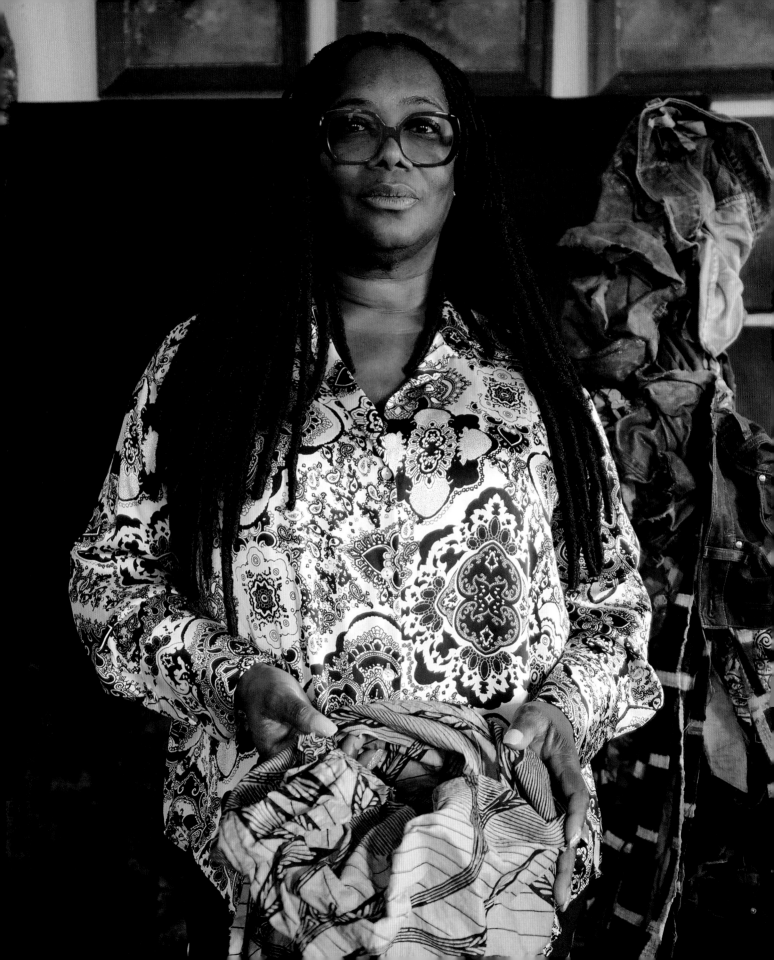

Dianne
SMITH

**AN INTERDISCIPLINARY ARTIST WHOSE WORK CARRIES
THE MEMORIES OF LOVED ONES PAST AND PRESENT**

My practice is organic, but there's control within that organic way of making. The control is a dance between myself and the materials I choose. I'm not always working with conventional materials, so I had to learn early on when to relinquish control and let the material guide my process.

What did you make as a child before you even knew to call it art or design?

My earliest memory is of coloring inside the lines and coloring brown people. I always used the chocolate crayon because it just made sense to me that people in coloring books would look like me, even Snow White. I was brown. My mother was brown, and all the people around me were brown.

My mother was a very strong and beautiful woman. She knew innately who I was, and so she bought me all these things that allowed me to be creative. She bought me a casting kit I could use to make plaster. I had a Talking View-Master, because we were fancy [*laughs*], and that was the first time I saw Rome and the Leaning Tower of Pisa. I had a teeny replica of a restaurant grill that I would plug in at the foot of the bed, and my mother would give me food to grill on it. She would make cake batter for me to put in my little oven. I think those moments were the imprint for this idea of making stuff. Coming from a Caribbean culture, you watch things being made or constructed all the time. Bread. Johnnycake. Clothes. Every evening when she came home from work, my mother sewed me a little outfit for school the next day. My friends nicknamed her Dominique Deveraux after the character Diahann Carroll played on the 1980s television drama *Dynasty* [*laughs*]. She was very glam. I always teased her, like, "You had to leave Belize. They couldn't hold you down. It wasn't big enough!"

Was there a moment in your career when you had to reinvent yourself or your practice because of an obstacle?

At twentysomething years old, I was painting what I thought I should paint because of what I looked like and what I believed the world expected of me. It was very representational work. I was doing these overly stylized paintings using African masks as inspiration. They were very detailed, layered, and textured in color, shape, and movement.

One day, the abstract painter Danny Simmons came over to look at my work and said, "It's clear you can paint, and you're probably a much better painter than I am. I just don't know why you paint *this* shit. Find your voice as an artist. Figure out who

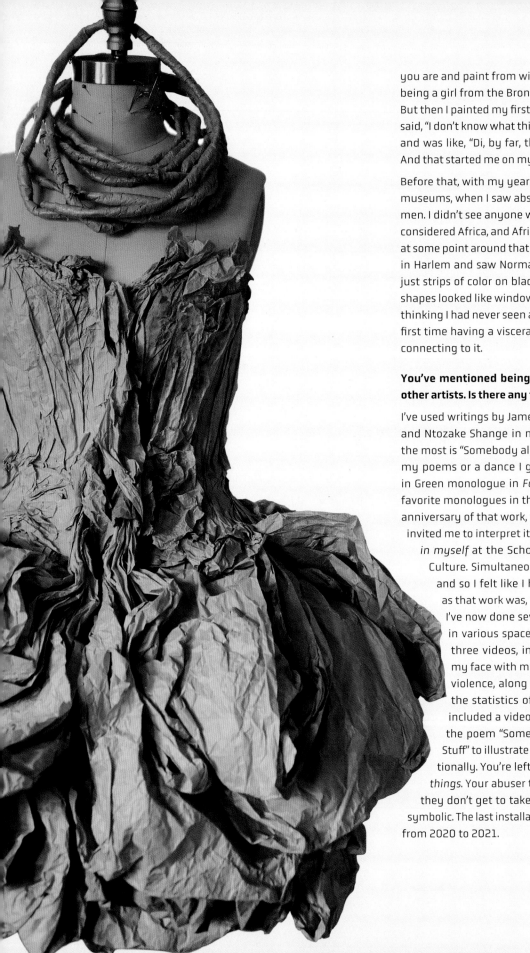

you are and paint from within." My first instinct was to revert to being a girl from the Bronx, like, "Who you think you talkin' to?" But then I painted my first abstract piece, and I called Danny and said, "I don't know what this is, but I know I'm done." He came over and was like, "Di, by far, this is the best shit you ever painted." And that started me on my journey with abstract expressionism.

Before that, with my years of studying art history and going to museums, when I saw abstract expressionists, I saw dead white men. I didn't see anyone who looked like me. Egypt wasn't even considered Africa, and African art was considered "primitive." But at some point around that time, I walked into the Studio Museum in Harlem and saw Norman Lewis's black paintings. They were just strips of color on black canvases, and the little rectangular shapes looked like windows in a tenement building. I remember thinking I had never seen anything so magnificent. That was my first time having a visceral reaction to abstract work and really connecting to it.

You've mentioned being inspired by the words and work of other artists. Is there any text that stands out to you right now?

I've used writings by James Weldon Johnson, Langston Hughes, and Ntozake Shange in my work. One of the quotes I've used the most is "Somebody almost walked off wid alla my stuff, not my poems or a dance I gave up in the street," from the Lady in Green monologue in *For Colored Girls*, which was one of my favorite monologues in the play. To commemorate the fortieth anniversary of that work, the curator Souleo (Peter Wright) had invited me to interpret it visually for the exhibition *i found god in myself* at the Schomburg Center for Research in Black Culture. Simultaneously, I had a domestic violence issue, and so I felt like I had to be as truthful and transparent as that work was, particularly at the time it was written. I've now done seven or eight installations of that work in various spaces. They're site-specific and comprise three videos, including one in which I documented my face with my iPhone after I experienced domestic violence, along with my voiceover narration reading the statistics of domestic violence. One installation included a video montage of images with me reading the poem "Somebody Almost Walked Off wid Alla My Stuff" to illustrate how domestic violence robs you emo-tionally. You're left feeling as if you have been robbed of *things*. Your abuser tried to take something from you, but they don't get to take everything. The idea of *stuff* is really symbolic. The last installation of this work was at Barnard College from 2020 to 2021.

How have you crafted a kinship with the land, people, and culture of the Caribbean?

I'll take one aspect of my brown butcher paper installations to start this conversation. I was asked to do a work about the history of African Americans in New York. That led me to think about the fact that at one point, there were more African people in Manhattan than anywhere else in the world because the slave ports were here. I couldn't think about that history without thinking about the transatlantic slave trade. I was walking in the Financial District and I looked down at the sidewalk and saw these cracks, and I thought, "I'm on the African Burial Ground. What other memories or histories are embedded in these cracks? What material could I use that would talk about this idea of history and marking and inference?" And butcher paper popped into my head.

Butcher paper is used to wrap cargo, to wrap meat. It's pushed into corners. It's used for shipping. It's a durable material, but it's also fragile. That made me think about Black bodies and how enslaved Africans were cargo throughout the Americas. Pushed into corners. Treated like property and meat. I started to use the brown butcher paper, and as time went on, I started connecting it more to who I am. Thinking about my grandmother, my mother, my aunts, and all the women of the Caribbean. When I'm twisting and braiding the paper, I'm calling on their hands; those memories are in my hands because I'm using the wrist motion of Granny kneading the bread or doing the wash with the scrub

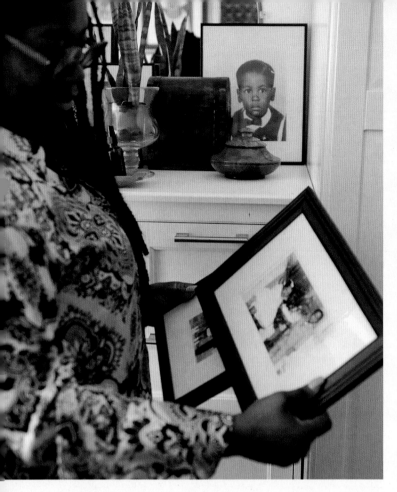

Bailey yesterday at the Print Fair and she was telling someone, "You don't know how much this woman right here saved me." She was telling the story of how she had done tiles with Travisanutto, and she was like, "That would not have gotten done had it not been for her." Because she called me one day, saying, "My computer crashed!" And I was like, "Girl, just come on over." I made her a big bowl of pasta and said, "Stay here as long as you need." I woke up at seven in the morning and she was still at it, getting projects done. That's part of my upbringing—sharing and giving.

How has the local Caribbean community informed or impacted your creative work or professional goals and opportunities?

The dance of Lenox Avenue, the synergy of Harlem, encapsulates who we are because you can find some of the diaspora everywhere you walk in Harlem. I remember my first trip to Africa, and then I thought about being in the Caribbean and I was like, "We are the same no matter where you go." When people are talking about the guy sitting on the corner here hanging out, I'm like, that's what we do in the Caribbean. That's what we do on the continent. This is who we are because at the end of the day, we are communal people. We're social people. We're vibrant people.

What I love about living in Harlem is that it's like Little Africa on 116th Street. I have very fond memories of being here as a kid, and it's always connected me to the Caribbean. Part of my thesis was a comparison of Haiti and Harlem, and exploring how Harlem has a nationalistic feel about it, just like Haiti. Harlem isn't a nation, but people are ride-or-die for Harlem. No matter where I go in the world, when I get back to Harlem, I know I'm home.

Does your work reflect your personal memories or, more broadly, the idea of memory as a form or material of art-making?

I'd like to go back for a moment to my paper installations. With the brown butcher paper, the marks that are in the paper when I twist and I roll it also make me reflect on my grandmother and other elders in the family, particularly the women. The wrinkles in their skin held memories, and the paper became a symbol of those wrinkles and all the memories that are embedded in them.

How do those memories live within me? How am I moving through the world with those memories? I will never know what all my grandmother's memories are, but I know they live within me.

I'm also working with what would be considered discarded materials that hold memory. I recently realized that I've been losing people since I was four years old with the loss of my older brother, who was only six. Throughout my life, I've been holding on to memories of people I've taken care of, and loved, and lost. My survival mechanism for losing all of them is the memories.

board in the backyard, wringing it out and hanging it up when the sun's out because that bleaches the fabric. Getting my hair braided, the leaves in the yard after the coconuts drop and turn brown—it all started to make sense. The weaving and tying and knotting of the butcher paper represents the weaving and tying and knotting of my family. That's how I connect, not just to Belize but to all of the Caribbean.

What does community look like for you as a maker living and working in the diaspora?

I'm an only child, so at key moments throughout my life, people have become my family. They don't have to be makers, but they're respectful of the fact that I am a maker, and they embrace that. That's part of why they love me. But then I do have other makers that I'm close to, and our relationship goes beyond just artist-to-artist. It's a reciprocal mentorship and sisterhood. It's a space of kindness, love, and empathy.

I can call Chakaia Booker at any time. She can call me at any time. I think when you take the time to get to know and understand people based on what they need, as opposed to what you feel they should have, you have a closer relationship. I ran into Xenobia

I would like to be remembered for being an artist who did the best I could to represent people who look like me, to tell our stories, to honor people of the diaspora in the best way possible.

DIANNE SMITH

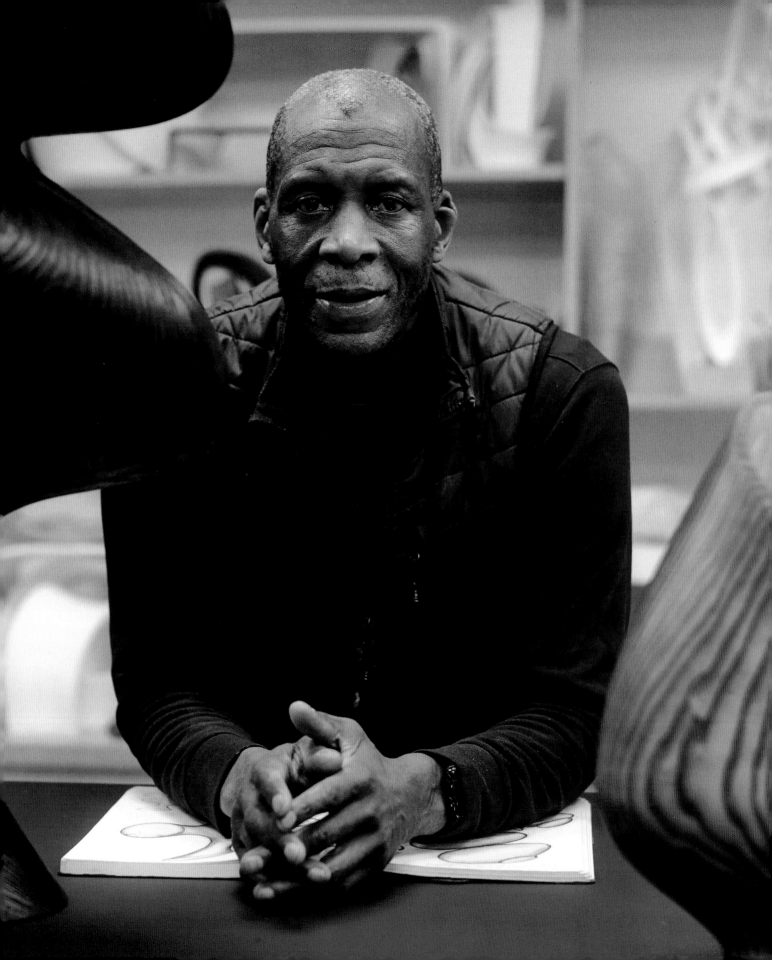

Donald
BAUGH

A WOOD SCULPTOR AND FURNITURE DESIGNER WHO EMPLOYS BOLD COLORS AND SUSTAINABLE MATERIALS

My practice centers both art and commercial work. The commercial part, which is making things like bedroom furnishings, provides an income so I don't have to rely on the art side for that. The art side is what I get excited about. That's where the passion is.

What materials are you using?

I've started taking a lot of influence from African face markings, which I translate in wood, generally upcycled timber. There's a lot of ash at the moment because of diseased trees. I've started buying my wood from foresters and tree surgeons; obtaining the wood in this way is important to my belief in sustainability. And the other wood I use is tulip, which is fast-growing and very soft.

What did you make as a child before you even knew to call it art or design?

As a child, I would always raid my mum's dressing table and take her hairpins. I enjoyed bending and twisting them into different shapes. They were not sculptures as such, but that kind of play definitely helped me experiment with form and shape.

What feelings are you trying to evoke through your work, and what do you hope viewers will do as a result of their interactions with it?

Color is integral to the pieces I create, and it's the first thing that grabs the viewer when they see my work. Color, to me, has a spiritual aspect, which goes back to my time living in Jamaica. The natural colors of the island are vivid, the colors in everyday use are vibrant, so they give a very "up" feeling. That's something I'm trying to evoke, and I'm trying to say that we shouldn't be afraid of color. Even if to the untrained (or trained) eye colors might seem like they shouldn't go together, I feel we should be bold and experiment.

What does community look like for you as a maker living and working in the diaspora?

Community, to me, is sharing my knowledge with everyone but especially with young people. This is perhaps an overused statement, but I truly believe in giving back. Collaboration is key to building and strengthening what I do; my plans extend to working and collaborating with a cross-section of creators.

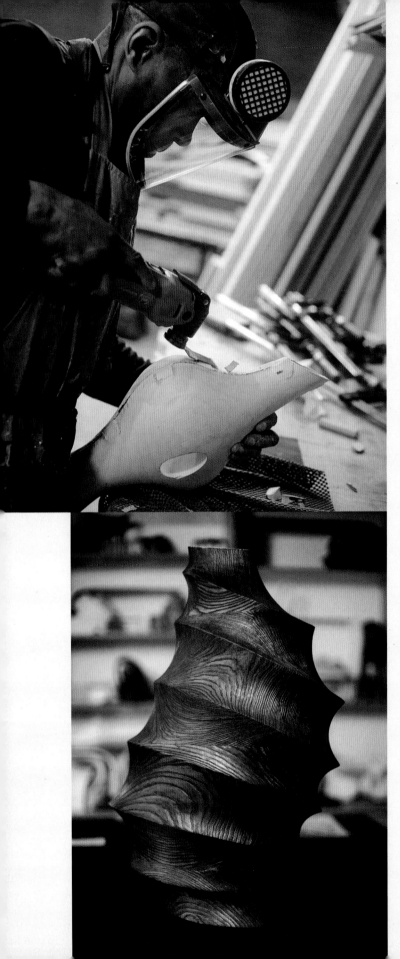

Can you talk about how or whether your work closes the gap between art and design practice, or whether you would like to close that gap more?

Well, I think partly that separation was a class thing. Art has become and is becoming more and more accessible. The perception of art being just for the elite is crumbling, and I would like to think I'm contributing to closing the gap.

What region or culture most influences you? Can you talk about your experience of finding kinship with the land, people, or cultures in Africa?

I've spoken about Jamaica's influence on my work, but I also traveled to Nigeria many years ago. The trip was purely a social event, not work. What struck me was the similarities between Jamaican and Nigerian cultures. Even though I was in a new country experiencing new people, smells, and sights, it felt very familiar, which was comforting and inspiring. While I was there I was reading a book by a well-known cabinetmaker that spoke about a prestigious college called Rycotewood School in Oxford, England. On my return, I applied to Rycotewood and started my serious journey to becoming a skilled craftsmaker.

Traveling to Egypt was different; I was at the stage where I was developing my sculpting and I actually sold some of my pieces to a school that turned out to be my first ever sales, which was highly motivating. While there I met and chatted with various carpenters and craftspeople. What struck me was that they seemed to have a fear of passing on their skills to the young, as they were afraid they'd lose business by doing so. Their attitude further compounded my desire to share my knowledge on this journey.

How have you translated the experience of being in Nigeria into your work?

The translation is only now coming through with three vessels I've made that are influenced by African facial markings. These are the Sessay vessels. This is my first real attempt to incorporate the markings onto the pieces and something that will develop further as I delve deeper into my own past and personal connection to Africa.

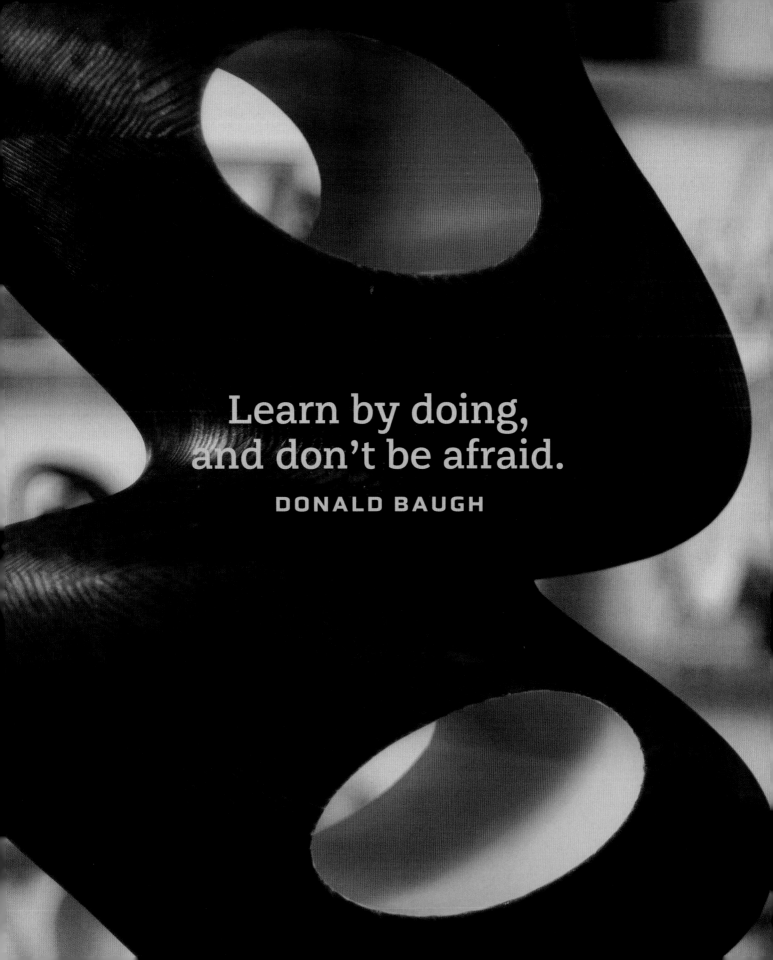

Learn by doing,
and don't be afraid.

DONALD BAUGH

Fabiola
JEAN-LOUIS

A MULTIMEDIA ARTIST WHOSE WORK TRAVERSES TIME AND SPACE TO REWRITE HISTORY

My practice is rooted in spirituality; it's about unpacking my identity, my culture, my Blackness, my femininity, as well as my masculine energy. I'm a part of the story that I'm telling, and I'm using time to do it. I call myself a time traveler artist or maker, which means that I'm starting with the idea of the self. I'm time traveling to try to have a better understanding of where I fall in that space of my selfness. The other part of my practice is using stories to heal, whether it's my own trauma or somebody else's.

What kinds of things did you make as a child, even before you knew to call it art or design?

As a child, I explored painting, and that's how I decided that I wasn't really a painter. I was more drawn to interior decorating: I was always bugging my parents to let me redo my bedroom and paint murals on my walls. It was really important for me to create my own personal space. I also did a little bit of experimentation with photography. I took workshops. Even now, if there's a good workshop, I'm going to take it. I ended up going to the High School of Fashion Industries, so I was able to be in this world of exploration on so many levels.

What materials are you using?

The main material in my work is paper, including sheets of paper, paper pulp/clay, and anything else in that realm. If it comes from a tree, then I'll use it. Most recently, I started diving more into mixed media. I'm using a lot of brass findings; wood stones, which I love; gemstones; and even dried insects.

How have you crafted a kinship with the land, people, and culture of the Caribbean?

Identifying as a Haitian woman is extremely important to me. I often tried to find ways to insert that in the work. Even when I was making *ReWriting History*, which was aesthetically European–centered, I had these Black Caribbean women in there, and that was me specifically making a comment about that. That was a way for me to bond and create kinship. I also insert symbols of my Haitian culture, like vèvè symbols, which many non–Haitian people aren't familiar with. They don't even know that they're looking at vodun symbols. But I do. The newer works that I'm creating now, which are more sculptural, reflect Haiti and the Caribbean as a whole, because we're so connected; we understand each other, and there's this unspoken language

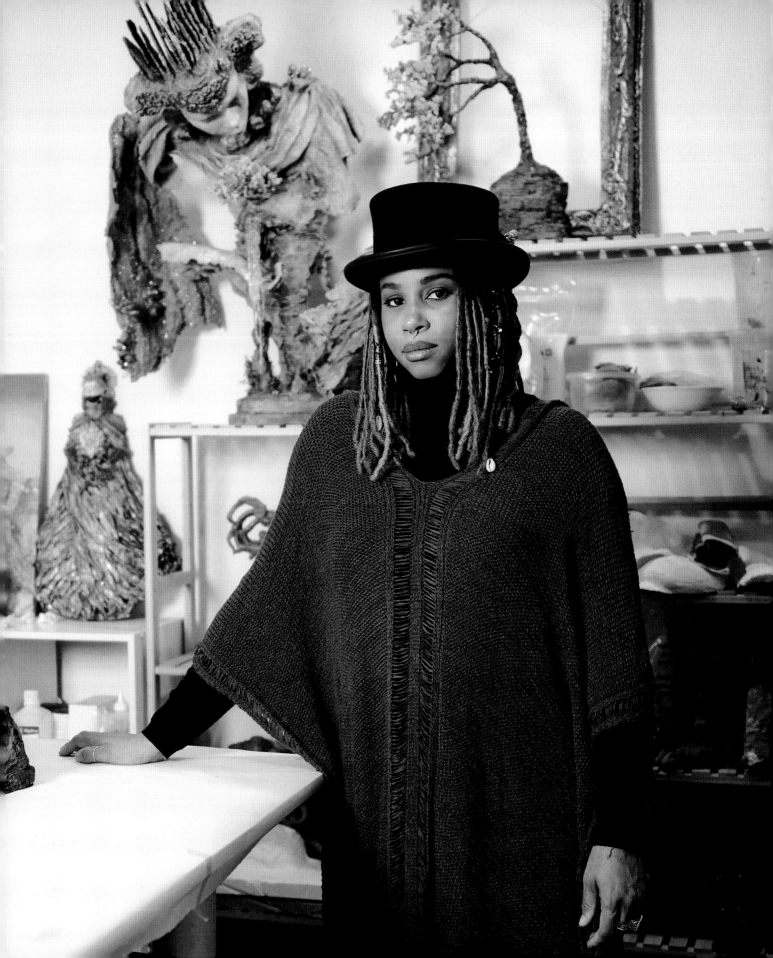

that we have. And you could be from any part of the Caribbean and get it. I'm looking at more African-centered spirituality practices for these pieces, and drawing from many spiritual practices embedded in objects like vessels. They're all based in Caribbean and African culture.

What part of your Caribbean identity or art practice do you think speaks to what is needed in the world right now?

Faith. I will start there, because the Caribbean may be small, but there's a reason it impacts the rest of the world like it does. These are groups of people that have gone through so much. The people are amazing. The culture is amazing. We know how to have a good time. We know how to show people how to have a good time. And I think that's because of the faith we've had to learn to have. We've had to have hope, hope for survival and faith that things are going to be okay. And that's something that I feel is tremendously lacking in the rest of the world. Tremendously lacking in society. That's one aspect.

Another is community. We know how to have community. We know how to build community. We know how to have a village. Unfortunately, when we leave that space and mingle with other people, like in the Americas, we can sometimes lose that. Culture gets watered down when you're not in it as much. Community is important in my work. As far as hope and faith, that's exactly what I'm trying to convey with the work. That despite all these things that happen, there's still a chance to be this quality human that I think we're all capable of being.

To what extent do you feel the need to reconnect to Haiti or the Haitian community as a member of the diaspora?

It's extremely important to connect. For me, it's simple. It's going to a Haitian party, doing some dancing; going to a Haitian restaurant or to a Haitian house party and speaking my language and trying to pass it on to my children. I purchased land in Haiti for me and my kids. Unfortunately, we can't build on it right now because of the state of the country. But I'm really thinking about as many ways as possible to stay connected to the country, to the culture, and to stay in the diaspora here, because I spent so much time out of the diaspora as a teenager. So now as an adult, I'm trying to make up for that.

I think that more of us in our generation are doing that: buying land and going back. There's a reverse migration movement, and a reconnecting to our roots there, too.

The diaspora is one thing, but it's important to go back home and sit with your people, see how their everyday lives are, see how they navigate things. For me, it's not enough to just wave the

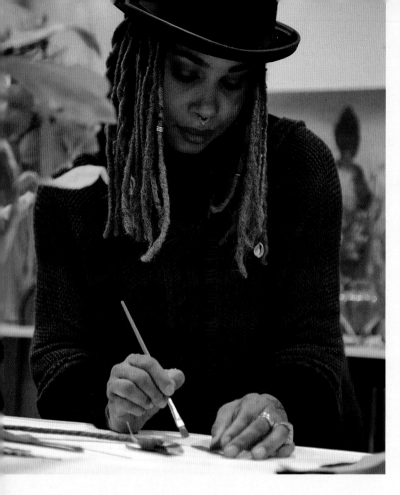

Haitian flag. It's not enough to just eat Haitian food. And Haitians are not going to let you get by with that anyway, because the first question they ask when they find out you're Haitian is "Do you speak Creole? When was the last time you went to Haiti?" There's always a Haitian test; they're always gauging your Haitianness. And I think we need to respond to that by going back.

That's why we bought the land in Haiti and took our children there. Because it's important for them to see how it is on the ground. How are people actually living? What is it like to not have running water and electricity for a large part of the day? And no paved roads to walk on. What is it like to have to hand-wash your clothes because you don't have a machine to do it for you? Those are things that, to me, solidify a connection to identity.

There is a significant Haitian community in Brooklyn. How has that informed or impacted your creativity or your professional goals and opportunities?

I was raised in a Haitian household, and for a long time, that was my community. It was just the family, because my mom was strict, and she wasn't letting my older sister, my younger brother, and me do a whole lot. And that taught me to be extremely

private and not really mingle with people. That carried on into my adulthood. So even though I live in Ditmas Park, which is considered Little Haiti, it was only about five years ago that I started really mingling with the Haitian diaspora. That was at the start of my career, so I don't know that being in the community itself has influenced the work, because I've always felt slightly different. I've always been kind of on the inside, but also on the outside looking in. And I've always approached my Haitianness in a different way than what I was used to seeing. There aren't many Haitian women who move and act like me.

Can you talk about how or whether your work closes the gap between art and design practice, or whether you would like to close that gap more?

I've honestly always seen art and design as one and the same. And design for me is also about functionality. How does it function? How is it going to function? Not just as a static or stagnant thing, when it's created, when it's done, but when I'm working with it, when I'm putting it on the human body.

How is it going to communicate with any other thing that I'm trying to make it communicate with? There's a part of my brain that has to have a kind of architect side to it, because of functionality, because of accessibility. How is the model going to get into the paper dress? Because I know I have to photograph it, and my viewers can't see the entry point. There are so many questions I have to answer in the creating process. Design is part of the equation right off the bat. And so I feel like there's not even a gap for me.

Thinking about the region as a space where we were forced to create a connection to the land, how do you see your relationship with the land itself? How do you connect to the ingenuity of the land in the context of forced diaspora? And since you use land-based materials, how is your use of materials speaking to concerns about land Indigeneity in the diaspora?

Being environmentally conscious in my practice is extremely important; I try my best not to use materials that are not going to break down. But on a spiritual level, I also chose to use paper because it was making a statement about the misconceptions that I believe exist when we're thinking about what represents fragility and what represents strength.

And paper was a great material to use in having that discussion. On the one hand, it's extremely fragile, and that's how we often see it. But we neglect or forget how strong it is and can be, and how much power it has. It can be a paper airplane, or currency—currency to buy human bodies, currency to divide communities, currency to make groups of people poor. And all the things

"I want to be remembered for how my work conveys a connection to spirituality."

that we know money used to do, where Black and brown lives are concerned. I needed to use paper to tell that story, those stories.

What preconceptions of Black womanhood are you seeking to address in your work? How does this reflect the message and role models in your family or ancestry, in your community, in your culture, and in the world outside of the Caribbean in the work of other artists?

One of the preconceptions that I'm always thinking about is softness. When I was picking up the camera and decided that I wanted to photograph just Black women, that was what I was thinking about because I didn't see that, aside from Black models like Naomi Campbell. It's not to say we weren't being shown, but softness is something entirely different—it's ease, joy, taking your time, claiming your time. That's part of the softness, the gentleness. Our culture doesn't teach us that because we're always supposed to be strong all the time. We're supposed to be hard; we're supposed to be resilient. We need to talk about how we can be more soft with ourselves, whatever that looks like.

What provocations about Black womanhood does your work offer to viewers? And what do you want them to feel, do, ask, or overcome when they encounter your work?

My mother's learning how to be soft with herself only now at seventy. It's inspired me to surround myself with women who think and believe in that as well. What I want to do with the work, the visual work, not just the sculptures but the prints, the photography, is encourage more women to question whether they're doing that for themselves and even more so, how it relates to their own sense of freedom. Because that's part of the softness, the gentleness; all those sweet things are part of a bigger thing for me. It's changing the way we define the word *freedom*. It is not just *not* being the oppressed. Freedom means being able to say, "I am an autonomous being who can do what I want to do, when I want to do it, in my joy."

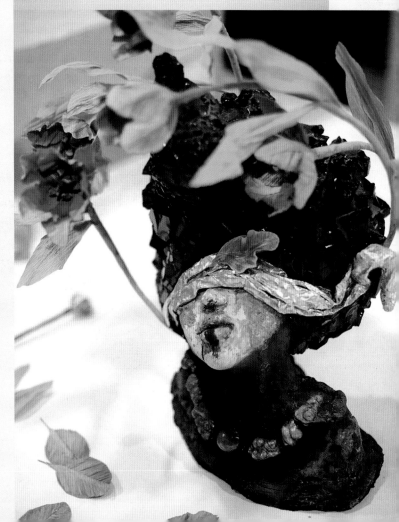

Firelei
BÁEZ

AN INTERDISCIPLINARY VISUAL ARTIST WHOSE WORK EXPLORES CULTURAL MEMORIES FROM ACROSS THE DIASPORA

My paintings, drawings, sculptures, and sound compositions are meant to contextualize the Caribbean within a global context. I center my experiences of landscape—the phenomenology of where I grew up, the sunlight, the moisture, the humidity. All the geospecific elements of my upbringing that nurtured me.

What did you make as a child before you even knew to call it art or design?

Wherever my sleeping area was would become a portal to some magic space. If I wanted to be a supergalactic being or a princess, I would transform the space with whatever materials I could find.

In the DR, there are these paper dolls called mariquitas, and I would realize everybody's vision of the perfect paper doll, because paper and pen are limitless in that sense. Anyone could have anything they desired: whatever gown, whatever outfit, whatever headdress. They would tell me, and I would draw it. Our paper dolls were a way to invent and just be fabulous.

Was there a moment in your career when you had to reinvent yourself or your practice because of an obstacle?

When I was going to school at the Cooper Union, I made a map that was meant to embody the balance between the Dominican Republic and Haiti, where I was on one side of the island doing steps for kompa and then on the other side of the island doing steps for bachata. All people had to do was put their feet on the steps and I would guide them through a certain movement, demonstrating two very similar ways to traverse that landscape . . . and that was like pulling teeth. The level of opposition to such a simple request was so intense. It's in these slow movements of translation, and by expanding the site of these limited spaces, that things change. In acts of self-translation.

I had moments at Cooper Union where there was a strong barrier to figurative art. I felt like I wasn't able to fully represent the people and places I love. Now, though, figurative Black bodies, Caribbean bodies, are more well-represented in the art world, and that's something my peers and I have been slowly pushing forward. Being able to see that is so rewarding.

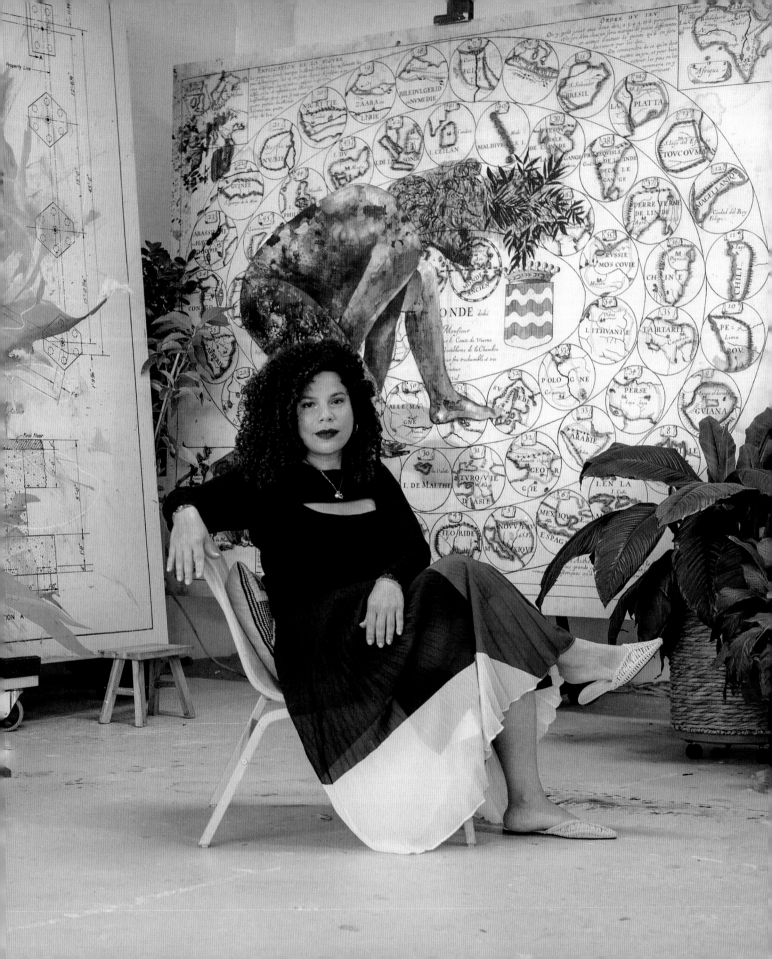

How have you crafted a kinship with the land, people, and culture of the Caribbean?

I try to center actual physical experiences in landscapes I create in my work. Sunlight in the Caribbean is source material for my use of color. Color theories expressed through Afro-diasporic religions throughout the Caribbean are embedded within my work.

I grew up in a town situated between mountains and the ocean, so I'm drawn to the experience of water evaporating between the two and the light diffusing. When I planned the mural for the MTA station on 163rd Street, that was the most important thing I wanted to capture, considering that that station is a nexus for people from the Dominican Republic and other Caribbean islands. I wanted to give that sense of light and landscape.

The mosaics were fabricated in Munich, Germany, and I wanted to make sure the manufacturer's notions of light wouldn't interfere with my vision. When I asked for a color sample, I found that they had this "Global North" sense of what's elegant or proper in regard to color, and that meant they had muted much of the work. I took specific color samples to Germany to say, "No, it has to be this tone. I know it doesn't feel right to you, but this is home. So try to be as geospecific as possible." If you go to the 163rd Street station and you go to the depths of four stories underground, you're going to still get that feeling of a sunrise or walking into your grandma's backyard and seeing the lushness. That comes through even in the depictions of bodies. The landscape is always embedded in the body.

What part of your Caribbean identity or art practice do you think speaks to what is needed in the world right now?

I always reference Carnival. There is the layering of language and the ability to reconcile both the joy and pain that are encoded within specific knowledge systems. My work featuring Carnival invites viewers to engage at their own pace. To know how to honor the ancestors, to honor all the different moments that propelled us forward as a whole, and that generate joy.

How has living in New York, which has a vibrant Caribbean community, informed or impacted your creative work or your professional goals and opportunities?

I did a show at the Caribbean Museum Center for the Arts, and that's the kind of space where I meet a lot of good friends and where I've had really good experiences, but I feel like the place where the Caribbean is really, really centered is the Schomburg Center, which was founded by a Puerto Rican person. There's a subsumption of Caribbean identity within the United States sometimes, where it feels like you have to choose camps—Latinx

or African American—like you have to almost relinquish the complexities of being everything in between. When I was invited to work with the Schomburg Center through the Studio Museum in Harlem, it was meaningful to see how they were working to divest themselves of binary definitions of identity.

I'm particularly interested in untangling—or maybe reweaving—how we close artificial spaces between art and design. How might we better honor or acknowledge the connections between art and design historically and ancestrally, when these two types of making practice were not separate?

Life and design are intertwined, and not in a commercial way. In the Caribbean, you're not going to have a store to help you figure out your home's identity or your design aesthetic. Instead, there is an ethos, an aesthetic that draws from ancestral experience. The aesthetics are so *lived*, and the lines between private and public spaces are more narrowly drawn and more interconnected. The corner store or the lottery booth and the home have a shared visual identity.

There's an archival quality to your work, drawing from experience and recorded history. What sources are you using to inform your work?

I access many archives, from those of the Schomburg Center to the Smithsonian Institution Archives and the David Rumsey Map Collection. I make a concerted effort to center the Caribbean within a global context, to look at materials from everywhere in the world. When I go to the Vatican Library, I don't say, "Give me all the papers you have on northern Haiti." I'll try to find everything that essentially could have led to a discourse about or reactions to that space. There's only so much that data can give. That's why you have to involve the senses and emotion and build a bridge. So my work is that bridge.

Is there anything else you'd like to share?

[*Laughs*] I'm sure there are a million things. That you have to be your own cheerleader, first and foremost. Even when you do something badly, you have to be like, "That's right. You did it; you tried that. You are on your path, and maybe this time it didn't work out, but the only option is to start again."

Creativity is exhausting, but we are limitless in our capacity for it. So just lean in to that and consider yourself a creative fountain. Live in a constant sense of abundance, of creative abundance, and know that you're inherently connected to a larger whole than you could ever have imagined.

Giana
DE DIER

A MIXED-MEDIA ARTIST WHOSE WORK EXAMINES THE HISTORY
SURROUNDING THE CONSTRUCTION OF THE PANAMA CANAL

My practice is a way to understand the motivations and intentions of those who came from the Caribbean to Panama during the construction of the canal, and a way for me to make peace with those things I do not understand because I have nobody from that time to speak to directly. It is a method of interpreting those stories, reimagining them in the now, and finding parallels between those experiences and my own in the present, understanding the place I inhabit as a Black woman in Panama and a descendant of Caribbean migrants.

What did you make as a child even before you knew to call it art or design?

I was always trying to make things. I have memories of sitting through some of those Bob Ross shows and thinking, "I wish I could do that," and trying to copy him. I tried making my own oil paints by mixing regular poster paints with vegetable oil, and I wanted to copy how Renaissance masters made paint with pigments, so I mixed chalk with egg to try to make tempera. I failed terribly. But it sparked my interest in art itself.

Was there a moment in your career when you had to reinvent yourself or your practice because of an obstacle?

Around the end of 2017, I felt a void in my work. I was making portraits using graphite mixed media, graphite ink, or graphite collage. I had all these ideas but not enough time or resources to execute them because it takes a while to finish a portrait in graphite. I was thirty-seven at the time, and felt I was old and the world was passing me by and everybody was having all these interesting experiences with their practices and showing their work outside of Panama. I felt like I was being left behind. I just sat with that for a while, thinking, "This is not working." I mean, it was good work, but it was not as good as I knew I can do. So I decided to forget about all these expectations and projects and showing the work. I took all these magazines and just started cutting them up and making collages. Then I started sharing them on Instagram. A curator contacted me, and that's how I was invited to exhibit for the first time in the Museum of Contemporary Art of Panama in 2018.

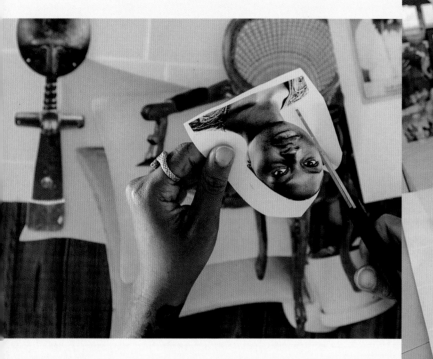

How have you crafted a kinship with the land, people, and culture of the Caribbean?

I've never been to the Caribbean itself. My connection is nostalgia through the stories I hear about my ancestors. I've created kinship through connections that my work has allowed me to make. Because I don't have that first-person account, I interpret what I've learned from family members, including through conversations with those who have passed away recently but whom I was able to speak with. And I meet people who are doing work or research around their own family connections to the Caribbean, which has helped me create a larger community through my work. I use my family's oral history and photo albums, as well as photo archives from Panama. Anything I can get my hands on, literally. I'm also using research from historians, particularly research done by women, such as Dr. Ariana Curtis.

The Caribbean is a small place that significantly impacts the world. What part of your Caribbean identity or art practice do you think speaks to what is needed in the world right now?

Learning as much as you can from your elders, and making sure the world knows that your people and practices exist. Understanding that the Dominican Republic is separate from Puerto Rico, which is separate from Jamaica. As Caribbeans, we speak as a whole, but also from our individual and very distinct religious practices, food, music, languages, culture, experiences, everything. That shows up in our art practices.

What feelings are you trying to evoke through your work, and what do you hope viewers will do as a result of their interactions with it?

Nostalgia. An understanding that there were Black laborers in Panama during the construction of the canal, who were here to start families and live happily. I want people to think about Black people in those situations, knowing that they have rights, like the right to live in freedom and joy.

What does community look like for you as a maker living and working in the diaspora?

Well, right now it looks like trying to build a community. There are not a lot of practicing Black artists in Panama. I would like to change that, to expand the community to see more Black artists showing their work in more spaces.

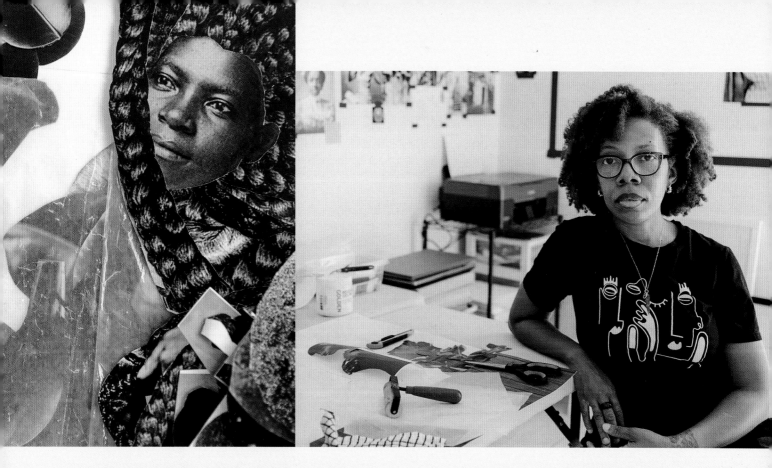

What provocations about Black womanhood or manhood does your work offer to viewers? What do you want them to feel, do, ask, or become when they encounter your work?

Currently, I'm thinking about Black women and labor. I'm subverting this view of the strong Black woman, this woman who can do everything and anything in the workforce while also taking care of children—her own and other people's. I'm trying to soften that idea and place her in spaces where she can be herself, explore leisure or rest, rather than act as a tool of capitalism. I don't really rest, so I'm living vicariously through my work right now. I want viewers to connect with that woman. To understand that she is deserving of leisure and the space to explore and be herself.

To what extent does your work engage with the feelings of both loss and gain in the experience of migration?

I'm trying to navigate that whole sense of leaving things behind and starting anew, and the sense of loss for what might have been left behind when people came from the Caribbean to Panama or Central America. There's loss, but also the feeling of gaining a community, because once they got here, they connected with other people from different islands. A whole different sense of Caribbeanness was created in Panama. It's a new Caribbean, in a way.

People found ways to connect with communities they were trying to assimilate with. There was a lot of negotiating with one another around language and rituals and food. Through my work, I've been trying to understand what it felt like to live in that time and deal with those things on a daily basis. I want us to remember and to continue the conversation, and to never forget where we came from.

"My connection is nostalgia through the stories I hear about my ancestors."

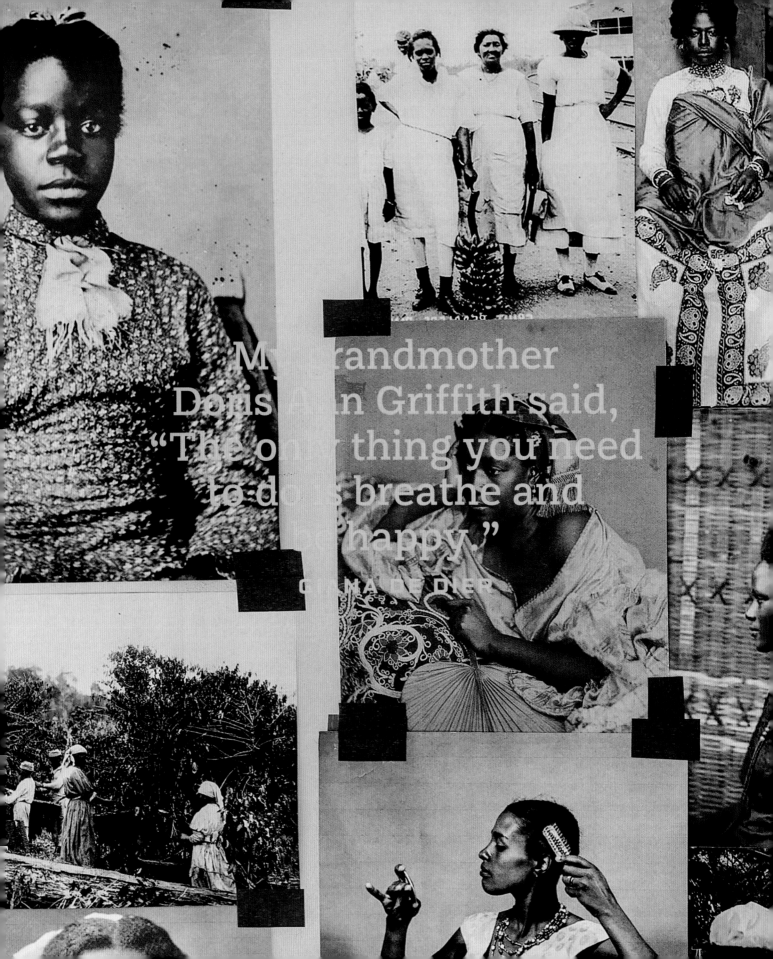

My grandmother
Doris Ann Griffith said,
"The only thing you need
to do is breathe and
be happy."

GAMA DE DIER

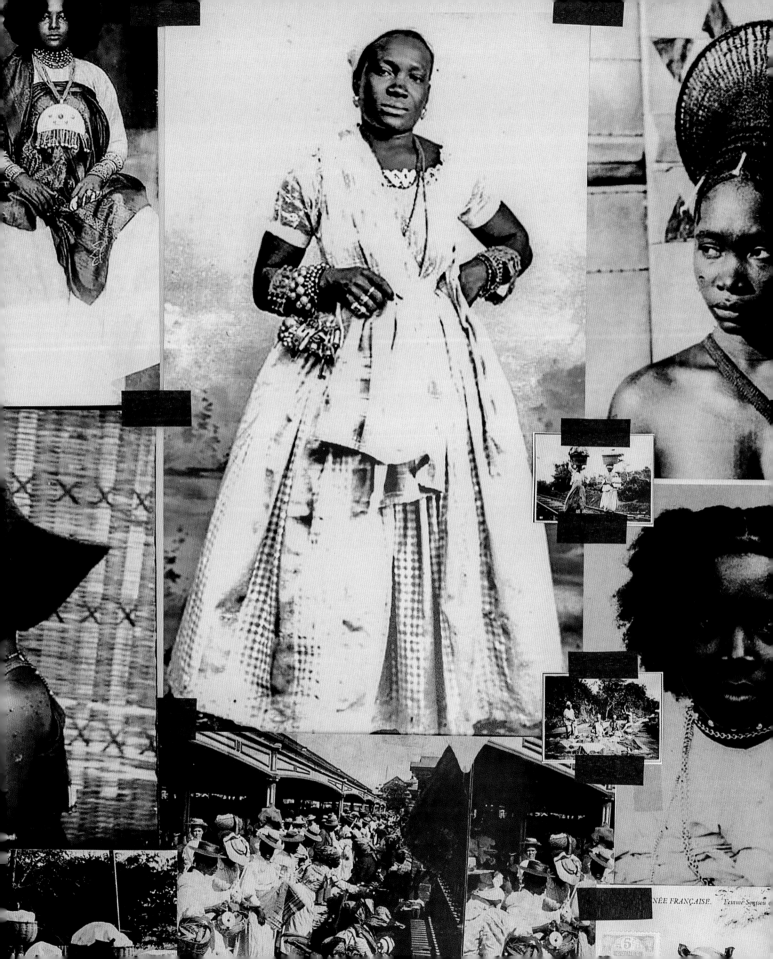

MATERIAL PRACTICES

OF CARIBBEAN ARTISTS
THROUGHOUT THE DIASPORA

BY CHRISTINE CHECINSKA

Look at any map and you will see that the Caribbean region sprawls, just like its impact does across the world. The Caribbean refuses to be contained. Wherever and whenever Caribbeans travel, we bring our histories, cultures, ancestral know-how, and artistic vocabulary with us. Not that there is a singular aesthetic or single point of origin for our creolized cultural expressions to return to. Rather there are connections, ties, a kinship with the land and culture that emerge through making and materials in the hands of the artists featured in this volume. There is a groundswell of creativity sweeping across the Caribbean and its global diasporas, whereby artists return—physically and metaphorically—to the region as a starting point for work that could be seen as a form of visual Nation Language, to borrow Barbadian poet and academic Kamau Brathwaite's term.

Nation Language is strongly tied to our West African ancestry and our natural environment. In its rhythms, timbre, and sound explosions, it resists the language of the colonizer, peppering it, distorting it with traces of Yoruba, for example. It actively invokes ancestral knowing, experiences, signs, and symbols in its expressiveness. It does not follow the pentameter, since, as Braithwaite wrote, "the hurricane does not roar in pentameters." So the act of speaking becomes a form of reclamation. The same is true for the artists' work, where material practices embrace the storytelling potential of coffee, cocoa, sugar, indigo, wood, salt, clay, water, hair, and linen to explore identity, critique misrepresentation, and call into being a future in which we and our land,

spiritualities, and philosophies thrive. In taking up these materials, the artists simultaneously activate and subvert histories of enslavement and colonization.

Certain artists proactively engage with ancestral practices and ways of knowing, becoming conduits, or griots, reconnecting us to nearly forgotten and fragmented pasts. Aspects of folklore, myth, spirituality, and ritual are creatively reconfigured. Charmaine Watkiss, for example, places herself inside mythical worlds that honor the herbal healing traditions of Caribbean women, which she renders in delicate pencil lines. Katrina Coombs's fiber forms incorporate cowrie shells, mirrors, beads, and semiprecious stones to express ideas springing forth from an imagined maternal figure. There is a connection here with Fabiola Jean-Louis's ongoing meditation on the cycle of life and death.

Regarding method, there is a revalorization of traditional craft-making techniques alongside a "bricoleur" approach, giving rise to a combinatorial aesthetic, and a strategic use of everyday things, or whatever is at hand, to make work. Alvaro Barrington, for example, deploys materials and techniques like burlap, concrete, cardboard, and stitching in his practice. Cosmo Whyte used a chain curtain often found in homes as a backdrop on which to project images of the 1981 Brixton riots; in an instant, the domestic becomes political. Similarly, emerging designer Rachel Scott takes the starched crochet doilies usually found in our mothers' and grandmothers' front rooms to make ready-to-wear fashion, proudly presenting a nuanced and sensual Caribbean style that is rooted in a connection to land and culture. Through her practice, Scott redefines sustainability, moving it beyond a concern with materials to consider a nonexploitative approach that puts people and traditional Jamaican artisanry first. This is an approach repeated across the islands. Sonya Clark's use of everyday objects such as pocket combs, coins, human hair, and dollar bills is inspired. But it is her method—the fraying, weaving, splicing, piecing—that becomes a way of suturing fragmented Caribbean histories.

Artists from the Caribbean engage in practices that are multifaceted in range and diverse in scope. But there are connections. Each embraces new modes of expression that reflect creolized and diasporic identities that emerge from movement and migration, enforced or otherwise, historic or contemporary. The materials and methods of choice culminate in practices that are akin to Nation Language, practices that center numerous and varied notions of what it is to be Caribbean and in so doing articulate particular understandings of the world.

Dr. Christine Checinska is the inaugural senior curator of African and Diaspora Textiles and Fashion at the Victoria and Albert Museum (V&A) in London. She was lead curator of the V&A touring exhibition Africa Fashion *in 2022 and the exhibit* Between Two Worlds *in 2023. In 2016 she delivered the TEDx Talk "Disobedient Dress."*

ibiyanɛ
ELODIE DÉROND +
TANIA DOUMBE FINES

A FURNITURE DESIGN STUDIO WHOSE PRACTICE
DRAWS ON MEMORY, SPIRITUALITY, AND INTIMACY

As soon as we started creating together, the word *conversation* resonated with us. It encapsulated not only the exchanges we had with each other but also the revelations we had after discussions with inspiring friends or former strangers. At the crossroads of our humanities, there was art, intimacy, and intentionality; each piece resolves itself in a form of documentation of that, based on research, memory, the within, and the other.

What did you make as children before you even knew to call it art or design?

Tania Doumbe Fines: As a kid, I used to assemble and/or build games with what I could find in nature or around, to play with my cousins. I've always been the kind to look for solutions or resources in anything.

Elodie Dérond: I honestly don't remember making anything. I asked my dad, and he doesn't either. I would just draw/paint, if that counts?

Was there a moment in your career when you had to reinvent yourselves or your practice because of an obstacle?

We feel like we've been blessed to always approach our creation with honesty, and let it be and become what it needs to, alongside our personal and professional growth.

How have you crafted a kinship with the land, people, and culture of the Caribbean?

Elodie: I was born and raised in Martinique, and before I left to study in Montreal, that was all I knew. Leaving brought me closer to my island; I couldn't find anything in Canada to relate to like I do my people and our culture.

Tania: I've received a lot of love and support from everyone I have met since I've been living here in Martinique. On a personal and professional level, and from the land itself. The similarities it has with my native country, Cameroon, are also touching, reassuring, and enriching. Martinique is home now.

In this interview, Elodie and Tania sometimes speak individually and other times speak with one voice as ibiyanɛ.

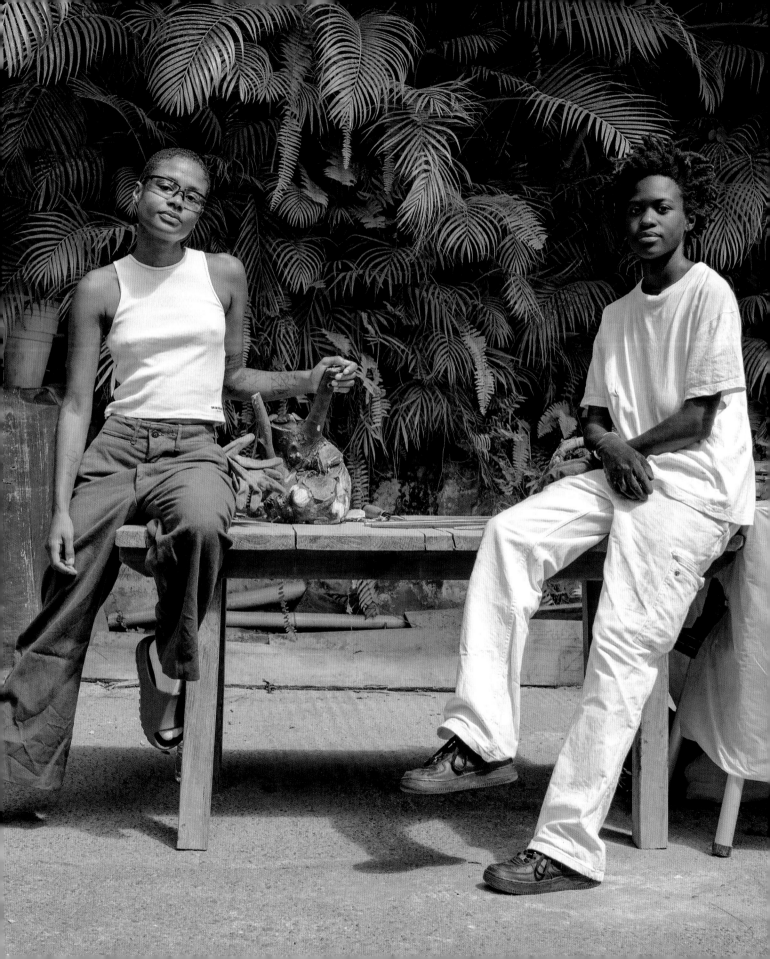

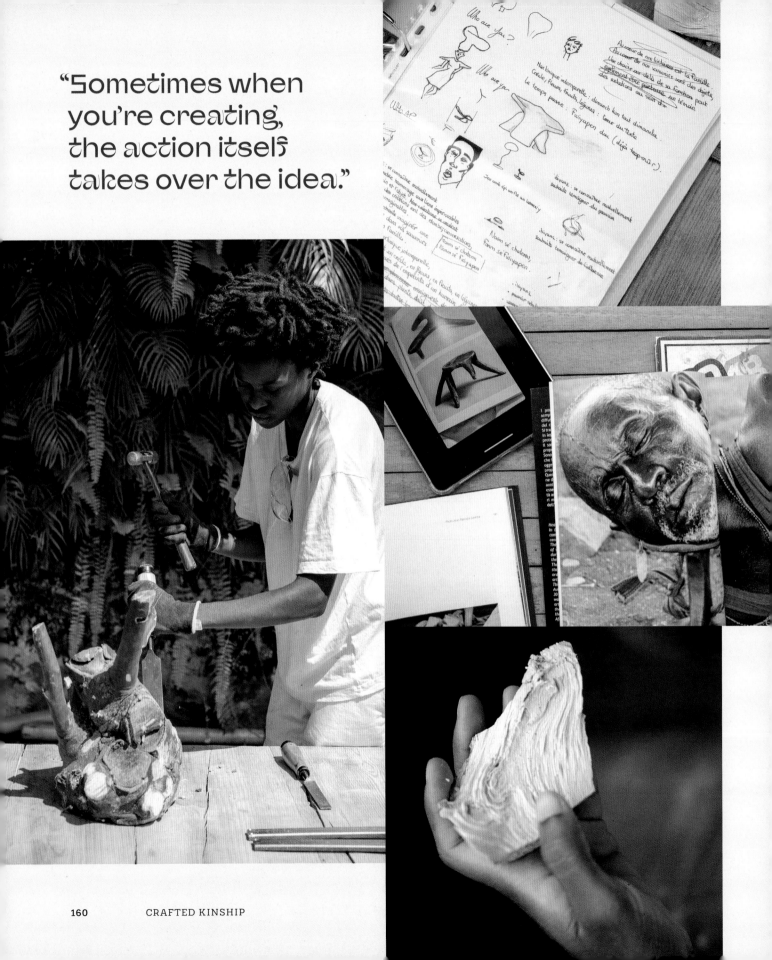

"Sometimes when you're creating, the action itself takes over the idea."

The Caribbean is a small place that significantly impacts the world. What part of your Caribbean identity or art practice do you think speaks to what is needed in the world right now?

We feel that we bring, from our respective cultures, values of community, openness, and a different sensibility in regard to beauty, comfort, being, and pace; as well as the consciousness of wanting to create spaces and communities that are liberated, safe, and nourishing for all.

How has your work sought to expand the view of non-Caribbean Black identity and culture?

As we as a duo come from both the Caribbean and Africa, a lot of elements from our backgrounds align, even as we expand our own views through learning about each other and experiencing things together. ibiyanɛ wishes to enrich the continuum of definitions and components of what it means to be Afro-descendant.

Can you talk about the collaborations you've entered into with partners and community members?

ibiyanɛ, by name alone ("to know one another" in Batanga), is about collaboration, giving and receiving simultaneously. ibiyanɛ was born out of and grew with community, from Venessa Appiah, who commissioned our first works, to our friend Pascale Chroné and Elodie's parents, who always welcome us working wood in a shared space, to the many creators we're very excited to build alongside of. Settling in Martinique, we met and have been welcomed and warmly assisted by local carpenter Jules Pognon. He has been a mentor and teacher to us. We collaborated with him in the making of our latest pieces, absorbing as apprentices how he approaches woodworking with his own innovative techniques, which he learned over years in the field.

Can you talk about how or whether your work closes the gap between art and design practice, or whether you would like to close that gap more?

Art, to us, always holds a function; design is somehow inherently beautiful and a vector of emotional power, by purpose only. It starts with an intention. With that sentiment, we don't make a distinction between the two in our practice; they simply take the space they need to occupy in every piece. Tania's background in interior design and Elodie's in fine art obviously influence the output, but we are removing ourselves from preconceived notions of both terms and simply create what we feel is true to us and our sensibilities.

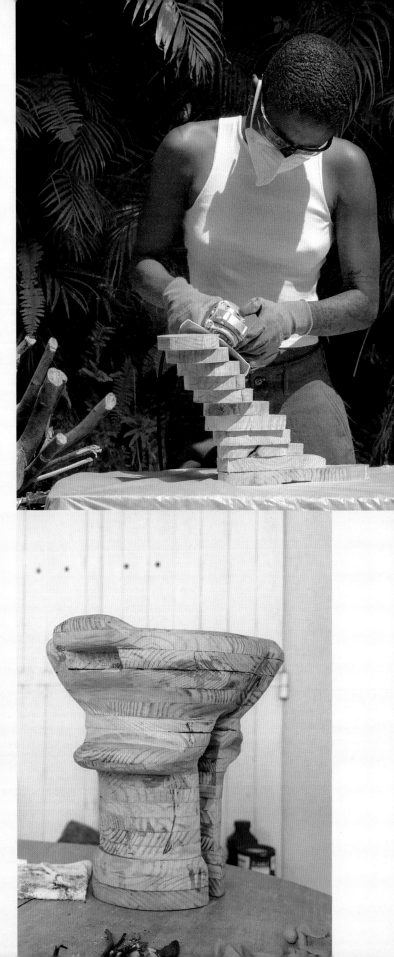

Does your work reflect your personal memories or, more broadly, the idea of memory as a form or material of art-making?

Our 2021 *Alè* collection is an homage to the unfading ties between human and object through the memories that the latter holds. We made an African stool that Tania was remembering from Cameroon, a rocking chair, or dodin in creole—Elodie's grandmothers each had one in their home—and a Martinican Ti ban, a seat that populates the homes on the island and serves many purposes.

Alè means "then" in Martinican creole and "now" in Guadeloupean creole; it was a beautiful way for us to connect the past and the present and to remind ourselves that the memories we cherish—like of a grandmother in her dodin, doing her hair, watching her favorite show that she never misses on TV—transcend time.

What does cultural memory mean to diasporic people or in the context of Black Caribbeanness?

Elodie: There's nothing I love more than to see Martinicans come together as one. Our cultural memory to me isn't just confined to museums and books but is alive. It's everything I love about us, every motion. It's creole, Carnival, bélé. It is talked, sung, danced, eaten, deconstructed, nurtured, evolving. It is the resilience of our ancestors. Through our culture, we engage with the past, present, and future, and still yearn for more.

To what extent does the theme of memory evoke specific feelings: joy, pain, longing, anger?

Memory to us is comfort and intimacy. It is scary to know how fragile it is; it is scary to forget. Do we genuinely progress as we fail to remember?

What are some of the sources you consult in your search for memories, or in your discovery of new memories?

Tania: Our connection to the human within and outside ourselves is at the core of our experience of life.

Elodie: I learn a lot through my cousin Karine. She's very curious about and connected to our heritage, collective and familial. At family reunions, she's the one to ask questions, guiding our parents to unveil more about our ancestors. She's also a creole teacher and someone I relate to on a very intuitive level. I'd say she embodies in that sense my family as the best source for memories. The intimate spaces that build themselves when we reunite hold cultural memories in the food we make and eat together, the stories we recall, the music we play, and what we know about it.

This is where the transmission happens. This is where I hear creole the most, and I savor it. A precious example would be Christmas. Growing up, we would spend Christmas Eve at my maternal grandparents', and we would do a "chanté Nwel." It's a Martinican tradition; they're happening everywhere from late October to December 24 and remain relevant through generations. We would play the tanbou bélé, tibwa (that was my thing), and chacha and dance and sing songs from the same little green book; sometimes everybody would remember a different version. My grandparents' home holds cultural memory.

Tania: I wholeheartedly relate to this as someone who grew up in Kribi, Cameroon; my family and the places where we celebrate carry the cultural memory that survives until it's transmitted again.

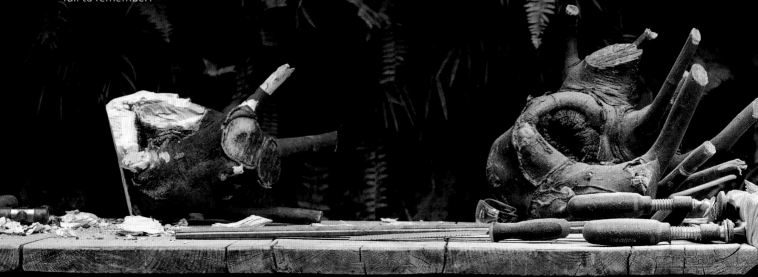

Elodie: That home that I talked about is uninhabited now that my grandparents are deceased. Everything remains the same inside: the furniture, pictures, everything is still there. Being there for the first time without them made us think about why we could still feel them in every room, in everything they owned and used, in that dodin, in the way my grandmother would do her hair. The inspiration for *Alè* was softly born from that place.

What facets of spirituality are most present or potent in your work? Do you see the act of making as a spiritual or sacred practice?

Both of us nurture our spirituality through intentionality, mindfulness, and surrender. We expect to give a lot of care to our process and to ourselves in the process of creation. That includes being patient with ourselves, trusting intuitively that continuously researching, documenting, witnessing will cause something to bloom in due time.

Also, leaving space for anything to be; we embrace the accident that became revelation, the boredom that led to another direction. Sometimes when you're creating, the action itself takes over the idea, and it applies to sculpting because we don't outline the forms. We just follow either a general idea or the flow that our structure revealed in the wood and trust the motion.

That's a reason why the first time we were commissioned to re-create a piece, *elombe 011*, which is quite complex and vaguely symmetrical, we had a hard time, mentally, handling

the constraint of sameness. For transdisciplinary artists, navigating in music and visual art as well as design, the act of making cannot be devoid of spirituality; it can be understood as a form of meditation, stillness, travel.

Does your work channel a particular diasporic and/or ancestral spirituality into the present?

We believe in extending perspectives on the way we occupy the world, exploring the values and sensibilities of Afro-descendant lineage and Black Atlantic communities we learn about. We recognize that the way living is approached resounds in the objects designed. A headrest, for example, can tell a lot about culture. In channeling, repeating, and revisiting practices and objects, our intent is to navigate between materiality and immateriality. Recently, we've been interested in the conscious use of fractal geometry in traditional African settlements.

How legible do you want your spiritual expression to be for "outsiders"?

We feel transparent and communicative enough for our expression to be understood by anyone who has the will to understand it. The materiality of our creations is not confined to necessity. Hopefully whoever encounters one of our pieces will emotionally grasp some or a good part of what it was intended to be. We trust that the thought and manual processes resonate in the piece, like conscious recollection.

Ishka Designs

ANISHKA CLARKE + NIYA BASCOM

AN INTERIOR DESIGN STUDIO THAT HONORS LOCAL INFLUENCES AND SUSTAINABLE PRACTICES

Our interior design firm is based in Brooklyn, New York, but we work globally, wherever the projects take us.

What's your approach to your shared practice?

Anishka Clarke: Our approach to design is formed from a shared, endemic history. I was born in Jamaica, and Niya was born in England to Caribbean parents—his mom is Jamaican, and his dad is Guyanese. My mom is Guyanese, and my dad is Jamaican, so we've connected through this interesting mix of Caribbean and South American influences.

Ending up in Brooklyn has brought a lot of cultural elements together to help inform the way we operate within the company itself. They've led us to a level of appreciation for nature and the environment, and an effort to be as sustainable as possible. We're focused on a very edited, pared-down design perspective, so we lean toward minimalism, but that's something we define culturally more than by the book.

Niya Bascom: We come from humble upbringings, and that humbleness also takes precedence in our design: minimal but full of life. A lot of our clients have the means to buy the best of the best, but sometimes we say, "You don't need everything to be the best of the best. You can use a pared-down design solution to allow a few celebrated objects to shine." Less is typically more for us, and that approach has created strong relationships with our clients because they see that we're not trying to spend every red cent on the frivolous and unnecessary. That comes from our upbringing.

We look at a project as a problem to solve, and that problem may not be solved by what's available in the marketplace. Or maybe the project's limitations prevent us

In this interview, Anishka and Niya sometimes speak individually and other times speak with one voice as Ishka Designs.

from going to the marketplace to solve that problem. So we've always leaned in to not having any fear about being individualistic and bringing our own unique design objects to a project. We've designed a sink; we've designed lighting, textiles, and rugs, to name a few. At the end of the day, we explore; we're adventurous. I think that is inherent in the way Caribbean people operate.

What did you make as children before you even knew to call it art or design?

Niya: I used to make everything. My father was a builder, so I've always been around building, and a creative spirit has always been within me. I didn't grow up with Toys "R" Us, so we created our own toys, making cars, trucks, airplanes.

Anishka: I used to do everything creative that I could get my hands on. When I got to high school, I made bags for myself because I couldn't stand the ones I had and couldn't afford fancy ones, so I created something different for myself. I also sold them to my classmates. And I used to design clothes and have the dressmaker make them. At the time, I lived in Jamaica, and we didn't necessarily have access to a wide range of shopping, so if I saw something or thought of something unique, I would sketch it and send it to the dressmaker, who would make it for half the price.

Was there a moment in your career when you had to reinvent yourselves or your practice because of an obstacle?

Anishka: Maybe it's not a reinvention. It's been more of a digging deeper into our souls to pull out who we are to be in a position to express ourselves freely and happily every day by doing what we do and being who we are right now. When I was working in finance, there was a reason why I was there. There was a purpose. I grew, I learned, I got to New York because of finance. So that's a beautiful thing. However, I don't think it was my destiny, and I'm thankful that I met Niya and had the courage to switch gears to interior design. I was just coming into my own as an artist and a designer. I've never looked back.

How have you crafted a kinship with the land, people, and culture of the Caribbean?

Anishka: Jamaica translates to "the land of wood and water," and at least one of those elements is a constant in our designs. I don't know if I'm necessarily thinking, "Oh, this is because of my Caribbean upbringing" when I'm working. Wood is a material and a resource that I see as beautiful, functional, practical—as strength. We're not producing something that is easily identifiable as Caribbean, but we gravitate toward this particular material, which I think represents the kinship that is ever-present throughout our work.

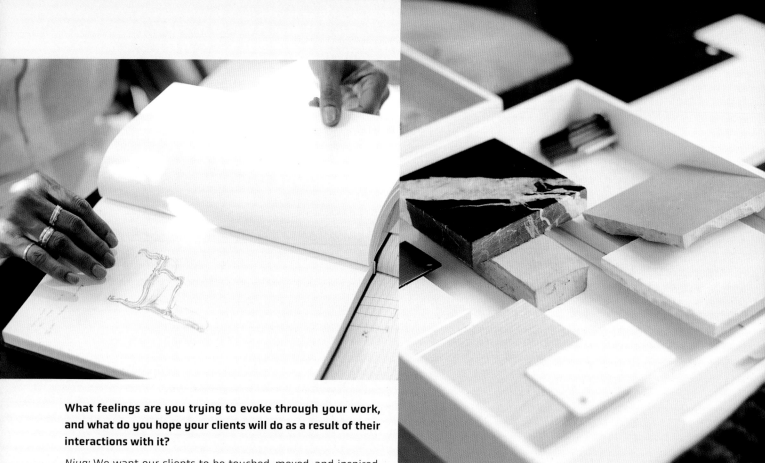

What feelings are you trying to evoke through your work, and what do you hope your clients will do as a result of their interactions with it?

Niya: We want our clients to be touched, moved, and inspired. We want them to fall in love with their environments. And we're trying to create a synergy, a place of warmth, a place of happiness, a place of kindness.

Brooklyn has a large, vibrant Caribbean community. How has that informed or impacted your creative work or your professional goals and opportunities?

Anishka: When we first started, we leaned in to our Caribbean network, which included tradespeople, millworkers, and other skilled artisans. Because of that, we got early recognition for our work from the Caribbean community and from our Brooklyn community. People were proud of another Caribbean person doing something really well and were happy to help lift that boat. So I definitely think that in addition to providing resources, our community helped to support us by virtue of talking about us and celebrating us and recognizing the work that we were doing until finally it expanded beyond the boundaries of that.

Can you talk about how or whether your work closes the gap between art and design practice, or whether you would like to close that gap more?

Anishka: Our work inherently involves both art and design. We're designing spatial environments, but art is an intrinsic part of that. If you look at the background of Niya's studio via Zoom, all you see is art. But it's not even just about fine art, like paintings or sculpture. We also value the artisans, like Malene Barnett, who are not just creating generic products but are making beautiful, artistic design. We love to connect with artists and artisans to help us realize the spaces we are designing. A project that doesn't involve our own custom work that is uniquely designed for that environment is now impossible for us. The art of design and the art itself go hand in hand.

What stories are you seeking to tell about colonial histories in the Caribbean?

Anishka: A few years ago, Niya and I had the idea to create a hospitality space or destination experience that reflected Ishka Designs' philosophy and our story.

We conceived of it as a community project in which everything—all the furnishings, fittings, and décor—would be designed by us and built by people in that community, ideally in Jamaica or on another Caribbean island. Part of the impetus for it was our growing realization of the fact that hospitality spaces lauded as beautiful, respected, and adored in the Caribbean all reflected a very colonial influence.

I've always felt like we, in the Caribbean, have not fully expressed, from an architectural design perspective, what we could have been if we hadn't been colonized. What if we had designed the homes around the environment that we live in versus emulating a style that is not particularly conducive to the region? Edna Manley College for the Visual and Performing Arts is a great example of architecture designed for the local environment—utilizing shade and sun positioning, breezeways and breeze-blocks, which is less about a European aesthetic and more about how the regional climate conditions influence the building language.

The goal is to build with the clay and the earth and the other materials that we have at our disposal to create the architecture that is necessary to support the environment, support the climate, support the health of the people, support the talent and the skill set of the people as opposed to relying on something that is foreign to us, or that has been forced upon us.

What facets of your identities are most prominent in your work?

Niya: I think it's important for African and Caribbean people to incorporate their identity into any- and everything they do. For example, my house was built in the 1800s by the Dutch. But when you come into my home, you know it is the home of a Caribbean man. My presence is here. It's on and within the walls. It's important for us to find ourselves within design, within art, within everything we do, because that's who we are. That is our strength. It can also be our weakness as far as the industry is concerned, because we're basically not bowing to the rules and regulations of an industry that hasn't represented us or honored our voices.

Anishka: Our identities are reflected in the materiality, too. We have to be able to see ourselves in these projects, culturally or spiritually. We're written all throughout those environments we've designed. I wouldn't work any other way.

Jasmine
THOMAS-GIRVAN

A MULTIMEDIA ARTIST AND SCULPTOR WHO INVESTIGATES CARIBBEAN HISTORIES AND ALTERNATIVE NARRATIVES

My work is an ongoing examination of the human condition through the lens of history, culture, folklore, and ecology.

What did you make as a child before you even knew to call it art or design?

I created imaginary worlds with my dolls using scraps from my mother's sewing. My stage was a vast green space that was our backyard.

Was there a moment in your career when you had to reinvent yourself or your practice because of an obstacle?

When I first graduated from Parsons and moved back to Jamaica, I started a family. There was no internet or FedEx, so I had to do everything the old-fashioned way, creating and shipping the work. In the fashion industry, there are seven seasons, and for every season you have to create new work. I basically had to learn the word *no*. I was a slave to that system because of its whims and fancies, and it was very precarious. Sourcing materials, just generally, was not ideal. Because it was so difficult, I decided to not continue to engage with that system and to focus more on creating work for my community, for galleries in Jamaica. This was an important turning point because I just abandoned the idea of relying on external markets and focused more on my immediate locale.

How have you crafted a kinship with the land, people, and culture of the Caribbean?

For me, crafting kinship begins with being curious and present. I always tap into my immediate surroundings. I'm open to things that arrive unexpectedly and I use materials that resonate within each specific location.

The Caribbean is a small place that significantly impacts the world. What part of your Caribbean identity or art practice do you think speaks to what is needed in the world right now?

Last night I went to the traditional Mas competition here on Trinidad. The participants integrate many seemingly disparate cultural heritages into an act of communal joy. What struck me the most was how the costumes reflected passionate guardianship of Carnival traditions, both in concept and crafting. People on the stage—which in Carnival is the street—craft their own costumes. They don't buy them, and so their offerings are lovingly embedded with the history of the masquerade. I saw elders of seventy, eighty, ninety years old performing with tremendous pride, wearing

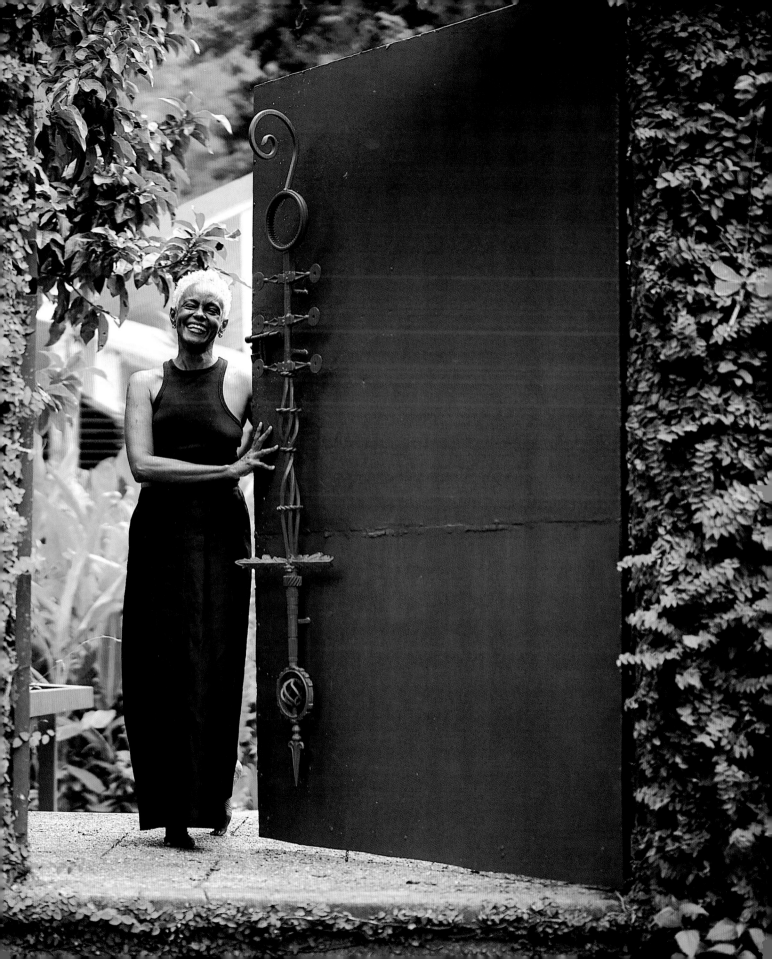

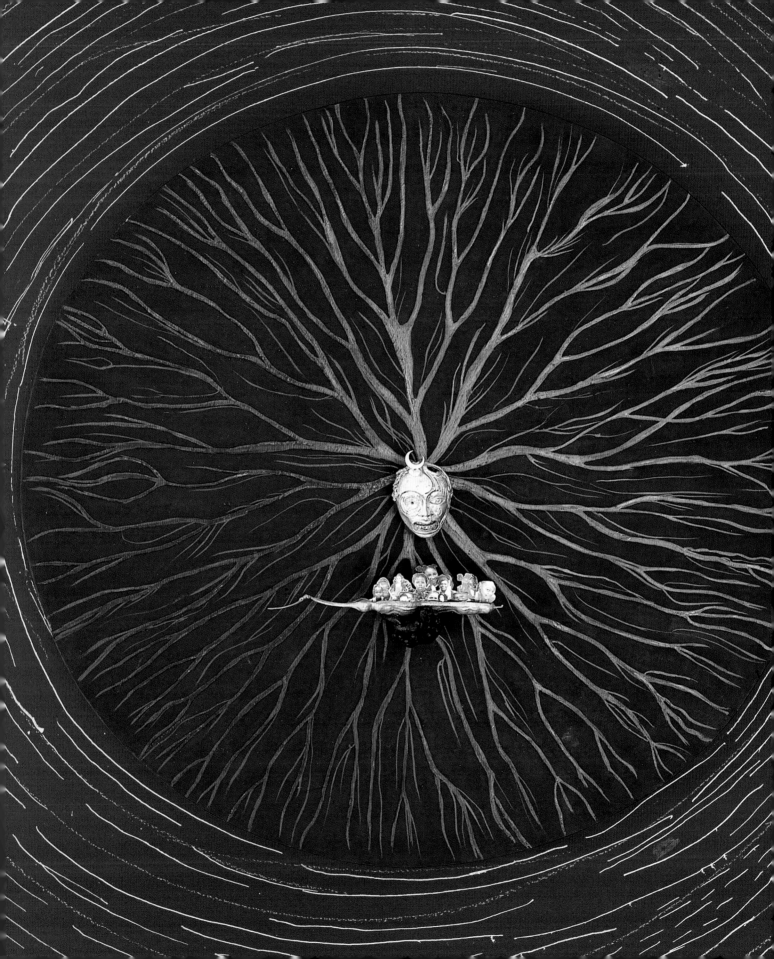

costumes that harken back to the genesis of Carnival—retaining the spirit of resilience, rebellion, and marronage. This practice reinforces the subversive power of community through ritual and the renegade practice of making as a form of healing. The participants are invested in the power of the imagination. Right now, the world is all about beautifully polished consumer items that are transactional. Joy is tethered to commerce. Traditional Carnival is the complete opposite of that. In this restorative theater, the performers and audience recognize the mutual benefit of this therapeutic vibe. As we say in Jamaica, "One han' can't clap." We need each other to thrive.

What feelings are you trying to evoke through your work, and what do you hope viewers will do as a result of their interactions with it?

I regard my works as triggers of experience or reflection. They often require the viewer to engage actively in order to appreciate the details. One has to bend or walk around the object. My hope is that the viewers will see themselves in the stories reflected in the pieces and enter into a wholesome understanding of their relationship with ancient futures.

What does community look like for you as a maker living and working in the diaspora?

It's an extension of what we've learned since we were children: to extend ourselves to the community by creating safe spaces around shared values. I do that through opening up my home to artists, and to other people who are on the same vibe. We are nourished by conversation, music, and good food!

Can you talk about how or whether your work closes the gap between art and design practice, or whether you would like to close that gap more?

When you are schooled in the North American system, it's all about product—a thing in and of itself. Traditionally here, objects were made to commune with, for the community, to be used. There were fewer things, fewer objects, but each one was revered and had a spiritual significance. When I create my work, I focus on value. When I say "focus," it's not in a structured way. I mean that the products I make draw from all the information I absorb when I encounter a particular material. It has a life of its own. When I create things, I think in terms of an object that adorns space and infuses it with a particular spirit. It's not inanimate; it's living and breathing.

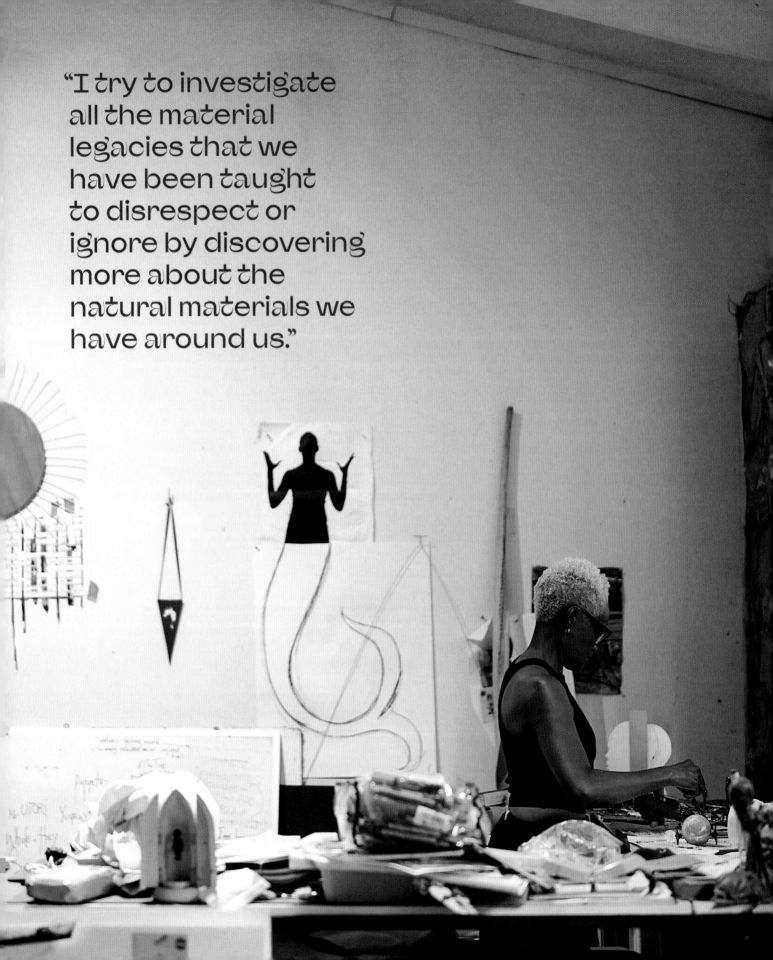

"I try to investigate all the material legacies that we have been taught to disrespect or ignore by discovering more about the natural materials we have around us."

What making practices have been passed down through generations in your family?

I try to investigate all the material legacies that we have been taught to disrespect or ignore by discovering more about the natural materials we have around us. There has been so much concern about the environment and global warming, but we are not sufficiently modifying the materials being used. To revisit these ancestral materials and the way they're utilized in harmony with nature and the environment is very important to me. It's a challenge that I love, because a lot of these materials and the ancestral knowledge about them are lost.

Which materials are you most connected to?

At the moment, I'm working with calabash. I'm discovering more about how to harvest it and embellish it. And I've been using seeds, palm fronds, unusual wood formations, and bird feathers.

Do you consider any materials sacred?

All natural materials are sacred and have a vibration beyond our understanding. They should be harvested in an ethical and respectful way.

I'm very proud of having been trained in traditional practices. The first part of my career was focused on perfecting European techniques, but then I decided to investigate things that were closer to me, materially, spiritually, geographically. I think what I have done effectively is blend those two worlds harmoniously in objects. I don't feel that you have to completely discard or disregard the European training and materials. It's not either/or. The fusion of cultures and practices creates a narrative that reflects the hybridity of the Caribbean. It's an amalgamation, which is reflected in the materials and in the imagery.

My work is sharing those subsumed histories, and allowing them to breathe and thrive. That is what really energizes me—finding through research and an uncomplicated engagement with the material and the environment other narratives and stories that have not been given prominence but are so resonant and powerful and so much a part of who we are. In doing so, I celebrate the resilience of our culture and our people.

Is there anything else you'd like to share?

I think it's best said by Federico García Lorca: "The poem, the song, the picture, is only water drawn from the well of the people, and it should be given back to them in a cup of beauty so that they may drink—and in drinking understand themselves." Beyond that, be true to the yearnings of your heart. If you believe in what you are doing, do not let anyone or anything deter you from it.

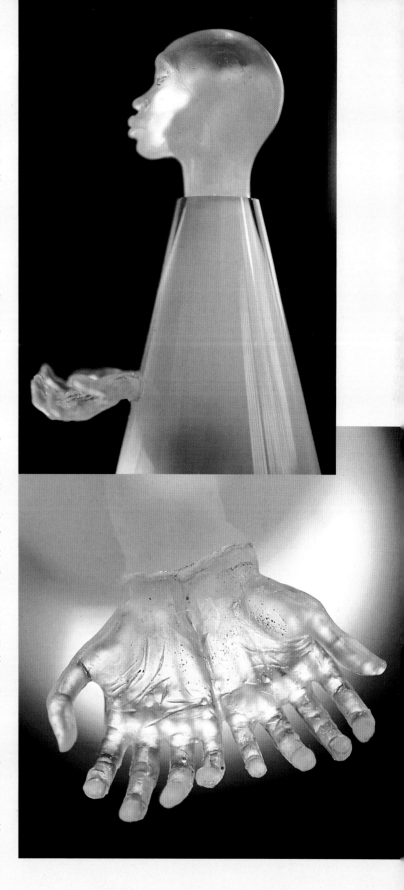

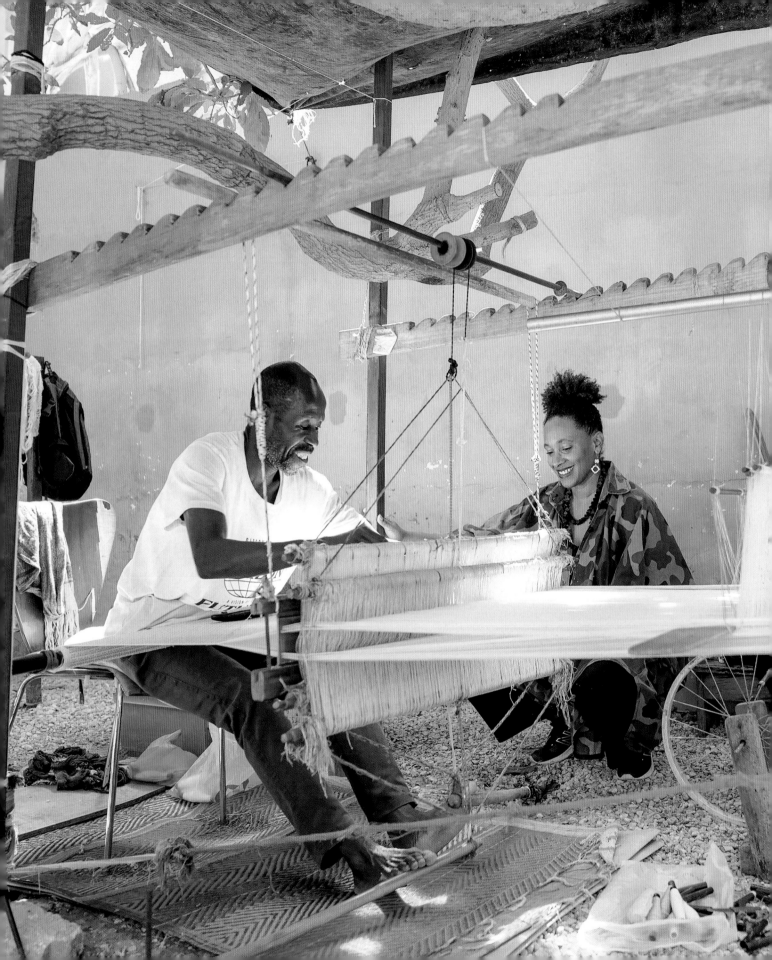

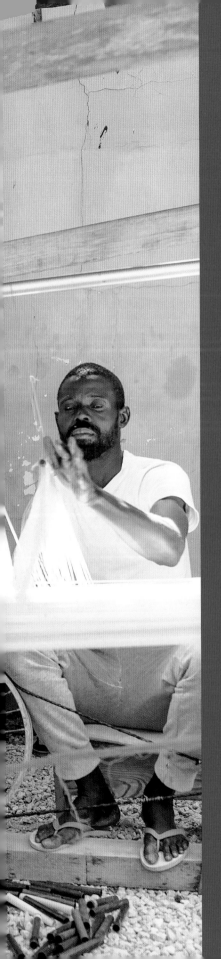

DOMINICA, MONTSERRAT + GUADELOUPE
⥾ SENEGAL

Johanna
BRAMBLE

A WEAVER DRIVEN TO TELL THE TRUTH THROUGH THREAD

Textiles and weaving are universal languages deeply connected to humanity. Weaving as metaphor is also about weaving links between cultures.

What did you make as a child before you even knew to call it art or design?

I did not really make things with my hands, but connecting my soul to nature was very important to me as a child, and it's still very important in my practice.

Was there a moment in your career when you had to reinvent yourself or your practice because of an obstacle?

I had been doing interior design for more than fifteen years when I had the chance to show my weaving internationally in both solo and group exhibitions. I participated in the Congo Biennale in Kinshasa in 2022 as well as the "Off" of the Dakar Biennale in Senegal. My work has been presented in French institutions such as the Bargoin Museum in Clermont-Ferrand and the Muséum d'Histoire Naturelle in Le Havre and at the Institut für Auslandsbeziehungen Gallery in Berlin, Germany.

I saw the impact that weaving can have on people and decided that I wanted to focus more on my weaving art practice. Weaving is a way of being. It's telling the story of our ancestors. When people show me their weaving, I can feel their emotion. The practice reveals things that they may have forgotten for years but that they reconnected to through weaving. My studio produces commercial products, but we are also doing artwork, and I'm thinking of leaving products and concentrating on art. This is a challenging moment.

How have you crafted a kinship with the land, people, and culture of the Caribbean?

The story of the Manjak people is strongly linked to the Caribbean. It's not the same story, but the connection is very similar due to colonialism. The Portuguese colonized Guinea-Bissau, which is where the Manjak had been for generations, but during the colonial period, a community of Manjak people migrated to Senegal. That movement and the mixing of cultures created a similar cultural expression that you see in the Caribbean, with the creole language and even the fact that the Manjak people have Caribbean-style music. The Manjak people have a deep tradition of weaving, which is passed along from father to son.

What feelings are you trying to evoke through your work, and what do you hope viewers will do as a result of their interactions with it?

Weaving has this power to reconnect people to their subconscious—to a feeling that they had forgotten, to long-lost memories. Through my work, I try to facilitate the connections people may wish to recapture with their innocence, their childhood.

What does community look like for you as a maker living and working in the diaspora?

I've been working between Senegal and Côte d'Ivoire, where there are a lot of Caribbean people, and a lot of mixed Caribbean-Senegalese and mixed Caribbean-Ivorian people. We connect around food. It's amazing how happy we are to share and reconnect with the fruits and vegetables that are not used here in the same way as they are in the Caribbean. Young Caribbean people are coming to work in Côte d'Ivoire, and I have a cousin in Guadeloupe who has a radio station to share experiences between Caribbean people coming to Africa and African people going to the Caribbean. The links are deep.

Are Caribbean people coming to Senegal primarily from the French-speaking islands? Or do you also find people from the English-speaking ones?

Most Caribbean people here are from St. Martin, Martinique, Guadeloupe. There are very few people from Dominica. But there's a club in Dakar, and we connect on a WhatsApp group if we want to share something or if we want to meet.

Can you talk about how or whether your work closes the gap between art and design practice, or whether you would like to close that gap more?

Weaving has the power to connect the two. It's coming through your hands and through your heart; if people are touched by the material, the patterns, and the colors and it evokes an emotion, then it doesn't really matter if you call it art or design. It's only because of the transactions with buyers that we need to impose a division—"This is art, and this is design." But in my practice, I want to open people's eyes about both the traditional meaning of weaving and the traditional use of it in everyday life.

What does joy mean for you? Why is it an essential form of expression for you through your work?

In French, *joy* is "la joie," and sometimes people call me La Joie. La joie is the fact that I've reconnected to my identity through the practice and products of weaving, and am connecting Africa and the Caribbean through our ancestors.

Can you talk more about the materials you use and how you select them?

I used to have no limits with materials, but it's changing because the world is changing. Now I'm more focused on material that is traceable, so I know the source. I am making my own raffia, and also working with a collective of women who create hand-spun cotton. Spiritually, I'm most connected with natural materials, but I also like the unexpected, so I give myself the opportunity to discover new ones.

How do you go about designing the weaves?

It's really about a complicity between traditional weaving and my freestyle practice. The natural material and how I can best show its properties will inspire the design.

Can you describe the process of Manjak weaving?

The specificity of Manjak weaving is very rare, because there are very few places in the world where this technique is used. Two people are needed: a weaver and an assistant. The weaver uses the warp and weft and a pair of pedals, and the assistant uses the stick of wood that goes up or down on the warp. With this technique, the duo can execute complex designs. The collaboration between the designer, the weaver, and the assistant is very strong. In my studio, we are experimenting with a new raffia yarn. I create and imagine an aspect or a pattern and then work with the weaver to materialize the idea, sharing our different skills.

You were saying that your focus now is more on installation art and exhibitions. Can you talk about any recent projects?

Last year, I had an exhibition at the Italian Cultural Institute in Dakar with the photographer Alun Be. We created a surprising installation linking yarn and music, like weaving music.

Another performative installation, created with Fatim Soumaré and titled *Magnitude*, was shown in the Chanel gallery at the IFAN Museum of African Arts in Dakar and at the 19M gallery in Paris. The idea was around dialogue. When you see a loom, there's usually one weaver and one warp. For this installation, I connected two looms, and they only had one warp to share. The warp started at around ten meters between them, and as they wove, the distance closed. It was an experimental work because when you weave, you have to figure out what the other weaver is doing. You have to be connected.

"I want traditional young weavers to be proud of what they're making and of their evolutive tradition."

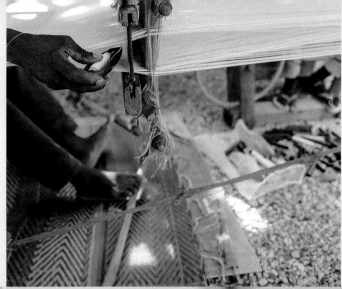

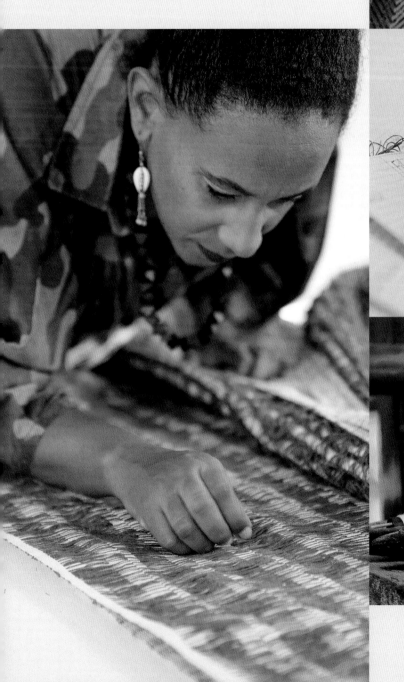

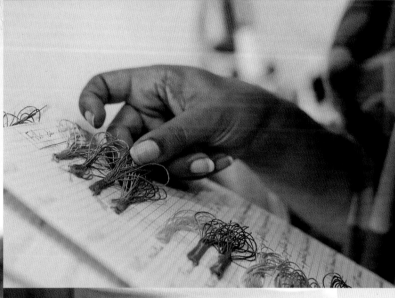

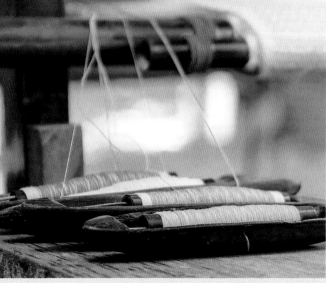

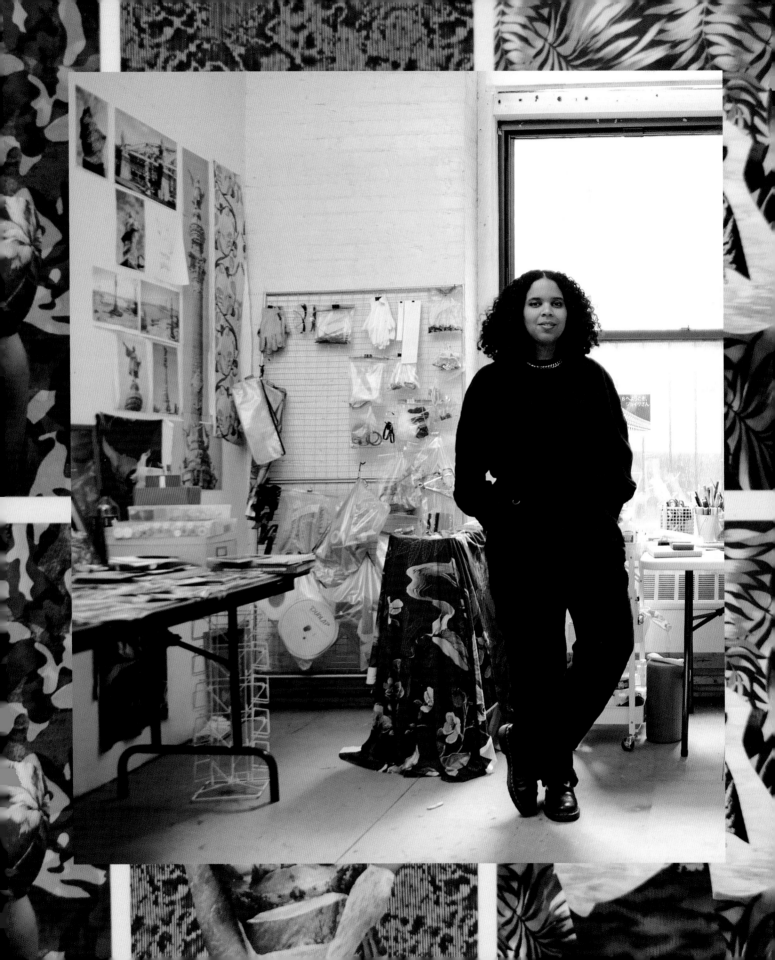

Joiri
MINAYA

AN INTERDISCIPLINARY ARTIST WHOSE WORK DISRUPTS TRADITIONAL NARRATIVES OF BLACK WOMANHOOD

I'm a visual interdisciplinary artist, and I also do performance art that has audio elements and other works that may have tactile elements. The different disciplines are usually informing each other, with ideas that go back and forth between mediums to express different facets of my interest.

What themes or subject matter are you trying to investigate through working in these different disciplines?

Mainly there are two big directions. First, questioning the Global North's romanticization and packaged idealization of Caribbean identity; a lot of that has to do with how tropical space is envisioned, and my work expands that idea of tropical space to encompass nature that is deemed tropical and the people who inhabit that space. Second, studying the experiences of women, people of color, Black people, and members of marginalized groups, more recently by exploring narratives that are indigenous to the region as an offshoot of that same interest in the tropical as something that is idealized and seen through this lens of exoticism that has survived for many centuries.

I'm using a version of the tropical pattern that itself has its own multiple histories, but in a sense, my work subverts the aesthetic that was developed in Hawaii between the 1930s and 1960s as Hawaii was becoming a state after being occupied by the U.S. During that period, tropical motifs were very popular in fashion (in the form of the Hawaiian shirt) and interior design. And that defined an aesthetic that later was plastered all over the tropics and became interchangeable with all these tropical spaces. I'm specifically interested in how the patterns tie in to the history of botanical illustrations and how they were, in their time, the latest technology to assess and control knowledge about these plants to later exploit them. I've been thinking of other ways to use those patterns so that they're not just tied to colonizer status.

What did you make as a child before you even knew to call it art or design?

I've always been artistically inclined. I did a lot with fabric, like making bags and clothes, even though I never took a proper sewing class. My mom has a clothing store, so I grew up surrounded by the idea of fabric and dressing as a form of expression and pattern and decoration.

Was there a moment in your career when you had to reinvent yourself or your practice because of an obstacle?

I never thought about it as an obstacle or a reinvention, but I do think there's a link between stopping painting and moving to the United States. I went to two art schools in the DR. When I came to the States to study at Parsons, I basically signed up for any class that wasn't painting. As a result, my practice became interdisciplinary and painting stopped being my primary medium. Since New York is so space-deprived, my practice became more modular with things I can print and then roll up to store or transport, and things that are concentrated, like a seed that grows or explodes and covers space expansively.

No matter where we are in the world, we return to our Caribbean homes as a source of inspiration for our work identities and spiritual belonging. How have you crafted a kinship with the land, people, and culture of the Caribbean?

When I migrated to New York and started meeting people from other places in the Caribbean islands, I discovered our similarities. The Caribbean is fragmented, and it's more difficult to go to different islands now, which translates to us probably not knowing each other very well in the Caribbean. But then in the diaspora, you get more opportunities to connect with people from different Caribbean islands, and with other visual artists because they're linked to culture and culture-making. Visual representation provides an immediate connection, and you see things that maybe you don't understand the context of on that particular island but that you totally relate to because you have the same things on your island. So much is shared: symbolism and archetypes and even landscape and the things that are inspired by that.

What part of your Caribbean identity or art practice do you think speaks to what is needed in the world right now?

The elusiveness about and resistance to classification because we are so diverse and multiple is something that the world needs right now. Ideas are fluid, people are hard to categorize, and there are influences from all over the world that contribute to our identity. It's interesting because people want to identify the things that make you something, and then even though the making of that something has been super fluid, the definition of it becomes rigid at some point. My practice is questioning that kind of superficial packaging of identity.

What does it mean for you as a maker working in New York to know there's a large Caribbean community around you?

The Caribbean that is seen here more prominently is the English-speaking Caribbean, just by virtue of the language. When I see or read things about those islands, I wonder, "What is the counterpart for this on my own island?" For example, Krista A. Thompson's *An Eye for the Tropics* is looking at the picturesque through images made of the Caribbean. Her sources are a lot of English-speaking Caribbean islands, but I'm thinking, "Wow, what was postcard production in the Dominican Republic like?" The history of representation through a photographic or ethnographic lens in the DR hasn't been unpacked or written about. So even though the Caribbean community in New York is very diverse, and we do have Dominican people, Puerto Rican people, Cuban people here, there are definitely different types of visibility for different parts of the Caribbean.

Has that sense of community informed or impacted your creative work or professional goals and opportunities?

In my circle, we're all trying to help each other grow, and there's a lot of collaboration. There are curators and cultural workers I've collaborated with who impacted the opportunities I had to show my art. It's something I think about when I'm in a position to create opportunities for other people.

Can you talk about how or whether your work closes the gap between art and design practice, or whether you would like to close that gap more?

I'm definitely trying to close that gap. Not interested in that gap. Don't care about the gap. I don't know why anyone else does. It is evident in my work that there's a lot of inspiration from and awareness of the history and use of design and the idea of taking the decorative or utilitarian and then making it anti-decorative. When I create patterned work, it can be shown in an exhibition, but if the pattern is repeatable, it's also applicable to different mediums, like wallpaper or fabric, or, with today's means of production, to objects like mugs. I have friends who are interior designers who ask when I'm going to have my patterns printed on fabrics. That sounds amazing but also scary. I don't want some rich white lady to use my burning tobacco leaf motif—which is inspired by Taino and Black people in the Caribbean burning tobacco to speak to their ancestors—as a decoration. Access to our cultural images isn't universal or indiscriminate, but once it moves from art to design production, it's harder to control because its intention is to be more widely accessible, and therefore more easily diluted.

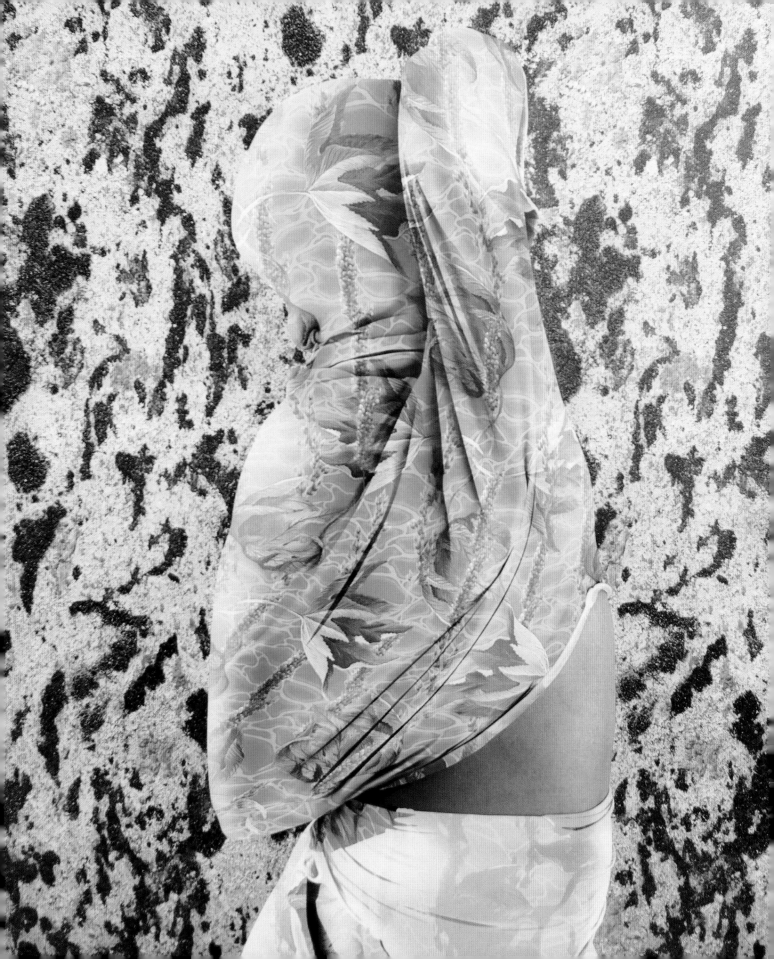

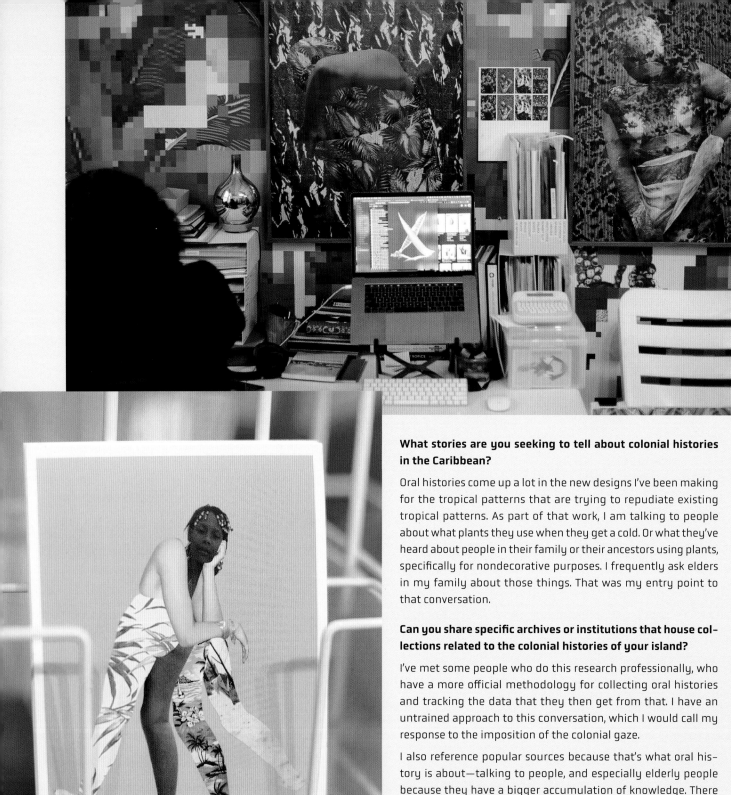

What stories are you seeking to tell about colonial histories in the Caribbean?

Oral histories come up a lot in the new designs I've been making for the tropical patterns that are trying to repudiate existing tropical patterns. As part of that work, I am talking to people about what plants they use when they get a cold. Or what they've heard about people in their family or their ancestors using plants, specifically for nondecorative purposes. I frequently ask elders in my family about those things. That was my entry point to that conversation.

Can you share specific archives or institutions that house collections related to the colonial histories of your island?

I've met some people who do this research professionally, who have a more official methodology for collecting oral histories and tracking the data that they then get from that. I have an untrained approach to this conversation, which I would call my response to the imposition of the colonial gaze.

I also reference popular sources because that's what oral history is about—talking to people, and especially elderly people because they have a bigger accumulation of knowledge. There are more institutions that house colonial history than anticolonial or postcolonial or decolonial anything.

What preconceptions about Black womanhood are you seeking to address in your work?

There are parts of my work that use preexisting imagery, usually from archives and "official sources," and sometimes from the internet or crowdsourced sites. I'm trying to expand ideas about Black womanhood by questioning the ways in which we have been stereotyped through those forms of image-making. Some works are collages of images from different sources, like ethnographic photos and postcards that were made in the Caribbean, as well as historical paintings that were made to depict the Caribbean region. They usually have to do with servitude and representations of Black women as sexual beings. I'm trying to combine those images in ways that challenge prevailing narratives.

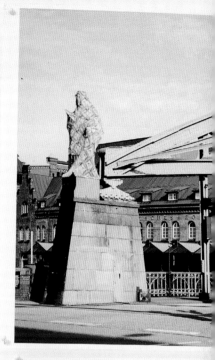

There are other aspects of my work that manifest more in patternmaking and video practices, for example with works like *#DominicanWomenGoogleSearch*, which draws from preexisting images, and my photo, video, and performance series *Containers*. Those two bodies of work are trying to resist that imposed gaze. And then also speak about the multiplicity of being beyond these classifications and preexisting notions and stereotypes. *#DominicanWomenGoogleSearch* is a work that has multiple pieces hanging in a room, constantly combining and making bodies that are objects and challenging the gaze. *Containers* features women in bodysuits that cover the face, embodying some of these images that I found. It is a regurgitation of the artwork in which you're seeing the same image and the same representation, but then through this ridiculous, maybe humorous mechanism thinking about trauma and how trauma is about the repetition in your head of the same thing over and over. This embodiment of a preexisting imagined pose is trying to unpack all those things.

All these tools are ways to challenge preconceived ideas about Black women. The other side of my work talks about Black women as vessels or containers of knowledge whose stories of resistance in the colonial era survive through oral histories. A recent work that I showed in China is a video where my mom and grandma are visiting relatives in the countryside and having conversations about progress. The idea of progress is questioned. There's a lot of new interest in that region because it's being developed for tourism. My work is trying to capture the region before all that change comes.

Juana
VALDÉS

A MULTIDISCIPLINARY ARTIST AND ART EDUCATOR WHO EXPLORES MIGRATION NARRATIVES THROUGH MATERIAL CULTURE

At the moment, my artistic practice involves combining two or three different methods. One of these methods involves collecting artifacts from contemporary culture that I come across in my everyday life.

What kinds of collectible objects are you drawn to and how do you use them in your art?

I recycle, recontextualize, and use these artifacts as art themselves. I collect these items because they provide me with insights about us, our culture, how people create things, how they view themselves, and how they perceive the world around them.

I frequently use men's white handkerchiefs as a material in my work, as they were considered a symbol of class and respectability in my parents' generation. Women, on the other hand, used delicate handkerchiefs that they would give to their suitors as a gesture of their affection. I find it intriguing to incorporate this narrative into my art through the objects I use. Material culture is an essential aspect of my work, as it enables me to integrate our personal history and the African diaspora into our lives.

In one of my recent projects in Miami, I created a video installation that showcases the experience of being trafficked or migrating from one shore to another. The video is projected onto a sail, and the space is filled with shipping pallets, creating an immersive environment that surrounds you. You become part of the environment, like an object, a commodity that's being shipped and moved around. We took photographs underwater, above water, and on land to capture the journey's anxiety and the loss of life that comes with it.

What did you make as a child before you even knew to call it art or design?

During my childhood in Cuba, in the early years of the revolution, we experienced scarcity of all things. As a result, we used to make paper boats and other toys with found wood, metal, and discarded materials. Since we lived in a small town by the sea, nature became our playground.

Was there a moment in your career when you had to reinvent yourself or your practice because of an obstacle?

After completing my graduate studies and beginning to work as a professional artist, I realized that the training I had received allowed me to create art about almost anything. At that point in my career, I was attracted to the concepts of transcendence,

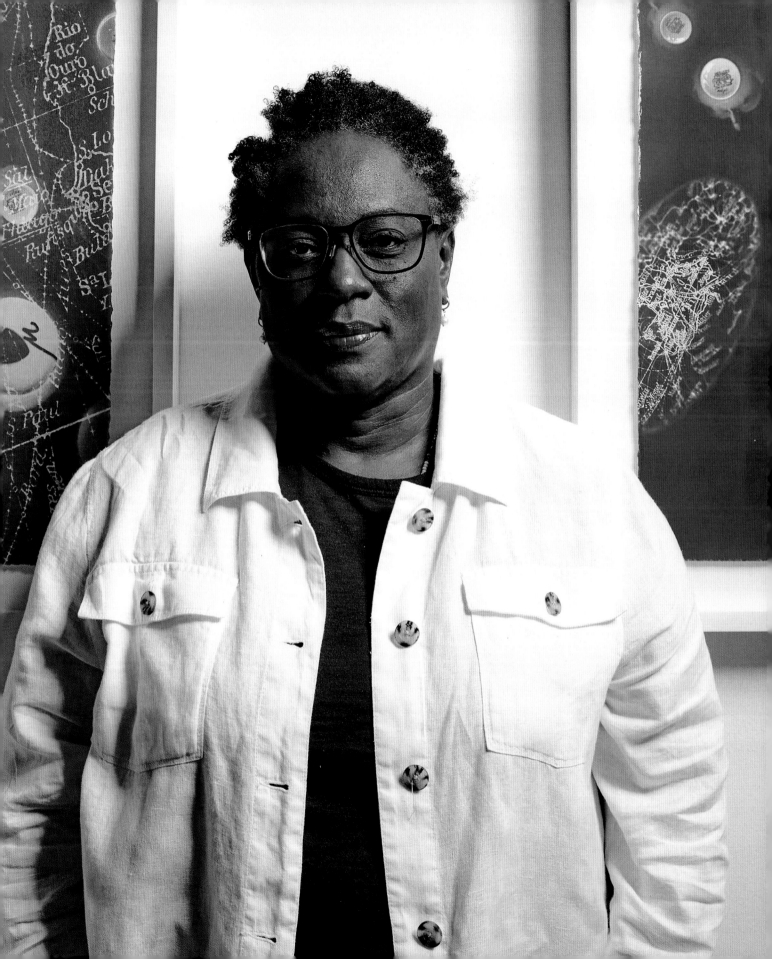

light, and spirituality, which can still be seen in my work but are not as prominent. As a woman, and more specifically as a Black woman, I had experiences that made me reflect on my identity. I knew that any art I created needed to address who I am and what that sense of self entails. This realization shifted the direction of my work to explore what it means to understand my identity as a Black woman in the Americas and in the Western world, including the displacement that occurs because of colonialization. Caribbean people in North America undergo a dual displacement and encounter external racialization from society while also experiencing it internally within their community.

How have you crafted a kinship with the land, people, and culture of the Caribbean?

I aim to capture the essence of what it means to be Caribbean through my work, which is characterized by an inherent sense of openness, looseness, and fluidity. Drawing inspiration from Yoruba religion enables me to establish a profound connection and foster a sense of kinship with my African ancestors while offering a more contemporary perspective for viewers. Simultaneously, I strive to convey the unique island experience by selecting materials that reflect my cultural identity, ensuring a deeper understanding of the narrative I aim to share.

What feelings are you trying to evoke through your work, and what do you hope viewers will do as a result of their interactions with it?

I create art to fill in gaps, create a continuum, and redefine the perception of people of color in a world where they are often marginalized. My work is introspective, encouraging the viewer to engage in self-reflection and challenge their preconceived notions of truth and ways of being.

How has living in Miami, which has a vibrant Cuban community, informed or impacted your creative work or professional goals and opportunities?

In recent years, the Cuban and Hispanic community in Miami has become more supportive of artists of African descent. As an Afro-Cuban, I have observed a positive shift in recognition and appreciation for the diverse talents within our community. Nevertheless, it is crucial to acknowledge that there has been internal racial discrimination impacting Black and Indigenous artists within the Hispanic community, underscoring the need for continued efforts to address and overcome such challenges for a more inclusive and equitable artistic environment.

What stories are you seeking to tell about colonial histories in the Caribbean?

We built British banking fortunes; shipping magnates from across the world were enriched on the backs of slaves in the Caribbean colonies. That money was sent back to Europe while colonizers extracted everything from our islands. Not just during slavery but even throughout the modern era, the post–WWII period. We have been guinea pigs for foreign interests. Barbados was one of the first places Westerners laid cable for the telecommunications industry. How do we come to grips with this history? We experience it on a psychological level. We may not be waiting for somebody else to destroy our bodies, but we are destroying our own bodies. We've been taught to dismiss our bodies and dismiss ourselves, and so it's easy for us to do violence to people who love us.

What sources are you using to inform this work?

I look through high school history books and watch documentaries on the Atlantic slave trade. I find documents from the plantations that used to operate here. And as I mentioned, I find things—like the pottery shards—just by being in historical spaces.

Since you use land-based materials, how is climate change impacting how you use materials and/or think about the land you're situated in?

Environmental issues and climate change have always shown up in my work. But they've had a dual meaning as I'm also talking about environment in terms of a household or a space. As for materials, reuse has always been a big part of my practice. I'm not saying that it's making a huge dent in the world, but every little bit counts, including just building awareness. I want people to care for things, and to care for themselves. A lot of my work is about my own self-care.

In 2017, I was using a lot of cement, which is one of the worst materials for the climate. The process of making cement requires the extraction of sand, which is really problematic for the environment. Even though I was making work about the environment and the issue of garbage, I was basically exposing my own hypocrisy by using this material that is ecologically damaging. Artists can try to be as net-zero as possible, but through our own everyday consumption, we are part of the problem. I really struggle with the materials I use. I've done research about other materials, like resin. But resin is also horrible. I try to use paints that are less harmful to the environment, but they're also corrosive in some aspect. I use clay, which is a natural product, but if we're sourcing it locally, there's only so much available within a very small state. It's not an infinite resource. Right now, I'm just trying to source the best materials I can to do the least harm.

CARIBBEAN ART AND DESIGN

BY DR. KENNETH MONTAGUE

The art world is a fickle, trend-driven market. It rewards the new but often views work from emerging regions as "exotic" rather than as serious artistic expression.

Collectors of art and design by Black Caribbean makers should not expect artists to "wear their history on their sleeves" but rather perceive how these original works reflect Caribbean contemporaneity. There are so many stories still waiting to be told—both in the Caribbean and throughout the diaspora. We need to stop trying to define a single identity for Caribbean art; there are many ways of being, and many new voices that will ultimately expand and enrich our growing archive.

As a Canadian-born art collector of Jamaican descent, I have a dual identity that informs my interests and fuels my passion for contemporary art and design. My Wedge Collection is my vehicle for collecting both emerging Caribbean artists and diasporic artists, often placing their works in dialogue with one another. There are affinities (Black pride, love of community) and differences (in particular, a notable use of local materials and a significant focus on the environment in Black Caribbean artists' works).

I have started moving back in time, acquiring important works by self-taught Caribbean artists in an attempt to better understand local histories and values. At the same time, I am so excited by the emergence of a unique design aesthetic that combines traditional craft with innovative technologies and hints at a new way of storytelling that will most certainly have global resonance. Art, craft, and design

are conversing with one another in these emergent works. There's no meaningful separation between them when you really understand these objects. Growing up, I lived in a household where functional items from the Caribbean—straw baskets, wicker chairs, embroidered wearables, and even a simple Dutch oven—struck me as seriously beautiful design objects. My father, who was born in rural Jamaica, immigrated to Canada in the 1950s and earned a graduate degree in industrial design from the Ontario Institute for Studies in Education at the University of Toronto (where I later earned my DDS). His elegant mid-century furniture pieces were often made from local woods like lignum vitae and mahogany.

The distinctions drawn between art, design, and craft are not apparent in the work itself—in how it's conceived or made—but in how it's shown. Contemporary Caribbean makers benefit from their creations being presented by collectors and curators in a more appropriate context: less "gift shop" and more "art and design studio." Both craft-as-labor and craft-as-artistic-expression are valid ways of producing, and indeed frequently overlap.

What is really needed, though, are more Black collectors. This way, the artistic legacies of both our ancestral and contemporary makers will be owned, preserved, and celebrated within our own communities—which is essential.

Dr. Kenneth Montague is a Toronto-based dentist and art collector and the founding director of Wedge Curatorial Projects, a nonprofit arts organization. Since 1997, Dr. Montague has been promoting both emerging and established artists via exhibitions, lectures, and workshops. His focus is African Canadian and diasporic art and design, which he also showcases in his privately owned Wedge Collection.

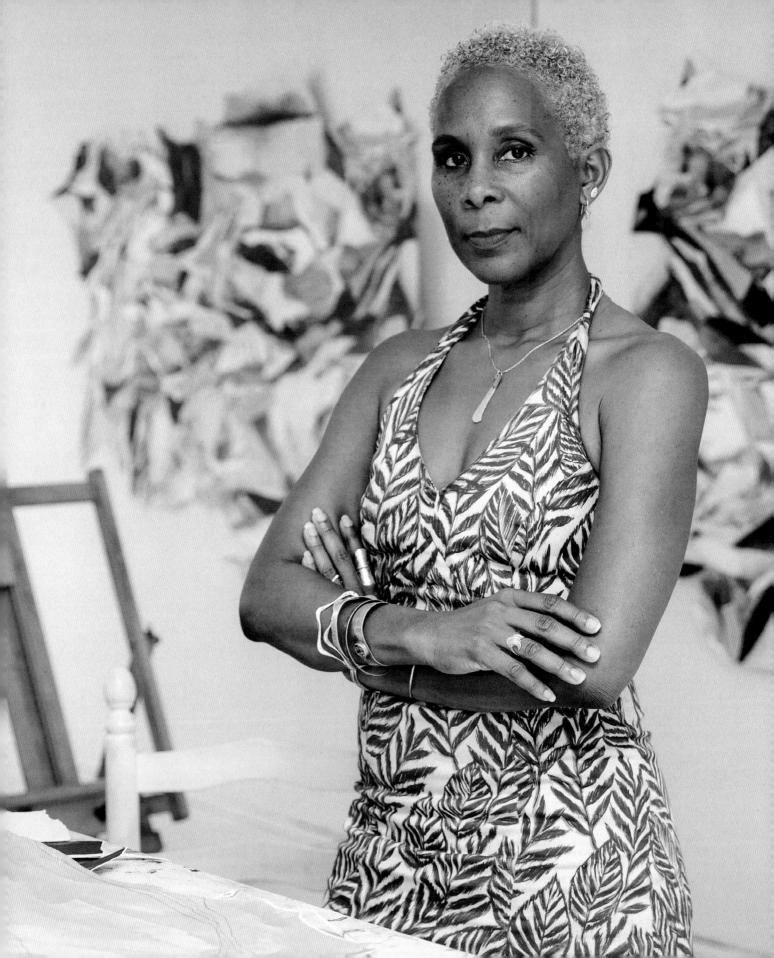

La Vaughn BELLE

A MULTIDISCIPLINARY ARTIST WHO DRAWS FROM ARCHIVAL SOURCES TO INTERROGATE COLONIAL LEGACIES

My practice is making visible the unremembered by thinking through questions of archival production, both by responding to colonial archives and looking at the things the colonial archives did not capture that remain in other forms, whether dance, architecture, our bodies. And then also by making a new archive.

What did you make as a child before you even knew to call it art or design?

I come from a family of seamstresses, so there was always lots of sewing happening in the house. I participated in that kind of making, but I really was an athlete. I got into swimming when I was about eight years old and got very, very good. My life was pretty much consumed by my athletic training. But I had the same art teacher from the ages of seven to seventeen, and he always encouraged me to be an artist, even though I rejected that label for a long time. He saw something in me way before I saw it myself. I only embraced being an artist well into my junior year of college.

Was there a moment in your career when you had to reinvent yourself or your practice because of an obstacle?

I created the public sculpture *I Am Queen Mary* with Jeannette Ehlers in 2018. It received worldwide coverage because there was so much buildup around that centennial year—the hundred-year anniversary of the sale and transfer of the Danish West Indies from Denmark to the United States. I had been working in the Caribbean in relative obscurity, and when *I Am Queen Mary* came out, I got so much attention. Danish institutions were interested in my work; I was showing in exhibitions and being profiled in the *New York Times*, on the BBC, in the *Guardian*. But after that year, I had a year of no exhibitions, no interest in my work, nothing. That was very hard to deal with. It's the ultimate fear—to go from invisibility to this incredible amount of visibility, and then back to invisibility. The way I decided to deal with that year was to delve into my practice, really get back into making. I also took that time to start writing. There's a benefit in being obscure because nobody's knocking on your door, pulling your focus and asking you to consult on their curatorial project. I had a chance to really think about what I wanted to do. That time was very transformative in my practice.

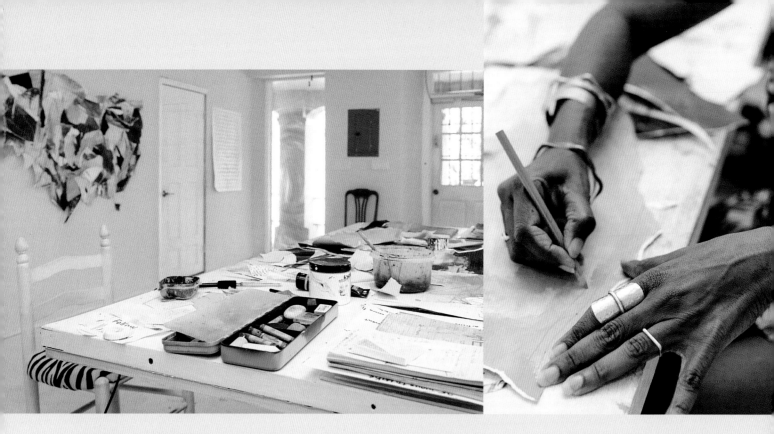

How have you crafted a kinship with the land, people, and culture of the Caribbean?

I've been thinking a lot about mapmaking, photography, and the kinds of histories that are embedded in the land and the relationships we forge with the land through our bodies. There are archives within us. It could be a dance move, a movement we have been doing for decades—centuries, possibly. Or it could be a ritual that has come down through various spiritual traditions.

What feelings are you trying to evoke through your work, and what do you hope viewers will do as a result of their interactions with it?

I want people to understand their relationship with colonial history. How their current situation is connected to a period that, in some ways, didn't end. I don't think there's any such thing as a postcolonial era, especially not in the Virgin Islands, where we're still a colony of the United States. In most other places, the past extends into the present in a way that's palpable. It's important for people to know how and why. The past only exists in the stories we tell about it, so if we're able to understand that and reshape those stories, we can begin to step into the future in a different way.

The Caribbean is a small place that significantly impacts the world. What part of your Caribbean identity or art practice do you think speaks to what is needed in the world right now?

A combination of empathy and what the cultural critic and scholar Saidiya Hartman refers to as "critical fabulation." I conduct research in a lot of archives, and so much of that work forces me to confront grief and loss. I often approach my work from a space of deep empathy for the characters and people and situations. The ability to deeply connect to another person's story and to imagine what they must have experienced or gone through is what's most needed in the world. That ability is essential to my practice.

What does community look like for you as a maker living and working in the diaspora?

The internet has provided a tremendous opportunity for us to see what other people in the region are doing, which helps me feel connected. I see how we're dealing with similar issues. But in my actual, physical space, I feel quite isolated. Part of it is the nature of being an artist and operating at a level that requires me to be very focused. At the same time, I live in the Virgin Islands, but I'm an artist in the world, and I feel very strongly about that. People on the outside probably look at the Caribbean as little dots in the ocean. But the Caribbean is the center of every major civilization in the world. We are inherently cosmopolitan and sophisticated. We've had to think through complex situations and histories. So in that way, I feel very worldly and part of the larger artistic community.

Has living in St. Croix impacted your creative work or professional goals and opportunities?

I literally cannot get things that are a certain size off the island, so my work has to be nimble and transportable. I have to be able to shift things depending on what materials are available. A lot of my work also deals with fragility, so I need to think about how pieces are shipped. That's the precarious nature of Caribbean societies where hurricane season happens every year. I feel like those things are very much a part of my practice. Fragility, fragmentation, nimbleness, resourcefulness.

Can you talk about how or whether your work closes the gap between art and design practice, or whether you would like to close that gap more?

My work is deeply impacted by architecture, archeology, and the design of spaces. It's asking us to think about why towns here are gridded on top of a landscape that had to be dredged to make that possible. They had to move rivers. How does that impact the environment we live in today? I work with colonial-era fragments, like pottery shards, to think about the fact that this commercial artery existed because Europeans wanted to have teas and coffees that came from the Caribbean.

In *I Am Queen Mary*, half of the sculpture uses stones from the ruins of colonial-era buildings that enslaved Africans built. Eleven years ago, I bought an abandoned eighteenth-century structure intending to transform it into an artist studio. But that building transformed my life and my artistic practice when I learned about the people who had lived there: African women who came from the western coast of Ghana, survived the Middle Passage, survived slavery, and managed to buy themselves out of slavery to own a house in the 1700s. That changed my way of thinking about objects, space, history, design, and why buildings are built the way they are—the height of the ceilings, the hand-sawn rafters, the level of attention to the space. Working on my studio space led me to really reflect on the relationship between design and my art practice.

There are some interesting obstacles to making art in the Caribbean. If you live in an area where many of the buildings were built during the colonial period, it's difficult to show work in spaces that are weighted by that history. You can't do too much on the walls; you can't touch this, you can't touch that. That happens in a lot of Caribbean galleries because so many of the major institutions that show work are also in colonial-era buildings that have a particular set of protections. Why do we always need to be in conversation with these buildings that were designed two hundred years ago under very difficult conditions?

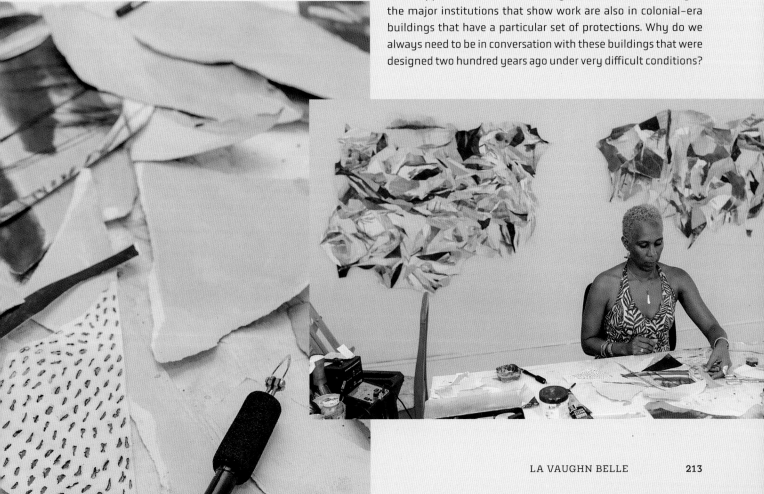

How does your imagination get beyond that? I don't think you can escape it. I attended a lecture the other day that was called "How to Escape Colonial Nostalgia," but I think that is impossible to do. You just try to find ways to survive it.

In the Caribbean, so much design and art is infused with colonial nostalgia. Think about how many things have words like *plantation* attached to them. Think about the ways in which people imagine Caribbean décor—it all reflects the colonial period. That's not what my grandmother's house looked like. That's not how she designed her home. But what's represented as Caribbean or tropical or coastal comes out of an aesthetic of colonial nostalgia. Those are issues that any artist in the Caribbean has to confront. It's why some of our work literally responds to that.

How are you thinking about materiality in your practice?

My materiality is connected to the environment I live in and the kinds of stories I think need to be told. It's based on the kinds of questions I'm interested in asking through my artwork. For example, a series of collages called *Storm (How to Imagine the Tropicalia as Monumental)* came out of my reflections on the iconic image of the palm tree that's imposed upon the Caribbean.

You know, most of these trees are imported. I wanted to challenge myself to reexamine that landscape and some of that iconography. I started thinking about the Caribbean as this space of a perpetual storm, so the palm trees are bent like in a storm. I started that series around 2015. Fast-forward to 2017, when we had major hurricanes again. My studio was damaged. I lost a lot of work. I lost a lot of materials. I thought some things had been saved because they were in plastic, but when I started to roll them out, the paper was cracking because the humidity had been absorbed through the plastic. I almost threw the paper out until a friend reminded me that it was the archive of the storm. So I started this series of collages using that paper as a way of creating alternative archives. Archives that address psychic and spiritual phenomena.

Another part of my practice is doing small cuts and burns in paper. It's a visual language I developed about six years ago when I was thinking through a visual language of resistance and trauma. The Caribbean is very marked by rebellion—revolts against slavery and colonialism, past and present. The historical rebellions were all fought using cutlasses and fire. Those were the two weapons. So I started using a tool to write on wood by making burn marks

to create this other documentation of resistance that's often not in the archive, at least not from the perspective I was dealing with. When I think about materiality in my work, I think about the ways in which I can respond to colonial nostalgia.

What material are you most connected to?

Probably paper. It's one of our dominant means of archiving. Even as a child, it's one of the first things you start to make marks on. It's the first canvas you learn to create on. As someone who's thinking deeply about archives, I work a lot with paper. And I like the look and feel of it much more than those of canvas.

That connects also to your interest in architecture and space, which really opens up the possibilities for materials.

I might work on plexiglass or doors. When you don't have art supply stores, you use what's available to you. I order a lot of my rolls of paper. I work in video as well, creating video essays, or what I call "lyric films." My practice is truly multidisciplinary. Tomorrow I could start making clay sculptures.

Is there anything else you'd like to share?

It's challenging to live in a colonial space. The impact of climate change, the impact and imposition of the tourist economy. The cost of living. We're inhabiting the site of trauma in a way that I think means you have to be a soldier to live here. It requires the resilience of a palm tree that bends but is never broken.

But on the other hand, we have this deep sense of communal care for one another. I lived in New York for ten years. You have more access to materials there. But it lacks the sense of community that can only come from living in a small town. I live in a place where when you go out, you're having five meaningful conversations, because you love people and you're sitting there asking, "How's your granny?" We all know that every hurricane season, we might lose everything we own. These are people you have multiple levels of connections with, whether it's a person you went to school with, your daughter's teacher, a friend. That's why I don't live in New York. That's why I live here. That's why I make from here, too. The communal care.

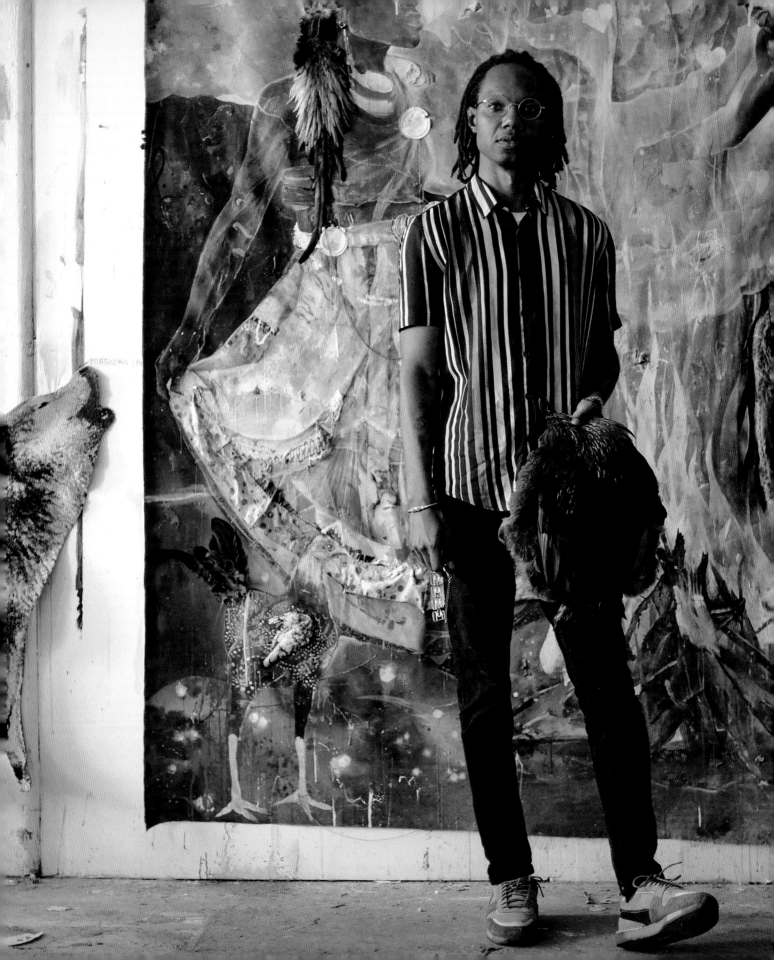

Lavar
MUNROE

I strategically gather materials from various places, including materials from my home—The Bahamas—along with those I've collected from my travels. I find making paintings somewhat similar to making music. There are many tones, melodies, and rhythms that make a painting work. These can range from expressionistic to organic to controlled gestures.

What did you make as a child before you even knew to call it art or design?

As a child, I enjoyed making cutouts. My earliest memory of this activity was around age seven or eight. My uncle was attending college in London, and my cousins and I became pen pals with him. My cousins would write traditional letters, but my letters took the form of cutouts and/or drawings. Another memorable aspect of my childhood was my obsession with studying the colors and patterns of jelly beans. Rather than eating them, I was always mesmerized by the plethora of pastel and marbled colors of the beans.

Was there a moment in your career when you had to reinvent yourself or your practice because of an obstacle?

I'm always reinventing my practice, but not because of obstacles. When I see other artists making works similar to mine—in color, technique, or concept—it turns me off. That's when I know it's time to let go and try something new.

What region or culture most influences you? Can you talk about your experience of finding kinship with the land, people, or cultures in Africa?

In 2022, I made my initial journey to Zimbabwe with the objective of undertaking a series of new works inspired by that country. Shortly after my visit, I was awarded a Guggenheim Fellowship, which funded my second trip there. My goal was to focus on the death and spiritual practices of the Shona people and how they were similar to and different from such practices in The Bahamas.

During my most recent visit, I was invited to an all-night ritual ceremony in a remote village, where members of an extended family sought to communicate with the spirit of a woman who had died a year prior to the event. Through traditional music, dance, singing, and the consumption of snuff (tobacco) and a locally brewed beer known as Seven Days—and the help of a mediator assigned by that community—they successfully reconnected with the spirit of the deceased woman.

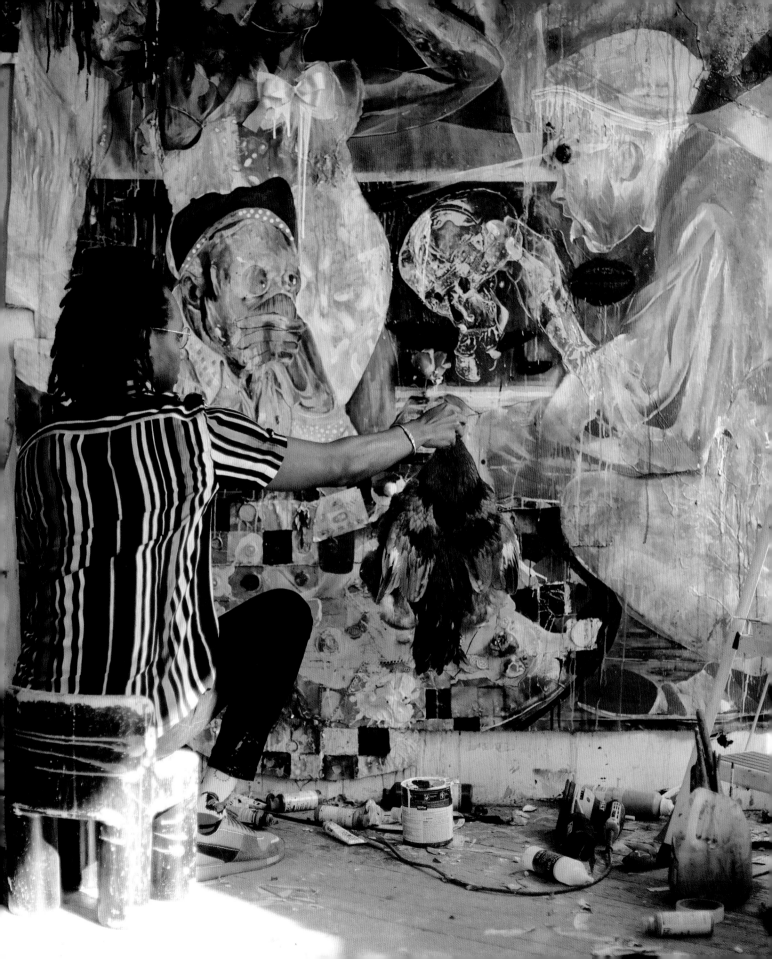

The ceremony is known as kurova guva (which when translated to English means "hitting the grave") and is an age-old practice of the Shona people.

Much of my practice borrows from the field of anthropology, where my thesis takes the form of paintings rather than text. My intentions are to continue visiting Zimbabwe to further build on my research. I will continue to examine and explore various facets of the culture with the goal of developing a robust anthropologic diary of large-scale paintings that compare spiritual practices in Zimbabwe and The Bahamas.

What materials are you most connected to? Has your approach to or use of materials changed over time in your practice?

I'm most connected to materials that I inherit. When my grandmother died, I inherited all her stuff: jewelry, letters, furniture. From my father, I have materials from his work as a parasailing instructor. I have a series of parachute works, which includes some of the harnesses I cut out in collage and embedded in some of the paintings. Through my putting their things in my work, they will live forever.

What facets of migration, movement, change, adaptation, assimilation, and/or diaspora are evoked through your practice?

My current research undertaking in Zimbabwe echoes an earlier one, where I spent several years visiting Senegal, studying and making paintings inspired by life and culture there. The work was initially supported by the Josef & Anni Albers Foundation when I was invited to live and work in Sinthian, a rural village in the region of Tambacounda.

During this time, I was invested in scholarship by Joseph Campbell with a specific interest in the monomyth, also known as the hero's journey. I spent eight weeks commuting between Sinthian and

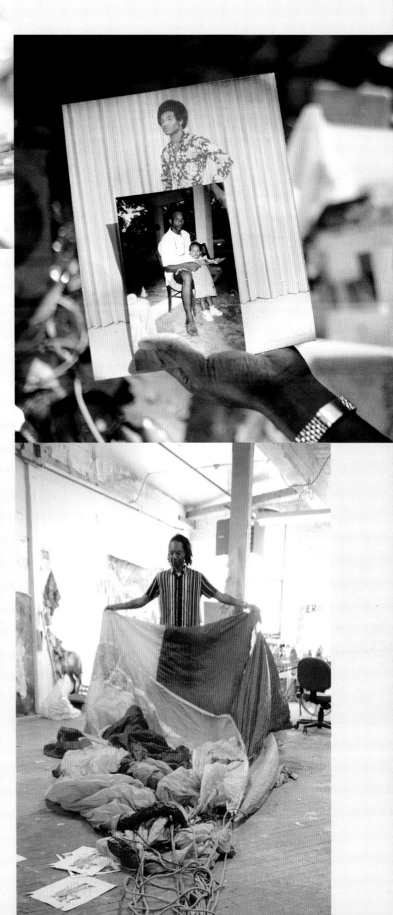

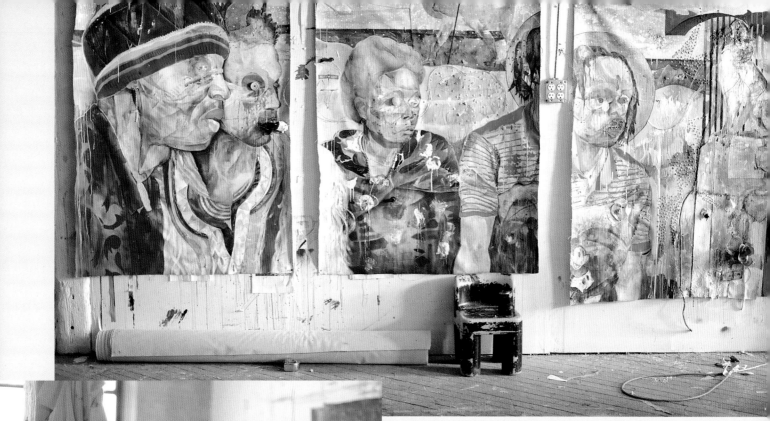

the city of Tambacounda via donkey-pulled carts, and from Sinthian to Gambia via canoe.

On subsequent visits to Senegal, I spent time in St. Louis, on Gorée Island, and in Dakar and surrounding villages. From my travels, I developed a series of canvases and sculpture based on seafaring and land-dwelling characters known as the Redbones.

My series of water paintings—*Of Seafaring Men*—that were shown at the Jack Bell Gallery in London in spring 2022 spoke about refugees who travel by boat, illness, and death on the water. In this work, I was interested in exploring the history of journey by water—pairing fantastical and mythological motifs with reality.

Do you see the act of making as a spiritual or sacred practice?

The studio is a very sacred space. The practice is extremely spiritual. My focus is heightened, somewhat like when one is in a church, synagogue, or mosque. I enter the space with the intention of engaging in critical dialogues. It is my belief that when I am making art, I'm being guided by a higher entity or being. There is an unexplainable connection that happens, which allows me to connect and communicate through the paintings and objects being made in the studio.

Leonardo
ꓭENZANT

A MULTIDISCIPLINARY ARTIST WHOSE WORK BUILDS ON A PERSONAL COSMOLOGY INSPIRED BY ANCESTRAL TRADITIONS AND RITUAL PRACTICE

My work serves the purposes of transformation, healing, conjury, and connecting with the ancestors, who provide strength and meaning. I embarked on a journey through the spiritual and ritual practices because of my past. I'm always navigating between the power to destroy and the power to create because my past is one of destruction. Even now within me, there are destructive impulses that I'm always challenged to confront in order to heal and transform them. These impulses become the impetus of my practice.

What did you make as a child before you even knew to call it art or design?

I played with fire. I was always fascinated by it. I would pour alcohol on the floor in lines almost like I was drawing with the alcohol, and I would set it on fire. Later, I learned that fire is one of the elements associated with various African deities and spirits. There's a Kongolese ceremony (which was transplanted as a cultural practice) in the African diaspora through Palo Mayombe where you arrange gunpowder in a formation of various cosmograms known as firmas or patimpemba, which literally means "power signs." Some people refer to it as ideographic writing. I would make these same kinds of configurations (as intuitive drawings, not with any knowledge of the rituals, which I only learned about as an adult) with alcohol, and then I would set them on fire in my house.

Was there a moment in your career when you had to reinvent yourself or your practice because of an obstacle?

I met this Dominican brother, Magno Laracuente, when I was fifteen or sixteen and he was thirty-five or thirty-six. We developed a close relationship, mentorship, friendship. I learned a lot from him about painting: mixing colors, composition, and how to deal with the materiality. He introduced me to all sorts of artists through our visits to museums and with his extensive library. I really looked up to him, to the point of feeling intimidated. I didn't dare state my opinion about certain things, but there came a time when I needed to find my own voice. Once, we were on the phone arguing about the colors I was planning to use for my sculptures—about the colors that work or don't work in terms of making art—and I became so enraged that I said, "Fuck you," and got off the phone. It was after this argument that I embraced the

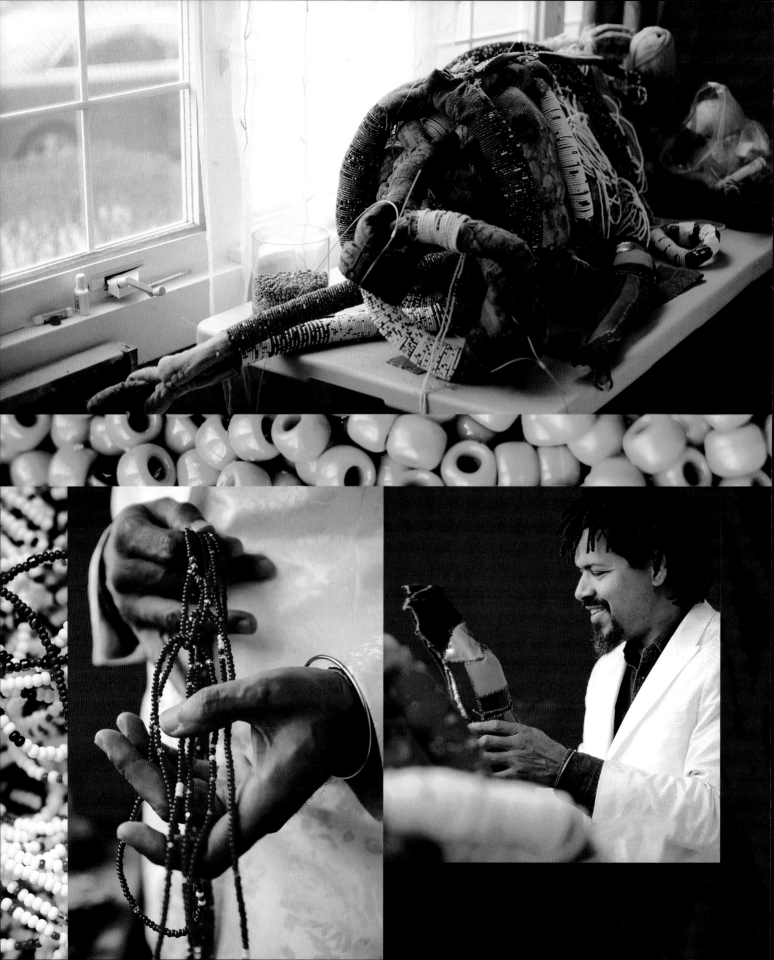

direction I was being pulled in with the sculptures. I decided to use the colors I wanted to with a certain defiance. His voice was formidable in my mind, but I had to find the willpower to focus on what I really wanted to do. There were times when I was making the sculptures when I almost had panic attacks. You can do all this research, but when you're trying to be honest and embrace your vision and your voice, creativity is really about what's inside of you. Do you have the courage to be vulnerable, to be open, and to express that vision, even or especially when it hasn't existed before in the particular form? I believe my ability to do so is why I was selected by the Museum of Arts and Design as a finalist for the 2018 Burke Prize for contemporary craft.

How have you crafted a kinship with the land, people, and culture of the Caribbean?

My first connection to the Caribbean is through my parents, who migrated from the Dominican Republic to New York. They're both Dominican, and my mother's side also has Haitian heritage, so I connect to the Dominican-Haitian thing. Even though I've never been to Puerto Rico, I feel connected to the people and the culture, especially the Black elements of Puerto Rican culture and the spirituality, and also Cuban culture because of my relationship with their African-derived traditions, like Lucumí and Mayombe.

I would visit the Dominican Republic during the summertime. I associate it with family, with love and the sense of reconnecting to a world that my parents came from and trying to imagine how they grew up. Nature there was so magical, with its big thunderstorms, palm trees swaying violently in the wind; the colors of the moths that accumulate on the walls at night; the hairy black spiders that are poisonous; the lizards; the insects; even the fruits—all those colors, shapes, and forms. It instilled in me a sense of animism. It all informs my sense of color, my aesthetic, my respect for nature, and my belief that there's a soul in everything.

The Caribbean is a small place that significantly impacts the world. What part of your Caribbean identity or art practice do you think speaks to what is needed in the world right now?

My practice is about resisting colonizing forces and things that want to oppress our spirit. It's about self-empowerment, the alchemy of the mind. Rituals are a powerful methodology for manifesting these things. Often in artistic spaces, we focus so much on the intellectual that we overlook the spirituality. But spirituality is the foundation of intellectual and philosophical knowledge. I embrace the intellectual, spiritual, and material manifestations of my aesthetic.

The inspiration behind the Haitian Revolution was the vodou ritual that emboldened the people to mobilize and defeat the most powerful military in the world. Without guns and everything Napoleon had, they won the war. Behind that was their spirituality and all the organizing principles that informed how they went about securing their liberation. That's intellectual. People demonize traditional African religions, or they think of them as backward or evil. But Haitian vodun and Mayombe are as complex and sophisticated as any religion or system of thought in the world. When people think of these practices as primitive it's laughable. It's just part of our colonization.

What feelings are you trying to evoke through your work, and what do you hope viewers will do as a result of their interactions with it?

When people experience my work, I want them to have a visceral response to the aesthetic and to recognize that I'm creating a unique world that is a representation of my unique soul. As a unique soul, though, I am a microcosm that mirrors the larger collective consciousness and the macrocosm.

What does community look like for you as a maker living and working in the diaspora?

Community is immaterial and material. I think of the land as a community. The ancestors are a community. In the landscape there are historical references and ruins, which I explored in my last solo exhibition, *Across Seven Ruins & Redemptions_Some Kamarioka*. The markers and historical spaces are imbued with collective memories, and you literally could be standing on an old slave plantation or sugar mill. As I move through these spaces and as I move across the land, I feel a resonance with the past, with the history of the place, with the ancestors.

But community is also in New York, a new community of artists I seek out when I need to work with Yoruba practices. Community is also the books, the historical artists that I sometimes feel I'm in conversation with. It's also the viewers and all those who participate in the art world.

Can you talk about how or whether your work closes the gap between art and design practice, or whether you would like to close that gap more?

For the ancestors, there was no rigid delineation of design, art, spirituality, and life. Everything was fused, including in the way rituals are designed to be multisensory and multidisciplinary. In a ceremony, you have singing to invoke a particular entity, signs and symbols being inscribed on the ground with chalk elements

"My practice encompasses alternate dimensions of vulnerability, strength, and beauty in the pursuit of striking a balance between the need to confront our ruins while cultivating our redemption."

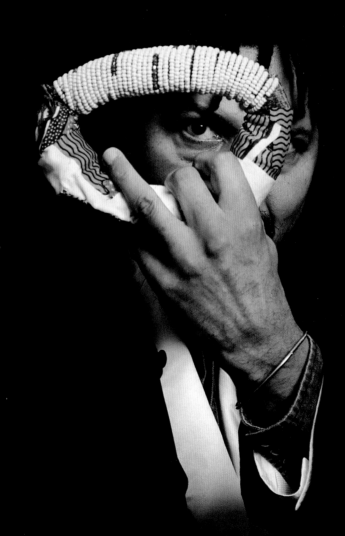

that give off smells, and objects or substances to touch. I refer to these as analogies to help elucidate the multidimensional approach in my practice.

What preconceptions about Black manhood are you seeking to address in your work?

The sense that there's no permission or space for us to be open and vulnerable. The inability to get in touch with yourself and to embrace your femininity, but in a way that doesn't take away from your masculinity. It's about creating a balance, to embrace openness with yourself and with other men, and show affection. The inability to do this fuels a lot of the destructive behaviors, the violence that I witness and that I experienced. The hostility, the addictions, the alcoholism, the domestic abuse. If you can't really express who you are—all of who you are—then you end up hating yourself; and if you hate yourself, you are going to find ways to escape and destroy yourself.

As I reflected on my own life's journey, I realized that my real power comes from embracing my vulnerability. That requires courage. Power is courage.

What does joy mean or look like for you?

Yesterday I was weaving beads together, finishing up a sculpture, and for no reason, I just laughed. Joy is connected to our irrational impulses, and those irrational impulses are connected to our creativity. They are connected to the inner child, which is connected to creativity and the divine self. All these manifestations are interconnected. Joy is a means of accessing a sense of agency over your life. For me, as someone whose people have been oppressed, joy is about resisting that oppression and daring to be who I imagine myself to be, or who I imagine I would like to be. That's political, because everything in the world is telling you not to be yourself, so doing that—being yourself—is the most joyful thing.

What materials are you most connected to? Do you consider any materials sacred?

My work resides in a liminal space between the sacred and the secular. All the materials I use are sacred, even if from an art-world gaze they might just be ordinary objects. Materials have metaphoric power, and they are symbolic on many levels. There are substances I use in my work that have historical meaning because they're associated with slave crops or alchemical rituals. I've incorporated coffee mixed with eggshell powder into my paintings and sculptures. The eggshell powder is a ritual ingredient, and coffee is ancestral in that it was cultivated as a slave crop. I make coffee for my ancestor altar almost every morning. The beads represent currency, and the means to give birth to ideas. Right before I started making my bead sculptures, I created a piece called *Beings Born from Word and Stitch*, which was constructed entirely from hand-stitched fabric and took about nine months to make—the period of time that a woman carries a child and the same period in which my daughter was born. It was inspired by the veil of a Yoruba king's egungun crown. It's like a beaded curtain right before their eyes that represents the threshold between the world of the spirit and the world of the living.

I want to share a little bit of what I wrote about that piece for an interview I did with *ArteMorbida* in 2022:

> This is a moment in the trajectory of my practice where I am beginning to think of art objects in a tactile, magical, three-dimensional, and ritualizing manner. This new perspective allows me to experience and see the artist as a bridge between the material and immaterial worlds. In thinking of myself as a channel, a conduit, a ritualist, a conjurer, and a type of "urban shaman," it situates my practice between the physical and spiritual world, at once sacred and yet secular.

> This was also a breakthrough piece for me because it involved letting go of painting as the dominant or exclusive mode of creating. I began to reinvent myself and my language when I let go of thinking of myself as exclusively a painter—a thing that I associated with the canon and symbols of colonization. It was the beginning of using other kinds of materials that are outside the Western concept of fine art. I started using materials that are often considered craft or "low art" and transforming them into a complex and innovative visual language. Working with rituals and materials used in conjuration like fabric, beads, coffee, achiote, rum, eggshell powder, and coins was a transformative and healing process for me. I was able to connect to the metaphors and histories embedded in them.

It was the first piece that I put something inside, connected to how you make different charms in Congo. There's always an intention behind why you're making something. I inserted prayers and affirmations I had written inside the different forms I created for that piece, even though people wouldn't see them. But the intention behind the work can be felt. It charges the work when it contains both materials that you see and materials that you don't see.

Leyden
YNOEE LEWIS

AN INTERIOR ARCHITECT AND DESIGNER
WHO MIRRORS HIS CLIENTS' CHARACTER THROUGH FORM

I am an artist and a creative, primarily practicing interior architecture and interior design. I work collaboratively with my clients; I don't just produce a product and present it. My practice changes with each project, and I have to be elastic and flexible in order for that to happen. I love people. I love the idea that somehow I can extract or mirror or parallel a spatial version of them.

What did you make as a child before you even knew to call it art or design?

My father is an artist, and he would take me to the Met or the Brooklyn Museum, where we would draw classical objects.

How have you crafted a kinship with the land, people, and culture of the Caribbean?

I am so proud to be of Trinidadian descent. There's nothing like being around Caribbean people and the way they make me feel. It's the laughter. Anything could be followed by a laugh. That attitude is embedded in my practice because I think about how I can make people smile through my work. How I can affect the way someone feels through environmental changes. There's a way of bringing Trinidad to every environment, not in a literal way, but through joy, the practice of joy, creating happiness, knowing that these spaces are set up to produce memories, togetherness, community, or even blissful solitude.

The Caribbean is a small place that significantly impacts the world. What part of your Caribbean identity or art practice do you think speaks to what is needed in the world right now?

Emotional, joyful intelligence. The mainstream history of architecture and design, including the decorative arts, is taught from a European positionality, and for that reason, it has all these modalities and theories around classical mathematical proportions. European design is very rational. It seems to be built on a myth of logic. We need to break free from that to invite personal intuition.

What does community look like for you as a maker living and working in the diaspora?

Community is the conscious search for freedom and support; letting go of isolation and false independence. One way that this is manifested in my life is with the Black Artists + Designers Guild (BADG), a community I belong to and create with. We're a family of idiosyncratic creators with our own creative spaces and practices.

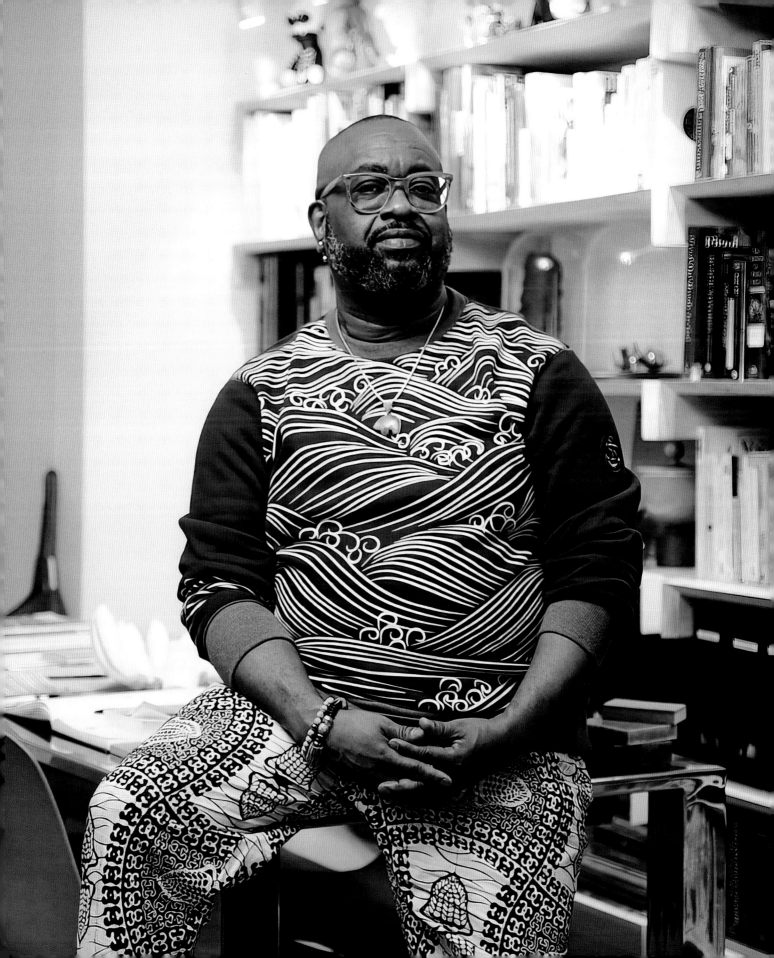

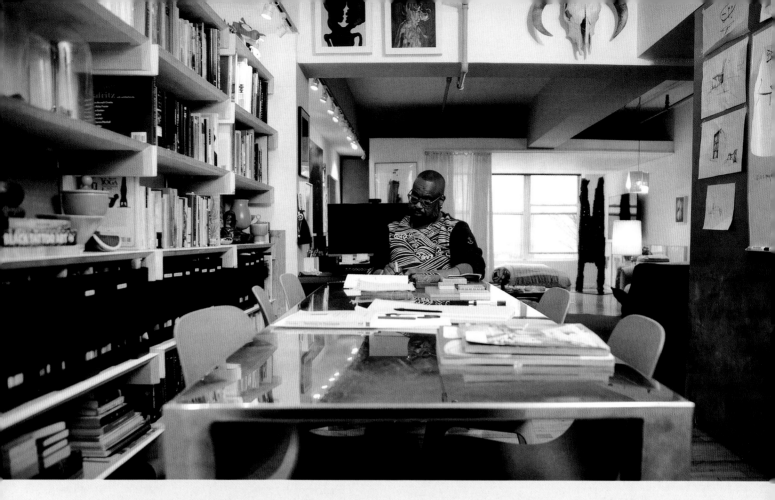

What feelings are you trying to evoke through your work, and what do you hope viewers will do as a result of their interactions with it?

Self-pride, self-imagination, and self-reflection. One of the things I loved about the BADG virtual concept house, Obsidian, was the open definition of family. As a currently single, queer Black man from the Caribbean, I find that my definitions of "home" and "family" are expansive and expanding. So here I am, in the practice of making spaces for people and their families, and I'm asking myself, "How does that need to look?" I honor each individual by looking at them deeply and without judgment, trying to understand who they are and what they desire in creating spaces for them. Emotional intelligence gets you there, not logical proportions.

How has your work sought to expand the view of non-Caribbean Black identity and culture?

When I approach design, I ask if it's expanding on the imagined African American or Afro-Caribbean people and our cultures. I was watching a documentary about Romulus and Remus, the twin brothers who founded Rome. I'm thinking, "Well, there were a whole bunch of Black people in Rome then, and there have always been Black people everywhere." But what's been claimed as Roman and classical erases the presence of Africans, who pioneered math and the sciences. I look at how things referred to as "European" are seen as purely "white" when in reality, the African diaspora has always been a part of European culture and influence. That history has been redacted. We see "European" history, for example, and don't recognize it as our own history. In my work, I claim the full history of Black existence on the planet.

All the work we've been looking at over the years was the product of a collaborative process, but the collaborators have not always been named.

You don't give your slave population any credit when they come up with a design. You don't go back to the salon and say that it was your head slave who came up with this chair leg. The history, in the way it's told, frames us as having had no voice whatsoever by giving complete ownership of European design or classical design to white people. It's a big problem. We understand the context of the history that meant we were considered property and didn't have a voice; but as Black creatives today, we can rewrite that narrative. We didn't have a voice, but that doesn't nullify our impact.

It's up to us now to rewrite the story that has been told to us because in the eyes of Europeans, we were property, but in our eyes we were always creatives, artisans, and makers.

The fact that we have been redacted—that's the painful part. The circumstances in which we were creating, that's painful. But the truth is, if we get beyond the pain, you will see us there.

Can you talk about how or whether your work closes the gap between art and design practice, or whether you would like to close that gap more?

This business of categorizing is a real problem. It is a vestige of colonialism. I don't know anyone who is solely one thing. And it's ludicrous to think that art and design fit neatly in separate categories. Historically, art and design have always worked symbiotically to elevate spaces and the spirit. My practice does not separate the crayon from the canvas.

The roles are being separated because of capitalism—so that we can evaluate a piece of art and it can grow in value and then turn into an object that can be transferred like a commodity. There are products, like a chair or a teapot, that do turn into that same value commodity, but nothing equal to the way art increases in value and is tradeable.

How do you use personal or spiritual memories as a form or material in your work?

I had the fortune this year of going to Venice, and it was the Blackest European city I'd ever experienced; it had so much Islamic detailing because of the mosques. And then I started to look at all the hand knockers on the doors, and they depict Black people. It makes me want to cry right now because Venice had to have been filled to capacity with Black folks. And it was Black folks who were occupying those mansions as merchants, because it was a merchant city.

I'll have these moments when I feel as if I've been someplace before. I feel a connection, like I'm not visiting this place, I'm revisiting it. It may be that I'm having what I consider a transcendental spiritual experience. In my work, I'm figuring out how to extract the DNA of the things I love, like the material culture I experienced in Venice, and import the feelings I derived from those experiences into my own work. For example, those Venetian hand knockers have become a starting point for further investigation in design and art projects in my studio.

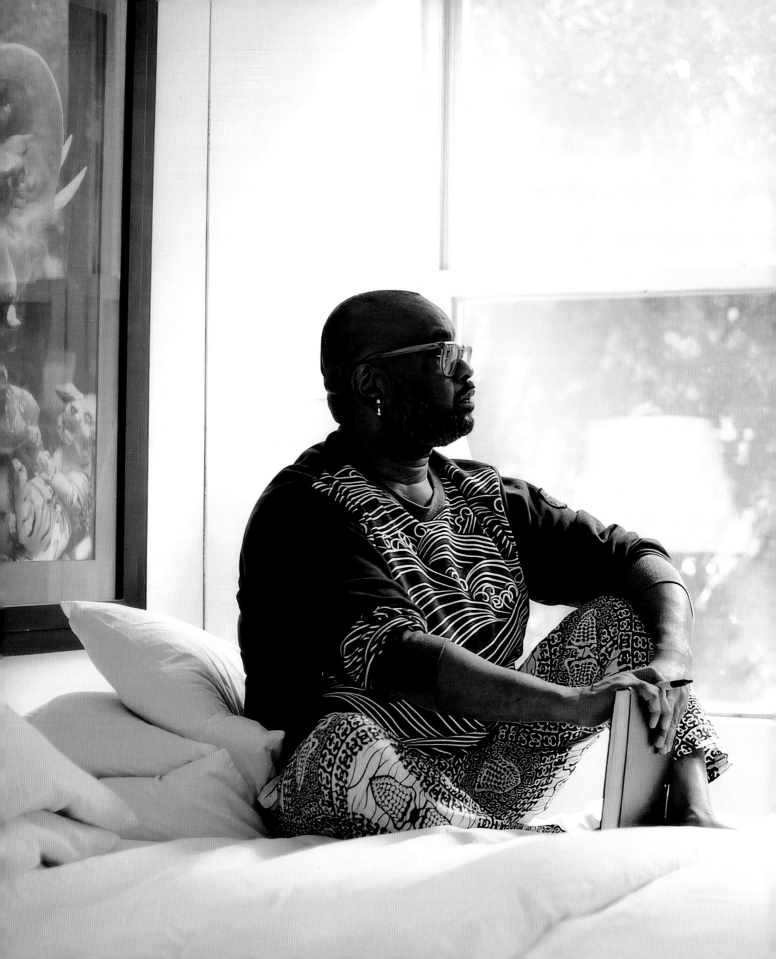

> "Physical things are fleeting. Eventually they will all be demolished, and other iterations will show up. There's a little bit of grieving with design, architecture, and interior design because of that."

What facets of spirituality are most present or potent in your work?

Emotional intelligence is spiritual intelligence. What is spirituality in religious archetypes? It's the construction of the church or the mosque, which is designed to channel natural elements like light and air in mystical ways. It's when the light beam comes in and hits the floor. It's when we've tuned out the noise and we can hear ourselves breathe or be quiet together in the space. Spirituality is our ability to be conscious of how we are feeling in our bodies and how nature is affecting that feeling.

The light that comes off the deck at a residential property I'm working on in Bed-Stuy, Brooklyn, right now is just like, wow! How can you take that naturally occurring poetry and apply it to an interior without having to resort to a blinged-out light fixture? How can we cultivate a palette that is conscious of the light that comes in and captures that moment? What is that light? What are those feelings and those textures?

I've noticed that you don't just start with a sketch. It continues throughout the process.

My practice is very iterative, like peeling the layers of an onion away so that I'm conscious of what is relevant in the physical conditions of a space. I keep drawing even though I'm sometimes drawing the same corner or the same detail repeatedly. I create one drawing to explore the millwork, or the way two walls meet at a corner. The next time, I'll look at color or lighting. I'm learning about the space and seeing it differently with each drawing.

You talk about your father and honoring him, and he's an artist. Is there any particular piece of his that is your favorite? Do you have his work in your space?

The piece sitting on my desk, which I look at every morning, is my dad's. My father started talking about astro-traveling when I was ten. He would meditate every morning for an hour—sit down on the cushion, get quiet, and really go there. That mindfulness, this traveling of the earthly plane, I see it in his paintings. He's always pushed me to think about the fact that this is only one plane of consciousness. The possibilities are endless.

Lisandro
SURIEL

A PHOTOGRAPHER AND FILMMAKER WHOSE WORK CENTERS
MAGICAL REALISM AND THE BLACK IMAGINATION

I often describe my practice as a documentary of the Black and/or Atlantic imagination. In my view, the imaginative lens offers one of the most compelling perspectives for understanding how folkloric figures play a pivotal role in shaping history and preserving cultural memory.

What did you make as a child before you even knew to call it art or design?

I was always a bit of a storyteller. When I was seven or eight, I created comic books with sketches and text bubbles featuring stories about my little sister and me venturing into a magical world I called "animal land," which was inhabited solely by animals. I vividly recall it feeling very real and thinking that the portal to this land existed somewhere in our backyard. I told my best friend about this secret world one day, and to my surprise, he said, "I've been there before." How could he have? I had invented it. So I asked him how he got there, and he proceeded to tell me about a *portal*, which I hadn't even mentioned to him. What he described was exactly what I had imagined. Children possess an innate wisdom. A childhood game of imagining contains profound mythological knowledge. That's what's special about nurturing imagination and allowing it to flourish.

Was there a moment in your career when you had to reinvent yourself or your practice because of an obstacle?

During my student days, I often struggled with assignments and commissions that required me to conform to the expectations of others, including during my studies at the Royal Academy of Art in The Hague, where I came close to failing. It was only when I began to prioritize my own intuition and centered my work around what genuinely brought me joy and inspired me that things started to improve. Art is not about creating what other people want to see; it's about conveying your unique perspective unapologetically.

No matter where we are in the world, we return to our Caribbean homes as a source of inspiration for our work identities and spiritual belonging. How have you crafted a kinship with the land, people, and culture of the Caribbean?

I'm from here, and grew up here amid my island's unique superstitions, lore, politics, and aesthetics. I'm also intimately familiar with the challenging aspects of this

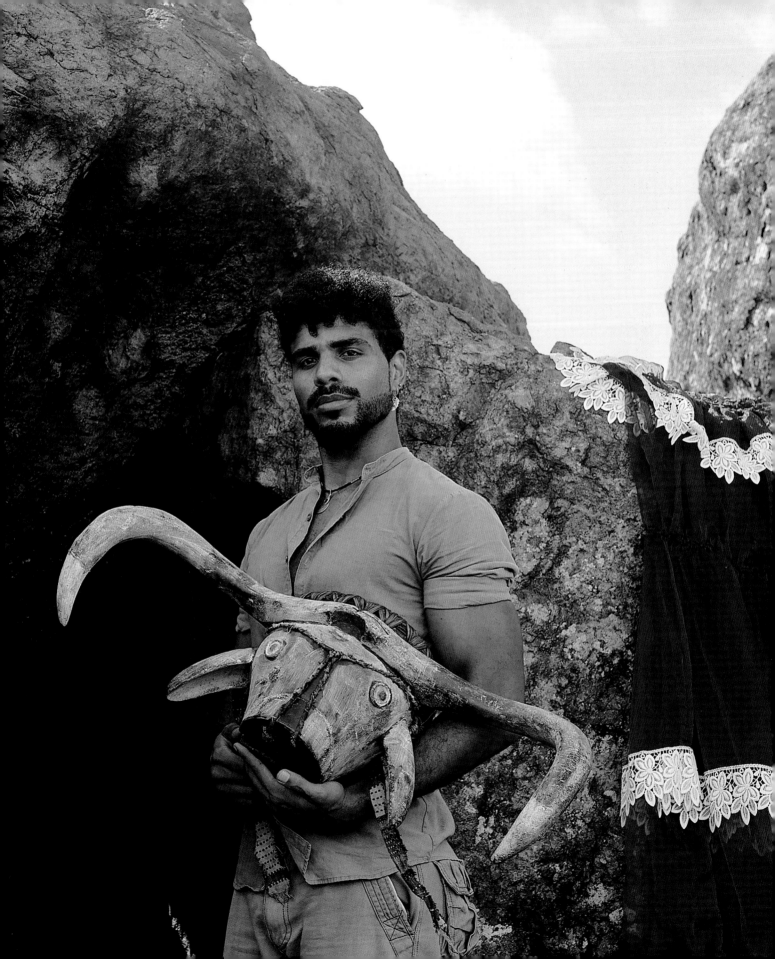

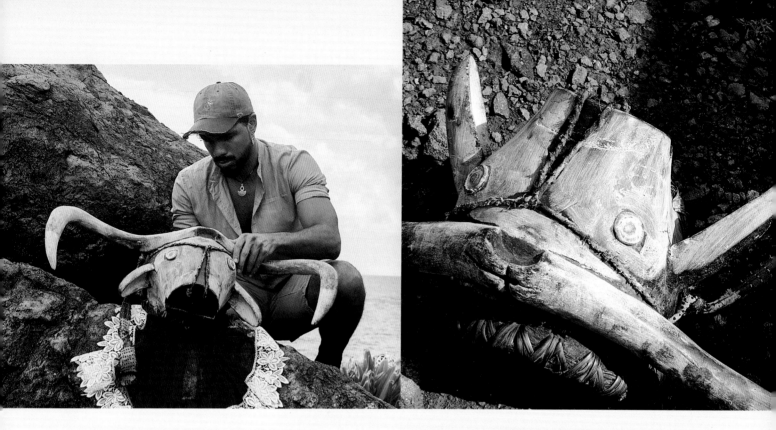

place, including the exploitative tourism industry, which often threatens to erase cultural memories and our rich history. I've seen vestiges of our memories being destroyed to make way for casinos and resorts. So I do have kinship and familiarity. I am an integral part of Soualiga, which is the Indigenous name for St. Martin. When I see someone digging into the hill to build yet another condominium, I feel like my very soul is being unearthed and taken away.

My work stems from a place of not knowing or not remembering who we truly are, who we could have been, or who we are destined to become. It's a somewhat existential search for personal and collective memories that have been erased through colonialism and institutionally induced amnesia. Traditional avenues for discovering our heritage, such as libraries and historical archives, may not provide the answers we seek, including about our ancestral origins—which tribe we came from, or the languages they spoke at the time, their spiritual languages. Our ancestry is African, but Africa has become both a historic place and a mythological one in our consciousness. It's a complex ontology that you inherit in the Caribbean. Allowing the superstitions, the ghost stories, the spirituality, the folklore, the fashion, the culture to manifest in ways that we can visualize—the Atlantic imagination or the Black imagination of the Atlantic world—is a powerful conduit for reconnecting with our lost memories.

The Caribbean is a small place that significantly impacts the world. What part of your Caribbean identity or art practice do you think speaks to what is needed in the world right now?

The Caribbean can offer valuable insights into the urgency with which we address the honest telling of history. Western people approach the Caribbean as an exotic playground, a place to take their luxury vacations and to have people of color as the backdrop for their lavish amenities. Recently I went to Senegal and to Gorée Island off the coast of Dakar, which is the site of the Door of No Return, which has deep, historical significance tied to the transatlantic slave trade. I was hesitant to go there, for emotional and spiritual reasons, but felt compelled to visit. And when we got to the island, I saw that this was, strangely, the most beautiful, cleanest, and most well-kept part of Dakar that I had seen to that point. It had the most landscaping, everything was painted in vibrant colors, the water was cleaner than it was in the city. It was inspiring to be there, from an aesthetic point of view. We were walking around, and I saw that there were beach stands on the coast that served food to tourists. There were little resorts and bed-and-breakfasts where people could stay and enjoy the island. The island had been curated as a luxury experience, with the cultural and historical elements added almost as an afterthought. It was odd to see, once more, that Black people in this space of immense pain and historical suffering were subjected to the role of servitude, catering to the whims of a predominantly white audience.

How could anyone have allowed the site of the Door of No Return to be transformed into this kind of beach destination for white European visitors? But then it kind of clicked, and I remembered where I'm from, where slavery actually took place, and how the Caribbean has similarly been transformed into a paradise for mostly white tourists. The Caribbean can address the urgency to understand the erasure of history because it's a firsthand experience for us. We see it here every day. Going to school, you drive past the slave walls and the plantations. All our neighborhoods are named after plantations. When you grow up in this space, you see how memory impacts a place, how trauma impacts it. I believe the Caribbean serves as a global crossroads of memory, a landscape that acts as a portal for transmitting ancestral wisdom from various times, cultures, and locations.

What feelings are you trying to evoke through your work, and what do you hope viewers will do as a result of their interactions with it?

I want to invite people , first and foremost, to ask the question, "How do we remember who we are?"

I can never speak for everyone on that because I am from St. Martin, which is a thirty-seven-square-mile island. I'm male; I'm biracial. I can only speak from my own experience, from my own identity, and my own relationship with the world, but I want to use that as a tool to get people to share their own stories. When I give presentations about my work at universities or in museums, I never talk about my images. The images act more as aesthetic and spiritual invitations to get people to have real conversations about Caribbean hauntology, memory, and deco-loniality. We share stories and we talk about the importance of memories, and then we use our collective imagination and an understanding of the immateriality of memory to conjure an understanding of identity.

What does community look like for you as a maker living and working in the diaspora?

St. Martin is a very small place, and for people to pursue higher education, we have to leave the island, which creates a brain drain. It's a Dutch island, even though it's anglophone, which is complicated, so a lot of people go to the Netherlands. But some creative people go to the United States or Canada to gain skills as sculptors, choreographers or dancers, actors. But there are certain things you can never learn abroad. These major institutions of higher learning don't know you, they can't tell your story, they can't teach you about yourself. That's something you can learn only through engagement with the community, including elders

who remember what happened and hold the stories that have been passed down from generation to generation that academia has forgotten. The Caribbean community is the institution for memory and cultural research.

Can you talk about how or whether your work closes the gap between art and design practice, or whether you would like to close that gap more?

You can't really separate the two as a responsible cultural practitioner in any genre, because as an artist, you channel an understanding of the collective beyond yourself, and you have the ability to manifest it. The design aspect comes into it when you can translate it for other people to understand. They're not different things, but two components of the same thing. And together they create a perfect piece. Without design, art stays immaterial. An artwork that communicates well is one that has both components in equal measure.

While I do draw deeply from nature in my work, I also bring in masks, fabrics, and costumes that I think will resonate. Objects are important because they can channel certain energies or memories that you don't even understand but that you're drawn to and want to use. This is, for me, when the design aspect comes in, literally in the design of objects, but also through kind of designing the framework for your imagination. You need a language to understand the rawness of nature or the rawness of your creative inspiration. Design provides the linguistic tools for you to understand your artistic continuum or imagination, as it were.

Do you consider any materials sacred? Are you concerned about the misuse of any materials that you consider sacred by those who do not appreciate or understand their cultural or spiritual importance?

Masks are very prevalent in the work, and so people ask, "What do these masks mean? Where do they come from?" The way I approach an object is through a personal engagement with it. If I come across a mask that embodies my own spiritual understanding of things, it's like meeting an old friend and trying to remember that friend beyond what academia can teach me. The first thing I do isn't look up where it's from or what it was used for but engage with it spiritually and see what it evokes in and of itself. I try to learn about the mask through working with it, and then I research where it comes from and what it was used for to see if there are similarities or differences with my perceptions. Those objects embody different kinds of entities or spirits or memories, which then start to live around me. I keep them in my spaces, like friends. The objects for me are sentimental, and they become part of a family unit. It's like this mask came into my life or I came into its life and we decided to make something beautiful together—or that the mask wanted to be seen in a certain way.

The objects I use in my work are all imbued with animus, they all house their own consciousness. This perspective differs from the Western paradigm, which often requires an explanation as a prerequisite for engaging with something. For me, objects are tangible ways to work with things you can't explain—bridges between the known and the unknown. That's how most of us in the diaspora operate. We're feeling around for our identity with one eye open and one eye closed. We can't see everything; we have to feel around for where we are, where we came from, and who we are.

I work with objects to evoke aspects of the collective imagination or allow them to manifest in a tangible form. To help the objects take on a life of their own. It's kind of like being born, I guess. We're all existing on this cosmological ether of consciousness. When you are born, you get funneled down into a body. You have this piece of consciousness that's with you in the physical space. I think that's what good artworks are. They're funneled-down consciousness in a physical object that becomes animated with the life you give it.

Is there anything else you'd like to share?

My ongoing project, *Ghost Island*, traces its roots to my childhood, when I imagined that distant and invisible island inhabited only by animals. In this project, the island also has mythological animals, our ancestors, our forgotten memories, and multitudes of orishas.

Here the trope of a ghost island adrift at sea throughout the Atlantic and Caribbean is used as a device for envisioning and discussing a collective Black Atlantic imagination. Ghost Island is where our history, identities, and wisdom can thrive and coexist. It's a space that belongs to no one yet welcomes everyone to approach and engage with it in their own unique way.

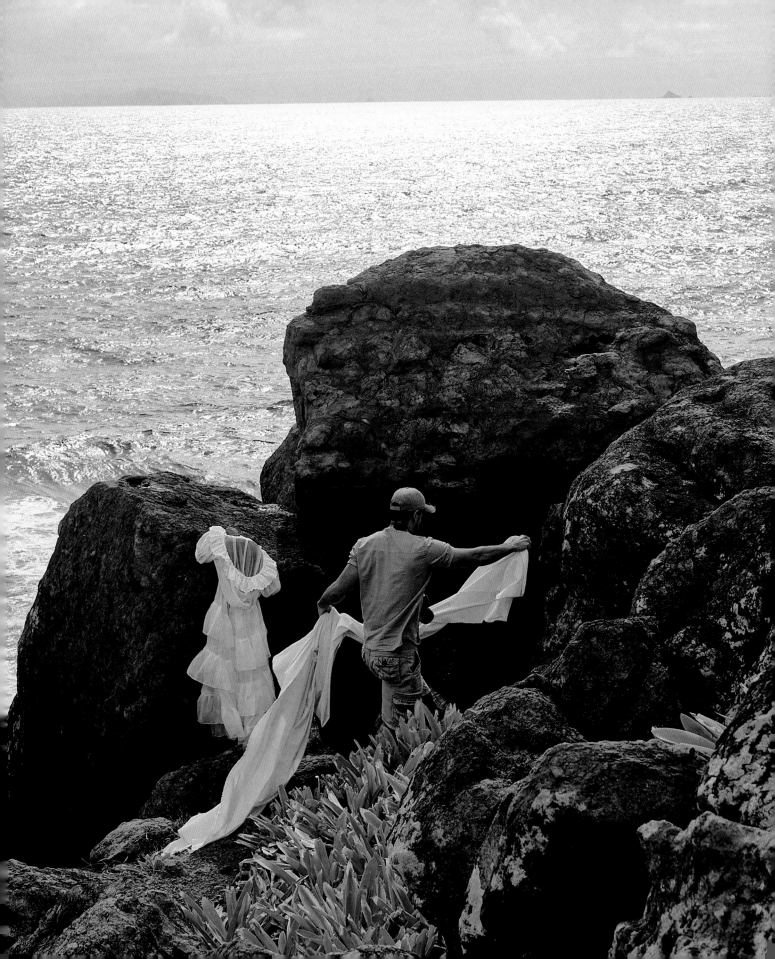

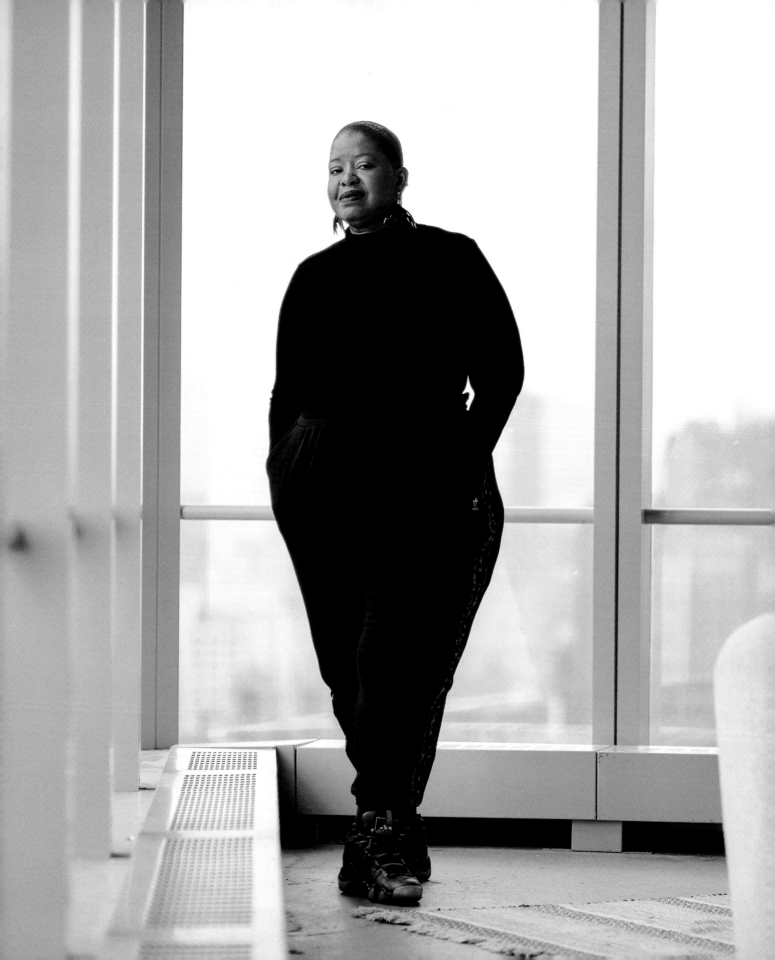

M. Florine
DÉMOSTHÈNE

**AN ARTIST WHOSE WORK SUBVERTS STEREOTYPES
ABOUT BLACK WOMEN'S BODIES**

My practice is on the move. I didn't choose to make art; art sort of chose me. My intention was to be an architect. But I wanted to travel and have different experiences around the world, and so I needed a practice that was portable. Almost all the works I created in 2009 and 2010 were done at the beach because I was able to tape everything down and work there, which was phenomenal. I've created a process that allows me to be very flexible and fluid in my studio practice. My main studio is in Oklahoma, but I'm often in New York working. I've learned to adjust and just let the work be.

What did you make as a child before you even knew to call it art or design?

I wasn't necessarily artistic as a child. I was more interested in engineering. In tenth grade when the school gave us the ACT test to help us determine what would be a feasible career path, I scored incredibly high in engineering because I was always into figuring out how things are put together. I took an art class because it was required, but all the other elective courses I took were about architecture and engineering.

Was there a moment in your career when you had to reinvent yourself or your practice because of an obstacle?

In 2016, the gallery that had been representing me held on to my work, which made everything difficult. I couldn't get it out of South Africa because the gallery wouldn't communicate with me, and so for a period of two years I didn't have any access to my own work. I had devoted so much time and energy into getting my work seen by curators at different galleries, and this one gallery made it impossible because they refused to respond to requests from other galleries. At that point I was in Ghana, and it felt like everything was starting to fall apart, including my finances and my housing. But after two years, I realized that I had been carrying this energy of being pissed off and I had to make a choice. I could either walk away from everything or reinvent myself. Literally restart my career. I had to figure out how to keep the ideas flowing so people could still recognize my work as mine even though it's completely different. That's how I started the collage work, using my remaining materials: some pieces of Mylar and two pads of paper. The collages were really small, and I just continued with that medium. I was able to work on canvas, which I wasn't necessarily a fan of, but it was what was available. From there, my practice blossomed into something I didn't even expect.

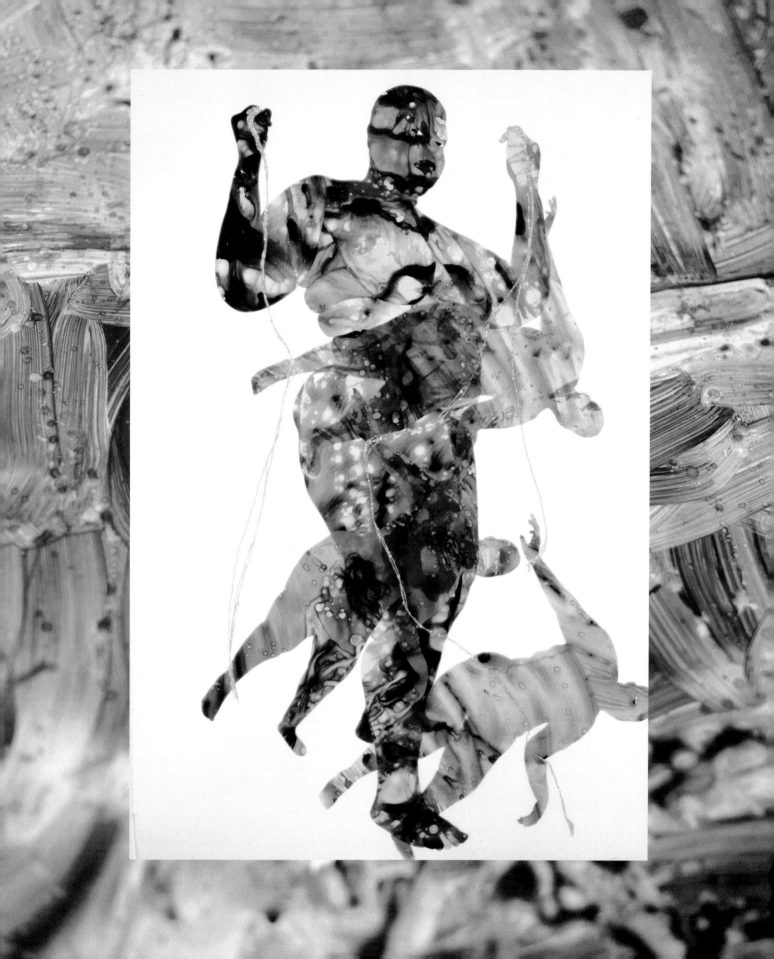

Can you talk about how or whether your work closes the gap between art and design practice, or whether you would like to close that gap more?

I think the gap in general has closed a lot. I don't think people are seeing themselves as makers versus designers as much because the processes are more fluid and creators don't necessarily fall into those silos. The makers are allowing that shift to happen. You can see how the bridge has formed between the two fields and between the two types of makers, whether you're a product designer, a visual artist, a graphic designer, or a fashion designer. Fashion is a great place to see those connections, especially where fashion designers are working with visual artists and vice versa.

I see myself as a maker as well. I have worked on some sculptures with an Accra-based designer who works in video and 3D modeling. I send him sketches, he interprets them using 3D software tools, and then I work with a local 3D printing studio to create prototypes. 3D modeling lives in the designer's realm, but it's now part of the fine arts world, too. So I don't see a very hard line between the two disciplines anymore.

Can you talk about your experience of finding kinship with the land, people, or cultures in Africa?

We're all rooted on some level to our West African practice. That spiritual practice that we have. Even though Christianity has tried its best to remove it from the people, it hasn't been that successful. You can be the most Christian person in any Caribbean country, but just go sprinkle some baby powder in front of somebody's doorstep and see what they do. Whom are they going to then, their priest or the Obeah?

As for how the culture of West Africa shows up in my practice, I don't employ anything in particular that the people there do or create, but I'm enamored with their weaving and bead-making with recycled glass. I mine those traditions. Part of it is asking myself if these ways of making are within us but somehow forgotten. Obviously, that loss is a result of colonialism, but there's another layer that's deeper than that, and I've been trying to figure out what that is.

I'm digging for some of that information; to try to bring that aspect into my work. That comes through conversations with people who are much, much older than me. I'm trying to understand our psychology and how our psychology is connected to our spirituality.

My explorations in West Africa are also a way to understand the three different positions of Blackness I experience: being a Black woman in the United States, being a Black woman in Haiti, and now being a Black woman in Africa, West Africa in particular.

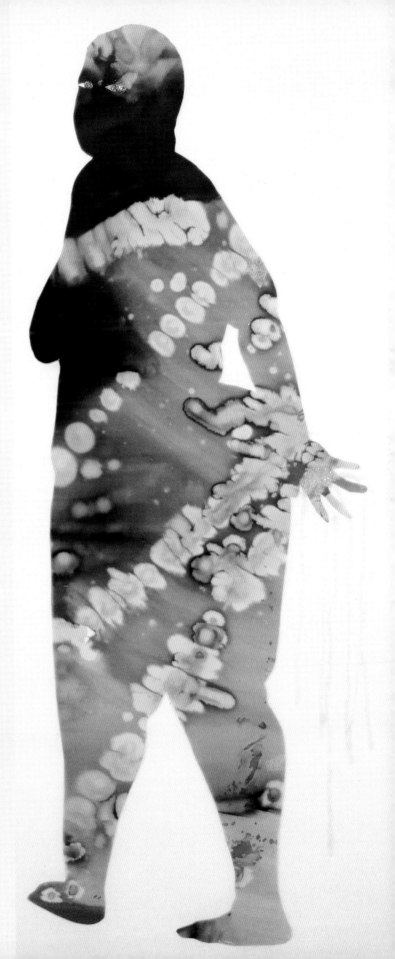

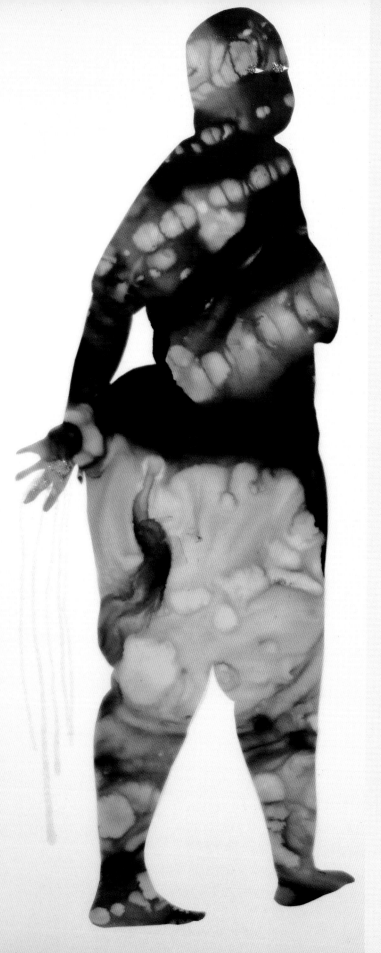

They're so vastly different. I'm looking at the things that tie us together. For example, the heavy influence that African Americans have in West Africa. So much of the material culture copied from the United States is African American.

Talking about Black womanhood, what preconceptions or provocations are you seeking to address in your work? How does this reflect the messages passed down through your family, in your community, and in the world?

These are such dangerous questions. They incite such fervor in people, which is great. But sometimes I just shake my head. It is a hard topic to even think about approaching. The Black female body has been weighed down with layers and layers of stereotype, bullshit, trauma. They go so deep that for each layer you pull back, there are about thirty more underneath.

I don't want to investigate the social construct—although you can't avoid it—but I do want to reveal the spiritual aspect of Black womanhood, which has also been degraded. My work provokes us to collectively consider whether we can just exist as women, period, without all the other layers that get added.

Is me being Black important to the work? If nobody knew me as the maker, would they not see race in it? The way I'm rendering women in my work, the way I'm rendering the booty: Do you see Black womanhood in it? I mean, you can go buy a booty tomorrow, so we can't even say that body type is ours anymore. I realized in my twenties how the Black body was always overtly sexualized. But now for me to see Black women on some level reclaiming the power of the sexual body, while at the same time demeaning the body—it's very confusing. Sometimes I just want to say, "Put some clothes on!" As women, we hold the power in everything. But then why do we behave as if we don't?

What facets of spirituality are most present or potent in your work? Do you see the act of making as a spiritual or sacred practice?

I think being an artist is a spiritual gift no matter what you create. And that is where I begin. It's not necessarily about money and fame or notoriety. It's really about using this gift to communicate with people in a way that is different, in a way that they can hear on multiple levels. The entire process is sacred. The minute I get into the studio and start working, my phone is silenced; everything is silenced. Sometimes I work in silence for hours.

One series I worked on was looking at quantum physics, which is completely in line with ancient African science. It's revisiting what we knew thousands of years ago. For me, the whole process of learning that was a spiritual process. I did that show in

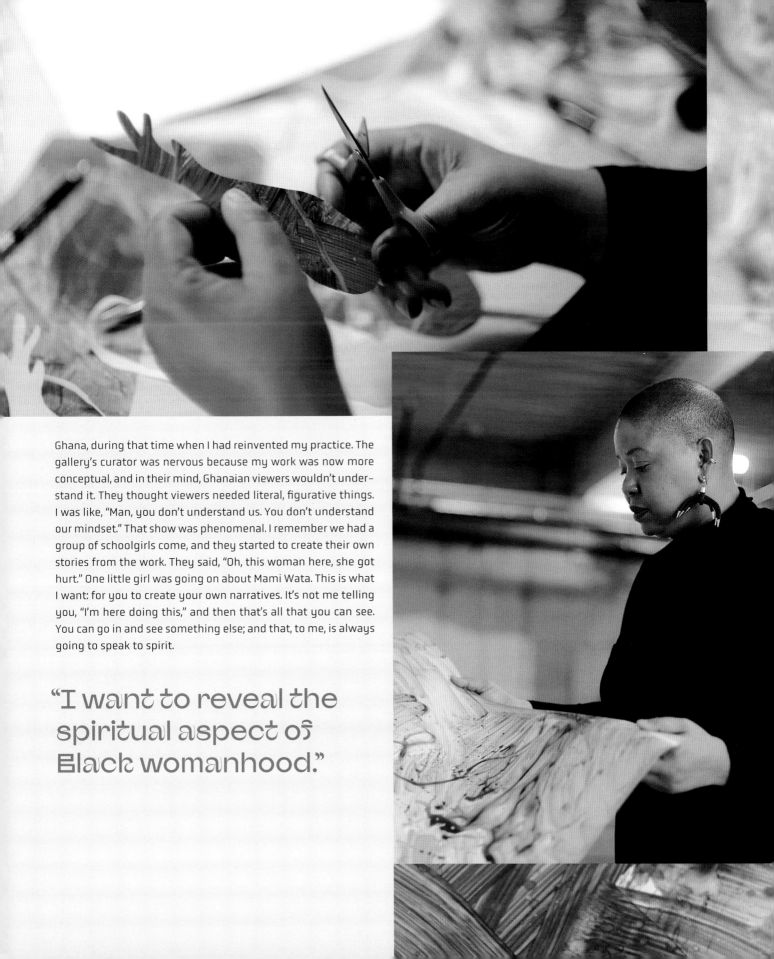

Ghana, during that time when I had reinvented my practice. The gallery's curator was nervous because my work was now more conceptual, and in their mind, Ghanaian viewers wouldn't understand it. They thought viewers needed literal, figurative things. I was like, "Man, you don't understand us. You don't understand our mindset." That show was phenomenal. I remember we had a group of schoolgirls come, and they started to create their own stories from the work. They said, "Oh, this woman here, she got hurt." One little girl was going on about Mami Wata. This is what I want: for you to create your own narratives. It's not me telling you, "I'm here doing this," and then that's all that you can see. You can go in and see something else; and that, to me, is always going to speak to spirit.

"I want to reveal the spiritual aspect of Black womanhood."

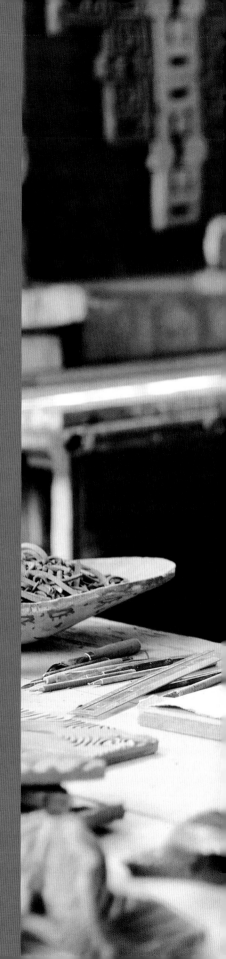

JAMAICA + ST. VINCENT AND
THE GRENADINES ⇄ NEW YORK CITY

Malene
DJENABA BARNETT

**A MULTIDISCIPLINARY ARTIST AND TEXTILE SURFACE DESIGNER
WHOSE WORK EXPLORES MARK-MAKING AS A VISUAL IDENTITY**

My studio practice is centered on Pan-Africanism; I build communities through-
out the Black diaspora by connecting and collaborating with Black craftspeople
and reimagining Black archives. My art pays homage to our ancestors, unearthing
Caribbean diaspora craft narratives that form a cultural synergy with African
American craft experiences. I also make art as a bridge to inspire the community
and open doors to more in-depth conversations about Black culture and the Black
diasporic expertise in craft. Through artistic research, I use pattern as a visual lan-
guage to connect our fragmented histories between African American, Caribbean,
and all Black diasporic experiences to our West African and Central African origins.

My creative approach involves exploring and experimenting with archival materials:
clay, fiber, glass, paper, and anything I can manipulate with my hands. The outcomes
include ceramic murals and sculptures and photo-based weavings. My studio practice
challenges the historical representation of ceramics where vessels are dominant and
pushes the boundaries of form to represent ceramics in nontraditional presentations.

What did you make as a child before you even knew to call it art or design?

I've been drawing and painting since I was eight, and I'm sure earlier than that.
I used to make and eat mud pies! I've come full circle now that I'm making clay
sculptures and murals. My mother exposed me to the power of making anything
you need with your hands. I watched her turn jute yarn into intricate macramé
wall hangings and sheets into curtains. She taught me how to sew and how to bake
and decorate cakes, too. We had a cake-decorating business for a short period, and
I drew the characters in icing based on clients' requests. I was very entrepreneurial
at a young age. I transferred my artistic skills into a hand-painted, screen-printed
T-shirt business and an African print–inspired children's clothing line.

Was there a moment in your career when you had to reinvent yourself or your
practice because of an obstacle?

Since 2009, I have designed rugs for residential, commercial, and hospitality interiors.
I was getting burned out and no longer wanted to work with interior designers to translate
their creative thoughts into a custom carpet. In 2017, after I completed a prominent hotel
project, I took a sabbatical from my rug design business and started to explore my art
again. I discovered a passion for clay and have yet to look back. During this time, I started

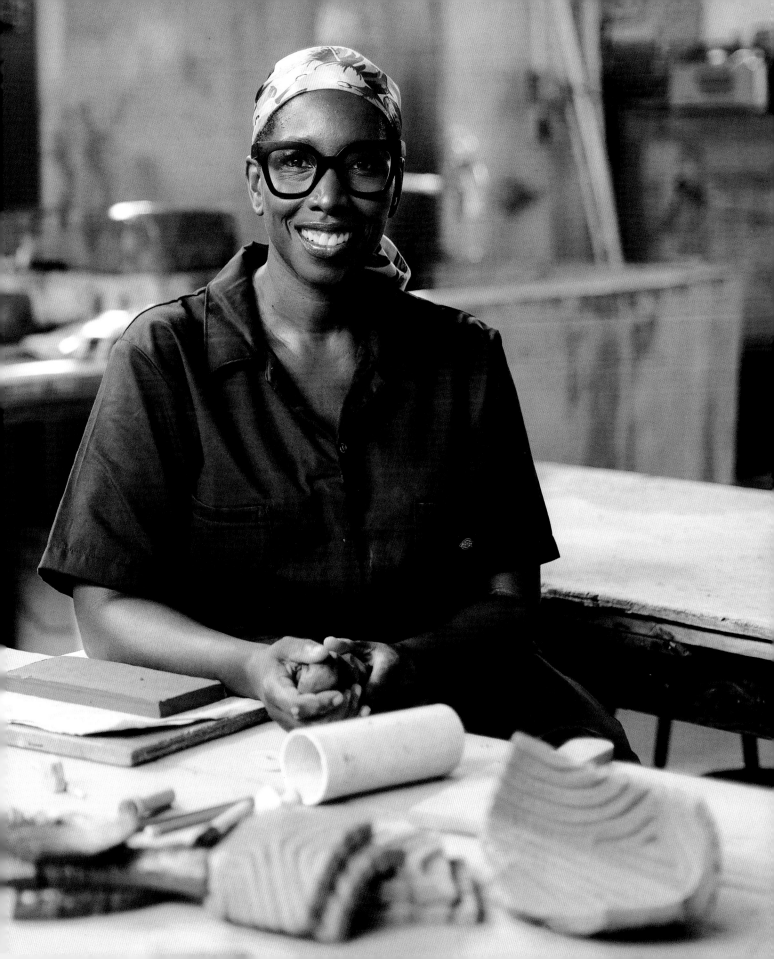

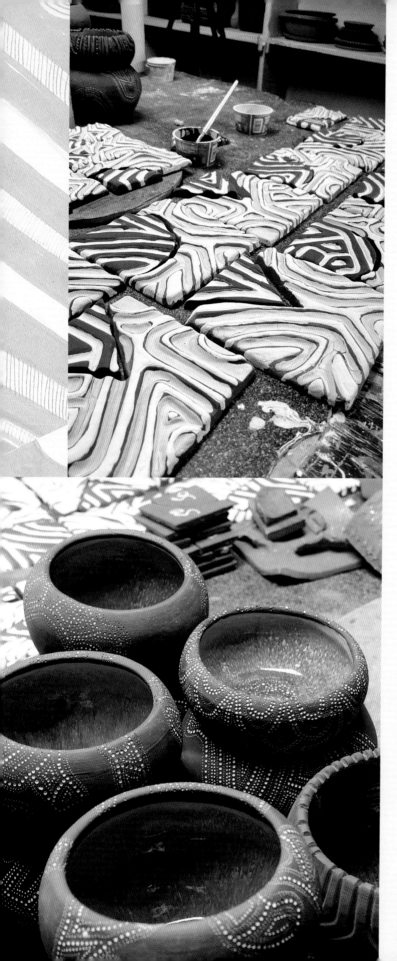

the Black Artists + Designers Guild (BADG), a nonprofit whose mission is to advance a community of Black makers. I've built a community through BADG, a family that will open doors for the next generation.

In 2020, my reinvention became more intense when I pursued an MFA in ceramics at the Tyler School of Art and Architecture. My self-creation began by tracing my heritage through DNA composites and comprehending the Black diaspora's creation in the Caribbean through the lens of Black women makers. The results brought me to Nigeria, Jamaica, St. Vincent and the Grenadines, and the United States. I focused on each country's local makers, their textile and pottery traditions, and the communities that fought for liberation against all forms of oppression. Through gathered fragments of intimate family histories consisting of photographs, oral histories, and my imagination, my work became a reinvention of self and archival practices in the hands of Black women makers. During this time, I was reading *A Map to the Door of No Return* by the Trinidadian writer Dionne Brand, and there's a quote from the book that sums up how I felt about this self-discovery and the ongoing process: "To live in the Black diaspora I think is to live as a fiction—a creation of empires, and also self-creation. It is to be a being living inside and outside herself. It is to apprehend the sign one makes yet to be unable to escape it except in radiant moments of ordinariness made like art."

How have you crafted a kinship with the land, people, and culture of the Caribbean?

I didn't realize this, but my crafted kinship started with my childhood. My mother is Vincentian, and my father is Jamaican. Even though they divorced when I was five, I observed how both carried memories from their homelands into their everyday lives. My mother cooked rice and peas and baked coconut bread. She was always sewing, redesigning the house, playing soca music, and hosting parties. My father had Bob Marley's "Buffalo Soldier" on repeat, ate an ital diet, and was Jamaican-proud.

These memories filtered into my art and design work. As I grew into my studio practice, these experiences encouraged me to investigate my African Caribbean heritage through materials, processes, colors, and patterns. Everything I make—sculptural ceramic murals inspiring us to reimagine our legacies, woven portraits using archival family photos, ceramic sculptures embodying ancestral traditions of pottery—is harmoniously crafting kinship with the region, bridging our diasporic experiences. Jamaica and St. Vincent independently have a solid African cultural retention, and a liberatory mindset from the Garifuna and Maroons runs through my blood. My art embodies this kind of liberation; I see the influences from both countries and the Caribbean region. I've been crafting kinship between Caribbean cultures for a long time but had yet to identify it as such.

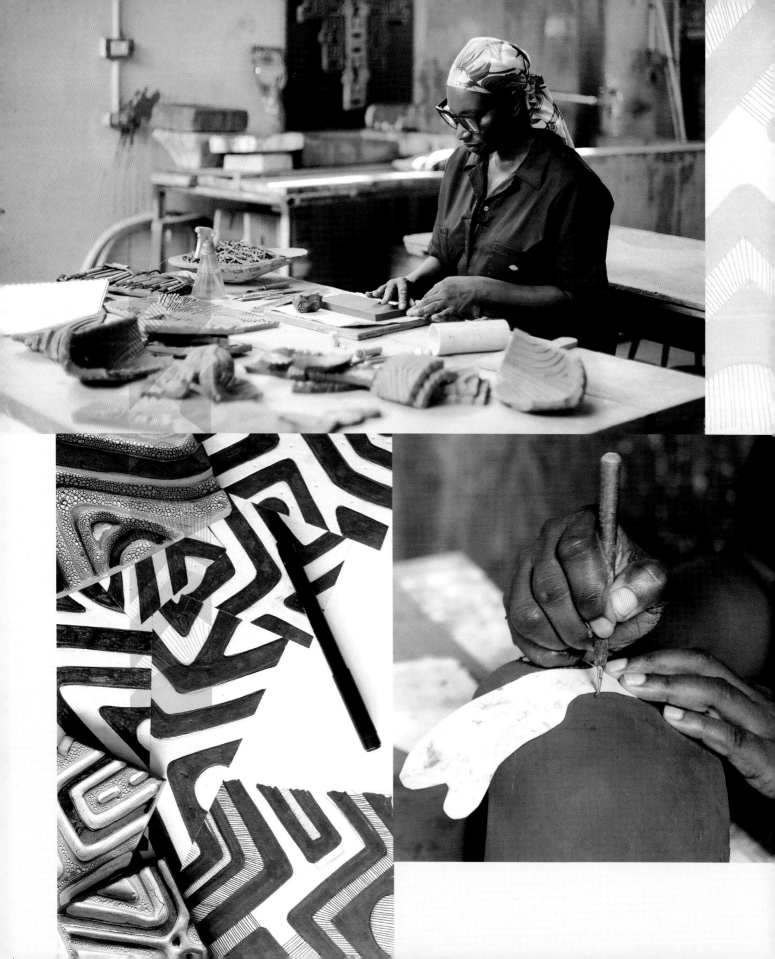

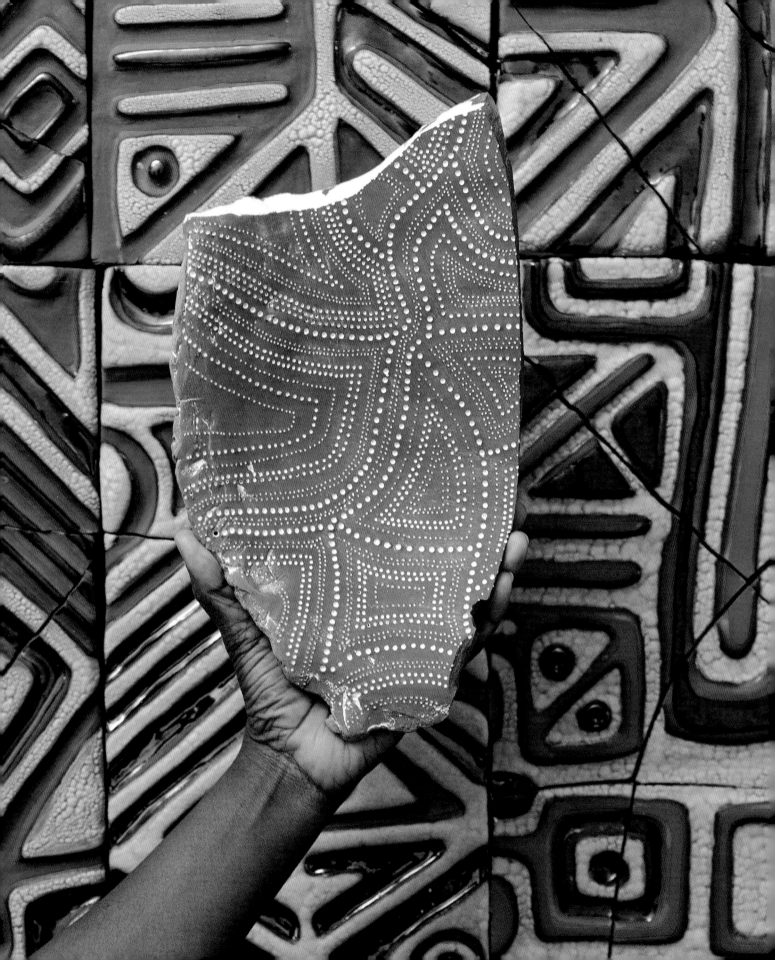

The Caribbean is a small place that significantly impacts the world. What part of your Caribbean identity or art practice do you think speaks to what is needed in the world right now?

My mother taught me to "work with what you have," and since I move around a lot, my art practice has shifted to embrace this motto. I now make art based on available materials and equipment. This same motto is prevalent in Caribbean identity. In Jamaica, the number of materials that are recycled for multiple uses is mind-blowing. If the rest of the world could think about ways to work with what they have rather than trying to make more things, we could have a more emotionally stable global community.

What feelings are you trying to evoke through your work, and what do you hope viewers will do as a result of their interactions with it?

I hope the work encourages people to be curious about Black Caribbean craftspeople and the objects they make and to realize that we are more connected than we think as Black diasporic people. I use surface decoration to draw people into the work because patterns can turn any surface into a beautiful object. Pattern holds history and is a signifier of and connector to our past. By tapping into the ancestral mark-making process, I draw patterns based on memory and intuition. The marks are repetitive and irregular and convey permanence. I want the viewer to investigate these marks and ask themselves: "What mark, what impact, do I want to leave on Earth? How can I contribute to Black archives? How can I support Black craftspeople?"

What does community look like for you as a maker living and working in the diaspora?

I am a community builder. Community is Black makers with various studio practices supporting each other through collaborations, sharing opportunities, and showing up for each other however we need. Community is important because it's how we thrive, grieve, and plan for our future.

I always seek to connect with Black makers wherever I go. In addition to having created BADG, I'm forming another community of makers through this book and my pottery research in the Caribbean.

To what extent do you feel the need to reconnect with your island or community as a member of the diaspora? And what does that reconnection look like for you?

There is so much I don't know about the Caribbean, and my desire to reconnect and learn as much as possible creates a constant need to investigate and piece our histories together. Since I'm a first-generation American born to Caribbean parents from two different islands, I never lived in the region until recently because of a Fulbright grant to study in Jamaica. The desire to reconnect is so strong that I dedicated part of my studio practice to documenting potters working in ancestral traditions throughout the Caribbean. I started the work in Jamaica, but the bigger goal is to visit every island making African Caribbean pottery. Next, I want to spend time on my mother's island of St. Vincent and the Grenadines. One of my Instagram followers recently said she teared up seeing my posts on Jamaican potters because she has never been to Jamaica, but her parents are Jamaican and she felt connected through my research. Her response confirms the importance of reconnecting, of amplifying Black Caribbean makers' experiences, and of recording as many as possible. For me, staying connected to the Caribbean region is essential to unravel our multilayered, diasporic experiences.

Is there a vibrant Caribbean community where you currently live and work? And if so, how has that informed or impacted your creative work or professional goals and opportunities?

My home base is Brooklyn, New York, the epicenter of the Caribbean diaspora. Access to cultural elements of the Caribbean informs my work. Living in Brooklyn exemplifies how Caribbean culture takes up space in different places. Even without the iconic landscape elements, such as the hot sun and the turquoise water, you still feel the essence and spirit of the Caribbean.

Can you talk about how or whether your work closes the gap between art and design practice, or whether you would like to close that gap more?

My art constantly blurs the lines between art, craft, and design because I use all three to create space for viewers to enter the work from multiple viewpoints. I primarily work in clay, portrayed as a lesser-value craft material, and use my surface design background to create patterns and ceramic murals. The *Legacy Wall*, a mural I created from hundreds of ceramic fragments to represent the beauty of being a part of the Black diaspora, can be interpreted as a high-end design. Still, the work is a perfect blend of art, craft, and design.

What region or culture most influences you? What stories, visual motifs, or symbols from that region are prevalent in your work?

My exploration of African origins is heavily influenced by terra-cotta pottery, textiles, architecture, and wood sculptures from West Africa, specifically Ghana, Senegal, Mali, and Nigeria. I've visited Senegal and Ghana multiple times. My first trips to

Ghana focused on textiles, such as kente and adinkra cloth; later, my focus was on pottery. During my earlier visits, I spent time alongside kente cloth weavers and adinkra printers. I learned wood carving, too. In 2019, Ghanaian pottery became the focus of my research, and I spent three weeks working alongside women potters of Kuli, a village in the Volta region. But the link to our ancestry was revealed when I started researching African Jamaican pottery. The hand-building technique used in African Jamaican pottery mirrors the Ghanaian and Nigerian technique, which is a part of our culture that our ancestors carried through the Middle Passage into the colonial period and the present. I remember on my first trip to Ghana, I felt like I was in Jamaica. I saw people who looked like my family. It was not until my recent research in Jamaica that I connected the dots to understand that the first people to arrive in Jamaica were the Akans, so they *are* family.

I primarily use terra-cotta clay and hand-building techniques, like the ancestors and current African and African Caribbean potters. Embracing the material and techniques allows me to build on the legacy and connect with the past to reimagine the future. I freehand draw my patterns and develop them intuitively. I repeat asymmetrical patterns and irregular shapes to keep the hand visible in each piece. My patterns are unidentifiable and cannot be placed within a specific country in Africa on purpose because I'm tapping into cultural memory and can't attribute the pattern to a particular ethnic group. Still, I hope the viewer feels connected to the entire continent and is not forced to be in a singular space. Feelings of nostalgia surface, and you can't help but be transported to somewhere in West Africa.

What traditions or expressions do you use in your practice and/ or daily life that were kept alive through the Middle Passage and survived to this day?

I constantly look at pottery-making techniques and the periods when colonization didn't affect our making traditions. I use the coiling method to make ceramic sculptures and the same repetitive mark-making on the clay's surface in my sculpture tiles, except I'm creating patterns on both sides of the objects to increase the piece's longevity and expand on the duality of the narrative behind the maker. Working on terra-cotta clay fragments, I continually grapple with the tension of gain and loss because we will never know what our ancestors experienced. But by creating new fragment pieces for the archive, I can find joy in having the power to deconstruct and expand our narratives in multiple ways, all while creating space for the ancestors to be honored.

Pattern holds history
and is a signifier of
and connector to
our past.

MALENE DJENABA BARNETT

Mark
FLEURIDOR

A MULTIDISCIPLINARY ARTIST WHOSE WORK INVOKES AND EVOKES JOY

I describe my practice as self-research—about my feelings, my family, the sky, the moon, anything I'm interested in. I work with textiles, quilting, watercolors, collage to reflect on my relationship with home, physically or in the context of my community, and how I value the people around me and the spaces I live in.

What did you make as a child before you even knew to call it art or design?

Music was my first sort of art-making because a lot of my family members are musicians, and they taught me how to make music and the art of improvisation. My parents' house was a gathering place for all the aunts, uncles, and cousins when they would come from Haiti to the United States. I found visual arts through YouTube, and that's when I fell in love with drawing and painting.

Was there a moment in your career when you had to reinvent yourself or your practice because of an obstacle?

I'm doing that right now. I needed to create a boundary between me and my audience. As an artist making such personal work, I've become very protective of what I share and how I decide to share it. I'm trying to figure out how I can make something personal but not have it physically represent people or use people's images, just reflect their presence.

I'm currently making more abstract works, although now they don't feel as abstract as I thought they would. In the past, I worked on more figurative pieces, portraiture, landscapes, and interior scenes for family members and for myself. The other day my dad asked me, "Are you not going to paint people anymore? Are you not going to paint your mom and me anymore?" I said, "I don't know, but that's not what I'm working on right now." It causes a lot of anxiety to totally change course in your work or your practice, but it's for the best for me right now.

How have you crafted a kinship with the land, people, and culture of the Caribbean?

There's a large Haitian community in Miami, so I've always been able to have that kinship in my life. Most of my cousins and family members are here, and I've been connecting with different Haitian artists from here, like Morel Doucet and Didier William. Our work touches on similar storylines, such as just growing up in Haitian households in Miami.

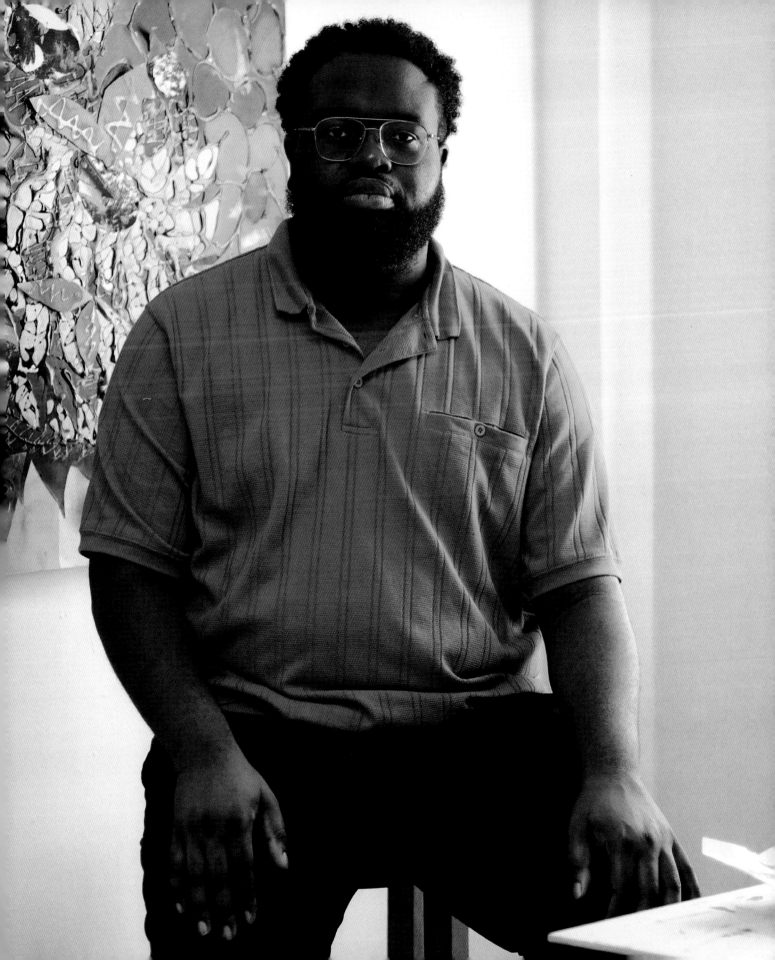

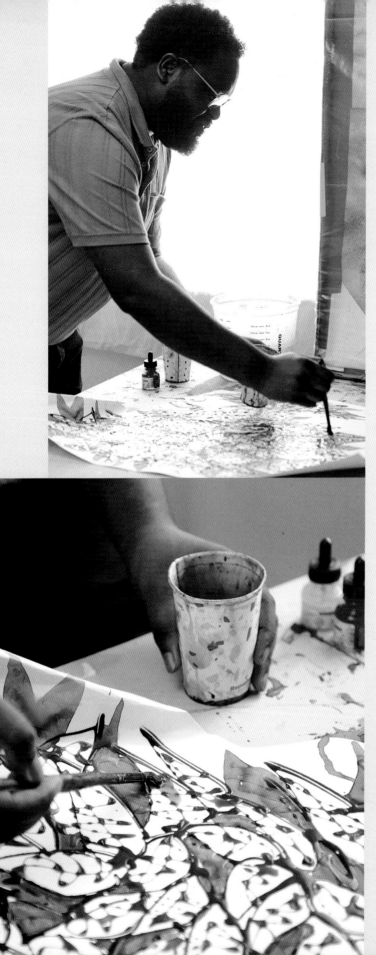

The Caribbean is a small place that significantly impacts the world. What part of your Caribbean identity or practice do you think speaks to what is needed in the world right now?

This sounds corny, but love. The community that I grew up with has provided a lot of love, care, and support to me and to my parents. I think in the world right now, listening to each other can go a long way.

Can you talk about how or whether your work closes the gap between art and design practice, or whether you would like to close that gap more?

I have a patternmaking practice, and I'm currently working on some public art projects that are more design-based. I feel like art and design are connected for some artists. I would like to touch on design more and to experiment with different processes like ceramics. I made a couple of wallpapers, which I'd like to do again. My practice is about exploration, trying things I've never tried before and seeing if they work for me.

This play between art and design seems to feature in the materials you choose.

I use a lot of lace and curtain fabric. I've interacted with lace a lot throughout my childhood. In my parents' church, lace was used to cover the bread and wine before communion. My mom loves collecting clothes made of lace or fabrics with different tones of brown, which I now gravitate toward in my work as well. I also make quilts out of paper, which is a switch from making textile works. I created this technique of using archival glue as a dry material to represent the stitching from a sewing machine. A lot of pieces I've been making for the last couple of years are quilts made from paper or using fabric without thread.

What does joy mean or look like for you?

I made a piece called *After the Storm* about the joy of crying and the joy of release. Crying can feel like a storm, and after the storm, you have clear skies. So joy can be a mix of many different emotions. When I think of joy, I think of laughter. I think of being relaxed, being comfortable, being in a space where you can be your true self and not have any fear of judgment. I think about creating joyful spaces out of things I like, such as fruits or strawberry candies that remind of my childhood. Many aspects of my art touch on objects from my life. I think of objects as symbols of joy and memory.

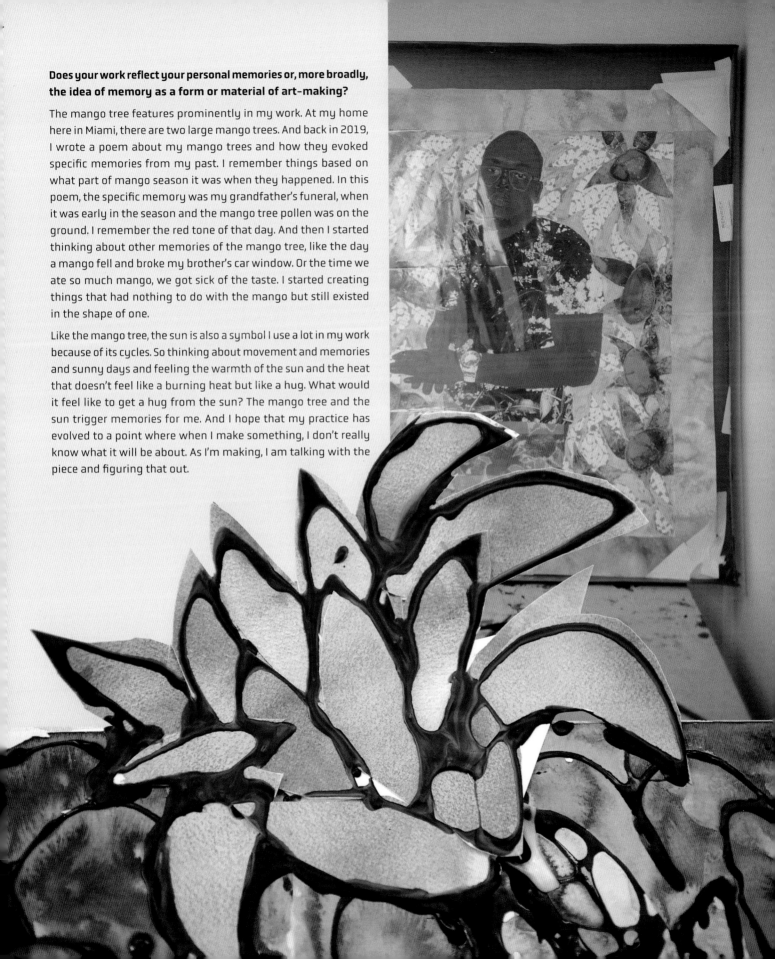

Does your work reflect your personal memories or, more broadly, the idea of memory as a form or material of art-making?

The mango tree features prominently in my work. At my home here in Miami, there are two large mango trees. And back in 2019, I wrote a poem about my mango trees and how they evoked specific memories from my past. I remember things based on what part of mango season it was when they happened. In this poem, the specific memory was my grandfather's funeral, when it was early in the season and the mango tree pollen was on the ground. I remember the red tone of that day. And then I started thinking about other memories of the mango tree, like the day a mango fell and broke my brother's car window. Or the time we ate so much mango, we got sick of the taste. I started creating things that had nothing to do with the mango but still existed in the shape of one.

Like the mango tree, the sun is also a symbol I use a lot in my work because of its cycles. So thinking about movement and memories and sunny days and feeling the warmth of the sun and the heat that doesn't feel like a burning heat but like a hug. What would it feel like to get a hug from the sun? The mango tree and the sun trigger memories for me. And I hope that my practice has evolved to a point where when I make something, I don't really know what it will be about. As I'm making, I am talking with the piece and figuring that out.

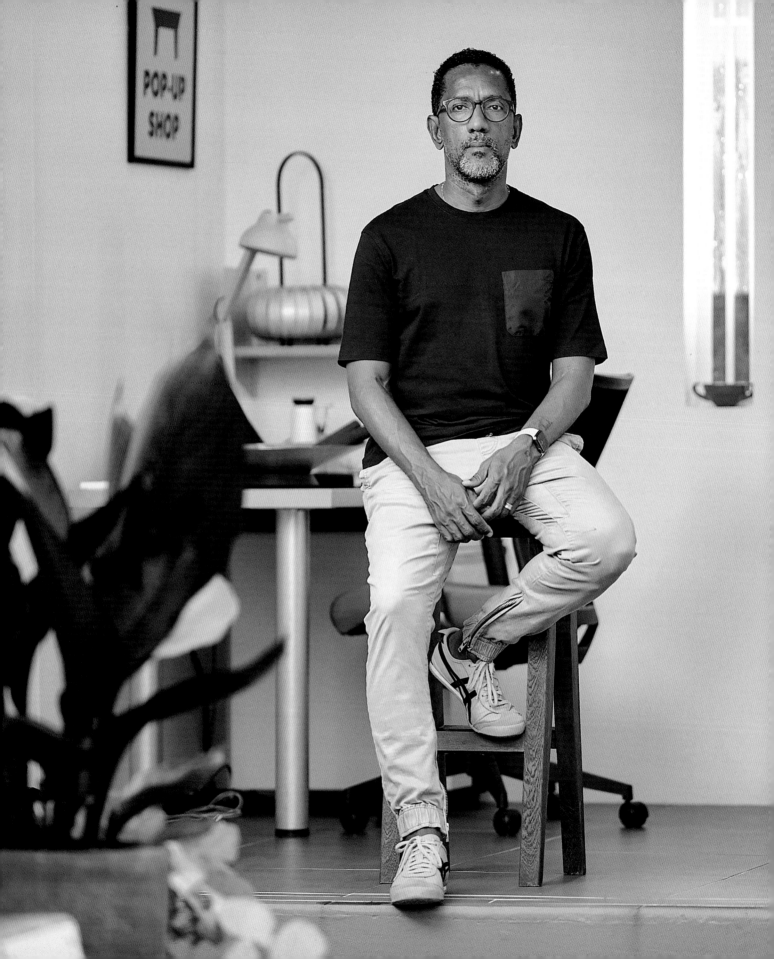

Marlon

DARBEAU

A PRODUCT DESIGNER WHO CREATES TO COMMUNICATE

I started my practice as a graphic designer, and so I design products as a way of translating two-dimensional ideas into three-dimensional forms, using a range of different materials. Because my work is rooted in visual design, I'm constantly attempting to communicate.

Was there a moment in your career when you had to reinvent yourself or your practice because of an obstacle?

I'm in that space now. At least two years before the pandemic, my career was starting to change as I shifted away from my work in commercial graphic design and started thinking about how to involve my practice in product design.

I was interested in the connection of people and their skills, working with craftspeople across the island. My wife, Melissa, and I decided to build a studio space where we could invite people into a more collaborative process. I wanted to rethink the meaning of the work, and whether I wanted it to be commercial and mass-produced. Some part of me, at least then, wasn't fully ready for what that meant, and how I had to change the way I operated. I had to think about why I am making these objects. I want to make quality objects that are compelling, even if their function is simple.

I've been playing with this idea of making delightful design objects that transform ordinary aspects of living into joyful experiences. I want my enjoyment in design and making to translate to the object so that whoever purchases it has some experience of the feeling I get when I make it. Every object I make should bring a degree of joy. That's meant bringing more patience back to my practice because it can take two years to develop a project.

What facets of your identity are most prominent in your work?

If anyone is paying attention to the way in which I name my products, they'll see that it's about local language. I'm trying to record the way we speak and letting that create a resonance with what you're looking at or experiencing. With *Peera*, for example, the name was sort of a joke. It was originally going to be *Pira* or *Peerah*, but I changed it to *Peera* as a reference to Geera pork [a Trinidadian dish] and because I discovered that a peera is actually a small East Indian sweet in Trinidad and Tobago. Infusing that essence of who we are in the Caribbean into the names of products is really important. I designed a bench called *Scene*. It's about being seen, wanting

> **"I've been playing with the idea of making delightful design objects that transform ordinary aspects of living into joyful experiences."**

to be seen, and it's also how we say you're causing crazy drama in Trinidad: "You're making a scene. Why you're being so loud?" It's basically using language that is not normally used to define a refined object in the context of an object that is not necessarily seen as sophisticated by outsiders. At every turn, there's an attempt to use language as a way of talking about identity through my objects.

How legible do you want these interpretations to be to non-Caribbean or non-Trinidadian people?

I'm not sure it's my responsibility to adjust them for anyone to understand. If the work is compelling or intriguing, it may lead to conversations and people's own investigation.

How does joy or a sense of play inform your work?

With the *Peera* box, there's a surprise factor, like when the bench and the wooden box are together, you don't know what it is. You think it's a toolbox, but then you pull it apart and discover that it's also a bench. There's an aha moment, and you start laughing! There's also the cultural level where small benches play a major role in people's lives, around the world and particularly in Trinidad. My dad had his little bench that he would sit on, even when he didn't have a formal workshop. He would sit in the garage on this little bench and construct components of the mailboxes he made. *Peera* is also a marker for my transition from a graphic designer to someone who designs products. The medium mimics a lot of

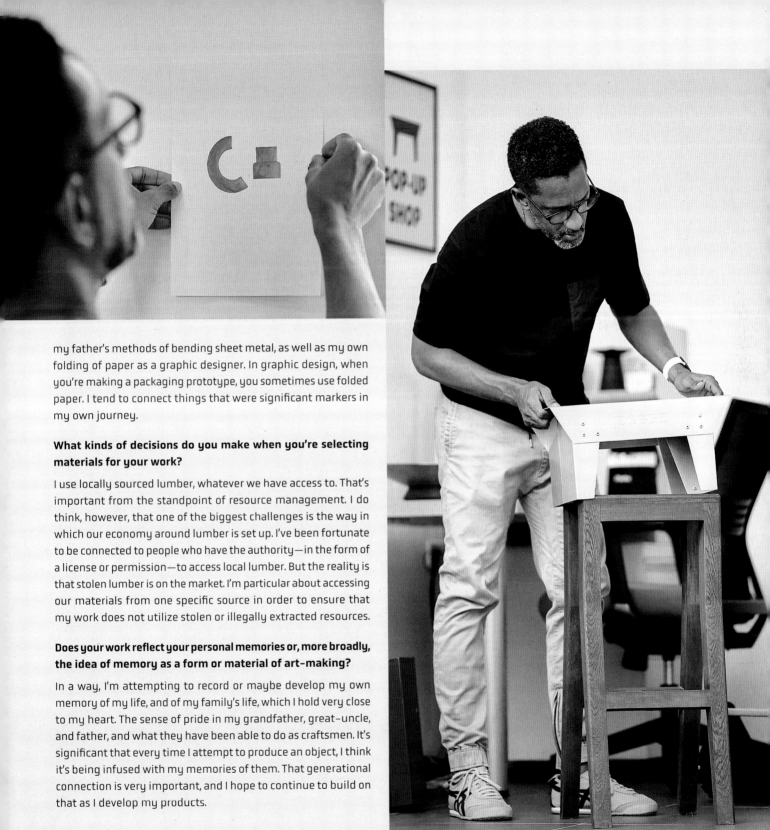

my father's methods of bending sheet metal, as well as my own folding of paper as a graphic designer. In graphic design, when you're making a packaging prototype, you sometimes use folded paper. I tend to connect things that were significant markers in my own journey.

What kinds of decisions do you make when you're selecting materials for your work?

I use locally sourced lumber, whatever we have access to. That's important from the standpoint of resource management. I do think, however, that one of the biggest challenges is the way in which our economy around lumber is set up. I've been fortunate to be connected to people who have the authority—in the form of a license or permission—to access local lumber. But the reality is that stolen lumber is on the market. I'm particular about accessing our materials from one specific source in order to ensure that my work does not utilize stolen or illegally extracted resources.

Does your work reflect your personal memories or, more broadly, the idea of memory as a form or material of art-making?

In a way, I'm attempting to record or maybe develop my own memory of my life, and of my family's life, which I hold very close to my heart. The sense of pride in my grandfather, great-uncle, and father, and what they have been able to do as craftsmen. It's significant that every time I attempt to produce an object, I think it's being infused with my memories of them. That generational connection is very important, and I hope to continue to build on that as I develop my products.

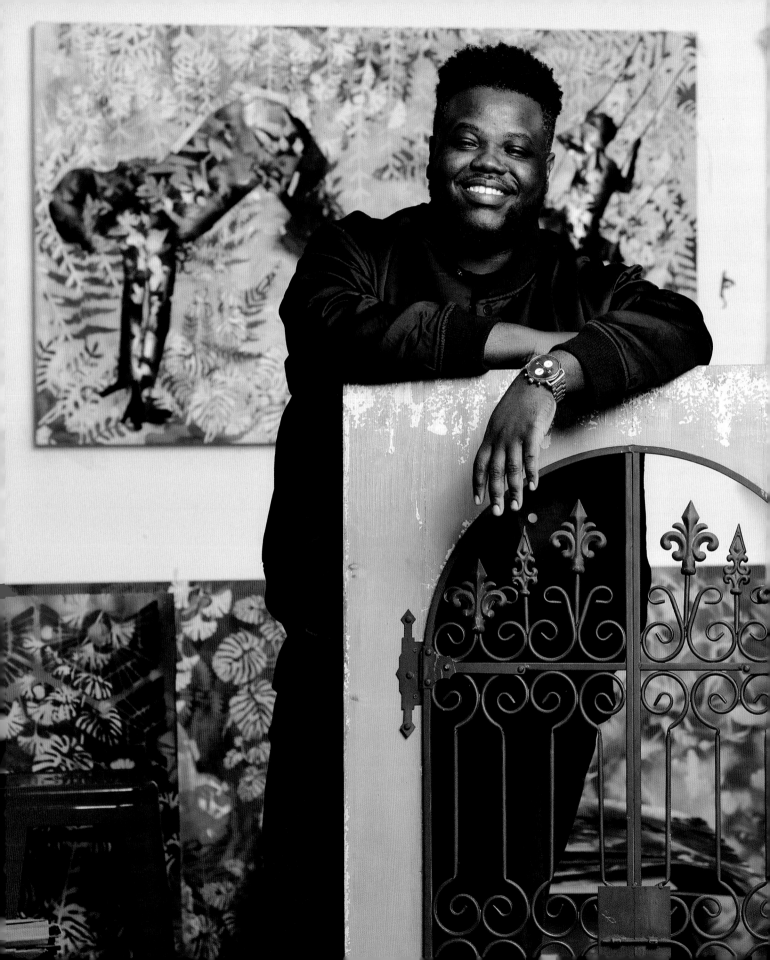

Morel
DOUCET

A MULTIMEDIA ARTIST AND EDUCATOR WHOSE WORK PROVOKES VIEWERS TO INTERROGATE TRUTH, REALITY, AND WHAT LIES BENEATH THE SURFACE

My practice is multidisciplinary, but the foundation has always been painting, drawing, and ceramics.

What did you make as a child?

Attending a specialized art school exposed me to various fundamental aspects of art. I engaged in observational drawing, created still lifes, explored plein-air painting, and delved into darkroom photography. Among my early ceramic creations is a white clay piece of a snail that my dad still proudly displays in his home in Haiti.

Was there a moment in your career when you had to reinvent yourself or your practice because of an obstacle?

During my time at the Maryland Institute College of Art (MICA) in Baltimore, I had initially planned to study illustration. In my junior year, a significant moment altered my course of study. I had a professor who was notoriously difficult and acted as a gatekeeper to the industry. After experiencing their teaching style, I realized I didn't want to subject myself to that kind of professional environment. That's when I changed my major from illustration to ceramics, which marks the beginning of my journey toward an artistic career. I graduated from MICA with a major in ceramics, a minor in creative writing, and a concentration in illustration.

I'm currently revamping my artistic approach once again. I recently stepped down from my job as a museum educator at the Institute of Contemporary Art in Miami. I'd been teaching for over ten years, starting at the Pérez Art Museum Miami. I was a member of the original team of educators who cut the ribbon. I was working in the building with a hard hat before it even opened to the public. I learned so much from PAM that I wanted to keep growing and climbing the ladder, but opportunities were limited there. After about five years at PAMM, I started to doing programming for other institutions on a contract basis, which led to my job at ICA, where I took over their education program and started from scratch. I've been very fortunate to have been part of two museums that were built from the ground up, and to have had the capacity to build programming.

But now my focus is on my upcoming gallery exhibition. I want that to set the precedent for what the next five to ten years will look like for my work. I've told myself that the energy you put out is always going to be reciprocated. So I'm being

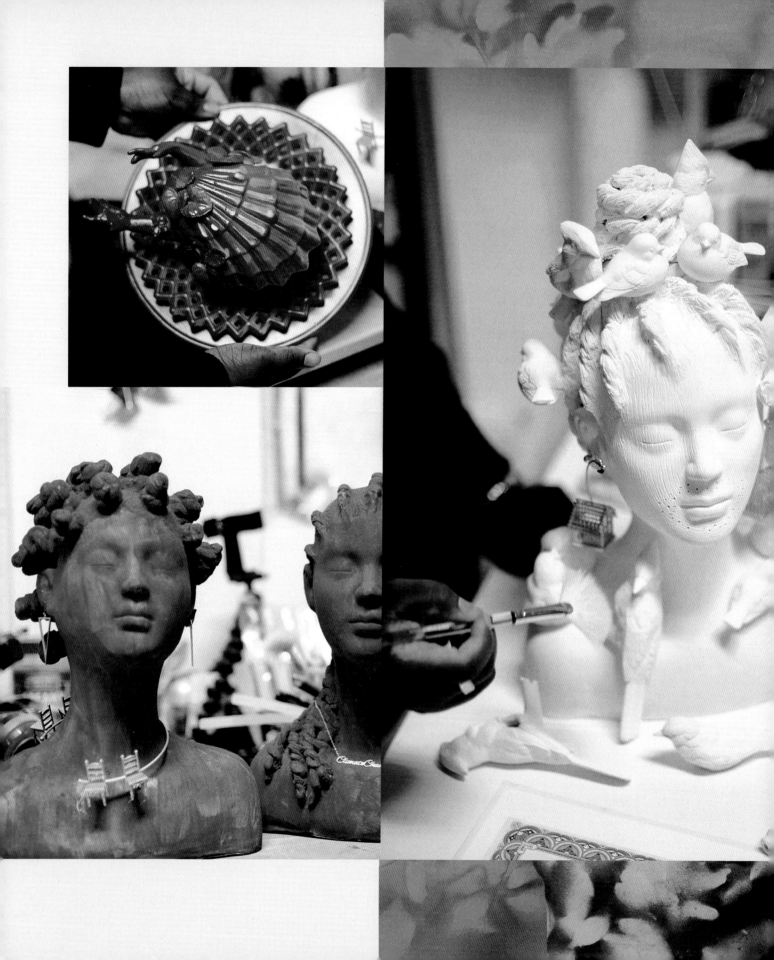

my authentic self and applying the skills I learned as a museum educator in my practice as an artist.

How have you crafted a kinship with the land, people, and culture of the Caribbean?

Ceramic is a thread that is woven into the fabric of humanity. Archeologists are able to understand the dietary conditions and medicines of past civilizations based on the pottery shards that are left behind. But ceramic also has elements of magical realism. I'm working with this substance that's been here on this earth for millions of years, that connects me to the past. Of all the tools available to me as an artist, this medium best creates that connection.

What feelings are you trying to evoke through your work, and what do you hope viewers will do as a result of their interactions with it?

I like to entice the viewer with beauty while reminding them of their complacency in the dying environment. I see myself as a beacon that disseminates the truth. You can take it, you can leave it, you can focus on the aesthetic of the work, you can admire the craftmanship and the beauty of it, but there's always more to it. I invite you to take that deep dive to investigate the many layers in my work. But I don't force it. I don't need an artist statement to tell viewers what the work is about. I want the viewer, based on allegory and storytelling, to come to their own understanding of the work.

How has your work sought to expand the view of non-Caribbean Black identity and culture?

When I was in college, I wanted to be this Banksy-like character who wasn't visible in producing the work. I just wanted to produce the work and put it out there. But I realized that people were forming their own interpretation of who I was—thinking I was a female artist or a white woman. I had to take agency over my work because I didn't want others defining my story for me. By staying behind the scenes, I was doing a disservice to myself and the work. I'm proud to be Haitian American, and that is the foundation of the work.

To what extent do you feel the need to reconnect with your island or community as a member of the diaspora? And what does that connection look like for you?

For me, that reconnection has been in the form of teaching in the community. Staff members at the Pérez Art Museum were a little more diverse, but during my first four and a half years at ICA Miami, I was the only full-time Black employee in the entire

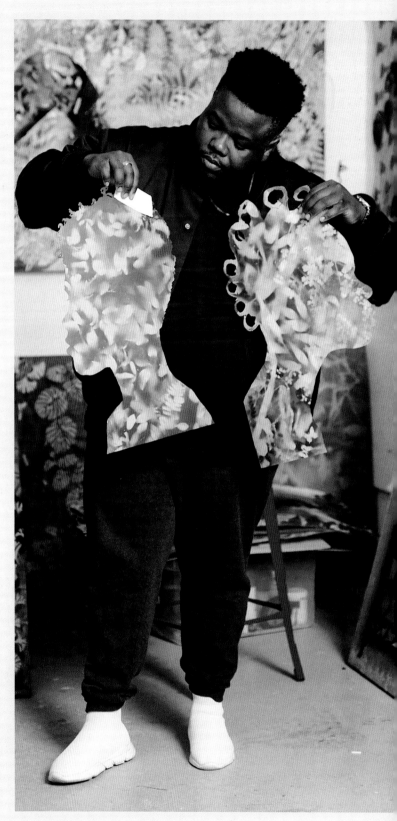

in 2005, which was the beginning of the neighborhood climate exodus. The gentrifiers in the form of developers followed. Imagine two months without power and only cold showers. The darkness would do something to your soul. The silent chatter of the night stars would fortify your spirit. My grandfather always said, "God is not the author of confusion and despair, but I wonder why he'd be putting us all these obstacles so often." Aren't we creatures of free will in our own demise.

I want to capture the essence of a neighborhood through authentic moments of joy. This picture shows it perfectly—the guys playing dominoes, the girls braiding each other's hair, and the grandma walking along the block every morning. These moments define the character of a neighborhood. That's why I'm working on a new project for my solo show, which will showcase Black joy and rest. We've seen enough Black pain and slavery movies—it's time to usher in a new era of Black art with a fresh color palette and imagery.

What facets of migration, movement, change, adaptation, assimilation, and/or diaspora are evoked through your practice?

I'm planning to introduce birds as a motif to talk about migration and traveling. Drawing from Maya Angelou's early collection of poems, I created an illustration titled *Black Maiden (The Caged Bird Sings a Soliloquy of Midnight Veil)*. In it, there's an open birdcage and the birds are free, but the Black maiden is bound by wire or vines. It's a way of exploring how our Caribbean islands have overcome colonialism but are still bound by economic hardship, and by lack of access to education, clean water, and electricity. These are the new Caribbean Jim Crow laws affecting different islands.

Is there anything else you'd like to share?

I would tell young, emerging artists from the Caribbean to find a community that supports your work. Be an advocate and champion for yourself, and don't give up. Failure is an opportunity to reinvent yourself.

museum. When I went into communities where students look like me, I could say, "You don't have to pursue a career in football or basketball. Museum education can be for you. We need more people who look like us in these spaces." I allocated a lot of resources to programming in Black and brown communities and with Black and brown artists and educators who needed the opportunity or the exposure. One of the programs I organized was arranging studio visits, which I believe can be very motivating for aspiring artists.

What does joy look like for you? Does joy in a Caribbean context feel different from its expressions in other cultures or countries?

I've come to understand joy as the intimacy of community and family. I wrote an essay in my journal on April 12, 2008, titled "Secrets That the Wind Carries Away."

> It's midday. The sun is baking the soil like eggs over easy. The air is filled with the sweet scents of jerk chicken and fried okra. Haitian kompa music beats the ground like caffeinated hammers. The men are gathered around domino tables gambling, making a fuss. The neighborhood boys are playing basketball with a broken milk crate for a hoop, and the girls are braiding one another's hair. The block is hot and vibrant, a tight-knit community where everyone knows one another, where three generations live in the same household. Hurricane Katrina struck us hard

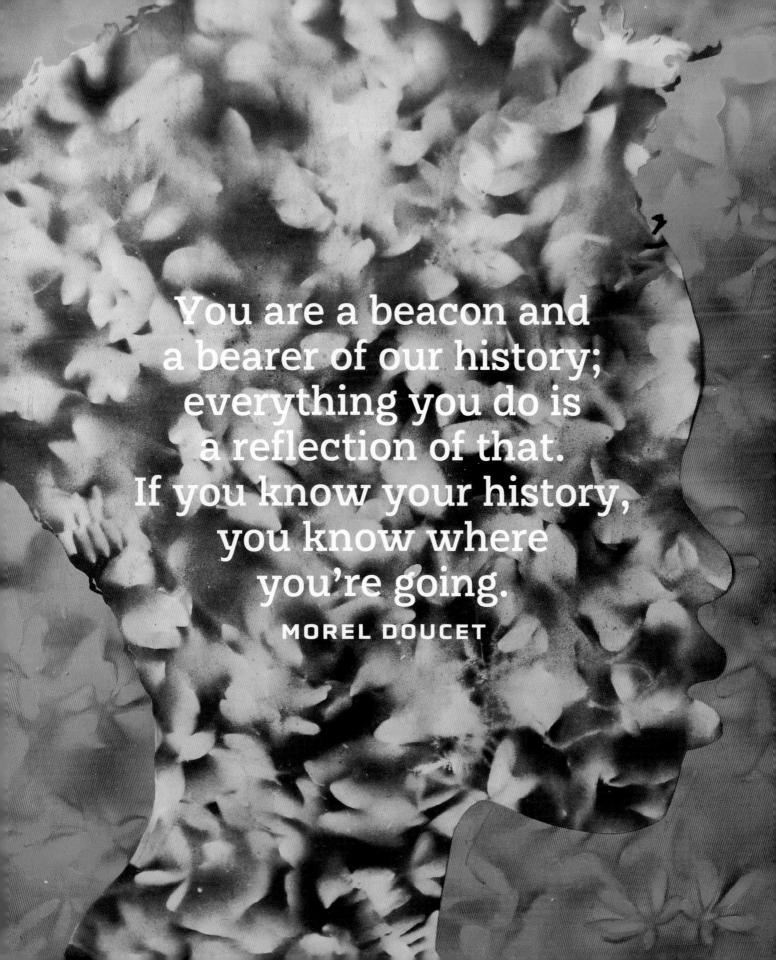

You are a beacon and
a bearer of our history;
everything you do is
a reflection of that.
If you know your history,
you know where
you're going.

MOREL DOUCET

CLOSING THE GAP

A VIEW OF CARIBBEAN ART AND DESIGN

DR. MARSHA PEARCE, IN CONVERSATION WITH MALENE BARNETT

How do you frame art and design as separate or interconnected practices in your research, exhibitions, and/or writing?

Practices of art and design share foundational considerations including line, shape, space, color, texture, balance, contrast, rhythm, and emphasis. Yet these two creative spaces are often partitioned. Designers are understood to be solution-oriented. They find answers to problems. In contrast, the artist is said to unearth questions. The gap widens in discourses that argue for a distinction based on attaching the notion of functionality to design.

Design is considered practical, while art can be made for art's sake, without a purpose or justification. This boundary, however, is an unsettled one. Writing about Black art, Maulana Karenga, the author, activist, and creator of the African American holiday of Kwanzaa, signals its function. He states, "The real function of art is to make revolution, using its own medium." Similarly, the late Jamaican cultural theorist Rex Nettleford described Caribbean artists as "functionaries" whose creative acts are "prime sources of energy" in a quest for cultural confidence. He underscored the social function of art-making with his observation that "Caribbean society, which is in dire need of a sense of community and of integration of personal awareness with collective consciousness, continues to cherish the . . . artist, perhaps because in serving themselves these functionaries must first serve their society." In my research in the field of visual culture, I am interested in the ways in which art and design engage the taken-for-granted—how they confront our assumptions.

Both art and design attend to our aesthetic experience. When I say "aesthetic," I do not mean beauty. Instead, I am referring to the idea of aesthetic as perception. In other words, I am thinking about how art and design address, challenge, and recalibrate ways of seeing. As cultural practices, art and design are also sites of power and meaning making. What kind of communicative agency do they facilitate? Which stories and experiences are represented or rendered invisible? What identities are foregrounded? Who is left unseen?

Some ideas persist and remain relevant in contemporary Black Caribbean art and design. Urgent themes include a look at climate change, Black spatiality and temporality, monumentality, memory, displacement and (un)belonging, care and well-being, the archive as a site of creative practice, and narratives that trouble the conventional boundaries of being human.

Historically, art by Black makers from the Caribbean was categorized as "craft." How do you see Black makers reclaiming the term *craft*, and using materials and methods that embody and/or critique forms of making (weaving, embroidery, pottery, wood carving, crochet) that were traditionally identified with craft-as-labor versus craft-as-artistic-expression?

The term *craft* is often associated with technique—a practice divorced from or regarded in opposition to expression. That is, craft as material and method, rather than craft as message. The reclamation of this term among artists involves redefining the link between craft and matter. In such efforts, how we understand

craft is widened beyond a process that yields only matter—a thing that has volume and mass; a thing with material substance—to make room for craft as that which addresses subject matter, ideas, and feelings. To reclaim the term is to broaden craft beyond the domain of manual dexterity, to include intellectual and emotional labor. Work by Trinidadian artist Adele Todd is one example. Her embroidered pieces explore "hard topics using soft materials" (to use her words), a paradox that heightens the tension in works that address violence, identity, and nationalism, among other concerns. John Beadle's sculptures in carbonized mahogany are another important reference point. The Nassau-based artist uses the act of wood carving as a language to express a range of ideas, including those of security and migration. Artist Anina Major draws on the Bahamian straw-weaving industry and her personal history (her grandmother was a straw vendor), translating this practice into her investigation of clay and the making of ceramic pieces. Her work attends to notions of belonging, memory, and the impact of globalization on craft traditions. Ultimately, practices by artists such as Todd, Beadle, and Major show us not only what it means to work with one's hands but also what it means to craft human relationships. As sociologist Richard Sennet says, "The craft of making physical things provides insight into the techniques of experience that can shape our dealings with others." This is the reclamation effort.

The Caribbean is a small place that significantly impacts the world. What part of your Caribbean identity or research/ curatorial practice do you think is resonant in the broader ecosystem of contemporary art and design?

The process of creolization continues to play a crucial role in the Caribbean, and it is a process that has implications for the practices of contemporary art and design. Martinican scholar Édouard Glissant tells us: "If we assume that métissage is generally the result of an encounter and a synthesis between two different components . . . creolization is a métissage without limits, the elements of which are manifold, its outcomes unpredictable." If we think about art and design as domains of creative encounter—as Creole spaces of making—this invites us to engage them in their complexity, with their potential for myriad outcomes that attend to everyday life, extending to the past and projecting into the future. Framing art and design in terms of creolization allows us to resist the formula or the cliché. It accommodates unpredictability, or what I call unruly relationships, among ideas, materials, places, and people—relationships that defy the logic of colonial order and being.

Dr. Marsha Pearce is a scholar, educator, and independent curator based in the Caribbean. She holds a PhD in cultural studies. Dr. Pearce teaches visual arts at the University of the West Indies at St. Augustine. Her curatorial projects include collaborations with the Pérez Art Museum Miami, the National Portrait Gallery in London, and the British Council.

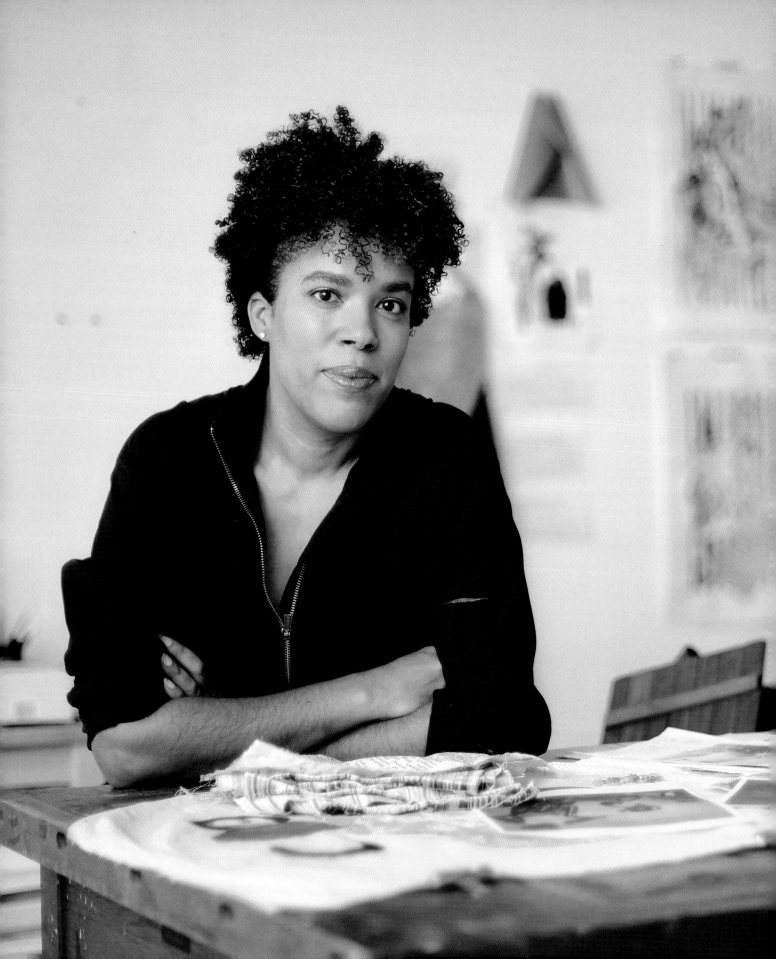

Nadia
LIZ ESTELA

A MULTIMEDIA ARTIST WHOSE WORK QUESTIONS OUR
RELATIONSHIPS WITH BORDERS AND MEMORY

I would describe my practice as something that's ever changing and growing. I work through paintings, performances, and installations. With my performances, I want them to register as a painting, specifically the brightly colored landscape paintings or still lifes of papayas, mangoes, and plantains that were in my mother's home. The imaginary worlds I create find threads of meaning with other people's lived experiences.

What did you make as a child before you even knew to call it art or design?

When I was seven years old and my parents migrated to the United States, I stayed with my grandmother, and she was so upset that all the paper in the house was disappearing because I was making paper airplanes obsessively. At that time, I didn't think anything of it, but I later realized that it was my way of dealing with my feelings of abandonment.

Was there a moment in your career when you had to reinvent yourself or your practice because of an obstacle?

I feel like I've reinvented myself in countless ways. I didn't own the word *artist* until I was older. I came from a working-class family, and making art was just something I did on my own, for myself. It wasn't until I was thirty-five that I went to graduate school, when my kids were seven, five, and two years old. My mom and dad said they always knew I was an artist. So did my husband. At the open house for my graduate program, people said, "You're supposed to be doing this." Who I am today is not the person I was two years ago or the person I'm going to be five years from now. That's the least I expect from my practice and the questions I'm asking.

How have you crafted a kinship with the land, people, and culture of the Caribbean?

Before the Dominican Republic became a tourist economy, it was a big exporter of wood. So I start my paintings by redrawing or tracing the grain of the wood panels, which is a form of mapping and remembering what was there before. The way I work is very much about what happens to a place or how we think about a place on the map. Because my source material is my history, I can't help but be directly tied to the narrative.

The Caribbean is a small place that significantly impacts the world. What part of your Caribbean identity or art practice do you think speaks to what is needed in the world right now?

I made an installation and performance piece in 2017 during graduate school titled *To Give, Forgive, Give*. For the performance, I cooked sancocho in the gallery and I invited other people to join me because sancocho normally takes three to five hours to make. In the Caribbean, that is how my mother and my aunts showed love: in communion. Whether you showed up at the beginning to cut up the plantains, or midway through to stir soup, or at the end to eat and then to do the dishes, all of it was a form of love, communion, and meditation.

What does community look like for you as a maker living and working in the diaspora?

In my performances specifically, I always invite this moment of meditation. We're going so fast all the time. Sometimes you can be in a room full of people and feel completely alone in the chatter, or you can feel completely held in a room full of people when it's silent. I crave moments of meditation when feelings of rest and belonging show up.

To what extent do you feel the need to reconnect to your island or community as a member of the diaspora? And what does that reconnection look like for you?

I remain connected through food. But also through the oral history I have found in the last couple of years. I appreciate the willing-ness of my mother and grandmother, for example, to speak a little bit more about earlier times. Because there was this idea that you were going to come to the United States, reinvent yourself, and forget all the things from your home country; they don't want to talk about that country. They want to let it go. But then they have children, and the children have all these questions. And as the older generations age, they begin to understand that their suffering or those things they're trying to remember to forget are the things that those of us who come behind need to know in order to become whole.

Can you talk about how or whether your work closes the gap between art and design practice, or whether you would like to close that gap more?

It's important to me to close the gap between art and design by using beauty. The genesis of existence revealed to us the spirit and living soul of the world through colors. I use the beauty of color and light the way designers do, to lure the viewer. I'm going to show you this thing to get your attention because it's so pretty. These colors will draw you in, but then I'm going to subvert your

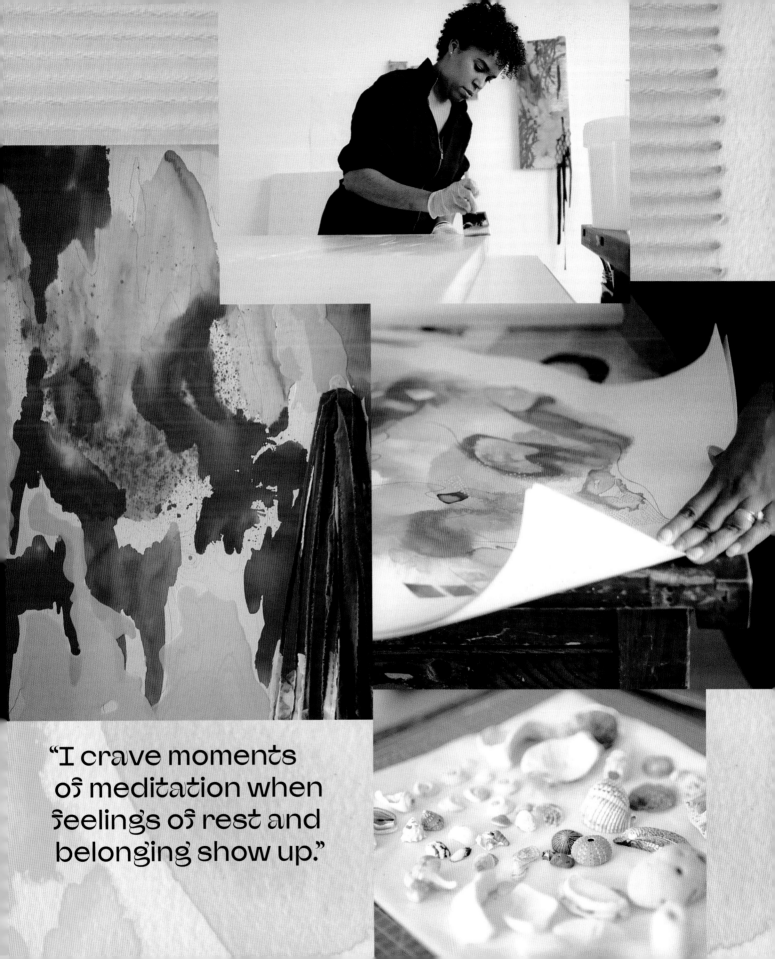

"I crave moments of meditation when feelings of rest and belonging show up."

gaze and ask you these questions—about race, about gender. I'm going to ask about your complicity in systems of oppression. I'm going to ask questions you don't want to talk about. I'll use a visual language of line, color, and space to address thematic ideas that I witness in the work. That's where I see the importance of design, in the responsibility of design and art.

What does cultural memory mean to diasporic people or in the context of Black Caribbeanness?

I reject the textbook understanding of what my Caribbeanness is. I make these paintings because my Caribbeanness does not come from what the textbooks tell me I'm supposed to be. It comes from my lived experiences, and my family, and the food and the colors and literally tasting the soil with my hands. My mom used to say that when it would rain, I would go outside and eat dirt. I learned later that that's a thing—that people eat or crave dirt. I don't feel that craving here in the U.S., but I felt it when I lived back home in DR.

Do you see the act of making as a spiritual practice?

When I trace the wood grain to start my paintings, there are times that I go into a kind of meditative trance.

Is there anything else you'd like to share?

In a talk at the New York Public Library in 1986, Toni Morrison said, "All water has a perfect memory and is forever trying to get back to where it was." As people from the diaspora and those who make work, we are all looking for the source. We're all looking in our dreams and in our worlds for the idea of home and place.

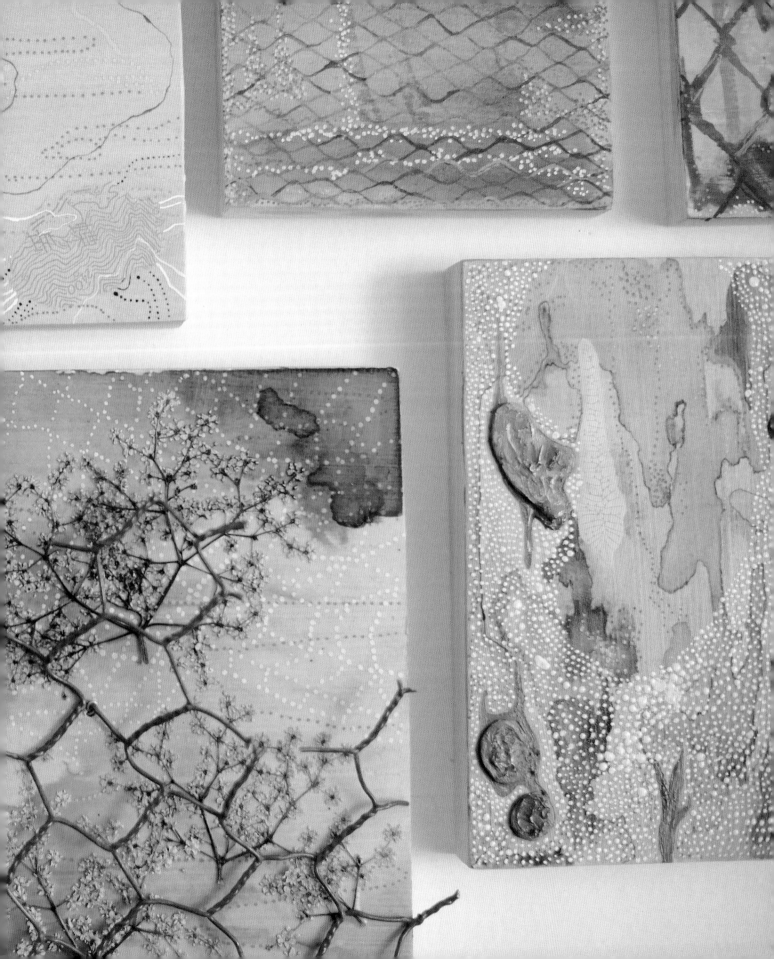

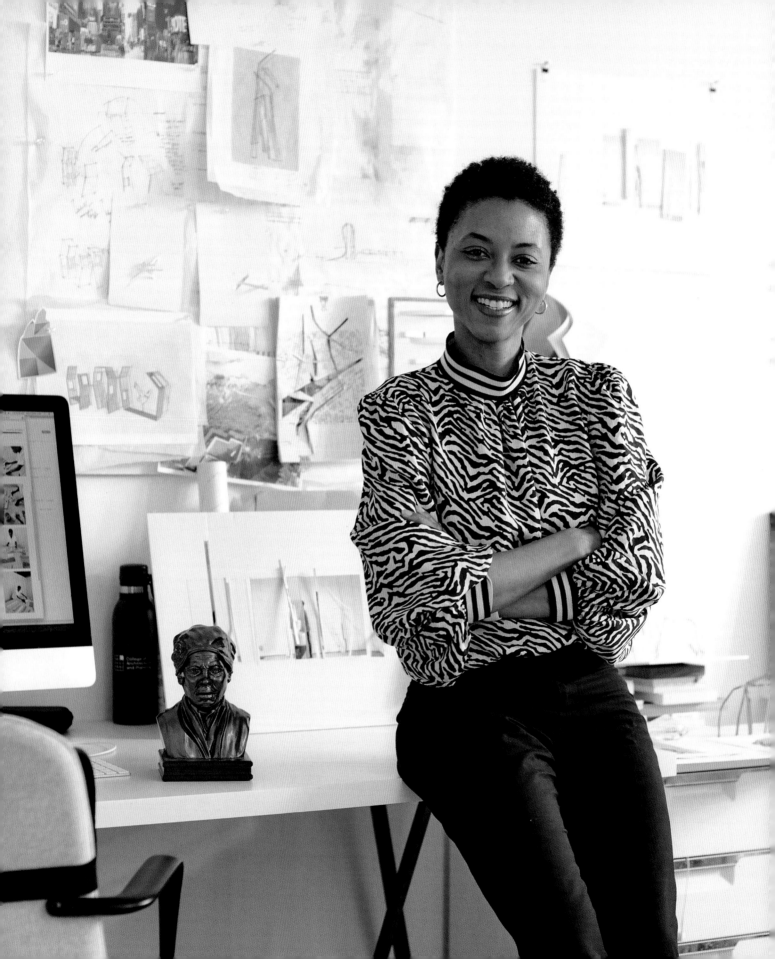

Nina
COOKE JOHN

AN ARTIST AND ARCHITECT WHOSE WORK
CLAIMS SPACE FOR BLACK STORIES

I have a multidisciplinary practice spanning collage, architecture, and public art. The practice aims to transform relationships between people and the built environment. The scale of the human body—both the single body and how bodies act collectively—is important to the work. It responds to the crisis of identity in moving from one world into another. The work explores identity as a layered experience, encompassing a multiplicity of possible manifestations in the complex engagement of individuals with urban life. It investigates formal compositions that claim space for the process of self-actualization, space within which we can all be seen.

An intuitive power is released when I allow my hands to guide the placement of lines on paper, the angling of forms in space, and the combination of found objects. I guide the work through an investigation of layered space, layered time, layered perspectives with the acknowledgment that urban landscapes are complex, people are complex, and life is complex.

What did you make as a child before you even knew to call it art or design?

I wasn't really a maker as a child. I thought I was going to be a doctor up until my last year in high school. Growing up in Jamaica, being a doctor or a lawyer seemed to be the only available options. I also had to stop art classes really early on as I switched to all science classes. In my last year of high school, I decided to take a painting and ceramics class in the evening after school.

Was there a moment in your career when you had to reinvent yourself or your practice because of an obstacle?

For about fifteen years, while my children were young, my art practice was on hold as I focused on residential architectural design. Residential architecture allowed me to work flexible hours so that I could more fully engage in the lives of my children. The design work was creative; however, it wasn't until my children were older that I was able to devote more time to reintegrating art into my practice.

What feelings are you trying to evoke through your work, and what do you hope viewers will do as a result of their interactions with it?

I'm hoping to evoke an understanding of a layered experience—that there isn't one way of seeing things or one way of being. We have multiple expressions of our identities as individuals, as women, as Black people. The collages, most directly,

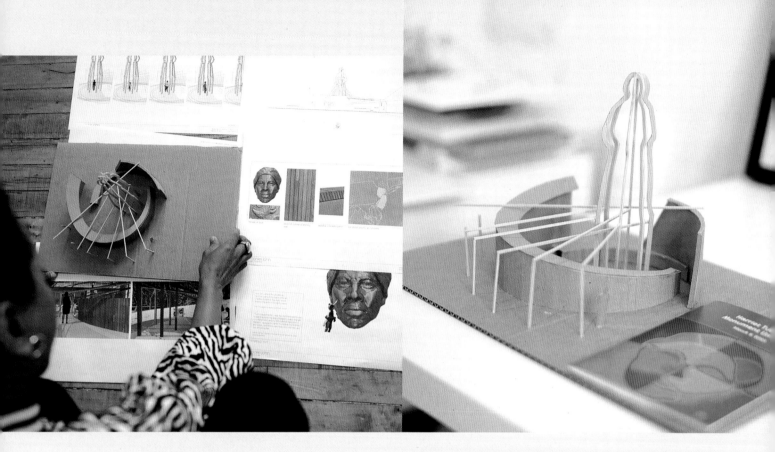

work with this intention of being able to see something different each time you engage with them.

What does community look like for you as a maker living and working in the diaspora?

Community means a safe space in which I can be my full self, giving me the power to be creative. My creative community provides support as I navigate both practical and artistic obstacles that I might encounter. It includes Black architects and best friends that I met as an undergraduate at Cornell University, my extended art and design community, and my Black designers community. I call on my community for business advice and for feedback on my creative process.

What does reconnection with your island look like for you?

I need to constantly reconnect with my island as a member of the diaspora. I have children, and it is important to me that they understand who Jamaicans are and what Jamaica is. My husband is from St. Vincent and the Grenadines, and so we go to either Jamaica or St. Vincent each year to spend time with family, explore the islands, and reconnect with people. I follow Jamaican artists, comedians, and news outlets on Instagram so that I can feel connected to the culture as it is evolving and not just stuck in my memories of what it was when I left thirty years ago.

Is there a vibrant Caribbean or Jamaican community where you currently live and work? And if so, how has that informed or impacted your creative work or professional goals and opportunities?

Jamaicans make up one of the largest immigrant groups in the New York metropolitan area, where I live and work. I am constantly observing and exploring how Jamaicans make a space for themselves in the complexity of this city. I engage directly with these issues in my collage and public artwork.

Can you talk about how or whether your work closes the gap between art and design practice, or whether you would like to close that gap more?

I understand my work as being on a continuum from art to architecture with public art in the middle. Architecture demands a practical groundedness because of its essential purpose of providing shelter. However, in my practice, there is a formal investigation in the architectural work that taps into pure intuition. Any viewer of my architectural work or public artwork should feel a strong emotional response to the space and forms that I believe make it art. I start much of my work with collages to engage with the intuitive and artistically expressive portions of myself that I want to be present in the work. This is true whether it is an architectural space, a public artwork, or a sculpture.

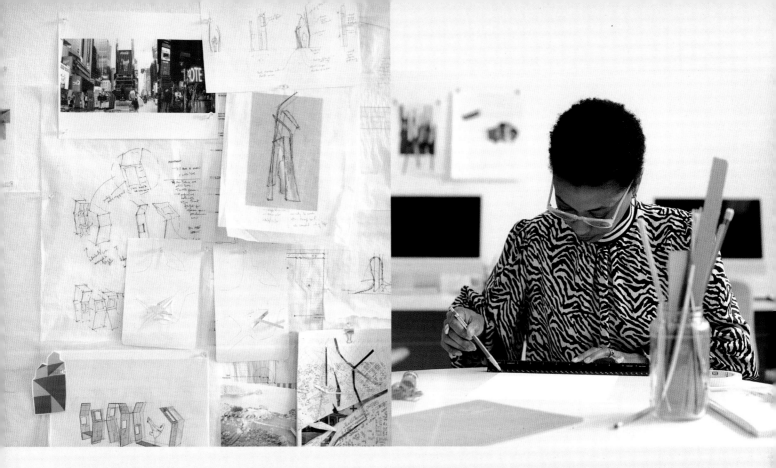

What preconceptions about Black womanhood or Black manhood are you seeking to address in your work?

The stereotypes of Black women—as fierce, oversexualized—render any women with different characteristics invisible. The Black man in the public space is oversurveilled, but the Black woman (often an essential worker) disappears into the background.

How does this reflect the message and role models in your family or ancestry, in your community, in your culture, and in the world outside of the Caribbean in the work of other artists?

My grandmother came to the United States from Jamaica and was a nurse's aide for the rest of her working life. She took care of the old and the sick, often in the background. My own mother remained in Jamaica and retained her fierceness, perhaps strengthened by the education she was able to receive there and the space she was able to carve out for herself in a country in which she could see other Black women in different roles. I have been inspired by many Black women writers—Audre Lorde, Saidiya Hartman—and their exploration of the invisibility of the Black woman.

What provocations about Black womanhood or manhood does your work offer to viewers? What do you want them to feel, do, ask, or become when they encounter your work?

Below is an excerpt from an essay I wrote that addresses this.

Invisibility

"Within this country where racial difference creates a constant, if unspoken, distortion of vision, Black women have on one hand always been highly visible, and so, on the other hand, have been rendered invisible through the depersonalization of racism." —Audre Lorde, *The Transformation of Silence into Language and Action*

The work references Ralph Ellison's *Invisible Man* and how, as Ellison says, we are unseen "simply because people refuse to see" us: "When they approach me they see only my surroundings, themselves, or figments of their imagination—indeed, everything and anything except me."

The work sits within the context of the tokenism of the sidekick, present but without voice; the hypersexual images of Black female bodies; and the stereotype of the angry Black woman (who should be nice and disappear).

It acknowledges Black-on-Black stereotypes—the 'Bama Black, African booty scratchers, and not being Black enough—all images that reduce. An extension of the violence that is paring down a subject to an image, as in Edward Said's discussion of Orientalism. With this "othering . . . the multifarious nature of Black humanity remains invisible."

What traditions or expressions do you use in your practice that were kept alive through the Middle Passage and survived to this day?

Combining resources from one world with those from another. A bricolaging of "making do." Creating beauty out of horror.

What facets of migration, movement, change, adaptation, assimilation, and/or diaspora are evoked through your practice?

My work explores the Black immigrant experience and how that affects identity. How people are seen or not seen. As well as how the Black immigrant might want to be seen (as different from the Black American) and the realization that they are seen as "just Black" regardless of how they identify themselves.

To what extent does your work engage with the feelings of both loss and gain in the experience of migration? Does your work explore the tensions between diasporic identity and community?

This excerpt from a presentation I gave at Art Omi in the summer of 2022 describes the loss and invisibility of the Black immigrant.

> As a Black immigrant from Jamaica, my work responds to the crisis of identity as one moves from a world in which being Black is not a defining part of one's identity to one in which it is *the* defining factor. I explore the resultant issues of dealing with invisibility and hypervisibility as well as the layered experience of identity encompassing a multiplicity of possible manifestations. I explore this multiplicity in the complex engagement of individuals with urban life and public space. My undergraduate thesis, *The Urban Porch*, completed in 1995, continues to provide the grounding for my work around issues of public space and community empowerment. The project searches for an architectural practice that deliberately carves out space for the disadvantaged and the displaced. It explores the in-betweenness of the West Indian community and their rejection of assimilation, which would put them on the lowest rank of the American racial hierarchy. Leftover spaces throughout neighborhoods in the Bronx and Brooklyn are claimed with community-programmed

interventions. The resultant urban porches provide a place where residents can perform cultural practices that connect them to home while being firmly rooted in New York City.

I keep coming back to these issues; to the in-between, layered experience of the "other" and the appropriation of space by subcultures as they make their mark on the urban environment, and the complexities of visibility, invisibility, and hypervisibility of being a Black woman navigating both public and private space.

"Tun yuh han' mek fashion"— use whatever you have creatively.

NINA COOKE JOHN

Nyugen
E. SMITH

AN INTERDISCIPLINARY ARTIST WHO CREATES OBJECTS AND PERFORMANCES, WRITES AND RECORDS MUSIC, AND MAKES VIDEO ART

There is a fluid stream of consciousness moving through my work that can be seen and experienced by those who spend meaningful time engaging with it.

What did you make as a child before you even knew to call it art or design?

When I was six or seven years old, I made "matchstick men" so my brother and I would have toy people that we made fight and "drive" the toy cars. I collected the used wood matchsticks at home. With the tip of a sharp kitchen knife or box cutter, I would shave off a section of the burned tip, and the raw wood that was exposed became the face and the rest of the burned area "hair." I then took a small piece of aluminum foil, stuck the matchstick through it, and twisted the foil to form little arms that could be bent to the desired position. I made jackets for the matchstick men by poking two holes in a small piece of paper or other material and pushing the foil arms through.

I also designed and made wrestling championship belts for my friends and me using cardboard, black gaffer's tape, spray paint, and markers. We were able to wear them, and they were adjustable.

Was there a moment in your career when you had to reinvent yourself or your practice because of an obstacle?

At the onset of the pandemic, while we were in quarantine, I experienced not having a desire to draw, paint, or sculpt. I turned back to making music. Around 1993, while in high school, I started to write poetry and raps, and I explored the possibility of a career in music during and after college, before making an intentional shift to the visual arts. I continued to periodically make music over the years.

As the lockdown began, my brother DR Smith and I began to make music remotely using an online platform that allowed us to work together in real time. He produced the tracks; I wrote and recorded lyrics. We developed the concept and invited collaborators—Gemma Weekes, a multidisciplinary artist/writer of St. Lucian background, and Melvin Andrews, whom I consider a living music archive and beat maker—to contribute to the project. The music was mixed by our friend Richard "Younglord" Frierson, a former Bad Boy Records music producer. The end product was a limited-edition box set called *ALGO-RIDDIM: A Bundlehouse Sonic Relief Pack*, which

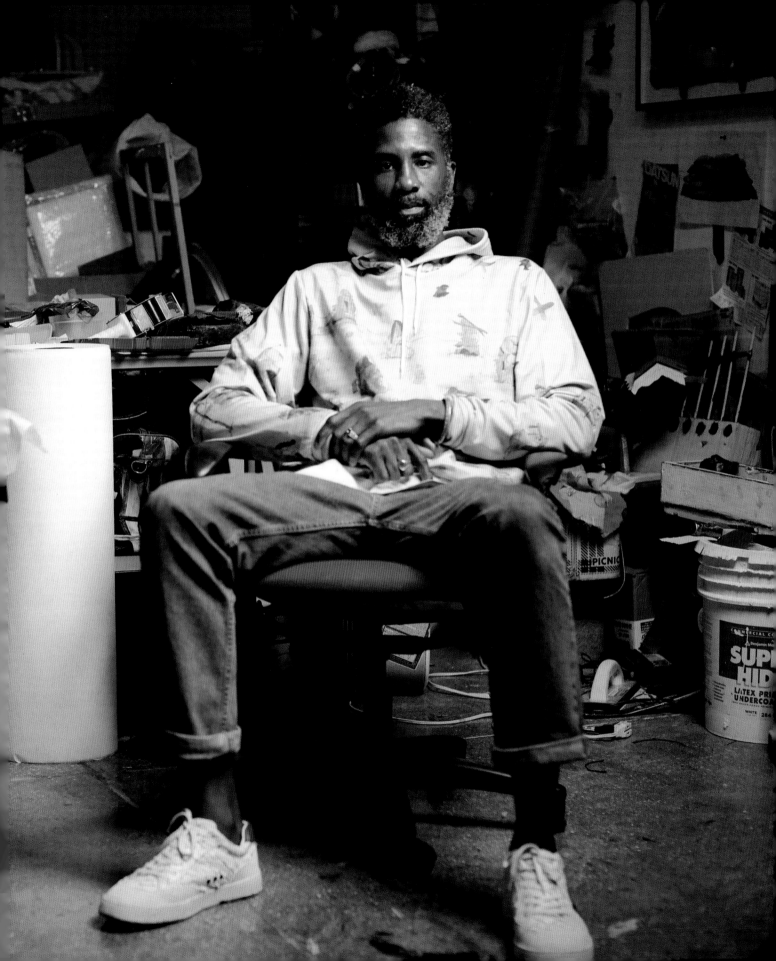

includes a ten-track red vinyl album and other limited-edition art objects. The content of the music is a reflection on my state of mind during that moment in time as we lived through what was happening in the United States politically, compounded by the deadly global pandemic.

How have you crafted a kinship with the land, people, and culture of the Caribbean?

In spring 2022, I had been thinking about the drastic ways in which my familial relationship with Trinidad and Tobago changes with the passage of time. Of the family I grew up knowing there, some have passed away, and I have become estranged from others due to lack of communication over decades. The people I have formed bonds with through art keep me connected to a place I still consider home. Frequently and deeply engaging with their work through social media, offering space for collaboration, accepting invitations to participate and collaborate, and visiting for experiential research are some of the ways that keep me connected. Not just in Trinidad, but also in Martinique, Barbados, Puerto Rico, and Jamaica.

What does community look like for you as a maker living and working in the diaspora?

Community looks very much like what my wife, Sherene the Queen, and I have been cultivating over the years as we work and vacation in the Caribbean and Africa. Friends visit from abroad and stay at our home, we visit them and stay at their homes, we receive photos of their kids as they grow, we collaborate on projects, we help make introductions, we recommend each other for opportunities, lift each other up on social media, check up on each other over the phone—these are just some of the ways we help to build community throughout the diaspora.

How has your work sought to expand the view of non-Caribbean Black identity and culture?

Although I identify as Caribbean American, my work is informed by histories, cultural practices, spiritual systems, geography, politics, and other topics that span the Black diaspora and contain references to specific places in the diaspora that are outside of the Caribbean. For example, at the time of this writing, three months since returning from Kinshasa, capital of the Democratic Republic of Congo (DRC), I am making a new body of work inspired by my learning about staffs, lukasa (memory boards), and other carved functional and ritual objects from the Luba people of Congo.

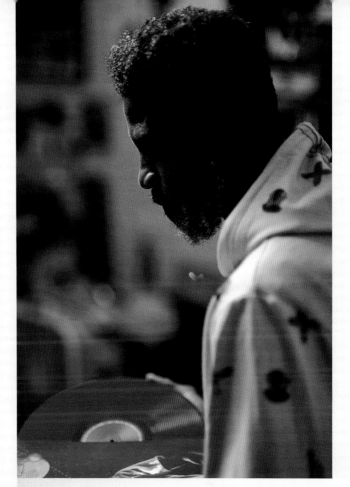

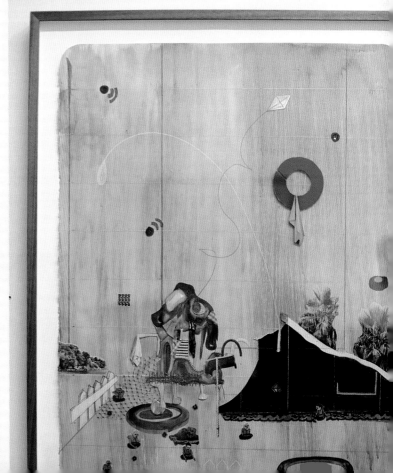

Paul
ANTHONY SMITH

A PAINTER WHOSE WORK REVOLVES AROUND LIFE JOURNEYS

We get only one life, and I try to show the vibrancy of that life in the images I create.

What did you make as a child before you even knew to call it art or design?

From an early age, I learned to understand what materials were. I had lots of aunts and uncles, and each one had their own artistry. My aunt sold soup for a living, and I saw how she went about washing the soup pot using the sandy soil to scrub the ash off the pot. She'd put a flour mixture around the handles of the pot so that no soup would leak from it. That flour acted as a substrate to help the pot sustain the mass of the soup. She made a broom out of weeds she would harvest down the street and dry. My fisherman uncle would carve boats in the yard, and my earliest imagination combined the smell and sense and texture of the tree as he carved out this two-foot-wide canoe. It smelled like wet rain. Even the floors of our veranda were polished with red iron oxide and brushed with dry coconut husks. Everything was to be used.

When I was in the third grade, I went swimming with a friend and bagged up some of the clay from the water's bottom to take home. And that's when I really first started playing with materials. When you grow up learning about everyday materials, you learn to use your hands as a tool in a different way.

Was there a moment in your career when you had to reinvent yourself or your practice because of an obstacle?

I'm always trying to reinvent myself, slowly morphing into a different being. I just had a show in Houston, and when I saw it, I was like, "Okay, I did those things. Now I must slow down and really think about the next ten years of my practice." I don't want to be too expedient. I want to take more time to resolve what I'm doing, to make things that are standouts. I want to be a bit more mature in what I'm presenting. If I put that care into my own lifestyle, I probably could teach others. As a Black man, I have a responsibility to encourage others to take care of themselves, because we often neglect our own needs. It's my way of thinking about the longevity of us.

I studied ceramics because of their crafted nature and because they reflect the history of ceramic-making going back to pots and mud houses. Everything I made, I would either give away or sell because I was like, I'll make more.

When I go back to Kansas City (where I received my BFA from the Kansas City Art Institute), a lot of people have my ceramic work. They have paintings that I made back then. I would paint at home and make ceramics in the studio at school, and the stuff I made at home would influence the stuff I made in the studio. The ceramics are considered craft, and the paintings are art, right? But they are both design and art. You make something and then add design to it to appeal to the masses. Even in art, there's a lot of individual design that is not very identifiable and distinguishable. A lot of the patterns and geometry that get used in my work refer to masks from the Congo. A lot of rudimentary geometric shapes are used as signifiers. Even the chain-link fence is a signifier.

What preconceptions about Black manhood are you seeking to address in your work?

I'm working against stereotypes people have about Black men, Jamaican men, not caring for their families and their children. One of my early works is a portrait of a man with his son in his arms. It conveys care. It asks the viewer to think about how you care for your son, your offspring, and nurture them to be better than you for the next generation.

A couple of years ago, I made a work called *Manhood* that depicted a blue sky above a tropical scene foregrounded by a dark chain-link fence. I was really trying to think about the prison system and being locked up abroad. You hear stories about people who go abroad for work but then get locked up and can't work. From inside, they're imagining what home looks like beyond the black chain-link fence. Part of that story is thinking about how not to be a failure to your family back home. You get the opportunity to go abroad, so you must use it to the best of your ability. Once someone has been locked up, they can't get out of that system. It requires perseverance. How do we persevere to be better people for our children as Black men?

I made a work in 2020 during the pandemic about people on the beach and a mother playing in the sand with her children while men in the background are having a conversation. We don't know what that conversation is about because it's a still image, but it's showing a cookout vibe, a vibe of coming together for that beach. It's calm. It's leisure. I put myself in it with my feet up, but you only see my toes. I'm trying to really think about how to talk about the care of us.

The Caribbean is a small place that significantly impacts the world. What part of your Caribbean identity or art practice do you think speaks to what is needed in the world right now?

It goes back to the leisure, which I don't mean in the sense of commodification but in the sense of relaxing, and not having to acquire anything or use anything that's destructive. Often in leisure, there's a lot of destruction—everything from sunscreen to plastic bottles that damage the oceanfront. The world needs to slow down for a good ten years so the abundance of life can come back within nature.

I've been thinking about seaweed. The Caribbean Sea is warming, and there's an overabundance of seaweed, which is high in nitrogen. All this nitrogen could go back into the soil to help more trees grow because seaweed is a natural fertilizer, but people don't think about it that way. When we used to go to the beach in Florida, we would take the seaweed and use it around the sourwood trees, mango trees, and banana trees and mix it into the soil to feed new plants nutrients.

I'm particularly interested in how we closed the artificial spaces between art and design. Historically, ancestrally, these two types of making practice were not separate. Can you talk about how or whether your work closes the gap between art and design practice, or whether you would like to close that gap more?

Art and design lift each other up. I'm not trying to close the gap. If anything, I'm trying to use each one to elevate the other, because they are different languages. Design is in everything. It's in nature. When we try to remove design from what we're doing, we're not being our true selves. As a creative person, you're always designing. Sometimes I watch construction workers pour concrete or make asphalt, and there's a lot of design that goes into that work.

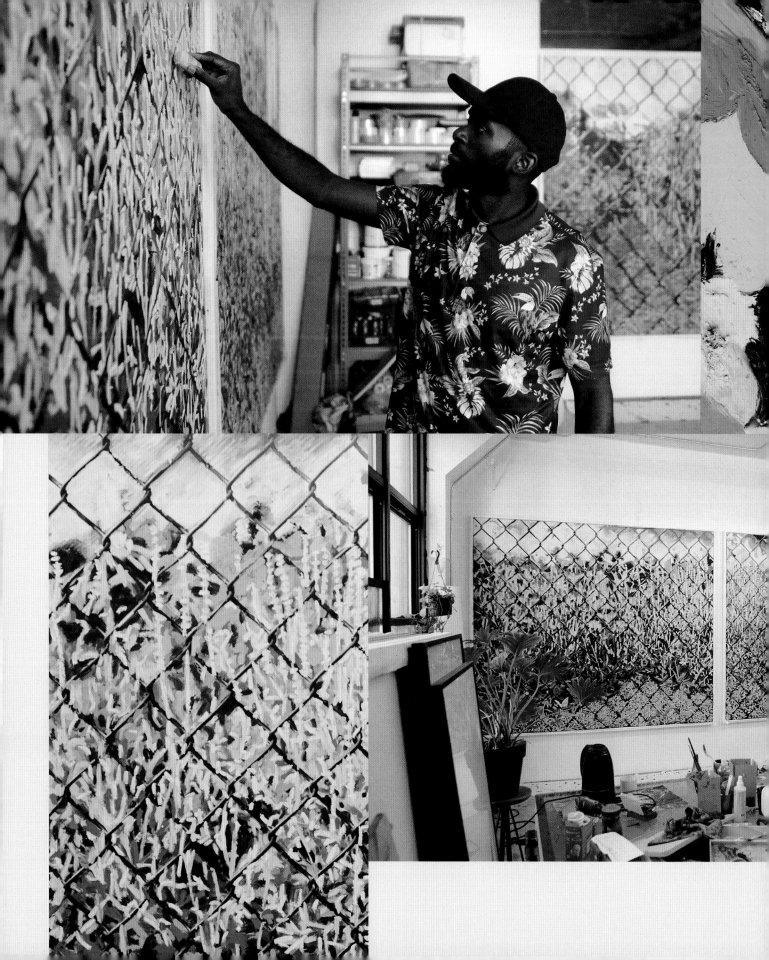

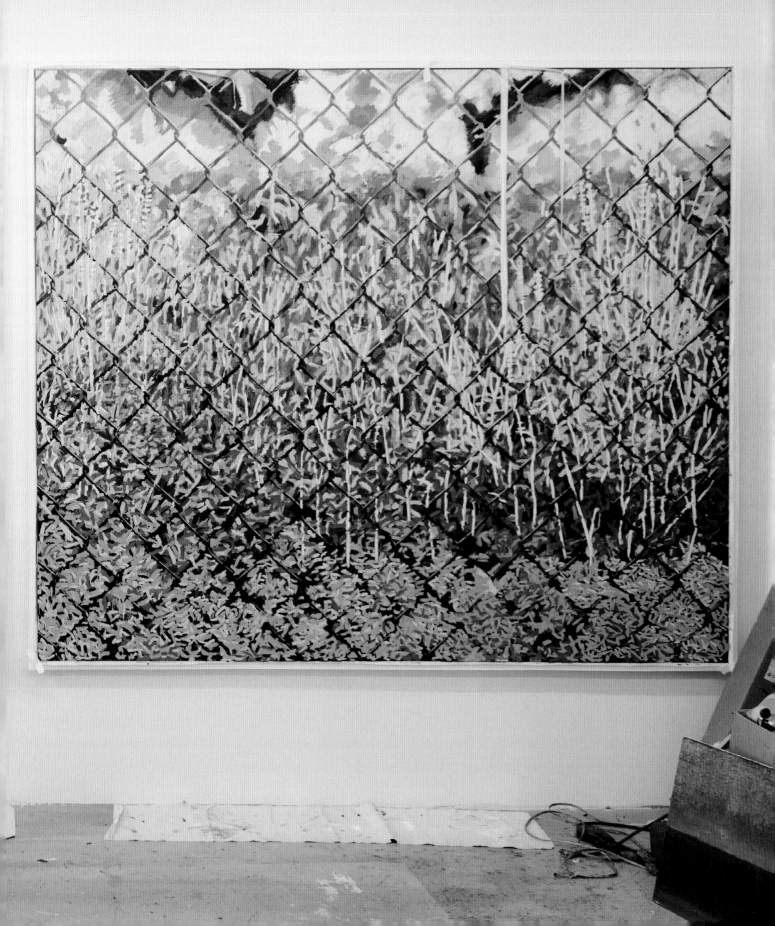

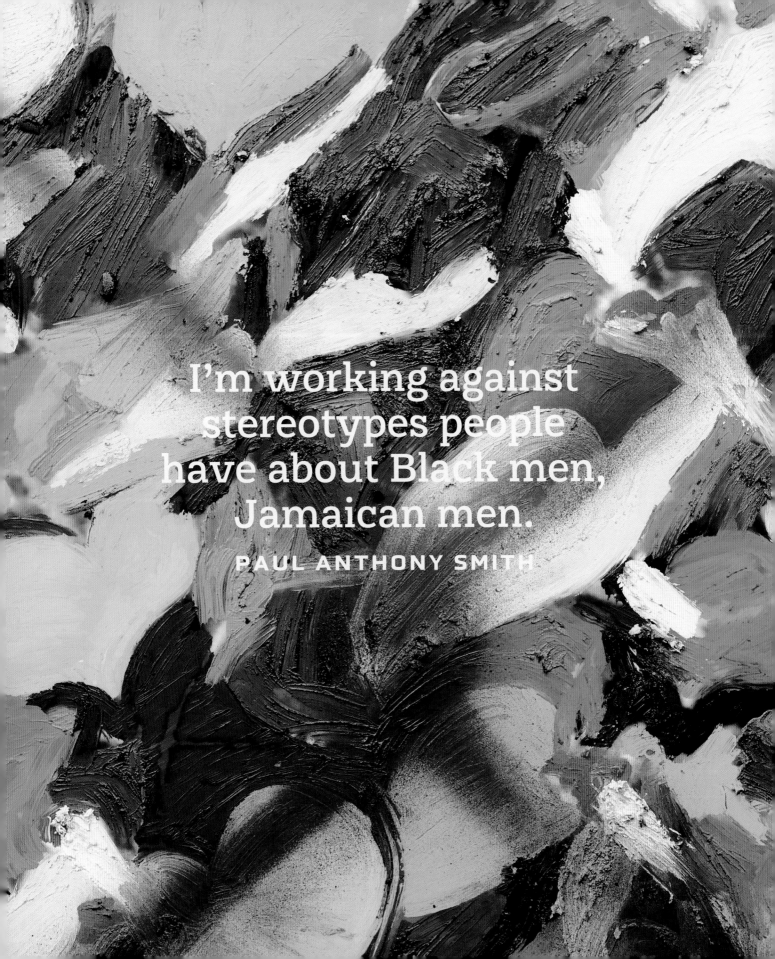

I'm working against
stereotypes people
have about Black men,
Jamaican men.

PAUL ANTHONY SMITH

Pauline
MARCELLE

A VISUAL ARTIST WHO CENTERS THEMES OF CONSUMPTION, RESILIENCE, AND SUSTAINABILITY IN HER WORK

I work in a range of media including video, painting, and sculpture. Colors are the foundation of my artwork. My sculptures possess fleshy colors and textures resembling human organs, crafted from my own clothing and that of loved ones.

What did you make as a child before you even knew to call it art or design?

I grew up in a household where arts and crafts were always around. We made conventional Caribbean woven straw hats, straw bags, Creole dolls. I helped with braiding hair and sewing it on the dolls, painting their faces, and making the clothing.

What feelings are you trying to evoke through your work, and what do you hope viewers will do as a result of their interactions with it?

When I'm not in Dominica, people think I come from the Dominican Republic; and when I'm in Dominica, everybody thinks I'm living in Australia. I want people to know about my native country, and to feel the soulfulness and joy of my Caribbean culture through my work. They can engage with my work to ask questions, to understand the specific history of Dominica. To know about the history of Dominicans who come from Maroon, royal African, Indigenous, and European ancestries. A lot of non-Caribbean people want to know more about the Caribbean; some have gone to Dominica, where they've learned more about the rich culture of the island, about its people and their philosophies. This is very encouraging. I hope they feel the connection that exists between Europe and the Caribbean. When Europeans exoticize the Caribbean, they should understand that it was a "little Europe" and that they are part of the representation that they've depicted as foreign and outlandish.

At the beginning of 2022, I started a painting series titled *The Catharsis* about the process of personal and global healing during these tumultuous, troublesome, and challenging times. We humans have become sick and unwell and are in search of some kind of release and enlightenment. The works explore Carnival and its cathartic nature, with the figures in the paintings expressing their vitality, passion for life, and value for onward human existence.

What does community look like for you as a maker living and working in the diaspora?

Living here in Austria, I have a community of friends from many different countries. There are not many Caribbean or even Black people here, like in London. They are predominantly from a variety of African nations, and they have their own

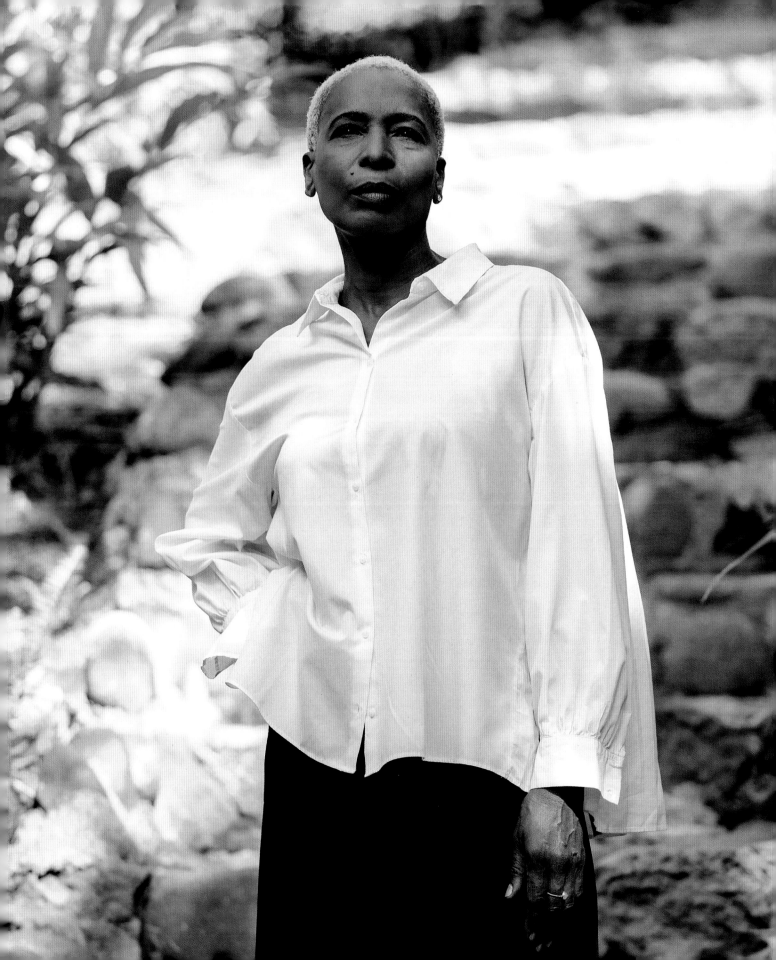

communities. I meet Black people within the African community, as well as in other international and local artists' communities, where everybody is looking for someone to lean on or to share their experiences.

In Dominica, I live in a village with about fifteen hundred people. Everybody knows everything about you, so community is in your face [*laughs*].

How has the lack of a Caribbean community where you live impacted your creative work or professional goals and opportunities?

Wherever I've gone in the world, whenever I've introduced myself as Caribbean, doors opened. When I went to the university here in Vienna, I was the only Black student for the first two years, and everybody wanted to be my friend [*laughs*], so I feel very good in Austria.

My mother came to the United States from Dominica, and she told me she was treated differently than Black Americans, because there's a sense that "you don't have the same anger and frustrations about white people in this country." I look at that as part of the separation in oppressive systems—a hierarchy between communities. Historically, that agenda has divided us as different identities and societies.

Is there a specific country in Africa that you're drawn to or have visited?

I've visited Ghana twice: first in the 1990s and then again in the 2000s. I worked in Johannesburg, South Africa, for five months, and I spent time in Cape Town, and some other cities like Durban.

I've been to Tanzania and visited my cousin who lives in Kenya. I'd like to visit Nigeria.

What materials or processes do you employ that are specific to an African region or culture? How does your work reflect ideas about the land, climate change, and sustainability?

I have a body of work called *Bend Down Boutique*, which is a term they use in West Africa for secondhand clothing. Clothes collected by the Salvation Army, for example, often get shipped to Africa to be resold. It's a paradox that when you give something to a charity, it's sold somewhere else where people really need the goods. In Ghana, I was walking along the beach and saw what I would call "cultural formations." They were mounds of second-hand clothes that had been tossed into the water and washed back up onshore by the waves. They formed the rubble on this beach. You could see them as ugly, but when I started taking pictures, they appeared surreal and museal.

Knowing where that debris had come from, why it was all over the beach, that the kids couldn't swim in that water because of the waste washing up onshore, I started to realize the part I played in this scenario, as a consumer. That's why I have been using my own clothing, or clothing from friends and family, to make my sculptures. That experience left a lasting impression on me and a lasting impact on my body of work.

What emotional resonances are you expressing through your work?

Everybody in my village knows me as Joyce—as in "joy." I was always a very inquisitive, active, happy kid. I think that if you're happy inside, that joy is a reaction to happiness. Happiness is the action, and joy is the reaction. This joy shows up in my work in the colors I use, which are very bright with a lot of sunny yellows. You feel your heart warm when you see the paintings.

At the same time, my work can be painful, angry, complex, intimate, spiritual, and critical. I wouldn't call these negative emotions, because you need a balance. And there's a purpose here. If you see bright, joyful colors in a painting, you think, "Wow, they attract me." But then you will start to ask, "What is going on?" If it was sad and dark, I think it would be heavier to spend time with. I don't want viewers to be stuck in this heaviness. They should experience the work as a catalyst for being kind to others.

Is there anything else you'd like to share?

I want younger Caribbean artists seeking avenues for their creativity—especially younger creatives migrating to different countries—to find their personal strength as they gain their footholds in the art world.

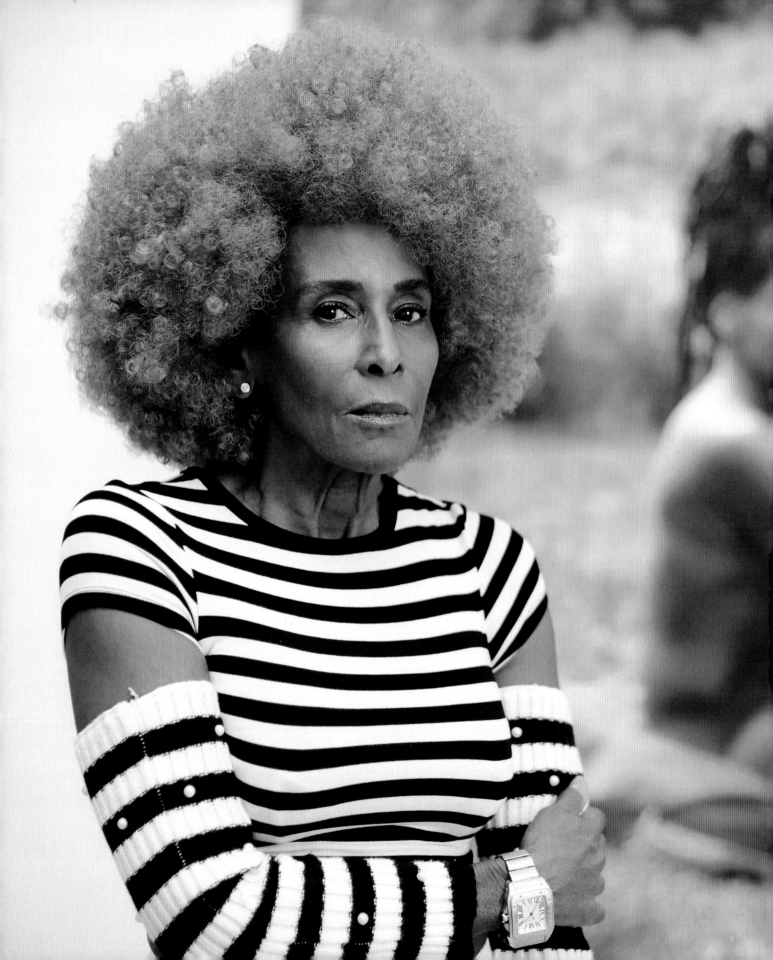

Renee Cox

A PHOTOGRAPHER WHOSE WORK CELEBRATES BLACK WOMANHOOD

My inspiration and my ideas come from my heart. I make a rather gallant effort in this society not to second-guess myself, and to listen to what my mind and my spirit are telling me.

What did you make as a child before you even knew to call it art or design?

In third or fourth grade when we had to do some drawing, I remember saying to myself, "Wow, I can fix art so that it becomes cool."

Afterward, when I was maybe ten, I picked up my mother's Super 8 camera and started making these little films—bad espionage kinds of films, because I was really into *The Man from U.N.C.L.E.*

Did you experience a turning point in your career?

After I read Eckhart Tolle, I had a change in my attitude, and in my work. That's when I got into soul culture, and I started taking a deep dive into fractals and sacred geometry. I learned from him that those thoughts I was having emanated from my ego, as he calls it. Your ego is not your friend. It's that voice in your head that says, "What you did really sucks." "You could have done that better." It puts you in that mindset of second-guessing yourself, giving in to negative thoughts. Before I realized what that voice was and where it was coming from, it paralyzed me.

How have you crafted a kinship with the land, people, and culture of the Caribbean?

That came through my relationship with the Maroons. My work *Queen Nanny of the Maroons* was shot in Jamaica over a two-year period. The Maroons were generous with their time with me. They were generous with their men with me, with their children. I have a great love and admiration for them and their revolutionary spirit. That to me is the crux of Jamaica: that feeling of invincibility. Like, I'm going to do whatever I say I'm going to do, and I'm not asking anybody for permission. That's the thing I take away from Jamaica. That determination, that pride.

What feelings are you trying to evoke through your work, and what do you hope viewers will do as a result of their interactions with it?

I want them to feel empowered. I want them to feel that they can go out there and do whatever they want to do and say whatever they need to say, assuming that it's justified and that they've done their homework, they've done their research, and they're not just talking out of their . . . whatever.

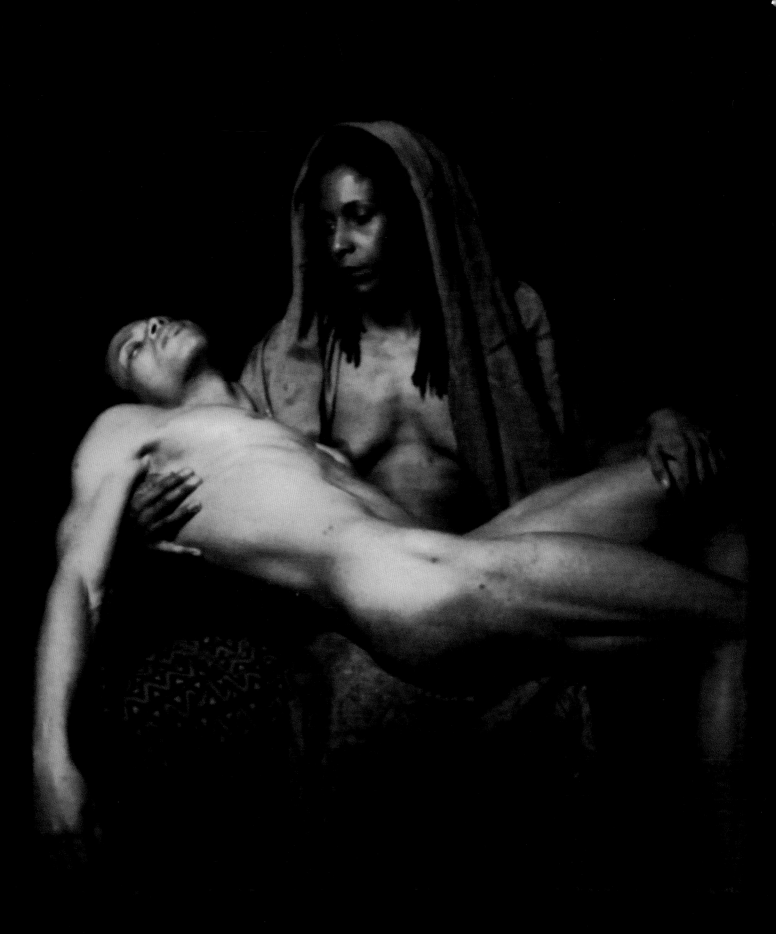

What does community look like for you as a maker living and working in the diaspora?

You create your own community wherever you go, whatever you're doing. When I was doing *Queen Nanny*, my community was the Maroons of Portland. My community is wherever there are … I was going to say like-minded, but I really mean well-minded people, because you don't have to agree with me. I don't mind a discourse. I believe that we can disagree over a glass of wine and at the end of the discussion have a toast, slap each other on the back, and go out dancing all night long. I'm not going home and figuring out how I'm going to annihilate you because you said something I don't agree with.

Can you talk about your experience traveling in Africa?

When I was in Ghana, I met a group of young white doctors. I said, "You must be learning a lot from the Ghanaians. I'm sure they have recipes and treatments for certain ailments that we could benefit from knowing." Those young doctors said, "We aren't learning anything from those people. We're curing them. We're bringing them malaria drugs and whatnot." They might as well have added, "We are all-knowing gods." I had to walk away. That attitude is so arrogant and narrow-minded.

What facets of spirituality are most present or potent in your work? And how legible do you want your spiritual expression to be for "outsiders"?

I will not do anything that makes Black folks look bad. I'm not interested in creating a victimhood around us, which is a very lucrative thing to do. I'm not going to shoot a bunch of greasy-looking Black folks fulfilling the stereotypes, because I believe that we already have a pretty bad PR department.

It's only in the last four hundred years that we've had to deal with this propaganda that we come from nowhere or that we all just came to this hemisphere as slaves. We've been robbed of our history by design, because that's another way of controlling and manipulating people. That's why it was important for me to give Queen Nanny her props and to create something around her legacy. I feel a responsibility to create imagery that is empowering and evokes pride.

Is there anything else you'd like to share?

Do what you feel you need to do, and don't be deterred.

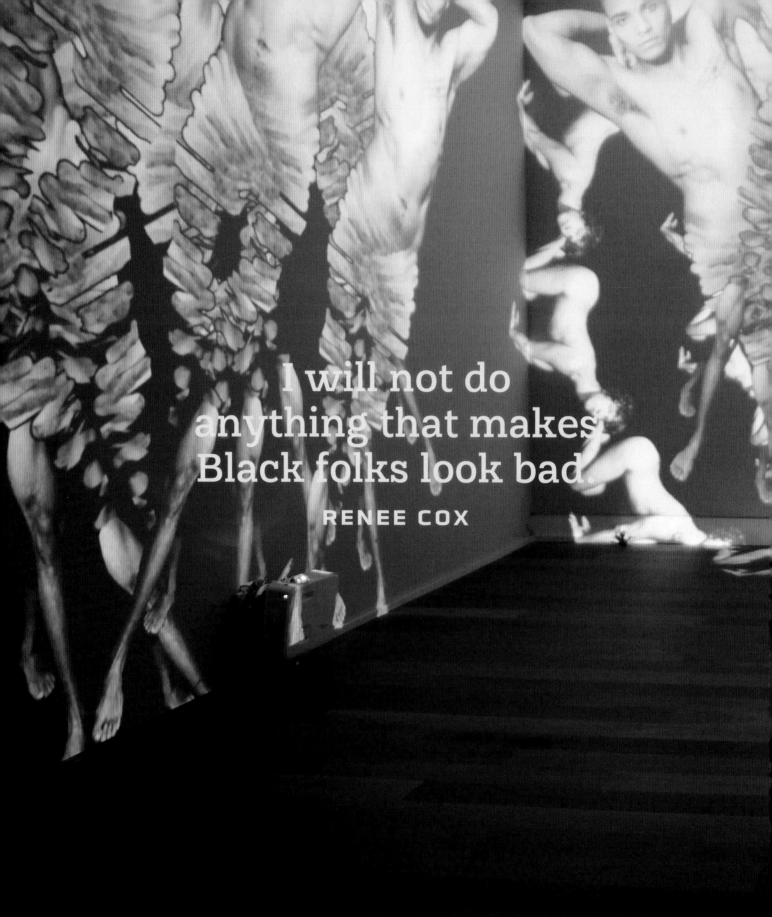

I will not do anything that makes Black folks look bad.

RENEE COX

Robert
YOUNG

A FASHION DESIGNER WHOSE WORK CENTERS ON CONNECTION, RESTORATION, AND PEACE

I'm an observer. I saturate myself in a situation when it's time for making or designing, and then there's a relationship between the patternmaker and the piece maker, seamstress, sample maker, and me. When mistakes happen, we adjust the garment until it transforms, but it's always a living piece.

What did you make as a child before you even knew to call it art or design?

The first thing I made was a mud tank, and I gave it to my mother as a gift. Maybe it was as a response to seeing scenes of the Vietnam War on TV. My family was involved in the February Revolution in the 1970s.

How have you crafted kinship with the land, people, and culture of the Caribbean?

Belmont, where my studio is located, was one of the first free spaces for Africans on the island of Trinidad around the time of Emancipation. Another free community was the Merikins from the company villages in South Trinidad. Even long after slavery, the economic conditions of forced work without proper compensation continue. Working conditions for people have changed, but not enough. The fight has always been to improve the conditions of people who were formerly enslaved and the Indigenous, to have a reconnection to the environment and have a more regenerative relationship with it. People buying from me despite all the white supremacy embedded in the global fashion industry is revolutionary, because it is mostly Black people who are my customers. Making fashion for us is a way of taking up space that makes us more free.

The Caribbean is a small place that significant significantly impacts the world. What part of your Caribbean identity or art practice do you think speaks to what is needed in the world right now?

Play, play, play. We need to play more.

What feelings are you trying to evoke with your work, and what do you hope viewers will do as a result of their interactions with it?

I have a design shaped like a cocoon that you place your body in to feel protected. I dress your spirit, to protect you and to embody what I learn about you.

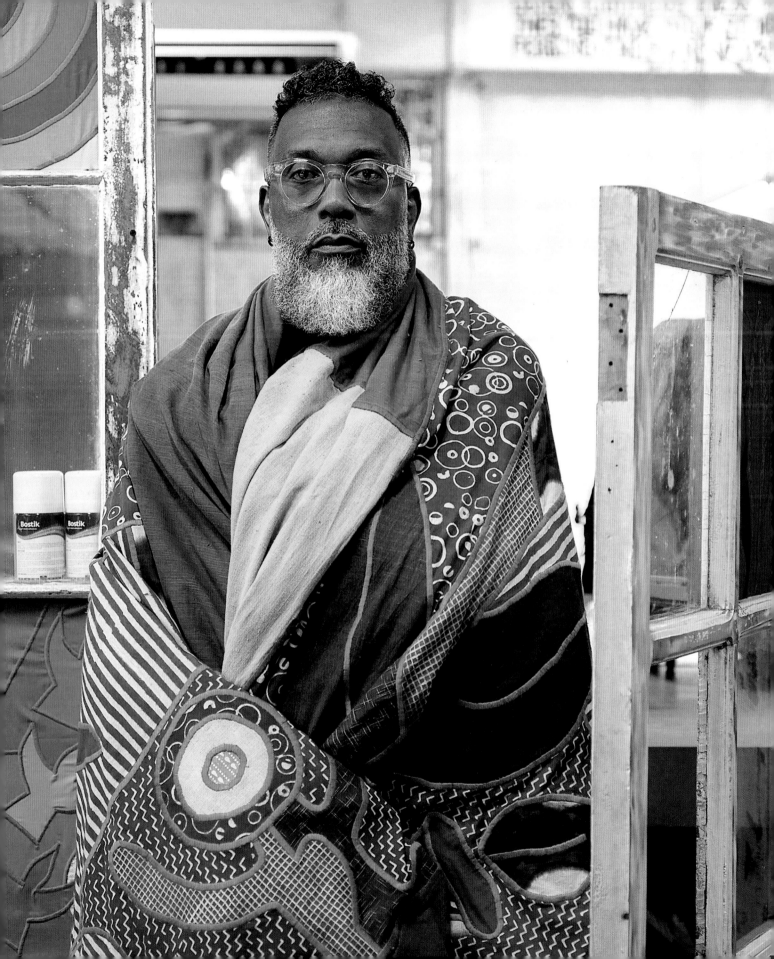

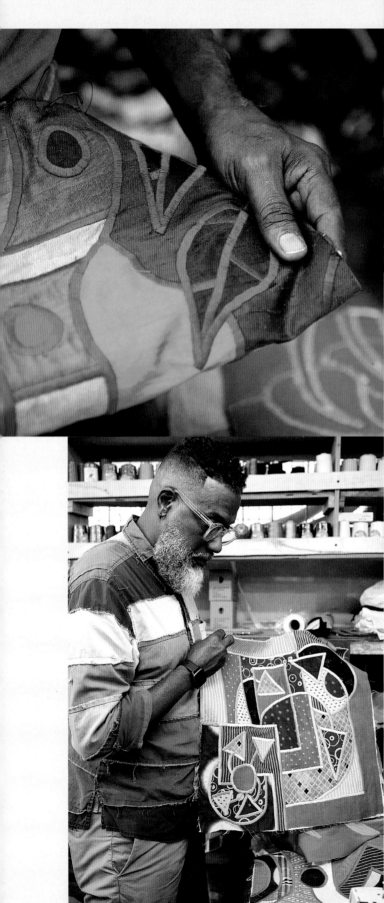

Can you talk about how or whether your work closes the gap between art and design practice, or whether you would like to close that gap more?

I think design is a white thing that is connected to extraction. ("White" is a way of separating us from others, the world outside our homes, the bush, and the trees; from our families, ourselves. We feel disconnected. That's what I consider "white.") A design has to be made into a product. It's about making everything the same. It is mundane, repetitive, and nonthinking. So I deliberately don't call myself a designer. I'm an artist who does design.

What ancestral knowledge has been passed down through generations in your family?

I would say the world can be crafted differently, afresh. I made this question up, as if I had ancestral knowledge: What decision would you make about cutting up a piece of land, moving a river, or using a damaging chemical? What answer would you give an ancestor if they asked you why you made that decision? You ask the question on their behalf because they have sacred spirituality; they have a different set of information because they are dead, all their patterns are dead, and they are now connected to the source. They can answer things differently. I have the responsibility for how I connect to people, how my work is made, and how people are treated while they make it. Our ancestors show us what they want this world to be.

Work expands or retracts
to fill the space provided
for its completion.

ROBERT YOUNG

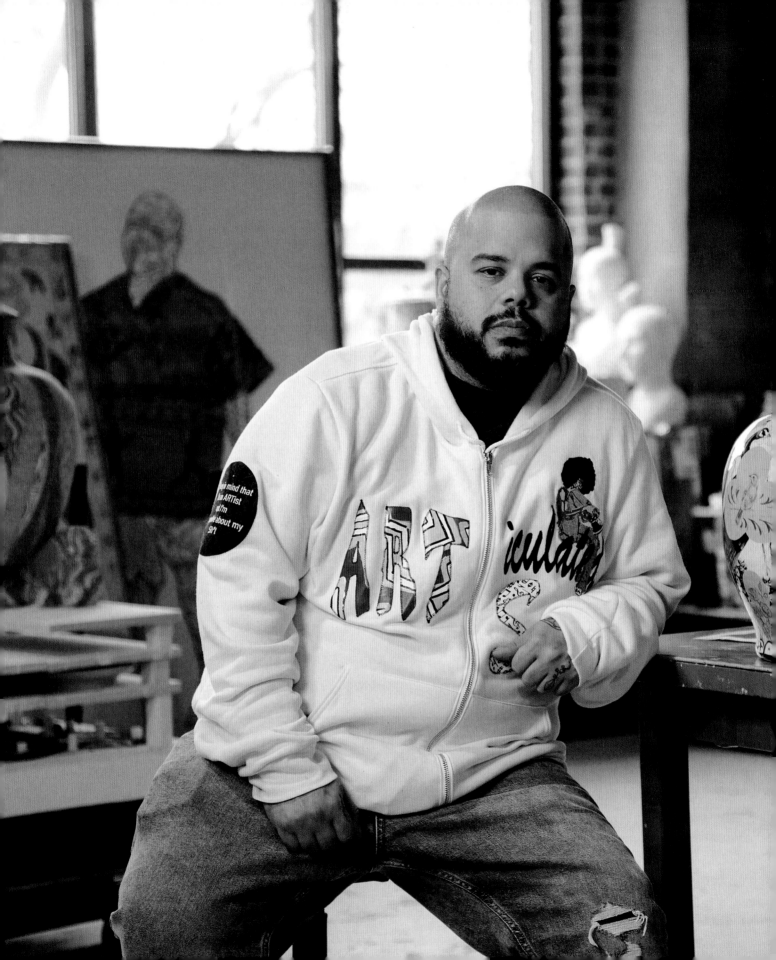

Roberto
LUGO

**A POTTER, POET, AND SOCIAL ACTIVIST WHOSE WORK HONORS
HIS LOCAL AND ANCESTRAL HERITAGE**

My practice is really driven by where I'm from, in Kensington, Philadelphia, and the people of that community. It's a very impoverished and transient place. I grew up with a majority of Puerto Rican and Black people, including many from the Caribbean, like the Dominican Republic, Jamaica, and Haiti.

What did you make as a child before you even knew to call it art or design?

I didn't have a lot of toys, so I would make up my own games. My mom says I used to play checkers with her hair rollers. Then in my preteen to teen years, I got influenced by graffiti. A lot of the young men in my school had composition books, and we would tag each other's books for practice. Your book was of the highest quality when it had a lot of people represented in it and with different styles. It showed your commitment to that art form. Even though I wouldn't have said this at the time, I think I fell in love with the graffiti culture because being a part of it was like being a part of something that was bigger than me.

Growing up, I didn't think about art being a possibility or an opportunity. I found myself in my adulthood working in this way. I feel like the only real way to operate is to make work based on my lived experience. There are a lot of murals in Philly that feature portraits of people of color. I think about wanting to see yourself reflected in art. When we paint other people who have come before us and given us opportunities, we're really painting self-portraits. We're really painting ourselves and seeing ourselves reflected in those people, in our heroes.

Did you experience a turning point in your career?

When my brother was incarcerated and I was in graduate school, he wrote me a letter and signed it "without wax." During the Renaissance, sculptors would fill holes—mistakes—in their work with wax. When a sculptor made something free of any flaws, they would consider their work "without wax." It's important to me to make authentic work.

Getting that letter from my brother felt like receiving permission to speak on his behalf, and on behalf of all the people he was incarcerated with. For a long time, I had a fear of offending people, but his letter made me less fearful, specifically of offending white people. You know, there are some great artists who are incarcerated

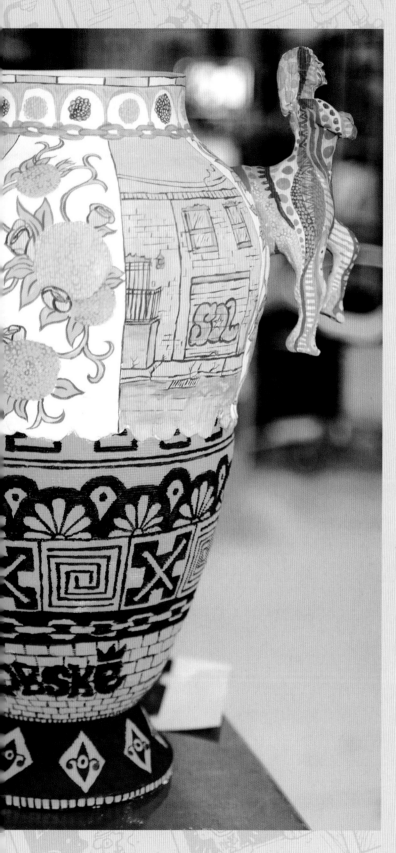

because of mistakes they made in their life, but also because the systems they grew up in led them to make those mistakes. Incarcerated people like my brother are paying a lifetime penalty. When I read his letter, I almost felt like I had woken up from a dream, as if I had been incarcerated and I woke up free. And with that freedom, how can I not do what I'm doing?

How have you crafted a kinship with the land, people, and culture of the Caribbean?

In 2020, I produced a solo exhibition titled *Boricua, Barrio, Bajo*, which means "Puerto Rican, neighborhood, clay." When my mom was growing up in Puerto Rico, the land was red because it had shifted so much through the history of the earth that it had picked up iron. That was in the actual clay, which my mother and her siblings stepped on when they played games and used to make sculptures when it rained.

I've always felt like I missed out on something not growing up on the farms where my mom and my dad grew up. About five years ago, I went to Puerto Rico to survey different spots for a pottery workshop. I started in the town of Utuado, where my mom was raised, which is in the very center of the island, up in the mountains. Both of my parents spent their childhoods in the mountains, which parallels my experience growing up in the ghetto in America like I did, because those are the cheapest places to live. In Puerto Rico, the higher you go, the cheaper the land because it's more and more treacherous and you're farther and farther away from everything. I really wanted to figure out how to create opportunities for Puerto Ricans to work with clay. They all have access to it, but the idea of using it to make things is a foreign idea. The Tainos, the Indigenous people of Puerto Rico, have a long history with textiles and other crafts, but there isn't as much of a history with clay. I wanted to explore that and help people identify what Puerto Rican ceramics look like. A lot of Puerto Rican contemporary artists make things with clay, but I'm talking more about how when you look at Mata Ortiz and Mexican pottery, you can see that it has its own visual language. I'm interested in helping Puerto Ricans find that organically. I'm working with a museum in south-central Puerto Rico to organize an exhibition with a community component that does this. I can go there and do a demo or throwing, but at the end of the day, I want students to start replicating what they see to create their own identity through that. To develop their own voices.

The Caribbean is a small place that significantly impacts the world. What part of your Caribbean identity or art practice do you think speaks to what is needed in the world right now?

What I find interesting about the Caribbean is how much pride people have in their culture. But it's so different from the pride

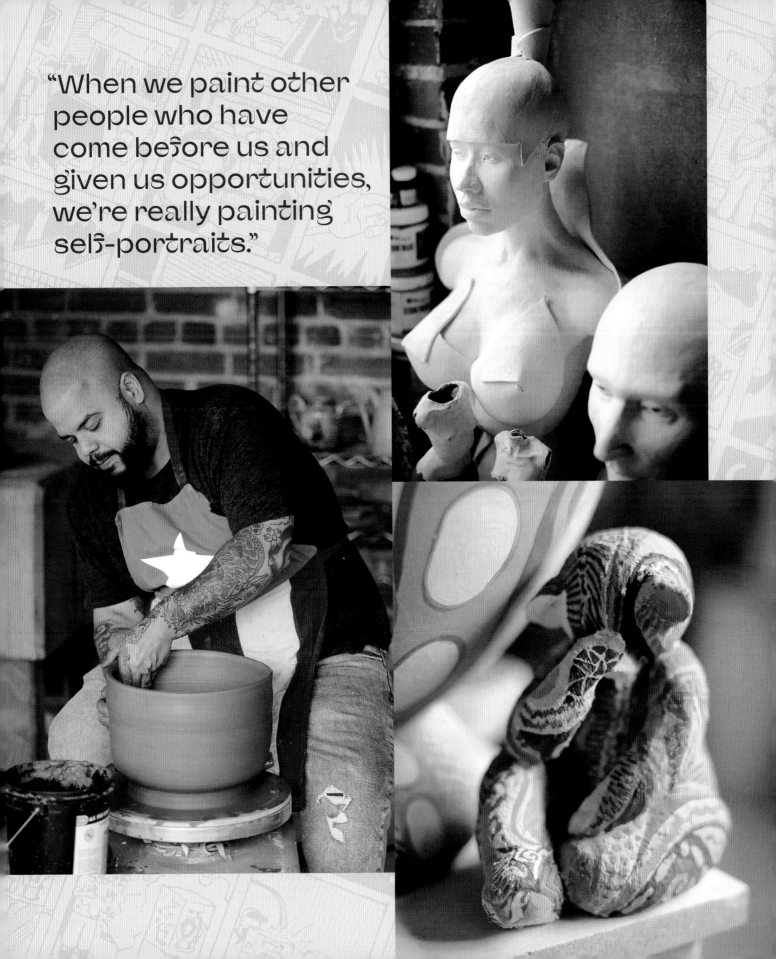

"When we paint other people who have come before us and given us opportunities, we're really painting self-portraits."

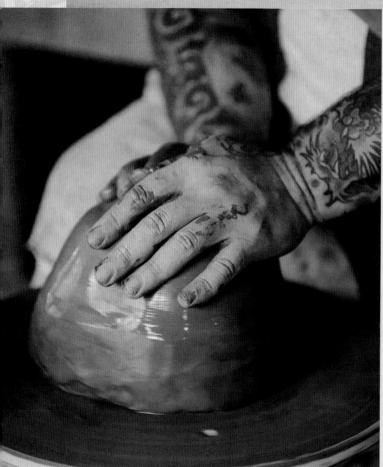

that I see in American culture. I feel like so much of the nationalism that happens in America is hollow and connected to race. I think Puerto Ricans are more proud of their holistic culture, like the food, the dance, the music, the land, the traditions, the dress, the look of the people, the history, and the cultural makeup of the people. If we were to have American pride that looked like that, American pride that was proud of diversity, then it would be something I would be really into. People could look to the Caribbean as an example of what pride in one's land looks like. It's a pride that's not rooted in hate of other people. There's a sense of humility in it.

What feelings are you trying to evoke through your work, and what do you hope viewers will do as a result of their interactions with it?

I think I'm trying to evoke a feeling of humility and transparency in that I try to be my complete self through my work and through my presence online and in the community. It takes a lot out of a person to be that vulnerable, so I don't think I could do it forever. It's a roller coaster of emotions. I love a lot of videos I see online referring to Black joy, because there's so much trauma that we have to see all the time. That has an effect on people, specifically communities of color who are seldom encouraged to seek help for our mental health issues. Being vulnerable about all the different emotions I'm going through and my mental health struggles may make people more comfortable with being

vulnerable themselves. I'm hoping to encourage other people to seek help as well.

Can you talk about how or whether your work closes the gap between art and design practice, or whether you would like to close that gap more?

My pottery work is shown in both art and design contexts. When you work in design, your work has bigger implications than just the functionality of it. You can make something that's functional, but when you make it in a way that represents something personal, it's talking about culture.

What facets of your identity are most prominent in your work?

As Puerto Ricans, we're constantly striving to find our identity. We're part of America, part of the United States, but we're also our own thing. Part of being Puerto Rican is wanting to be *in* Puerto Rico but not having the ability to be because there are so few jobs. That sense of identity is a huge part of my work.

Often I have to say less to be able to connect with people who like my work but don't necessarily share the same cultural connections or experiences. For example, one of the first things I made on the wheel was a fire hydrant. It was a soap dispenser because when I was younger and the water got shut off in the neighborhood, everybody in the community would use the fire hydrant. It was also the sprinkler system and a place to have fun. It was a cultural connection. When I made these pieces, people started buying them for relatives who were firefighters. It had no relevance for them to this culturally significant thing my community and I had experienced.

How does joy show up in your work?

I'm constantly striving to bring joy back into my life. I was a much more joyful person when I was young and ignorant of the racism around me.

I never felt that I wasn't accepted growing up. But then when I went to mostly white spaces in college and in the art world, I felt that way. Joy is a celebration of overcoming all those things. It's the place I'm trying to be, and so to have moments in my life that are joyful, like the connections to my children, the connections to people, is the goal. Without joy, I'm not sure what the rest of this is for.

Is there anything else you'd like to share?

You always have something to contribute. There's room for you and your voice and for you to tell our story in a different way.

1900–1984
JAMAICA

RONALD MOODY

BY SANDY JONES

Described by cultural theorist Stuart Hall as "the pioneer figure" to pre-Windrush Black British diasporic art, Jamaican-born sculptor Ronald Moody was part of a group of writers, intellectuals, and activists who formed the Caribbean Artists Movement. During his fifty-year career, he also wrote short stories and poetry and made a series of broadcasts for *Calling the West Indies*, produced by Una Marson for the BBC World Service in the 1940s.

Moody was part of a prominent Jamaican family that included the physician and founder of the League of Coloured Peoples Harold Moody and bacteriologist Ludlow Moody. He arrived in Britain in 1923 on board the RMSP *Oriana* to study dentistry at the Royal Dental Hospital in London.

A visit to the British Museum convinced him to change direction and become a sculptor. Profoundly affected by the "inner feeling of movement in stillness" he discovered in the Egypt gallery, he began to teach himself to carve by experimenting with the plasticine and plaster from his dental work.

In 1935, Moody completed his first oak head sculpture, *Wohin*, one of a trinity of figures that included *Midonz* (1937) and *Tacet* (1938). However, it was his oak sculpture *Johanaan* (1936) that launched his career. Bought by British actor and writer Marie Seton, it also caught the attention of Brazilian documentary filmmaker Alberto Cavalcanti, who helped Moody secure a solo show at Galerie Billiet-Vorms in Paris in 1937. In 1939, he was one of twenty-nine artists represented in the exhibition *Contemporary Negro Art* at the Baltimore Museum of Art in the United States.

Moody's work reflected his wide range of interests. He explained, "My past is a mixture of African, Asian, and European influences and, as I have lived many years in Europe, my present is the result of the friction of Europe with my past. This has not resulted in my becoming an ersatz European, but has shown what is valuable in my inheritance, which I think shows in my work." His experience of war also engendered a preoccupation with humankind's potential for both destruction and self-preservation.

In 1953, Moody designed a carved mahogany lampstand, which signaled a return to the theme of the heroic figure that featured in his earlier sculptures. In this case, the human figure forms the base of the sculpture, above which are two lizards, which are believed to have been inspired by a similar one carved on an African oliphant, or bone hunting horn, that Moody had in his collection of artifacts. The lightbulb holder balances in the jaws of a creature, possibly a snake, the universal symbol of human fallibility. The base, carved with an octopus and a starfish, speaks to Moody's concerns for preserving our environment.

Sandy Jones is a design historian who trained at the University of Brighton and the Victoria and Albert Museum, where she is curator of Architecture and Design. She has a particular interest in twentieth-century graphic and product design and began her career running brand identity and product innovation programs.

BLACK CARIBBEAN ART AND DESIGN

BY MICHELLE JOAN WILKINSON

As a curator of Black art and design, I am interested in practitioners based in the Caribbean, the United States, and Europe. Curatorial work encompasses research, acquisition, cultivation, educating collectors and donors, publication, translation, and also inspiration, which is about allowing the work to inspire other artists as well as viewers, collectors, and other curators. The experience of an exhibition can generate excitement, new ideas, and certainly affirmation for artists who see themselves reflected and interpreted in new ways.

CORE THEMES

Some of the core themes I see emerging in contemporary Black Caribbean art and design at the moment are materiality and memory. I've noted narratives related to history, colonialism, and how spaces of childhood and family homes linger in modern approaches to design. Architectural and spatial tropes recur. Sometimes landscape is prioritized and problematized. I find works by Terry Boddie and La Vaughn Belle especially compelling as both artists draw past and present together by juxtaposing contemporary landscape imagery against archival materials, including maps, site plans, photography, and artifacts. In their work, materiality is memory. I've been similarly fascinated by the work of the British Caribbean artist Simone Brewster, whose furniture and jewelry designs recast historical symbols and forms into modern and sleek objects—and product names—that are loaded with symbolism (for example, her *Negress* chaise, 2010, and *Mammy* side table, 2011).

Beautiful objects double as lessons about race and gender. A thread that I find in works by many Caribbean artists and designers is this feeling of friction between past and present, between heritage and reinvention.

It's been interesting to see artists drawing on materials connected to colonial histories and slavery such as in *Coffee, Rhum, Sugar & Gold: A Postcolonial Paradox*, an exhibition curated by Dexter Wimberly and Larry Ossei-Mensah at the Museum of the African Diaspora in 2019. For contemporary artists and designers to revisit these material histories pushes the material knowledge forward. Similarly, knowledge of handicraft traditions can inform contemporary design and birth new generations of use, scholarship, and making.

ORIGINS AND TRADITIONS

Artists using cyanotype, indigo, and other blue hues draw on traditions from across the African diaspora, from textile dyeing to home design and décor. The origins of these materials are deeply personal. Within the African diasporic context, the blues have resonance visually, sonically, spiritually. Indigo, in particular, is rooted in African diasporic history. Indigo-dyed textiles have been made in West and Central Africa for generations, and the indigo crop was a staple of the South Carolina plantation economy during the period of enslavement in the United States. In experimenting with color and materiality, artists like Andrea Chung, Sonya Clark, and Firelei Báez make statements about how traditions are reinvented.

ART, CRAFT, DESIGN

It's in the context of curating and collecting that questions of art versus craft versus design often come into play. Questions about which terms are used when and where can be both generative and reductive. For me, "craft" is a synonym for artistic expression and a focused expertise, as in "honing my craft." I thought a lot about notions of craft in the Caribbean context when I was writing about architectural practices during the colonial era, because Black builders in the Caribbean were seen as "skilled craftsmen" but not necessarily as architects, designers, or even builders. The word *craft* became a way to delimit the range of their expressive contributions, and in some ways, it also became a frame for Caribbean creativity as primarily folk-traditional. I do think that type of prescriptive thinking has changed, and there are several scholars, publications, museums, and galleries whose long-standing work has represented the spectrum of creative production coming from

the Caribbean. *ARC Magazine* was a highlight in the 2010s. Websites and forums have brought greater visibility to Caribbean practice that is not folkloric or touristic. And Caribbean-focused exhibitions have similarly championed interdisciplinary, experimental, conceptual, and other ways of working.

However, contemporary craft, traditional craft, and the maintenance of handiwork and craft traditions across generations and locales are important in their own right. I see the histories of craft as a language that can be drawn upon for contemporary artistic practices that may not be read as "craft" in the final product. This was one of the premises of my 2011 exhibition, *Material Girls: Contemporary Black Women Artists*, which looked at the way artists were drawing upon family histories with practices from sewing to gardening to metalwork to explore new directions for material-driven art. For collectors, particularly for collectors of Caribbean descent, I am interested to see how Caribbean histories of craft—crochet, woodworking, pottery—can be prioritized. For example, work by Morel Doucet, Roberto Lugo, and Anina Major illuminates transformations in pottery that I think collectors would find profound and personally meaningful. I know that as I get older, I value these traditional practices more. I see the beauty in forms of creativity, like elaborate crochet work, that were quite commonplace when I was growing up but that I didn't take the time to appreciate then; I no longer take them for granted. I'm excited to see how artists reconnect to these forms through the lens of today's technologies and topical concerns.

COMMUNITY AND LEGACY

Just as many of the makers share in their interviews, I find that as a curator, I also need to find and build community—as Malene Barnett has done with the Black Artists + Designers Guild. We are collectively stewarding our legacies. Certainly, part of legacy-making is connecting people and leaving behind not just your own work but also the possibility of more legacies being built by the individuals you're supporting and advocating for.

I invite makers to document their work at every stage of their career. Artists whose studio practices are in the Caribbean and who are interested in working across the diaspora benefit from having a robust online presence. But not just a portfolio of images, because, again, documentation is key. Artists and designers should learn how to accurately describe the work, its themes, its material concerns, and its narratives so that researchers—curators, collectors, scholars—can discover it through internet and social media searches. Proactively

building awareness of their work can catalyze much-needed engagement and support (emotional and/or financial) as the artists build a studio practice.

Being in the public eye is not going to be a priority or even comfortable for every artist or designer. Some people want to be in museums and publications and to achieve a certain amount of public recognition. Others may prefer a more interior practice that is not concerned with external validation. For each maker, I think that understanding their motivations, goals, and process of making is key for meeting their own happiness quotient. In some circumstances, creative work—which is time and labor—can adequately support the maker's essential needs. But sometimes, the cost of making creative labor the generator of income is too high.

As a curator, I am committed to documenting and preserving the legacies of contemporary Black Caribbean makers, and to making their work accessible to both casual museum visitors and scholars. My work serves as a bridge, in a sense, as I partner with makers, my institution, publications, and viewers to inform new dialogues and new opportunities.

Michelle Joan Wilkinson is a curator at the Smithsonian National Museum of African American History and Culture (NMAAHC), focusing on architecture and design. At NMAAHC, she organized Shifting the Landscape, a symposium on Black architects and planners. Wilkinson's "V is for Veranda" project explores Caribbean architectural heritage.

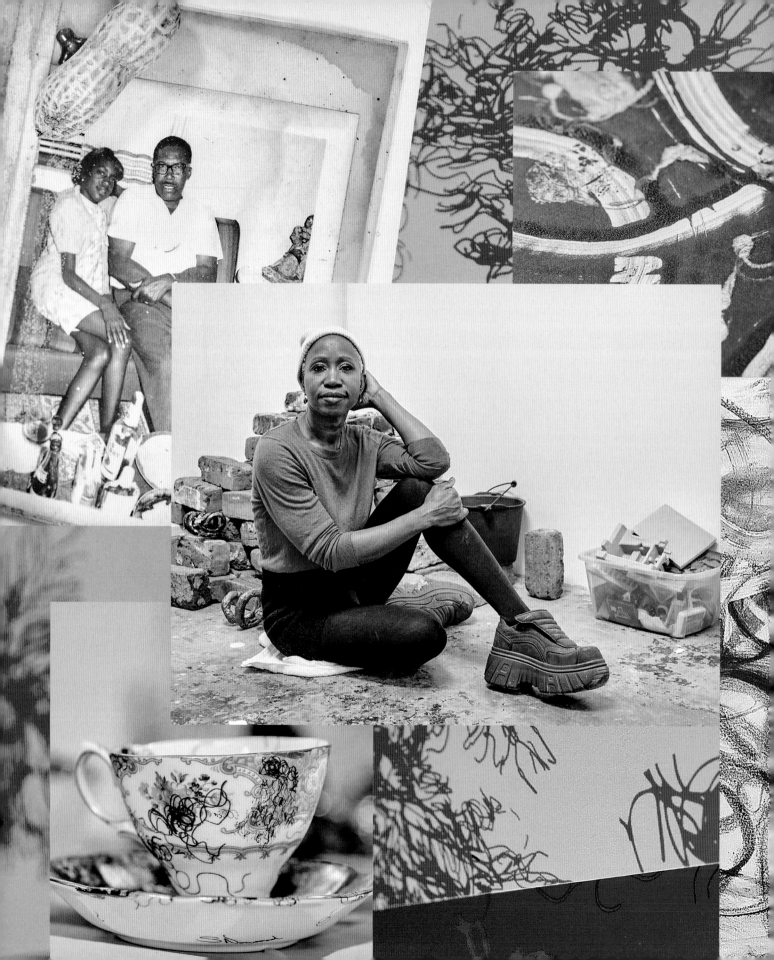

Sharon
NORWOOD

AN INTERDISCIPLINARY ARTIST WHO USES
ART AS A CATALYST FOR CRITIQUE

I'm an intuitive maker who articulates my understanding of the world through art.

What did you make as a child before you even knew to call it art or design?

When I was twelve or thirteen, I wanted to be a writer for soap operas. But after my first heartbreak at around sixteen, I secluded myself in a room and started drawing. That was the first time I thought I might be interested in art.

Was there a moment in your career when you had to reinvent yourself or your practice because of an obstacle?

As an undergraduate, I wanted to be a painter, but near the end of my degree program at the University of South Florida, I took a ceramics class, and the response I got from folks was amazing. They really loved the work I was making in that medium. That was the reaction I had been hoping to get with my paintings but never did. It made me realize that maybe I have a natural way of handling clay that's more intuitive than my interactions with paint. But I wanted to connect this new work back to painting, so my first piece was called *Marry Me* and was me literally marrying my ideas about painting with ceramics.

How have you crafted a kinship with the land, people, and culture of the Caribbean?

By networking with local Jamaicans. That creative engagement informs my practice and helps me unpack some of my ideas about what it means to be a Caribbean person.

The Caribbean is a small place that significantly impacts the world. What part of your Caribbean identity or art practice do you think speaks to what is needed in the world right now?

It's such a rough political time. I've had to limit my intake of the news because I'm very empathic and I find myself in a dark space.

The Caribbean artists I truly admire are, like me, talking about colonial history. We're all unpacking this cultural inheritance. Whether you're in London; British Columbia, Canada; or Savannah, Georgia, we're all connected to the Caribbean. Amplifying those connections feels like what we need right now. I've been thinking about inheritance recently. Depending on what you inherit, it can be easy to refute or dismiss the way

What does community look like for you as a maker living and working in the diaspora?

It means reaching out to folks I meet virtually, who don't get to be in the spotlight enough. Connecting with them, exploring our network with them, and creating opportunities with them. Community really does bring me joy. We're all doing our own little thing, but we're making space for each other.

What facets of your identity are most prominent in your work, and how do you use your art practice to speak to your Caribbeanness? Has the expression of yourself changed over time?

My white porcelain teacups painted with curly lines that are meant to resemble my hair speak to my Caribbean heritage and to my identity as a Black woman. These pieces subvert the idea of respectability that Caribbean people often strive toward through colonial rituals. In the Caribbean, tea is something we have all the time, but the tea ritual reeks of "respectability," like Western ideas about beauty that were imposed on us but which we continue to perpetuate and idealize. Like the Queen's English. It's a colonial trope that we're always measuring ourselves against. The work I make is questioning that understanding of ourselves.

What materials are you most connected to? Has your approach to or use of materials changed over time in your practice?

Initially I was using porcelain because the narrative about porcelain being this pure white material intersected with colonial ideas about race. I wanted to think about my material and these specific choices that I was making, especially as an abstract artist, reducing my language or reducing my material. I chose porcelain to interrogate what it meant to me as a Black woman. To assert my agency over the material. As time went on, I discovered that the material has certain limitations. For example, it's hard for me to sculpt with dark clay because the shadows make it hard for me to see and to make the forms the way I want.

I also use found objects because they are familiar. They speak to lived experience, which allows me to play with the question of what is hidden in plain sight. Why do we reach for certain things? How are those things connected to how we've shaped our understanding of the world and to our lived history?

that inheritance came to you. If you are of Caribbean descent, you may be acutely aware of your inheritances, including the generational traumas that have been passed down through your family or community. If you have property, you're acutely aware of how that land was used and how that, too, was passed down through acts of violence and trauma. Caribbean artists can perhaps help amplify those conversations about our cultural and literal inheritances.

What feelings are you trying to evoke through your work, and what do you hope viewers will do as a result of their interactions with it?

The gaze is very important in my practice. I want viewers to become aware of things that are hidden in plain sight. For instance, my ceramics series *Split Ends* features small, intimate ceramic and porcelain pieces in forms that are very familiar—a teapot, a teacup and saucer, dinner plates—but that familiarity intersects with something uncomfortable. These pieces look special, like the kind you would only bring out at Christmas or for a wedding. You might covet an object like this. It's a visually beautiful thing that seduces you into coming closer, and then when you get close and realize what's there—tufts of curly hair—you have to negotiate your way into a different understanding of the objects. I like my work to serve as catalysts to help folks ask questions like, "Why does this makes me feel uncomfortable?" "Why is the curly hair disgusting to me?"

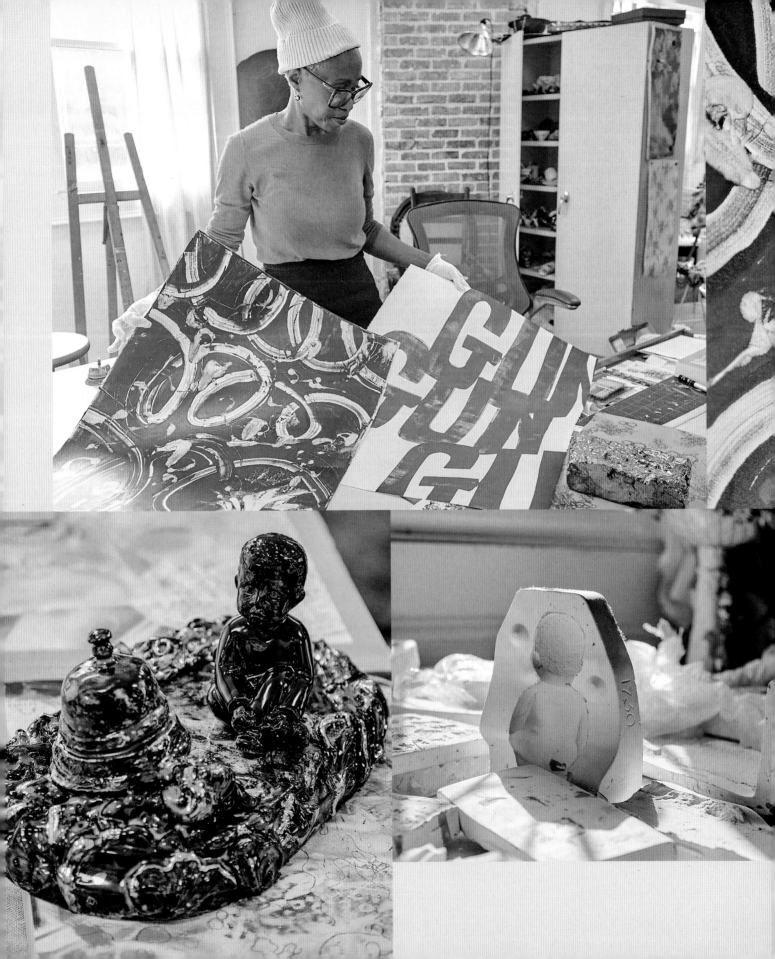

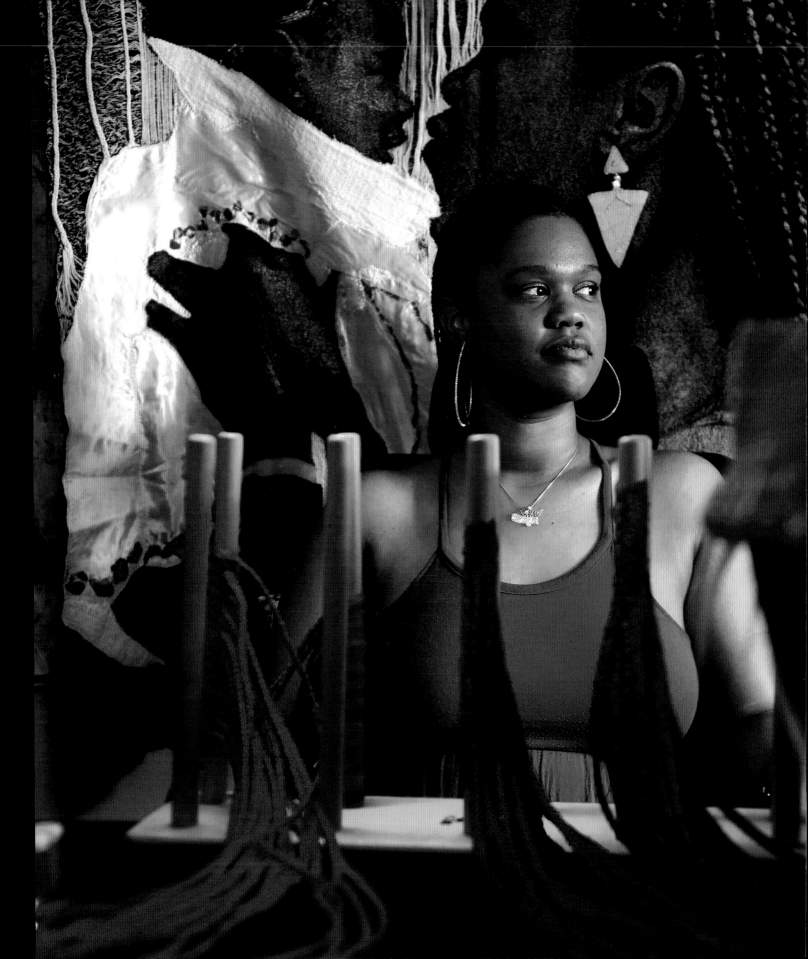

SHENEQUA

A MULTIMEDIA ARTIST WHO USES THE TRADITIONAL CRAFT OF
WEAVING, INCLUDING WITH THREAD AND HAIR, TO TELL STORIES

I would describe my practice as a lifestyle. It started off as three separate entities: art practice, personal life, and teaching. Now it's merged into who I am. What I do in my art studio feeds into what I teach, which honors the everyday people I'm inspired by.

What did you make as a child before you even knew to call it art or design?

My earliest memory is of those coloring books that had numbers to tell you what colors to use. I had a lot of those. I loved coloring.

What feelings are you trying to evoke through your work and what do you hope viewers will do as a result of their interactions with it?

A sense of connection. My work speaks my truth, and I'm aware that it's not going to resonate with everybody, because art is subjective. As long as I stay true to myself and my story, I've done my job. When others are viewing my work, I would love for them to have some sort of connection to their own story, or memory, or experience.

What does community look like for you as a maker living and working in the diaspora?

For me, community is still conceptual. I'm not there yet. I'm just now in the process of speaking with a couple of friends about a collaborative project.

But two of my fondest memories speak to feeling a sense of community and partnership. The first is of my time in Ghana as an apprentice to master weaver Sebastian Dayi, who taught me how to weave traditional Ghana textiles. Although we shared a language as weavers, there are aspects of teaching someone a new way of making that can't be communicated verbally. So there was a lot of paying attention, observing, and being in the moment.

Then there was my collaboration with Stevie Stevens (a performer) on my graduate thesis, a body of work called *Sacred Cloths*. It was my first collaboration that was very intentional and the first time I'd ever given someone my work to live with. It was so special that Stevie wanted to be a part of this project with me. We worked basically my entire second year to make it happen. We talked about everyday life and my process and concepts about sacred cloths and her finding her connection to the work, which added another layer. She taught me how to face my fear about performing in front of others and how to communicate my ideas through movement. It was a beautiful collaboration. That was very, very big for me because I usually make everything alone.

What preconceptions of Black womanhood are you seeking to address in your work? What provocations do you offer to viewers?

Black women are complex in the most beautiful way. When people look at my work, their first encounter with it is through beauty. It's through rawness. It's through the colors I use. I want to celebrate that beauty. I don't want to talk about the angry Black woman. I don't want to talk about what we lack or this invisible cape we're forced to wear, saving others and not ourselves. I'm celebrating all facets of what we have to offer, while acknowledging the fact that we have to come back to offering that to ourselves first. Every single piece I've created is a love letter to Black women.

What materials are you most connected to? Do you consider any materials sacred?

Yarn, synthetic hair, and cotton have been staples of my work for a very long time. I earned a degree in fibers and textiles, but I fell in love with weaving. It forces me to be patient, to take my time. It speaks to my meticulous attention to detail. When I started to play around with synthetic hair, specifically, it was a way to honor the relationship I have with my hair and my family of women. I was raised in a household where you had to have your hair done all the time, and I was very fortunate to be around people who know how to do hair, from my aunt who owned a hair salon to relatives who braided hair. Later, I went to school in the Midwest, where I had no family, and so weaving became my way to connect with them. I would re-create and reimagine my time with those women by going to the beauty supply store and playing around with different hair designs. Then I started adding hair accessories to my weaving, braiding and styling the fibers as if I was doing someone's hair.

For Black women, and Black people in general, those spaces where we get our hair done are sacred. You come in one way; you leave another way. Whether you're in somebody's house or the shop, you are literally transformed in some way, shape, or form—physically and mentally.

Weaving and textiles also forge my connection to Ghana, to the continent, and to my ancestors. When I was in Ghana, it was amazing to see all these bold patterns and colors. My practice has been a way to tell stories, because whatever I was going through, whatever I wanted to say, I could do it through the patterns. The stories are embedded in the textiles. Some things you just don't need to say. They've already been said.

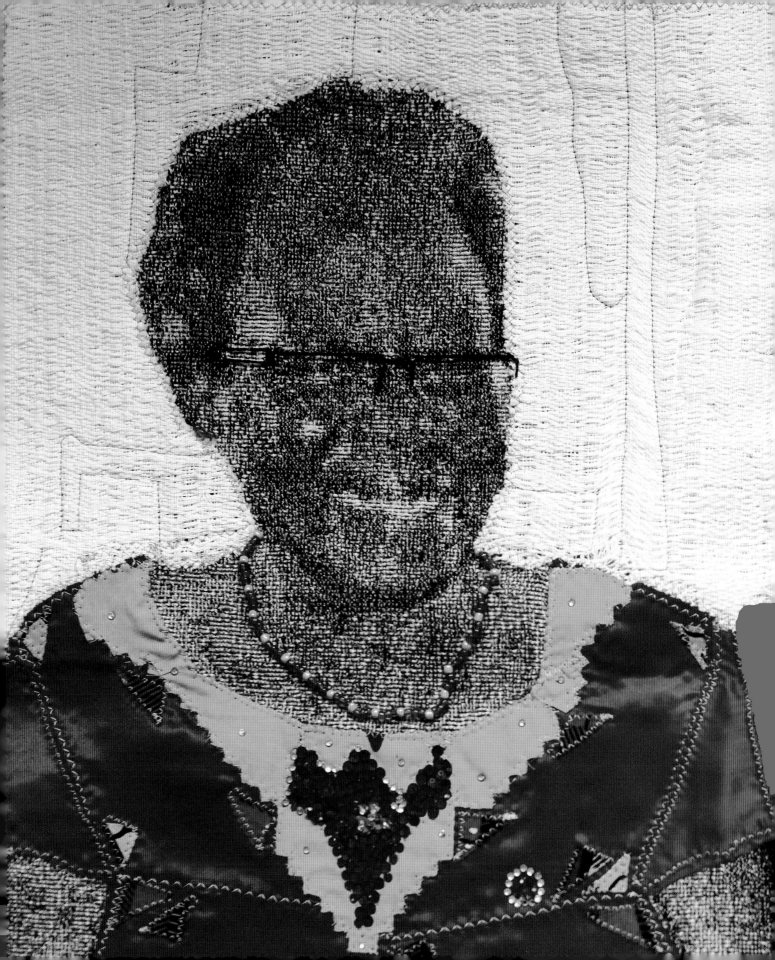

Black women are complex
in the most beautiful way.

SHENEQUA

Simon
BENJAMIN

A MULTIDISCIPLINARY ARTIST WHOSE WORK EXPLORES THEMES OF INTERCONNECTEDNESS AND INTERDEPENDENCE

My practices in photography, video installation, sculpture, and printmaking reflect continuous learning, exploration, and questioning of the world.

What did you make as a child before you even knew to call it art or design?

I constantly drew as a child. I drew things that I wanted to have that I had seen in the world or on television. I also drew a lot from my imagination, making comic strips with made-up characters. Drawing for me is a form of writing. It's the form of language I'm most proficient in.

Was there a moment in your career when you had to reinvent yourself or your practice because of an obstacle?

There isn't any specific obstacle for me other than maybe myself. I think we all get in our own way sometimes. But having an imagination and having had that fostered from a young age, I've always believed that I could do different things. There's a reinvention that comes from a passion for making things, and a curiosity about what is possible. I get to a point where I see that something I'm doing is connected to something else I'm interested in, and then a transformation occurs. But not all transformations are reinventions; I see them more as a natural evolution.

How have you crafted a kinship with the land, people, and culture of the Caribbean?

I've crafted a kinship through distance and curiosity. When you're in it day-to-day, you're just too close to it, whatever it is—the land, the people, the culture. It's easy to overlook what's in front of you. Having distance from home and living in New York, where I'm exposed to many Caribbean cultures, has shifted my perspective of the Caribbean. Immersing myself in history and the great legacy of Caribbean thought, literature, music, and poetry has helped me gain an understanding of the present moment. These insights guide me as I imagine what the future could look like from a distinctly Caribbean perspective.

The Caribbean is a small place that significantly impacts the world. What part of your Caribbean identity or art practice do you think speaks to what is needed in the world right now?

The world is completely interconnected and interdependent. This way of under-standing coexistence had to happen in the Caribbean first, because it was a major global crossroad—ground zero for a globalized world.

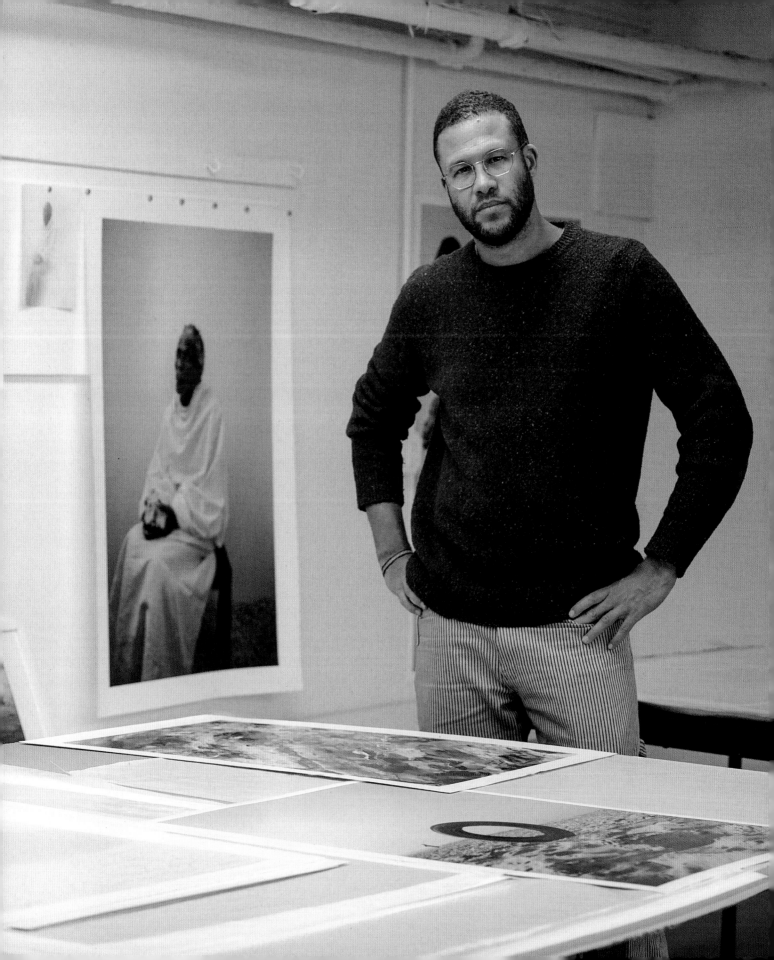

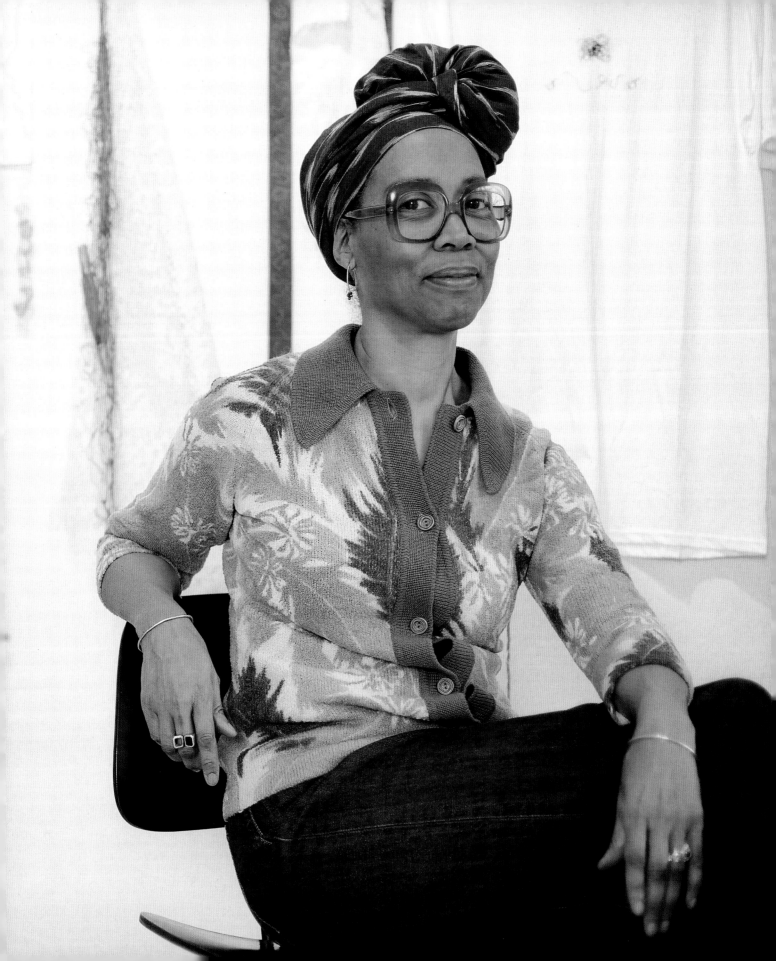

I've been asking makers throughout this project to talk about their relationship with art and design. But I think your critique of those definitions is more about the divide between art and craft. Can you talk about how you approach that in your practice and in your teaching?

I'm going to speak to craft, which gets separated from art because of Eurocentric constructs and definitions of art started in the guild systems in Europe. As a result, the definition of art gets limited to painting and sculpture. If I tell someone I'm an artist, they'll ask what medium I use. If I say I'm a textile artist, the next question often is whether I made what I'm wearing, which I may or may not have, but it's also very limited. I want them to think more broadly, so I'll explain that I unravel Confederate flags with other people as a performance. That way you know more about me as an artist than if I say I'm a textile artist. It actually lets you know I'm making work that is about community, that is about dismantling white supremacy, and that is also about textiles and symbols. If I tell you I created a multimedia performance piece that includes a hair bow, with a dreadlock, and features the MacArthur-awarded jazz violinist Regina Carter playing "Lift Every Voice and Sing" and "The Star-Spangled Banner," you know much more about me as an artist than if I say I make work around hair. I'm collaborating with some of the greatest musicians who walk this earth, and we're playing musical instruments that are tied to Africa. Maybe the person I'm talking to doesn't know about the violin's connection to Africa.

I find craft everywhere in the world, and those narrow definitions of what art is, I do not find those everywhere in the world. The word *craft* suggests power, as its origins are in words for strength and skill. There is power in craft. I seek to claim that power on every occasion, even here at Amherst. The classes I teach are textile-based, but I don't define those classes narrowly, as art, design, or craft classes. I teach a bead class called Talking with Beads, an embroidery class called Drawn with Thread, and a critique class called Critiquing the Critique, which I teach as a studio art practice. All address how we make art within community and why.

Even in the studio class, I invite students to examine how we are being critical about the mediums that we're using. What are we taking for granted? How are we defining what art is, and whom are we letting define it for us?

Just choosing the material of textiles or beads is a political act that honors the idea of craft. Craft can extend itself into what is called art and it can extend itself into what is called design, and that's a beautiful canopy for it all to be under. I let craft claim all that space. If someone says they're a painter, I ask, "What are you painting on?" Most of them will say, "Canvas." So that means

they're a textile person, right? Why is it just the paint that's honored? We have to break down those hierarchies.

So much of your process and your approach to making draws from ancestral memory. Is that conscious, or do you think it's coming from a deeper place?

I feel like there is ancestral memory in everything I do, whether I'm aware of it or not. Sometimes when an idea comes, I can retrace my steps to understand where it might have come from, but when the idea just comes, it feels like a gift from the ancestors. Like all of this, my brain, everything. That's all DNA. I'm the repository of that.

What provocations about Black womanhood or manhood does your work offer to viewers? What do you want them to feel, do, ask, or become when they encounter your work?

One of the projects I'm so proud of was asking seven Black femmes if I could set their poems in my hair font, Twist, and then asking each of them to read their poem out loud so that it would get embodied through their voice. I worked with a Black printmaker, Amber Braverman, who printed the poems individually. Then we printed all seven poems on top of each other (with a nod to the artist Glenn Ligon, because I just love the idea of making them hairier). The piece is called *1-877-OUR-CURL*. If you call that number, you can hear any of the poems individually. But my favorite is when they are in chorus. It is so beautiful to hear these Black femmes reading their own words.

I've also worked with Black men. I did a project inspired by Courtney Holmes, a barber in Iowa who in 2015 was giving free haircuts to boys who would read to him. First of all, he was teaching children that their ability to read has cash value! But also that they're going to get love, attention, and care. That was a beautiful thing around community. A poetry organization called O, Miami commissioned me for a project in 2016, and I did something similar—offered free haircuts (we paid the barbers) in exchange for reading a poem out loud. I selected Calvin Hernton's "The Distant Drum," which is a powerful political poem. Every time one of these brothers read it, they got a free haircut.

I've led workshops in university and college spaces where I've instructed participants to sit next to someone they don't know—I mixed up the whole room so they were not sitting next to their friends—and tell each other a hair story. Then they recount the story they were told but in the first person to emphatically embody it. Everybody has a hair story.

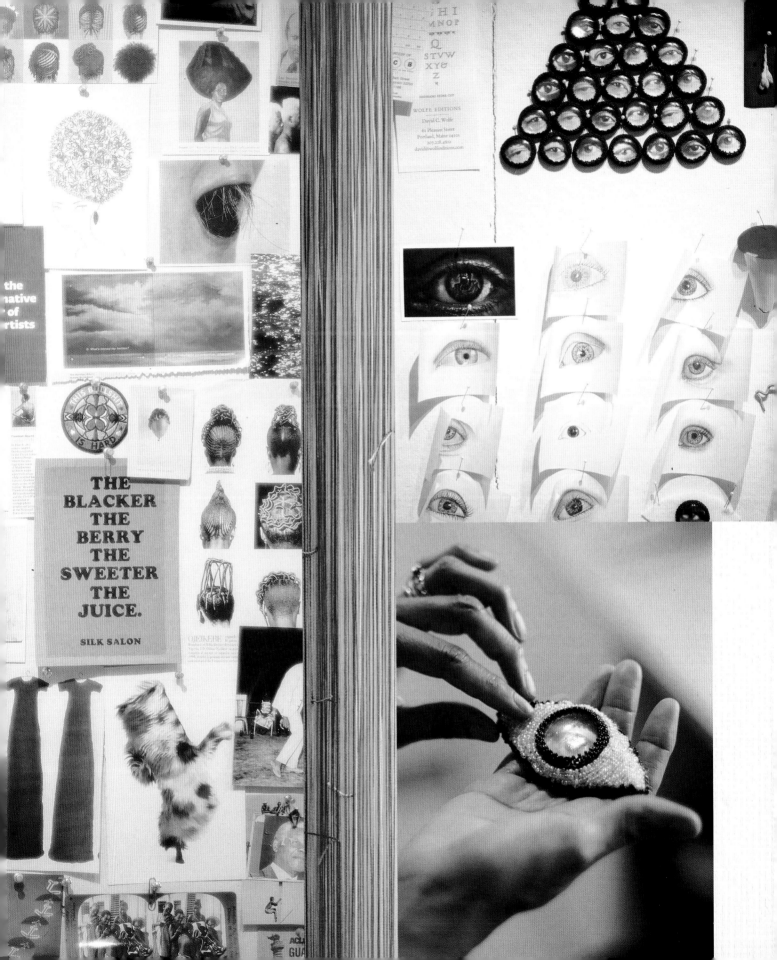

Storm
SAULTER

A MULTIDISCIPLINARY ARTIST SEEKING TO SUBVERT HARMFUL STEREOTYPES OF MASCULINITY

Photography led me to cinematography, which then led to directing and video art.

What did you make as a child before you even knew to call it art or design?

Being in Negril, which is a tourist town, I could buy disposable cameras that could shoot twenty-four pictures. There's no screen to check what you are shooting, so I would just shoot twenty-four pictures. But I was always interested in framing and composition, not just documentation. I had a sense for that very early on. I was also into design and liked thinking about designing fonts. When I was in high school, I didn't want to be a filmmaker yet. I designed film logos.

Was there a moment in your career or art practice when you had to reinvent yourself or your practice because of an obstacle?

I remember sending an experimental video art piece I made early in my career to someone who had played an important role in my art life, and she said, "Yeah, this ain't it." [*Laughs*] That made me step back and assess.

Filmmaking is a coming together of many things, including an idea, music, sound, lighting, the weather. You have to be like water, and be able to change direction or compromise when you arrive at a space and the conditions are different from what you expected. Obstacles come, and I've accepted that I have to be able to maneuver to get to the result I want.

How have you crafted a kinship with the land, people, and culture of the Caribbean?

I feel like I have crafted a kinship with my peers, elder creatives, and younger creatives in film, music, and academia. I'm a resource for a lot of those artists. I collaborate with a lot of them, not only the ones here in Jamaica but also artists in Trinidad and Caribbean artists in Miami, New York, and all over. I try to be active in terms of how much information I pass on. I try to be open when people approach me about working. I try to show my country and culture in a way that is true, that is commenting on the world through our lens.

I cofounded a group called New Caribbean Cinema, a film collective where my peers and I worked together to create community filmmaking, even as we were doing individual work. We would pool our resources to support each other's work. We were mostly first-time, independent filmmakers making work that spoke to Jamaican stories.

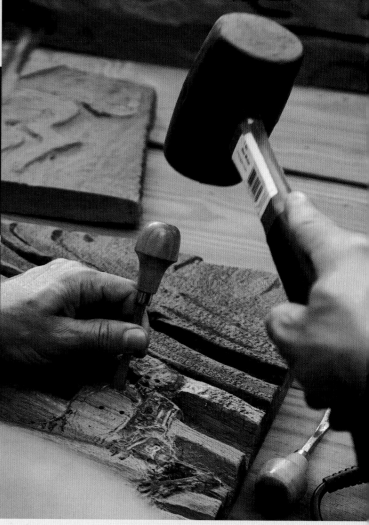

We created a space to host conversations with filmmakers in an intimate room. The work was "challenging" or unusual for Jamaican screenings, and that felt kind of tight. It felt like everybody there was committed. We were sitting there, talking about what we were going through. That's what community and kinship look like: action and conversation.

The Caribbean is a small place that significantly impacts the world. What part of your Caribbean identity or art practice do you think speaks to what is needed in the world right now?

Caribbean people are people of the future. We are a cultural, racial, and spiritual meshing, and not that there aren't still issues of shadeism here, but across the region—on some islands more than others—we have gotten past the colonial and racial reckoning that a lot of countries are still dealing with. I think there's a resilience and a push to enjoy life. Look at Carnival. That represents freedom of the spirit and the soul. It suspends all laws, but it also has this feeling of original humanity expressing itself. Slow economies have hindered Caribbean people, but we know how to live on, how to live well and live loud and live life to the fullest. I think the world could learn something from that.

Your work addresses manhood and masculinity. Can you talk about that from the perspective of a Jamaican filmmaker?

My work is definitely focused on masculinity, and specifically Jamaican masculinity. These ideas were ingrained in me by my older brother and his friends and by the general culture. It's hypermasculine, extreme, and can be very destructive.

I created a new piece titled *Laugh Now Cry Later* that was shown in the *(IN)Dependence* exhibition at the Olympia Gallery at the end of 2022. That was the first wood sculpture I ever attempted, so it's very crude. It's a portrait of a guy with tattoos that express his outlook on life, on the world, on his body. Every one of those tattoos says something precise and recognizable about typical Jamaican maleness. One was "Death before dishonor" with a big scorpion. The Dennis Brown song "Death Before Dishonor" was famous when I was growing up, so I knew that phrase, and I always thought it was crazy. But I see it out here right now. There are lots of men walking around in this country right now who are ready to fight if they feel disrespected. We laugh about the overly

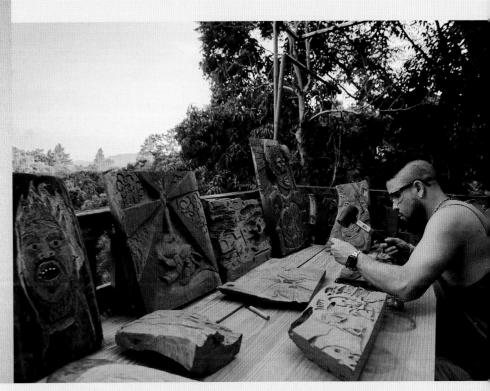

performative masculinity. We laugh about it, but we celebrate the music that celebrates it. I paired that sculptural element with a photograph I had taken in 2006 of a crime scene, and it says, *Mad. Sickhead. Nuh good.* Which is about the things we tell ourselves, but it's right in the culture, and it's right in the behavior.

I would normally print photographs on flat paper, but I printed this one on canvas to give it a three-dimensional quality. The crudeness of that piece really matched the energy of this portrait. I signed it by putting on a semi-hidden tattoo as a signature, but also to be like, "Look, these aren't behaviors I'm exempt from."

What facets of your identity are most prominent in your work?

I do think there is a certain darkness, unpredictability, and under-lying tension in the work for me that feels the most like my voice.

What are some of the sources you consult in your search for memories, or in your discovery of new memories?

That act of going through images I've taken over many years unlocks memories. I'm constantly taking pictures, so there'll be some image that's fresh in my mind and I'll put it next to another photo I took some time ago and just have them on a little box. Then I'll run into a picture I took in Cuba in 2012, when I was

"Caribbean people are people of the future."

documenting athletes or street art or something textural like an etching. All of a sudden, I have these three images and there's something about the composition, the color play, the tones, what they're saying; it all comes together to say something so much bigger.

I use my filmmaking to treat photos like a storyboard. I am recap-turing my memories and almost creating new ones or giving them new purpose. That's how I've been thinking about this photo project: giving purpose to your memories, holding on to them as something like they're not just past.

Derek Walcott wrote, "Sit. Feast on your life." So I'm trying to feast on my life. I'm trying to not make all the spaces I've lived in and all the strange experiences I've had mean nothing.

Studio 397
SAMANTHA JOSAPHAT + LUIS MEDINA

AN ARCHITECTURE PRACTICE THAT CENTERS SUSTAINABLE AND ETHICAL DESIGN

Studio 397 is a hybrid of architecture and interior design. We try to make sure there's a strong understanding of how architecture influences interior design, but we also respect how interior design is ultimately about the feeling that someone has when they're walking through a space. We achieve harmony between the two different design scales with balance and an appreciation for both. Our designs make a statement while also feeling timeless.

What did you make as children before you even knew to call it art or design?

Samantha Josaphat: I took advantage of my resources, which was the furniture in my house. One day my room was an airplane, and the next day it was a grocery store. I loved taking what I had in my room and reorganizing it to imagine what else it could be.

Luis Medina: I took a lot of drawing classes, and in middle school I took woodworking class, which I really enjoyed.

Was there a moment in your career when you had to reinvent yourself or your practice because of an obstacle?

Samantha: Yes. July 10, 2017, the day I decided to leave corporate America and start Studio 397. I had already spent too much time, money, and tears in the profession, and so I told myself, "Let's try something different and see if we get a different result."

Luis: Launching Studio 397 was a pivot for me, from construction management to design. But I really had to reinvent myself when I decided to leave accounting and finance and go into construction management. I had moved to New York and joined a big accounting firm, but I never liked it. In trying to figure out what I really wanted to do, I knew I liked to see things take shape and be built. Watching my grandfather work in the construction industry was exciting. That was an exciting job to me, so that's when I decided to make a big change.

In this interview, Samantha and Luis sometimes speak individually and other times speak with one voice as Studio 397.

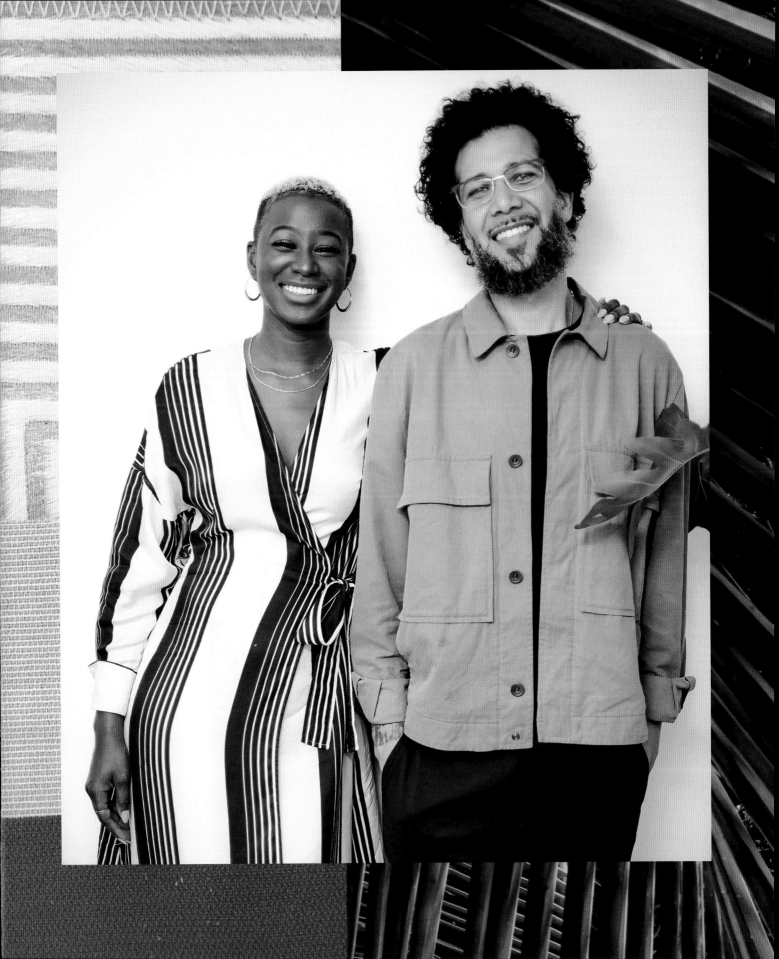

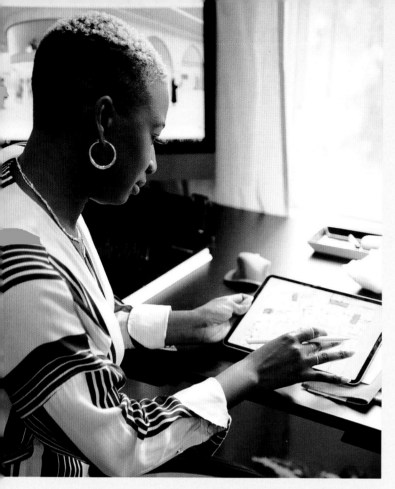

How have you crafted a kinship with the land, people, and culture of the Caribbean?

Samantha: For me it's this idea of weaving things together. It tends to be the role of the architect to bring different pieces and people together in a project to create harmony. I think of it like braiding hair. I'm always connecting back to hair, even though I don't have any right now. Growing up, I used to do different hairstyles, like braiding or pressing. Weaving would be my connection to my heritage.

The Caribbean is a small place that significantly impacts the world. What part of your Caribbean identity or design practice do you think speaks to what is needed in the world right now?

Samantha: I love music and think it is a form of diplomacy that helps connect people to different cultures. As an architect, I know the importance of music. How can I incorporate rhythm and movement into our designs to serve as that form of diplomacy between people?

What feelings are you trying to evoke through your work, and what do you hope viewers will do as a result of their interactions with it?

Samantha: I want our work and the connection to the Caribbean to speak about a sense of confidence in their identity.

Luis: When I think about a space that's peaceful and beautiful, I'm talking about nature. We want to design spaces that provide an energy of peace and relaxation.

How has your work sought to expand the view of non-Caribbean Black identity and culture?

Samantha: There's an aesthetic we like that tends to be this clean, minimal design that is always attached to Scandinavian architecture and design. But I'm Black and Caribbean, and if I like that and if I create that, then it's a type of Black Caribbean design. We hope that we continue to show that this isn't just Scandinavian design; this is good design coming from different people from around the world. There's so much diversity and history that you're going to see many different influences within the design itself.

Thinking about the region as a space where we were forced to create a connection to the land, how do you see your relationship with the land itself? How is climate change impacting how you use materials and/or think about the land you're situated in?

Luis: It is obvious to us, and hopefully to everybody, how climate change is impacting islands and coastal areas more often and drastically, and how countries that don't have the resources that the United States does are not able to protect themselves from these changes. The changes are mostly driven by countries with the most resources because they tend to have the biggest carbon footprints. I got certified as a Passive House designer because the decisions we make have a big impact on people who are vulnerable.

Samantha: People in our industry who work on big projects are often removed from vulnerable communities and don't always have that connection, like I do with my family in Haiti and Jamaica. There's a deeper sense of responsibility. I can't connect back to my culture if my culture isn't protected because of my actions. So it's important to choose vernacular materials that are in close proximity to our project site when possible so it doesn't cause all this off-gassing in the space or pollution from transporting the materials we're using. I'm trying to be conscious of every line we draw. What is this line's impact on the world? Who is involved in this line? It's not just me drawing this line and the contractor

"We want to design spaces that provide an energy of peace and relaxation."

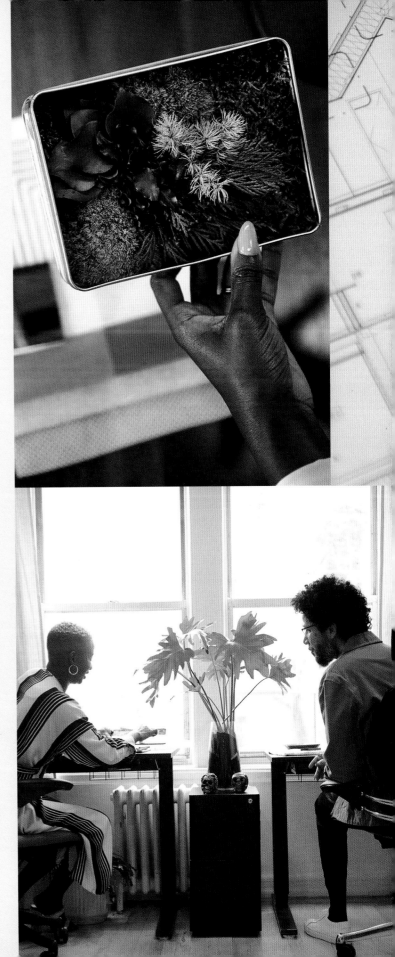

putting something up; it's someone making this material, someone transporting this material, someone taking time away from their kids and putting their body in harm's way to put up this material. We're trying to be conscious of all the different impacts our design decisions can make in relation to climate change.

Has your approach to or use of materials changed over time in your practice?

Samantha: This connects back to the conversations I had with my grandfather about the use of concrete and how it's his architectural identity. I love the beauty of concrete, but I also know its impact on the environment. What we've been trying to do is figure out how we can express that aesthetic with new technology and by connecting with vendors or researchers at different universities who are changing the composition of concrete. Are we adding more air to it or adding more sustainable aggregates to it? My perception of concrete has changed over time and has changed how I want to use it, but I still love it. As crazy as it sounds, I see concrete and I see outside. If I can blend that boundary between the indoors and outdoors, I feel like that's a successful project. So I'm invested in the research around how technology can improve the sustainability of these traditional materials that have such an impact on my sense of beauty.

Luis: I used to think it was bad to use wood because you're cutting down trees. Now we're more educated about materials. Different woods can be sourced responsibly and treated in a way—sort of pickled—with chemicals that are not bad for the environment. They have more stability and can be used in place of hard, tropical wood, which usually comes from places where there's a lot of deforestation. So both concrete and wood are materials we are always researching, trying to keep up with the latest developments on how they can be greener materials.

Is there anything else you'd like to share?

Samantha: I like proving people who underestimate us wrong with silence. I don't even have to say anything. At some point it's just like, "Deal with it."

Terry
BODDIE

A PHOTOGRAPHER, MULTIDISCIPLINARY ARTIST, AND EDUCATOR WHOSE WORK EXAMINES MEMORY, HISTORY, AND CULTURAL IDENTITY

I experiment with different techniques and materials in a single pictorial space or object in order to play with perceptions and evoke memory.

What did you make as a child before you even knew to call it art or design?

Much of how I approach my practice now is embedded in some of the things I made as a child. I think anyone who grew up in the Caribbean remembers making their own toys, like go-karts, spinning tops, or kites. All these things encouraged us to translate materials into form, which is what we do as artists. Crafting the object, seeing how materials either resist or comply through my investigations of them, gave me insight into what was possible.

Was there a moment in your career when you had to reinvent yourself or your practice because of an obstacle?

Having to take what was given to me in the form of education and augment it with ancestral knowledge to make sense of how I sit within my own practice, and also within history. So much of what we were taught in the diaspora was lacking, and so my reinvention was about gathering those elements that were not valued within that structure.

No matter where we are in the world, we always go back to our Caribbean homes as a source of inspiration for our work, for our sense of belonging. How have you crafted a kinship with the land, people, and culture of the Caribbean?

I'm from a largely agricultural, rural environment, and that finds its way into my work, where I might use, for example, a grape leaf or mango leaf to represent a human brain or a weapon, respectively. I use the shapes and the material iconographically or metaphorically. The leaf that falls from its tree still retains the genetic material of that tree. Even when we are dispersed, we still retain the genetic material, memory, and history of our places of origin. When you see a leaf being used in my work, it's expressing the idea of a connection to the root.

I've also used sugar mills to reference mausoleums because of the role they played in the dehumanization of the African body. I created a photo collage that I titled *Crypt* using a windmill ruin on the former Hamilton plantation on Nevis. Underneath the photo of the windmill is a fragment of the slave ship architectural plan to indicate the relationship between those two systems. Floating in the negative space are

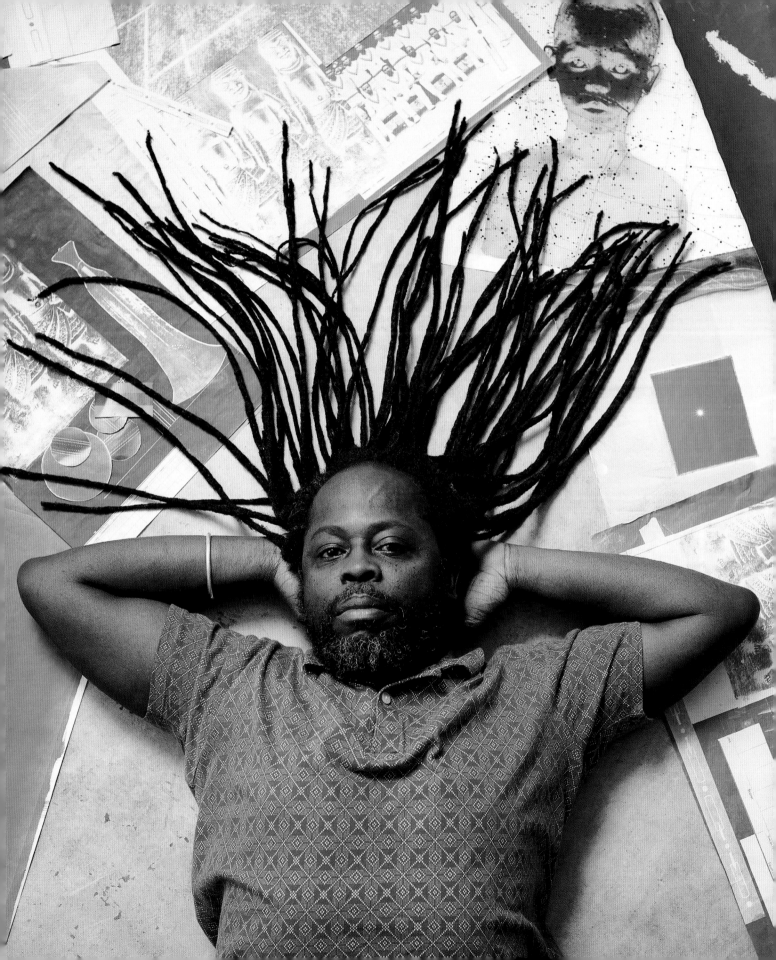

diagrams that show the engine that powered the plantation system, which was later replaced by machines during the industrial revolution when steam was used to crush the cane. But during slavery, this giant juicer was operated by human beings. They would go up the steps and push the canes through the rollers to extract the juice, which would flow to the boiling house. This is pretty gruesome, so forgive me, but someone would stand next to the person feeding in the cane because if that person got pulled into those rollers, the other person was ready with a machete to cut off their limbs in order to save their life. When you know that history and see the violence of it, you understand that this plantation ruin is not a structure that should be lived in.

The Caribbean is a small place that significantly impacts the world. What part of your Caribbean identity or art practice do you think speaks to what is needed in the world right now?

The ability to interrogate visual images, particularly colonial images that were made with the first cameras where the subject in front of the camera was passive and not in charge of their representation—a colonial trophy. I teach the history in order to reimagine those images and restore the dignity of those ancestors. Through acts of empathy, we can somehow connect to individuals across time and see them for who they were beyond the narrow fragment depicted in that image. This is why iconography is such a wonderful thing, because you're able to transmit so much information through symbol and form.

What feelings are you trying to evoke through your work, and what do you hope viewers will do as a result of their interactions with it?

Communicate across cultural divides so that people who may not share my geographical identity and history can still connect to some aspect of what I'm trying to transmit to the world.

How has your work sought to expand the view of non-Caribbean Black identity and culture?

A lot of my work addresses the cross-cultural aspects of Black identities that are not limited to the Caribbean. We are all impacted by the same historical and social forces. There's a whole series of images where I use locked hair as iconography, which may be specific to places such as Jamaica and Kenya but speaks across geographical borders because it addresses an identity that originates from the continent. Egyptians had locked hair, for example. I think the *Blueprint* series is probably the most direct example because it portrays the entire ecosystem of slavery and colonialism regardless of where we are from in the diaspora.

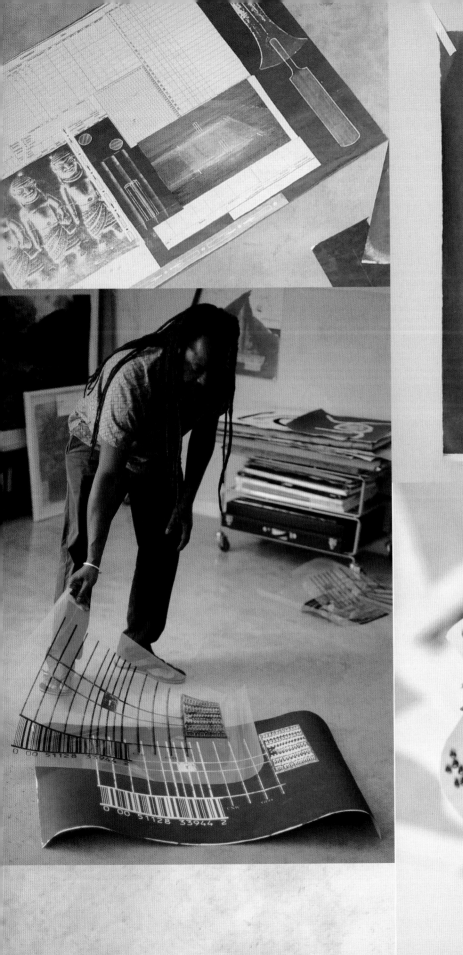

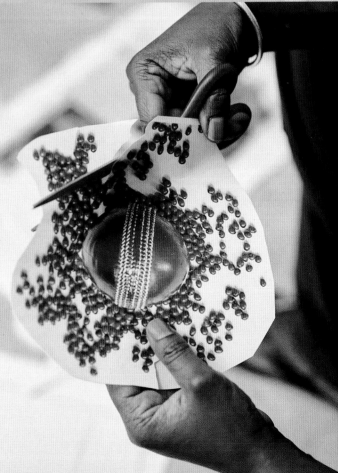

To what extent do you feel a need to connect to your island or the community as a member of the diaspora? And what does that connection look like for you?

One of the ways I connect is by being a part of the Nevis Historical & Conservation Society, which is engaged with the preservation of and advocacy for the physical island and its history. I try to assist as much as possible in making sure they're visible and able to keep that mission alive.

Is there a vibrant Caribbean community where you currently live and work?

There is, actually; in the Oranges where I am, and also in Maplewood, Montclair, and Newark, New Jersey. We have our own Caribbean festivals, Carnival, and businesses.

Can you talk about how or whether your work closes the gap between art and design practice, or whether you would like to close that gap more?

The gap should be completely collapsed. I don't want you to think of my work as a market object. I think of the people who acquire my pieces as custodians or caretakers, in a way. They're people who acknowledge their responsibility for that piece, and in the best circumstances, share it with a public institution where many people can see it.

What materials are you most connected to?

Gelatin silver is the term for the substrate on the surface of the paper that when impacted by light causes a photographic image to form. Technically it is gelatin embedded with silver halite crystals. I purchase it as a liquid and then make my own photo paper.

Because of its malleability, it offers a lot of possibilities for how to coat it onto a surface, which has great potential in terms of how the image is interpreted. In graduate school, I was making photographs using regular photographic paper. I was in seminars with painters and printmakers who had no language for how to talk about my work critically because they had never taken a history of photography class. They critiqued my photographic work as you would a print or a painting. But a photographer would talk about their work completely differently, and so out of frustration, I started making photographic prints that looked like drawings and paintings. I augmented the emulsion with color underneath, color on top, and mark-making, but the primary ingredient was photographic materials, even though the photograph wasn't readily apparent. So my investigation of material started out of frustration, but then it became part of my creative practice.

Locks of hair are also a material. I create images of locks strewn across surfaces photographically, although they look hand-drawn.

I took a fragment of a lock, put it onto a light-sensitive material called orthochromatic film, exposed it to light, processed it, scanned it, and then printed it. All those stages are photographic, but the eventual image looks like a Franz Kline drawing. Sometimes it's about fragmenting the process to communicate an idea most effectively to the audience because I don't want the viewer to get bogged down in the photographic part of it. I want them to see idea clearly. The photographs of locks configured in various ways are investigations of language systems and how language is formed through history, through iteration, through proximity to other people, and through other cultures. It is formed over time, sometimes over generations, and over hundreds of years.

The length of my hair is an index of time. My personal experience is sort of locked into my hair. You know, when you grow your hair, essentially it's a living history. When I make images with locks, it's to refer to the process of history and memory, and the time it takes to form personal experiences. I'm creating my own language system, if you will, by using my own hair as a reference point.

Does your work reflect your personal memories or, more broadly, the idea of memory as a form or material of art-making?

I've been thinking about using scent as a memory trigger in an installation context. Memory is not an isolated exercise. I'm constantly in conversation with my siblings to contextualize memory because we each remember the same things differently.

I also look to archives as a site of memory. One of my reasons for being involved with the Nevis Historical & Conservation Society is that they have a huge archive, which I can mine for materials that I use in my work. I also use that material to engage school-age children on Nevis to look at history critically. To interrogate it, and sometimes discard, push back against things that are not useful for how we see and frame ourselves. Archives speak to us across generations.

I feel sometimes that I'm being given memories by my ancestors, a kind of memory gift across generations. The things that I remember directly when I engage with my ancestors, those are a product of memory, which becomes part of the work.

Is there anything else you'd like to share?

What you are making now as an artist and how you describe your practice is something that the next generation will see and be enriched by. Maybe you don't think of it that way now, but remember that we have to leave signs for the next generation to follow.

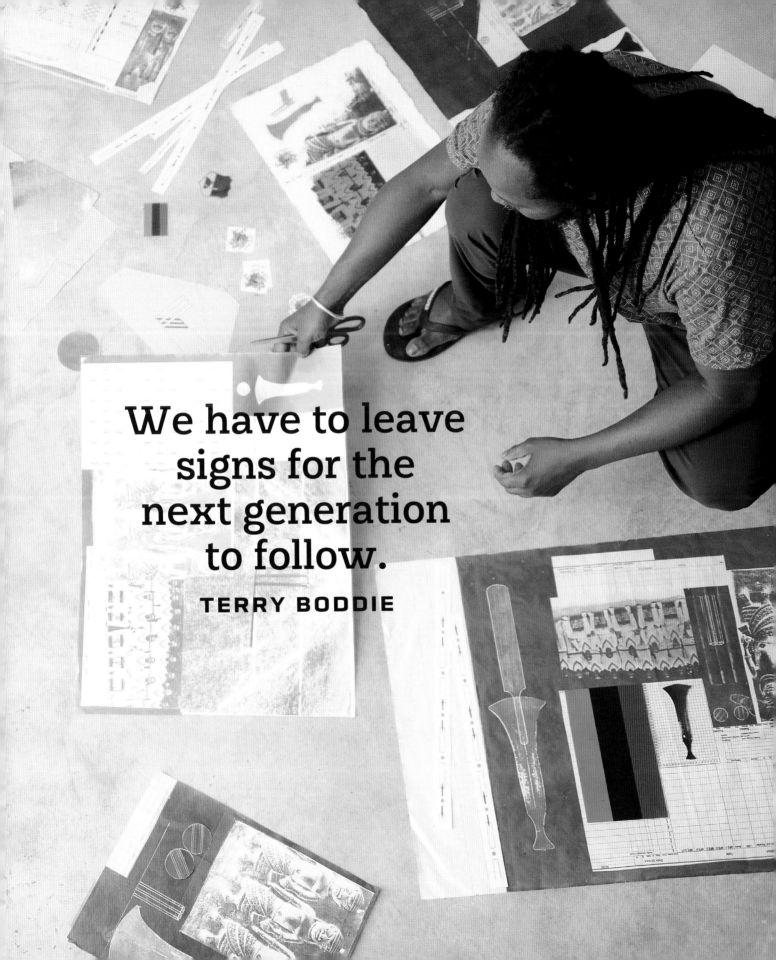

We have to leave signs for the next generation to follow.

TERRY BODDIE

ACKNOWLEDGMENTS

Curating and making this book taught me that being a Pan-Africanist maker (artist, designer) and community builder can take many forms. Through this book, I built a new creative family, a community of Black Caribbean makers who kindly opened the doors to their studios, lives, and places of inspiration to me. Their commitment to using their talent to reinvent themselves and critique colonial narratives, Caribbean identity, preconceptions of Black womanhood, and the environment for the future of Black people is the same dedication I hope people embody to uplift the community around them. I admire and respect everyone profiled in the book, many of whom this project allowed me to meet for the first time. I can't thank them enough for trusting me with their stories and sharing spaces I know are private to many. This book would not have been possible without them.

Thank you to Shoshana Gutmajer at Artisan Books, who, in the fall of 2020, during my first year of grad school, sent me an email asking if I had thought about writing a book. Little did she know that I had tried to write a book many years prior. When it was time to pitch my idea to Artisan, I thought about a quote from Toni Morrison: "If there's a book that you want to read, but it hasn't been written yet, then you must write it." Thank you for giving me the time and space to bring this to fruition.

In the winter of 2022, Jennifer Rittner joined as the editorial director and helped me organize my thoughts, compile the list of makers, edit copy, manage the project, and so much more. I am immensely grateful for Jennifer's hard work, support, and enthusiasm for the project. I would not have been able to complete this book without her keen eye for words, care, and thoughtfulness in making sure every contributor, whether maker, scholar, collector, or advocate, was represented beautifully and respectfully.

I started outreach in the summer of 2022, and photographer Alaric S. Campbell and I began photographing makers that September. Between September and December, we traveled between Baltimore and New York to complete the only stateside photo sessions together before I was off to Jamaica for ten months on a Fulbright. Alaric made gorgeous images that set the creative direction for the entire book. I've worked with him for more than thirteen years, and our collaboration is always a joy. Thank you, Alaric, for believing in this project and making the most beautiful archival photographs for the community.

In addition, I had the pleasure of working with thirteen independent photographers across four continents: Amilcar Navarro, Ania Freer, Ari Skin, Brie Williams, Cydni Elledge, Jaryd Niles-Morris, Jason C. Audain, Kelly Marshall, Nicolas Derné, Nicole Canegata, Sidy Ba, Tarina Rodriguez, and Yuri A. Jones. I'm proud that half the group is female-identified photographers and many are part of the Caribbean diaspora. Each photographer was eager to contribute and understood the importance of making this book come to life. I can't thank them enough for contributing and making the most stunning imagery.

To Karin Cho Myint, my all-time favorite creative collaborator, I can't thank you enough for believing in the book's vision and providing the creative envelope that binds our narratives for the present and future generations. Your insightful, creative eye and thoughtfulness in representing the Caribbean as a beautifully designed cultural artifact is a necessary addition to the archive. This book is the fruit of our collective labor and will inspire many.

Many thanks to Artisan for allowing me to introduce this community of makers to your publishing family. To Lia Ronnen, Shoshana Gutmajer, Suet Chong, Jane Treuhaft, Laura Cherkas, and Sibylle Kazeroid for editing the manuscript; big ups to all of you! Your enthusiasm and guidance kept me motivated and reaffirmed the importance of this book.

To my friends and family, thank you, especially my sister, Debbie Sirico, for stepping in when needed and cheering me on with any project idea. I know I can always share the news with you first. Thank you, Nicole Emser, for helping with research, editing interviews, and anything needed to keep the interview process moving. And to Michael Hatcher for always styling me to look my best, no matter where you are.

To my professors at the Tyler School of Art and Architecture, Lauren Sandler, Roberto Lugo, Karyn Olivier, Rachel Grace Newman, and Alex Strada, your encouragement to go deeper into my research and studio practice inspired me to make this book. Thank you!

Thank you to everyone taking the time to experience this work in order to investigate Caribbean histories, see the region from a different perspective, advocate for Black Caribbean makers, visit the spaces they create, and embrace and implement Caribbean folklore and sayings into your lifestyle. For us to move forward, we must go back, and I'm thankful for each maker's willingness to go back in time and be a role model for our future. Big ups to all Black Caribbean makers and the diasporic community members who are sharing our stories, building legacies, and creating work that honors our resistance, resilience, and existence. Let us continue to create, be joyful, and make our ancestors proud. I see you; we can be seen together, and now the world sees us, too.

Malene Barnett is an award-winning multidisciplinary artist, textile surface designer, and community builder. She earned her MFA in ceramics from the Tyler School of Art and Architecture and undergraduate degrees in fashion illustration and textile surface design from the Fashion Institute of Technology. Malene received a Fulbright Award to travel to Jamaica in 2022–23 as the visiting artist at Edna Manley College of the Visual and Performing Arts in Kingston.

Malene's art reflects her African Caribbean heritage, building on her ancestral legacy of mark-making as a visual identity, and has been exhibited at galleries and museums throughout the United States, including the Mindy Solomon Gallery in Miami, the Museum of Science and Industry in Chicago, Sugar Hill Children's Museum of Art & Storytelling in New York City, the African American Museum of Dallas, and Temple Contemporary in Philadelphia. Malene's art and design work has appeared in numerous publications, including the *New York Times*, *Galerie*, *Elle Decor*, *Architectural Digest*, *Departures*, and *Interior Design*. In addition, Malene hosts lectures on advocating for African Caribbean ceramic traditions and has participated in residencies at Anderson Ranch Arts Center, Watershed Center for the Ceramic Arts, Greenwich House Pottery, Judson Studios, the Hambidge Center, and Haystack Mountain School of Crafts.

Malene is also the founder of the Black Artists + Designers Guild, which supports independent Black makers globally. When she's not traveling the world researching Black diasporic aesthetics, Malene resides in Brooklyn, New York.

GREAT-GRANDMOTHER, SIMONE LEIGH AND ELI ALBA **₪ GIANA DE DIER** MY GREAT-GRANDMOTHER AMELIA GRIFFITH **₪ IBIYANE: ELODIE DÉROND** MY MATERNAL GRANDFATHER, ROGER NUMA, AND MY PARENTS, RENÉ AND CHANTAL DÉROND. **TANIA DOUMBE FINES** MY MATERNAL GRANDFATHER, BENOIT DOUMBE, AND MY BROTHER, JULIEN FINES DOUMBE **₪ ISHKA DESIGNS: ANISHKA CLARKE** MY MOM, JOAN JAGARNAUTH, AND MY PATERNAL GRANDFATHER, OSWALD CLARKE. **NIYA BASCOM** ALL MY ANCESTORS, BUT IN PARTICULAR, MY GRANDMOTHER MS. ABBY FREY, AND MY COLLEGE PROFESSOR OF AFRICAN STUDIES, KENNETH JENKINS **₪ JASMINE THOMAS-GIRVAN** MY GRANDMOTHER FRANCES SMELLIE AND MY PARENTS, EVELYN AND DONALD THOMAS **₪ JOHANNA BRAMBLE** SHEILA HICKS; JOCELYNE ETIENNE-NUGUE, AN ETHNOLOGIST FOCUSING ON AFRICAN CRAFTS AND THE AUTHOR OF MANY BOOKS; AND A WOMAN I CALL MY MAMA OF WEAVING: MAÏTÉ TANGUY **₪ JOIRI MINAYA** MY GRANDMA **₪ JUANA VALDÉS** MY MOTHER, ZORAIDA VALDÉS **₪ KATRINA COOMBS** ALL THE WOMEN WHO CAME BEFORE ME IN MY FAMILY **₪ KELLY ANN WALTERS** ZELDA ICYLIN WALTERS, MY PATERNAL MATRIARCH, WHO IMMIGRATED TO THE UNITED STATES IN 1970. SHE WAS A POWERFUL FORCE WHO CONTINUES TO GIVE ME STRENGTH AND INSPIRATION EVERY DAY **₪ KRAIG E. YEARWOOD** MY UNCLE ANTHONY PHOENIX **₪ LA VAUGHN BELLE** MY FATHER **₪ LAVAR MUNROE** MY PARENTS, BEVERLY ELIZABETH AND FREDLIN MUNROE; MY GRANDMOTHERS, SADIE CURTIS AND REBECCA HANNA; AND MY CHILDREN, BEVERLY ANN AND ENZO CALYX MUNROE **₪ LEONARDO BENZANT** MY GRANDMOTHER IBAYE PATRIA **₪ LEYDEN YNOBE LEWIS** MY FATHER, LIONEL JOSEPH LEWIS, AND MY MOTHER, SHIRLEY ANGELA LEWIS **₪ LISANDRO SURIEL** DECOLONIALITY AND THE MYSTERIES OF NATURE **₪ M. FLORINE DÉMOSTHÈNE** THE DEITIES THAT WE'VE SUMMONED FOR YEARS IN OUR PRACTICE **₪ MALENE DJENABA BARNETT** ALL BLACK WOMEN MAKERS **₪ MARK FLEURIDOR** MY PARENTS AND MY OLDER SISTER, AND THE MOTHERS IN MY LIFE **₪ MARLON DARBEAU** MY GRANDFATHER BENJAMIN DARBEAU; MY DAD, RONALD DARBEAU; AND MY GREAT-UNCLE EGBERT DARBEAU